In the Gardens of Impressionism

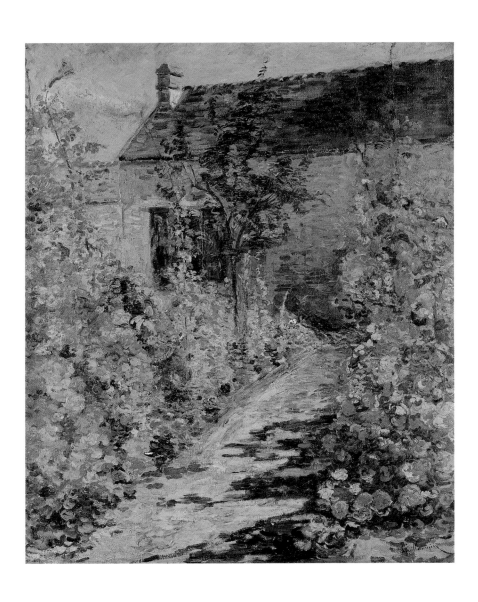

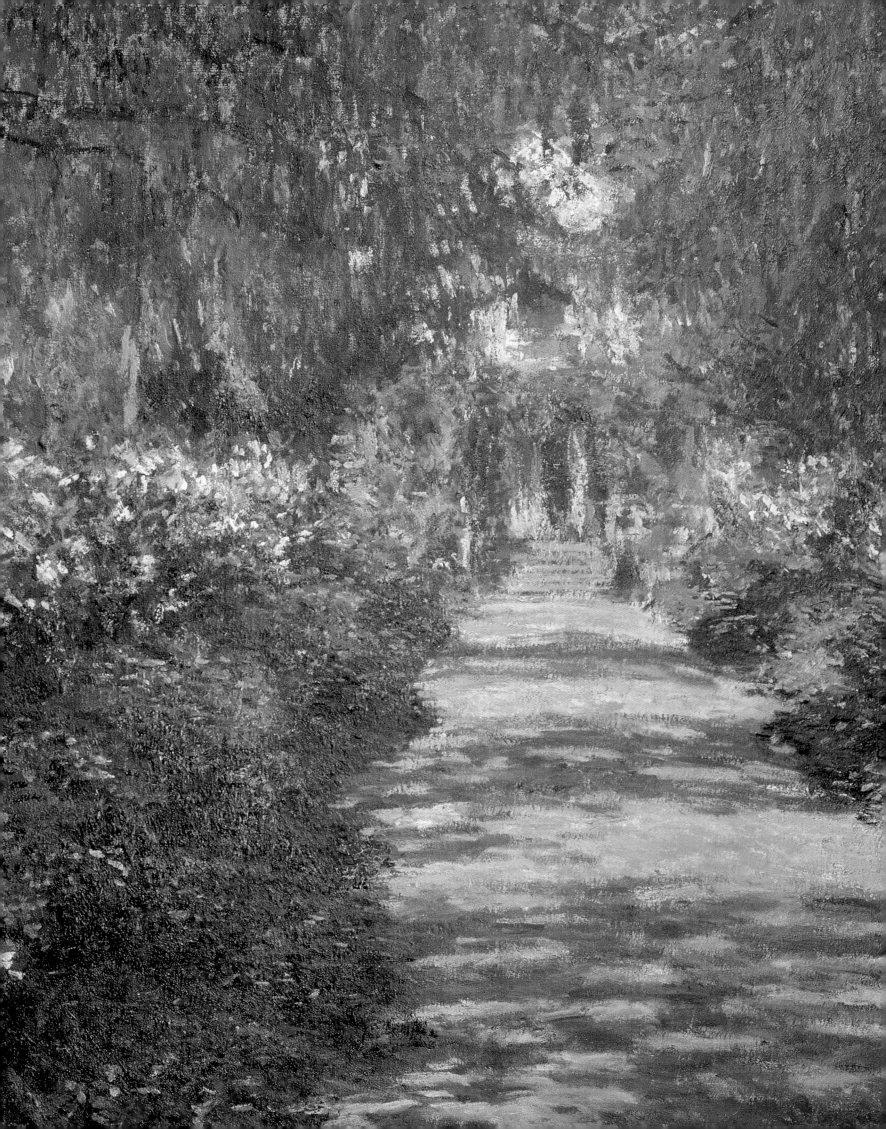

In the
Gardens of
Impressionism

CLARE A. P. WILLSDON

THE VENDOME PRESS

For my parents
Dr John A. Willsdon and
Dorothy I. Willsdon

First published in the United States of America by
The Vendome Press
1334 York Avenue
New York, NY 10021

ISBN: 0-86565-2325

Library of Congress Cataloging-in-Publication Data

Willsdon, Clare A.P.
 In the gardens of impressionism / Clare Willsdon.–
1st ed.
 p. cm.
 Includes bibliographical references and index.
 ISBN 0-86565-232-5 (hardcover : alk. paper)
 1. Impressionism (Art)–France. 2. Painting, French–
19th century–Themes, motives. 3. Gardens in art.
I. Title.
 ND547.5.I4W53 2004
 758'.5–dc22

 2004011317

Printed in Singapore

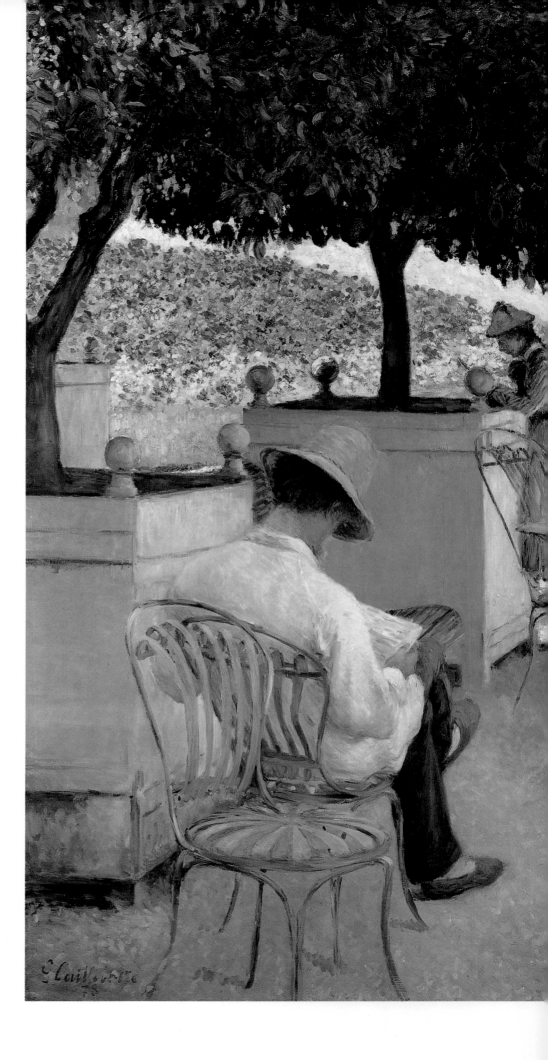

p. 1 Armand Guillaumin, *The Nasturtium Path*, c. 1880

pp. 2–3 Claude Monet, *Main Path through the Garden at Giverny*, 1884

pp. 4–5 Gustave Caillebotte, *The Orange Trees*, 1878

CONTENTS

Preface

Stéphane Mallarmé, the writer and friend and supporter of Impressionists such as Claude Monet, Pierre-Auguste Renoir, Camille Pissarro, Berthe Morisot, and Edouard Manet, in 1876 set gardens at the heart of the group's work: 'these artists as a rule find their subjects close to home, within an easy walk, or in their own gardens'.[1] A picture by Monet of his flower-filled garden at Argenteuil, with his infant son Jean playing tranquilly, had, in fact, been one of the major works in the Impressionists' 1876 exhibition, while one of a laundress washing clothes amid the flowers and foliage of a private Paris garden had featured the same year in an exhibition of Manet's work.

Public parks and gardens were likewise 'close to home'. The Bois de Boulogne, the Tuileries Gardens or the Parc Monceau in Paris were painted by a number of the Impressionists, just as Renoir transformed the garden 'square' before the church of La Trinité near his studio in Paris into an oasis of dappled sunlight and luminous shadow, and Monet and Pissarro portrayed London parks. But Pissarro also painted cabbages and beans in kitchen gardens. And by the late 19th century, Monet was not only creating and painting the supreme 'garden of Impressionism', at his new home at Giverny, but also seeking out gardens at considerable distances: in Bordighera on the Italian Riviera in 1884; in Antibes in 1888. Meanwhile, like Monet, other Impressionists became 'artist-gardeners', such as Gustave Caillebotte at Petit Gennevilliers near Paris, or Renoir, who in his later years delighted in keeping a semi-wild garden near Cagnes on the French Riviera.

The birth of Impressionism had coincided with an unprecedented explosion of popular, commercial and municipal enthusiasm for gardens, gardening and all things horticultural. 'Plant hunters' were introducing exotic flowers and plants from Asia, America and Africa, while new techniques of hybridization and cultivation were swelling the catalogues and nurseries of the great French, Belgian and British growers such as Vilmorin-Andrieux and Truffaut of Paris, van Houtte of Ghent, and Veitch of London, who all came to prominence in the 19th century. Stimulated by Paxton's Crystal Palace in London, conservatories, and the flowers which flourished in them, including rare orchids, became virtual status symbols. The expansion of the railway system turned numerous parts of the Riviera into market gardens, from which cut flowers were sent to Paris and beyond, while the parks painted by the Impressionists in Paris were part of Napoleon III's and his Prefect Haussmann's 'Transformations' of the ancient French capital into a modern city of space and light.

Meanwhile, even before the Impressionists, a flower garden had been specially created at Lyons as inspiration for the painters who created the designs for the city's famous floral silks. Two artists much admired by the Impressionists – Eugène Delacroix and Gustave Courbet – had also begun to explore the potential of gardens as pictorial motifs. And as Impressionism came to prominence in France, so parallel movements in other countries further developed the close associations between horticulture and Impressionist painting.

Aspects of the 19th-century 'garden movement' and its links with French Impressionism were considered by Sylvie Gache-Patin in a pioneering chapter in *A Day in the Country* (1984), while Robert Herbert devoted a chapter to parks and gardens in his *Impressionism: Art, Leisure and Parisian Society* (1988). Paul Hayes Tucker and Virginia Spate have explored Monet's garden subjects at Argenteuil and Giverny; Robert Gordon, Claire Joyes,

Charles Moffett, Charles Stuckey, Daniel Wildenstein and others have documented Monet's life and work at Giverny. The garden historian John Dixon Hunt has situated Impressionist garden painting within the tradition of the 'picturesque'; Pierre Wittmer has linked aspects of Caillebotte's and Henri Le Sidaner's work with other horticultural traditions.

This book, however, is the first in-depth study of the Impressionists' affection for gardens, whether as motifs in their own right, or as a stage for a variety of human activities and events, and it is part of my ongoing research into the role of gardens in 19th- and 20th-century art. Taking a thematic approach, the book places the Impressionists' garden paintings within their wider social, political, cultural and scientific as well as horticultural contexts, and shows their influence in other countries. It identifies the range of gardens represented by Impressionist painters – from private and family gardens to urban parks, 'social' gardens, kitchen and market gardens, and the 'artist's garden'. In turn, it looks at individual pictures in the fascinating context of the then popular 'language of flowers', and of ideals such as 'Paradise regained', and the landscape as a 'garden'. What Pissarro called 'sensation' – the experience of the senses – comes into vivid focus, as do ideas about colour, revivals of Romantic beliefs about the purity of nature, and traditions of gardens as places of healing.

This book is for all who have an interest in gardens and the ways they have been represented. Impressionist garden imagery, and its evolution and world-wide spread, greatly enhance our understanding not only of Impressionism as such, but also of its times. Gustave Geffroy, an early and staunch supporter of the Impressionists, put the matter bluntly: it was 'fantasy...to believe these thoughtful and self-willed artists chose their subjects indiscriminately'.[2] Their garden pictures were often deeply charged with meaning and significance. While they set before us the evocative sights and scents of numerous plants, including sophisticated roses, sunlit curtains of wisteria, perfumed lilac, bushy azaleas, stately agapanthus, tulips and gladioli, and a galaxy of waterlilies – or more mundane cabbages, artichokes and carrots – they were thought-provoking, even symbolic. Evoking nostalgia, repose, children's play, dancing, music, *amour*, intrigue, or mourning, as well as manual labour or decorative display, they fascinate by their sheer variety. In telling stories or suggesting moods, they often embody visions of renewal. Impressionist paintings of children in gardens, meanwhile, offer an analogy with the notion of the *kindergarten* – child garden – movement.

If my own introduction to the magic of making things grow was as a child, when my parents gave me a corner of their garden for my own, it is their perceptive insights which, in turn, have enriched my understanding of the 'gardens of Impressionism', just as their sustained support has enabled me to pursue my continuing researches into art and gardens. While the book is dedicated to them, I hope it will enable many others also to share my joys of discovery in opening the gates and following the paths of the 'gardens of Impressionism'.

Clare A. P. Willsdon
Glasgow, 2004

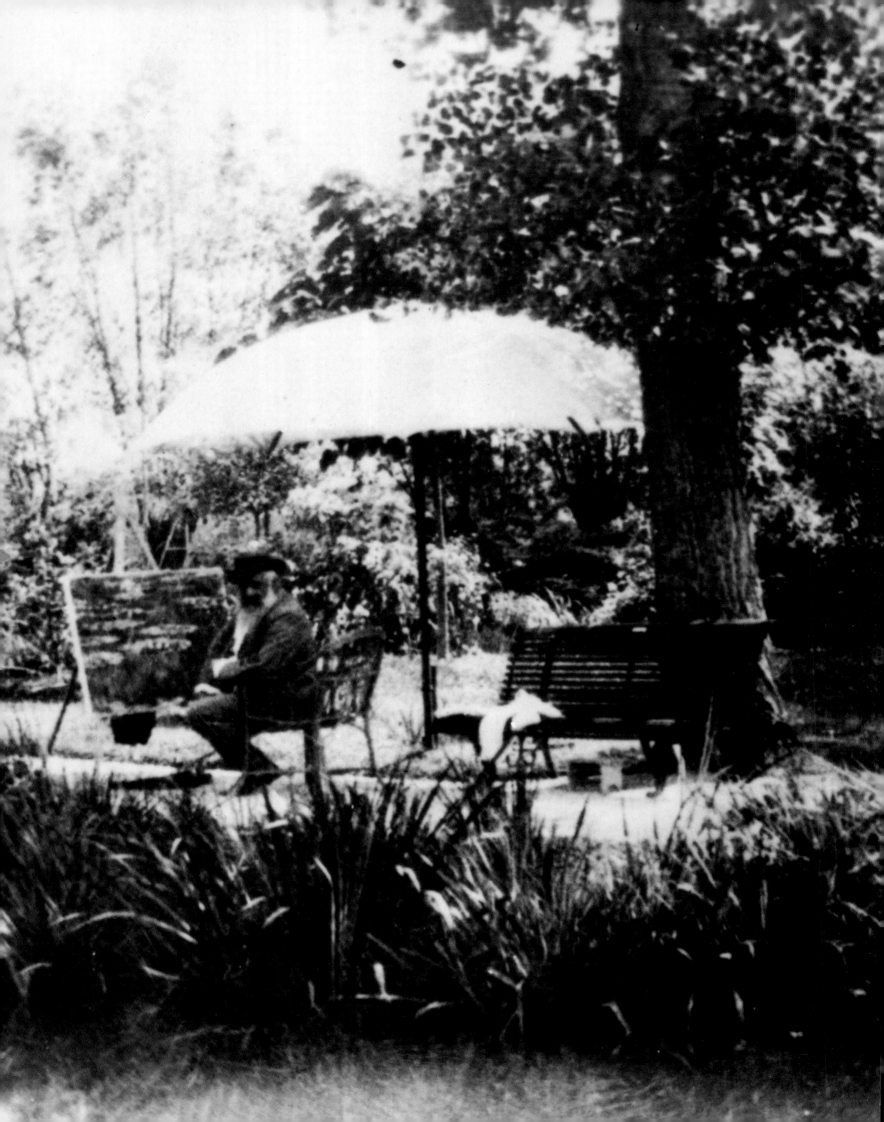

Introduction

Writing in 1900 from her château in Picardy, the Impressionist painter Mary Cassatt suggested that a gardening enthusiast from her native North America 'might get some ideas from French gardens, they do know about gardening over here'.[1] A love of gardens, after all, runs deep in French blood. Cassatt herself in her later years cultivated a fine rose garden, where, as her sight dimmed, she ultimately distinguished its varieties simply by their scent.[2] But the medieval kings of France had already long before this kept a garden – the Jardin du Roi – on the Ile de la Cité in Paris. Medicinal and herb gardens, as well as vegetable beds and orchards, were similarly cultivated at monasteries such as Clairvaux, while the delightful illustrations adorning the *Très Riches Heures* calendar manuscript of the Duc de Berry show the tending of fruit and vegetables on his estates in 15th-century Burgundy. And then there is Versailles, where the park created by Le Nôtre for Louis XIV, with its *bassins*, *allées* and symbolic statues, was the great apotheosis of the French 'formal' garden.

With such a horticultural heritage, it is perhaps not surprising that Napoleon I, when asked in exile in 1821 what he had found 'the most beautiful of all in Paris', replied, 'The view over the Tuileries and the gardens there' – gardens also designed by Le Nôtre.[3] Nor that Claude Monet, surveying the fragile waterlilies and multitude of other flowers he grew a century later at Giverny, should in turn declare his garden 'my most beautiful work of art'.[4] Monet's Giverny paradise, was, however, like Cassatt's a little further south-west, the outcome of the much wider love-affair with gardens on the part of the Impressionists, who effected an essentially creative transformation of garden motifs into pictures – and through these, sometimes even back again into 'virtual gardens'. Both images of gardens as such, and

1 Monet painting at Giverny, *c.* 1915
Monet described his garden at Giverny as his 'most beautiful work of art'. Here, he paints beside the waterlily pond whose construction he began in the early 1890s.

2 John Leslie Breck, *Garden at Giverny (In Monet's Garden), c.* 1887
Breck was one of many American artists – the *givernistes* – who painted gardens at Giverny from the late 19th century. He had privileged access to Monet's own garden in the late 1880s, creating a group of paintings of its richly varied flower beds.

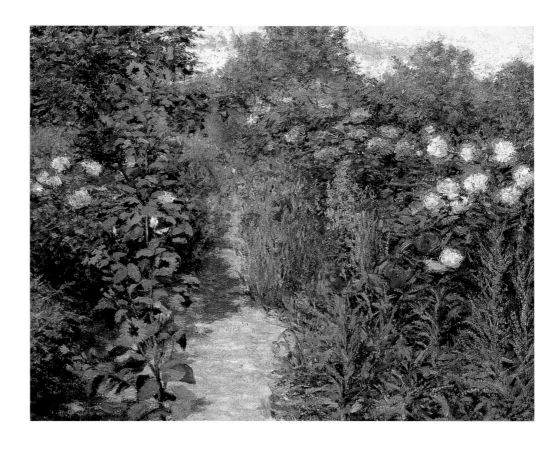

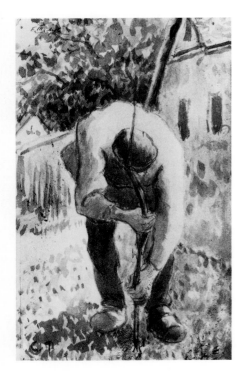

as significant *milieux* for a diversity of incidents and activities, are the subject of this book. By way of introduction, this chapter explores some of the key characteristics of gardens as an Impressionist theme, and traces a number of the ideas and events which combined to make gardens such a significant feature of Impressionist art.

First, however, a brief look at who the garden painters were, and some of the gardens they painted. In 1862, long before Monet's work at Giverny from the 1890s to his death in 1926, Edouard Manet had made a historic garden in Paris the setting for his *Music in the Tuileries*, the pioneering depiction of 'modern life' which effectively launched the Impressionist movement. Influenced by the *plein-air* (out of door) techniques of colleagues such as Monet and Pierre-Auguste Renoir, he later painted the Monet family in their private garden at Argenteuil, and, in the early 1880s, the leafy private garden at Bellevue near Paris of the opera singer Emilie Ambre, and similar gardens at Rueil and Versailles.[5] Pissarro, meanwhile, found inspiration in the distinctive blue-green and purple harmonies of village vegetable-plots, and was mockingly dubbed 'an impressionist market gardener specializing in cabbages'.[6] A number of paintings by Sisley evocatively juxtapose rustic orchard gardens with the remains of royal parklands. And if Renoir was prompted in the 1870s to rent a studio at rue Moncey in Paris by the homely garden attached – 'An old apple tree, with a child's swing hanging from it, won his heart'[7] – it was in an old-fashioned garden in Montmartre, as well as in the acacia-planted grounds of the Moulin de la Galette restaurant there, that he undertook some of his most famous paintings. A rustic southern garden at Cagnes on the Riviera, filled with roses and olives, formed the backdrop both to his final years and to his late nudes.[8]

As well as Monet and Cassatt, a number of other Impressionists were gardeners themselves, or came from families that gardened. Caillebotte, for example, found subjects for pictures in the well-stocked garden he cultivated at Petit Gennevilliers on the Seine during the 1890s, a sequel to the restful shade and well-watered lawns, orange-trees and geraniums of his family's estate at Yerres, south-east of Paris, which he had painted earlier. In the 1860s, before his tragic death in the Franco–Prussian War of 1870, Frédéric Bazille depicted his

3 Camille Pissarro, *Compositional study of a male peasant placing a bean-pole in the ground*, c. 1894–1903
With his left-wing sympathies, Pissarro often depicted working men or women; this drawing is associated with a cycle of prints of rural labour he produced with his son Lucien.

4 Claude Monet, *The Gardener of Graville*, 1856
Monet's earliest surviving figurative landscape, showing a gardener tending plants. Graville, in his home town of Le Havre, had a horticultural reputation by the early 1860s as the site of fine gardens with gladioli, camellias and azaleas, which were cultivated by the grower Lefrançois.

5 Félix Bracquemond, *Marie Bracquemond sketching on the Terrace of the Villa Brancas*, 1876
Braquemond depicts his wife, Marie, herself in the act of drawing. While he did not wholeheartedly approve of her pursuit of art, a private garden was at least a socially acceptable place for women to paint *en plein air*.

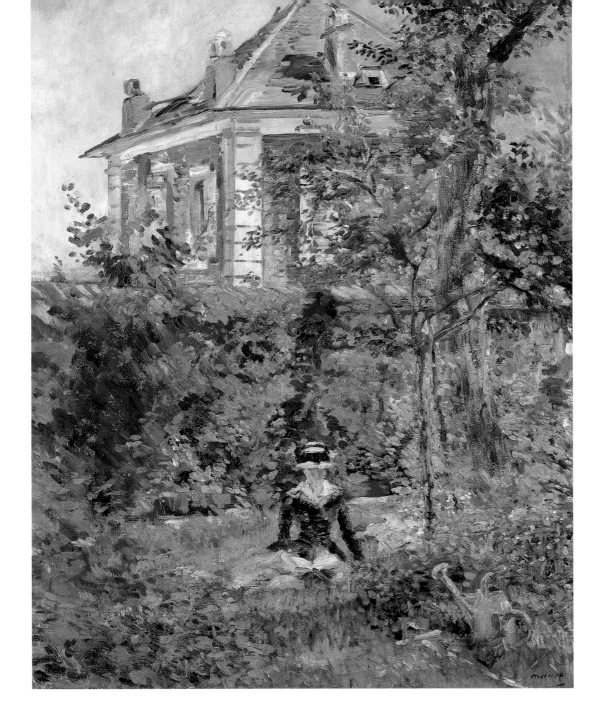

6 Edouard Manet, *Marguerite in the Garden at Bellevue*, 1880
Painted near the end of Manet's life, when illness restricted his mobility, this shows the burgeoning growth of the garden of a property near Paris which he rented from the opera singer Emilie Ambre while undergoing a hydropathic cure.

7 Gustave Caillebotte gardening at Petit Gennevilliers, photograph taken by Martial Caillebotte, February 1892
Several of the Impressionist painters were themselves keen gardeners – notably Caillebotte, whose garden at Petit Gennevilliers, attached to property which formed his home from 1887, is the subject of a number of his later paintings.

family's estate at Méric near Montpellier, just as Monet at this time portrayed the gardens filled with roses and gladioli which his family tended lovingly at Sainte-Adresse near Le Havre. Monet's first surviving figurative landscape is, in fact, a pencil sketch of 1856 showing a gardener watering seedlings in one of the many *petits parcs* (private gardens) of Le Havre.

For women Impressionists, such as Berthe Morisot, Marie Bracquemond, and, of course, Cassatt herself, gardens were 'safe' or socially acceptable places where they could not only stroll, sew, read, or play with children, but also paint from real life. Morisot made the nodding hollyhocks in the grounds of her holiday retreat at Bougival near Paris implicitly share in the companionship between her toddler daughter Julie and her husband Eugène Manet – the painter's brother – which she captured with lively brushwork during the early 1880s. She also often portrayed the Bois de Boulogne, just beside her family's home at Passy in Paris – 'this garden which posed for *maman*' as Julie later dubbed it.[9] Nearly all the core artists of the Impressionist group in fact painted parks or squares in Paris – including the Parc Monceau, as well as the Tuileries already shown by Manet. For Degas, meanwhile, Cassatt's friend and early mentor, gardens played a different role. He is said to have hated the

scent of flowers, and walked out of a dinner party if there was a bouquet on the table, yet in 1865 painted his friend Madame Paul Valpinçon beside flowers newly picked from her garden, and some twenty years later commented on seeing a 'delicious' tree in his neighbour's garden in Paris, 'If the leaves on the trees did not move, how sad they, and we, would be!'[10] Just as the movements of ballet dancers and racehorses became his favourite subjects, so he often visited friends with gardens, at Saint-Valéry-en-Somme or La Queue en Brie, where he indulged his own pleasure in exercise. The art dealer Ambroise Vollard recalled how 'He was to be seen marching up and down the garden path, his eyes protected by large dark spectacles, and taking the greatest care to avoid the flower-beds'.[11]

This book gives attention primarily to work by artists who were contributors to, or, like Manet, closely associated with, the Impressionist exhibitions held in Paris from 1874 to 1886. The many garden paintings of Vincent van Gogh, like Paul Gauguin's vision of a Tahitian 'paradise', or Paul Cézanne's portrayal of his family's overgrown estate in Provence, essentially form part of the movement of reaction to Impressionism which emerged from the 1880s and, being the subject of separate work by the author, are not included here other than as comparative examples. The final chapter, however, considers pictures by some of the many followers of Impressionism, both in France and beyond, who maintained or reinterpreted significant aspects of the movement. Henri Le Sidaner, for example, painting well into the 1930s, immortalized the 'white', 'yellow' and 'blue' gardens he cultivated in the medieval citadel of Gerberoy near Beauvais [233, 239], just as his friend Henri Martin painted his Italianate garden at Marquayrol near Toulouse. Max Liebermann at Wannsee near Berlin [251]

8 Henri Martin, *The Pond at Marquayrol*, c. 1930
Impressionist-style garden painting continued well into the 20th century. In the 1930s, the 'second-generation' French Impressionist Henri Martin was still painting the geranium-planted garden he had tended at Marquayrol, his home at La Bastide-du-Vert near Toulouse, since the early 1900s.

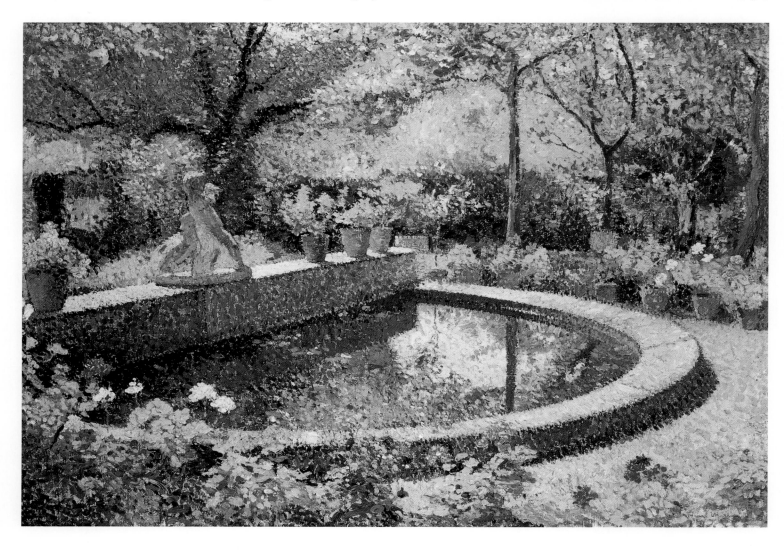

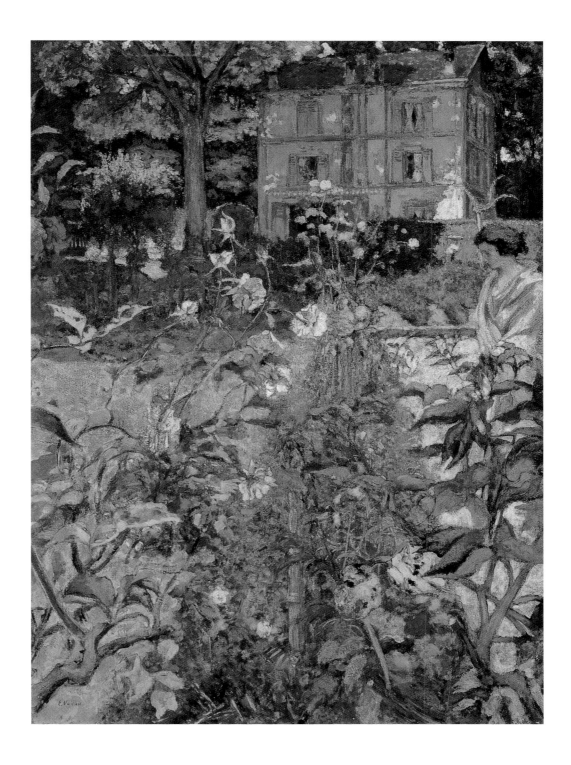

and Prins Eugen at Waldemarsudde in Stockholm also personally grew gardens where they painted in the early 20th century. Bonnard and Vuillard, who periodically visited Monet at Giverny, both found recurrent inspiration in gardens: Bonnard portrayed his joyously luxuriant gardens at nearby Vernonnet and at Le Cannet on the Riviera [10], as well as those of family members, while Vuillard painted the intimate gardens of friends, and the public garden overlooked by his studio at Place Vintimille in Paris. Gardens were a favoured motif especially, however, for the American Impressionists who formed a 'colony' around Monet at Giverny at the turn of the century, and whose subjects back in the USA included both private back-yards, and the lavish new parks of major cities such as Chicago and New York.

These are but a few examples of the vast diversity of 'gardens of Impressionism'. The rise of Impressionism coincided, after all, with what in France was popularly termed 'the great

9 Edouard Vuillard, *Morning in the Garden at Vaucresson*, 1923 (reworked 1937) Vuillard, like Bonnard, developed a more decorative form of Impressionism. At Vaucresson he painted the secluded garden of the Clos Cézanne, the pink-stuccoed house owned by his friends the Hessels; Madame Hessel is believed to be the figure in blue at centre left, partly screened by the foreground roses and foliage, as she tends flowers in a border.

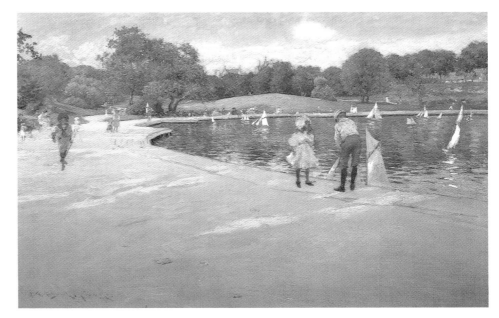

horticultural movement' – a phenomenon which turned gardening into a leisure pursuit, and made the enjoyment of gardens 'recreation for the eyes'.[12] The veritable craze for horticulture it engendered is central to the story of Impressionist garden painting; it created many of its motifs, and encouraged a market for its sale. The origins of the French horticultural movement lie in the social and political changes which followed the Revolution of 1789 and gave many more people than ever before the opportunity to own or rent land, or to have regular access to public parks and gardens, but it also reflected the introduction into Europe from the early 19th century of numerous exotic plants and species, and their subsequent cross-breeding.[13] It gave particular emphasis to flowers – in place of the allegorical statues and stately drives and *bassins* of Versailles – and it quickly became associated with fashion, 'decoration', and the bourgeois 'good life', though it also found many supporters amongst those from more humble backgrounds who eagerly grew flowers on their windowsills or in their kitchen gardens. Paris itself, as rebuilt both by Napoleon III during the Second Empire from 1852, and during the Third Republic from 1870, meanwhile became effectively the biggest French 'garden' of all, with its former royal parks now thrown open to the public, and new parks, floral squares and avenues of trees which overall amounted – so it was proudly claimed by the mid-1860s – to no less than 440 metres (1444 feet) of greenery per inhabitant.[14] Simultaneously, however, the environs of Paris saw the introduction of intensive forms of commercial cultivation, of flowers as well as fruit and vegetables, as the capital expanded in the wake of industrialization. These new kinds of horticulture coexisted with the enduring tradition of the kitchen gardens (*jardins potagers*) so often painted by Pissarro, which remained an essential feature of many rural communities, as did the cultivation of 'rustic' flowers such as nasturtiums. The Impressionist Guillaumin, for example, captured the exuberant colour of a rural garden almost bursting at the seams with these brilliant orange flowers, just as the novelist Gustave Flaubert (whose work was much admired by Pissarro) had described them climbing round the windows of thatched cottages in Normandy in his story of traditional peasant life, *Un Coeur simple* (A Simple Heart). It was, in fact, the nasturtium flower, which Monet would later grow in profusion at Giverny, that Degas proposed should be the emblem of the Impressionist group. Their first exhibition was held in Nadar's studio on the boulevard des Capucines in Paris, *capucine* being the French for nasturtium.[15]

10 Pierre Bonnard, *The Garden*, c. 1936
Bonnard, who cultivated gardens in both the north and south of France, deliberately allowed his plants to grow in riotous profusion. Here, he looks from his home at Le Cannet, the Villa Le Bosquet, along the garden path; the perspective is closed by an orange tree, whose golden fruits glow in the southern sunshine.

11 Armand Guillaumin, *The Nasturtium Path*, c. 1880
Often associated with traditional rural life, the spectacular nasturtiums in this cottage garden bring to mind Flaubert's description of the flowers in *Un Coeur simple*.

12 William Merritt Chase, *Lilliputian Boat-Lake, Central Park*, c. 1890
American artists who had studied in France returned to depict gardens which included the new parks in Chicago and New York; their images often emphasize social aspects, or turn the city into a landscape.

13 Charles Marville, photograph of the Marquess of Hertford and Sir Richard Wallace with a lady in the garden of the Bagatelle mansion, Paris, c. 1855
By the mid-19th-century, an explosion of interest in horticulture was underway in France, and by the 1900s the Bagatelle was famous for its rose garden, where Nijinsky would dance the 'Spectre de la Rose'.

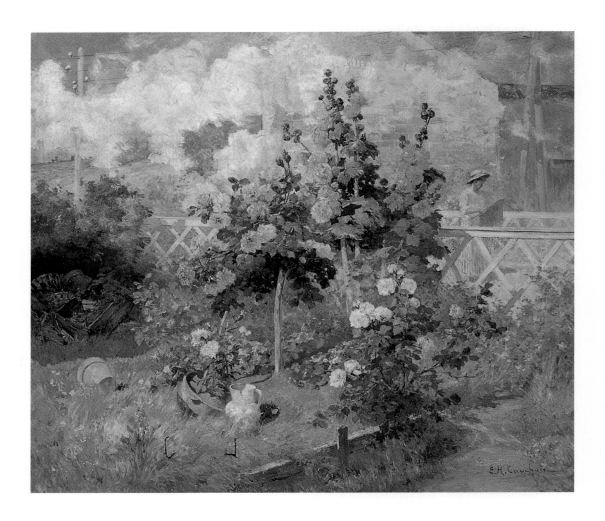

Gardens and gardening were, of course, also popular in other European countries and in the United States in the 19th and early 20th centuries; the emergence of local horticultural societies in England was in fact directly emulated by the increasingly green-fingered French. Equally, gardens had been painted before Impressionism, from the Virgin's *hortus conclusus* in medieval art to the Rococo idylls of Watteau, Boucher and Fragonard, or Constable's two paintings of his father's kitchen and flower gardens.[16] But it was arguably in France that, through the advent of Impressionism, painting and horticulture first became more intimately interlinked than at any previous period. For it was Impressionism which opened artists' and viewers' eyes to outdoor sunlight and seasonal nuance, by giving primacy to *plein-air* techniques instead of work in the studio, and modern-life subjects in place of history, literature or the Bible. As much as flowers and foliage, it was, in fact, the play of sunlight on fashionable dresses worn in a park or summer garden, the lively interaction of contemporaries at leisure as in Manet's *Music in the Tuileries*, or the friable, newly turned soil of humble vegetable plots, which made gardens a natural choice for the Impressionists. As Renoir put it, 'Give me an apple tree in a suburban garden. I haven't the slightest need of Niagara Falls.'[17]

The art and emotion of the garden

Gardens are traditionally reinventions of 'primal' forms of nature which serve as subliminal reminders of a world before mankind – an unsullied Eden or a lost paradise or Golden Age – and as such they already carry meanings and associations, even before their interpretation by Impressionist or other artists. As nature shaped and trained by human hand, gardens are themselves works of art, however rudimentary – as Monet noted with regard to Giverny.

This is what makes pictures of gardens – art made out of art – inherently different from the images of nature 'in the wild' created by the Romantics before Impressionism: views of precipitous mountains, stormy seas, or Niagara itself, for example, which typically evoke a sense of awe, fear, or vulnerability on the part of the spectator. It is, nonetheless, in the enclosed, familiar spaces of gardens that, often more clearly than in the wider landscape, we may discern the shifting patterns and effects of the seasons, weather and atmosphere – those elemental phenomena which so fascinated the Impressionists. It is in gardens, likewise, that the perception of such phenomena readily becomes intertwined with personal associations and emotions. Whether private ground or a public park, a garden is typically a constant where you regularly walk, or which you see every day from your window. And even if, like some of the gardens created as part of the great international exhibitions held in Paris at the Impressionist period, it is a sight designed to attract foreign as well as local visitors, a garden still retains that essential stamp of human intervention. The accessible, familiar or domestic character of many 19th- and early 20th-century gardens – even when these involved attempts to evoke a natural appearance – was perhaps, indeed, what led the novelist Marcel Proust, a great admirer of Monet's work, to call the mind of a creative artist an 'internal garden' (*jardin intérieur*).[18] The 'language of flowers' – associating meanings and significances with individual flowers, and evolved by the Romantics from Turkish practice and Renaissance and Baroque symbolism – was in fact a prominent aspect of mid- to late 19th-century French fashion and social etiquette, turning gardens into places where sentiments and feelings could quite literally be cultivated.[19] Its prevalence, especially in relation to the principle of 'suggestion' rather than direct statement which was followed by Mallarmé and other writers close to the Impressionists, has intriguing implications for the 'gardens of Impressionism', as we shall see in later chapters.

Equally, it is the character of a garden as a piece of local, familiar nature which is vividly evoked in a work such as *The Train has Passed* by E.-H. Cauchois, a Rouen follower of Impressionism: the smoke left by the vanished train along the track beyond the garden fence intensifies our empathy with the garden's slower, seasonal pace, embodied in its blooming flowers, some of whose pots have been rudely blown over by the train. It is surely significant that it was in tandem with the development of his own Giverny garden, itself situated next to a railway line, that Monet became progressively more dedicated to painting in 'series', as a means to capture the effects of weather and the seasons upon a single motif seen over and over, time and again, and through this, to imbue his art with what he called 'more serious qualities', and 'what I feel'.[20]

Simulation, *sensation* and synaesthesia

Gardens and garden pictures can, however, also be understood as 'simulations' – the phenomenon identified by the modern French philosopher Jean Baudrillard as a defining feature of modern consumer society.[21] Simulations make an original available vicariously, for mass consumption. If gardens simulate primal nature, paintings of gardens add a further stage to this process, renewing or reinventing the simulation. In the era of Impressionism, the consumer society was, of course, itself taking shape as we know it today, as department stores, for example, were established in Paris and other leading cities; the Impressionists' own exhibitions are themselves part of this development. The writer and early proponent of Impressionism, Emile Zola, certainly declared Monet's paintings of his family's flower-filled gardens at Sainte-Adresse near Le Havre both 'one of the great *curiosités* [specialities or collectibles] of our art', and 'one of the markers of the tendencies of our age'.[22] The 'gardens of

Impressionism' thus need to be seen as both intimately bound up with, and at the same time a means to transcend, the culture of transience which lies at the heart of the consumer society, with its worship of fashion, and disposable products. It is the creative tension between these seemingly opposite functions which runs like a Leitmotiv throughout this book.

In an age when experimental science was taking rapid strides in France,[23] however, it was the primacy placed by Impressionism on *sensation* – on personal response, both physical and emotional, to the stimuli of the external world – which, just as much as 'the great horti-cultural movement', *pleinairisme*, or 'simulation', surely led the Impressionists to paint gardens as frequently and systematically as they did. Pissarro, after all, defined Impression-ism itself as nothing less than an art 'based on sensations'.[24] Garden painting as we think of it today – something which gives prominence, even when figures are involved, to the colours, textures and forms of cultivated nature – is from this point of view not only more or less an Impressionist invention, but also an answer to the definition of art itself provided by the writer and friend of the Impressionists Gustave Geffroy, as something which 'concentrates mankind's sensations'.[25] It is worth pausing to explore some of the implications of the concept of 'sensation' in relation to gardens and their depiction, before looking at the particular historical developments and ideas which, by bringing gardens into so much favour from the mid-19th century, set the stage for their appearance in Impressionism.

As enclosed or otherwise limited spaces, gardens literally concentrate the sensations they afford – of perfumes, textures and even sounds (buzzing bees or singing birds), as well as of colours and shapes. The kinds of stimulus to sensation offered by many gardens in France during the Impressionist era, where newly introduced plants from exotic lands could be found alongside ever bigger, more vividly coloured, pungently scented or heavily fruited cultivars, was, of course, yet more intense than ever before. Prompted by the great Universal Exhibition held in Paris in 1855, where lavish gardens formed part of the display, the poet Baudelaire already described, for example, the effects of the 'mysterious flowers' from distant countries, in colours which 'penetrate the eye despotically'.[26] Not all gardens were, of course, as 'sensational' as those at the Universal Exhibition. But if, by 1903, the composer Claude Debussy was inspired to create the innovative sound-world of his *Gardens in the Rain* simply by 'the smell of the wet earth and the gentle patter of rain on the leaves' he had experienced in an everyday garden during a June thunderstorm,[27] then Impressionist painters also found new means to make their purely visual medium simulate the garden's sensory *richesse*. These typically involve the viewer: broken forms and suggestive brushwork which we involuntarily complete in the mind's eye, and colours and colour juxtapositions which intensify visual effects, and evoke other sensations. Shadows, for example, are rendered not traditionally as grey, but often as blue, green or violet, to take account of light reflected within them; sunlit areas appear the brighter in relation. Such effects evoke warmth and coolness; smoothness and roughness; the atmosphere of summer or the stillness of frost. The 'narrative' or activities portrayed in turn 'concentrate sensations' yet more intensely – the dancing and sociable exchange in Renoir's *Ball at the Moulin de la Galette* [164], for example, invite us to imagine strains of music and lively chatter, while pictures such as the American Chase's *Open Air Breakfast* [17], or Le Sidaner's and Bonnard's 'garden table' paintings, place luscious fruits and waiting cups or glasses seductively before us. Manet's 1880 paintings at Bellevue [6] suggestively include a prominent watering can – a symbolic note of coolness beside the hot red geraniums 'vibrating' against the green grass, but also, perhaps, a witty allusion to the therapeutic hydrotherapy he was then undergoing for the illness from which he died two years later.

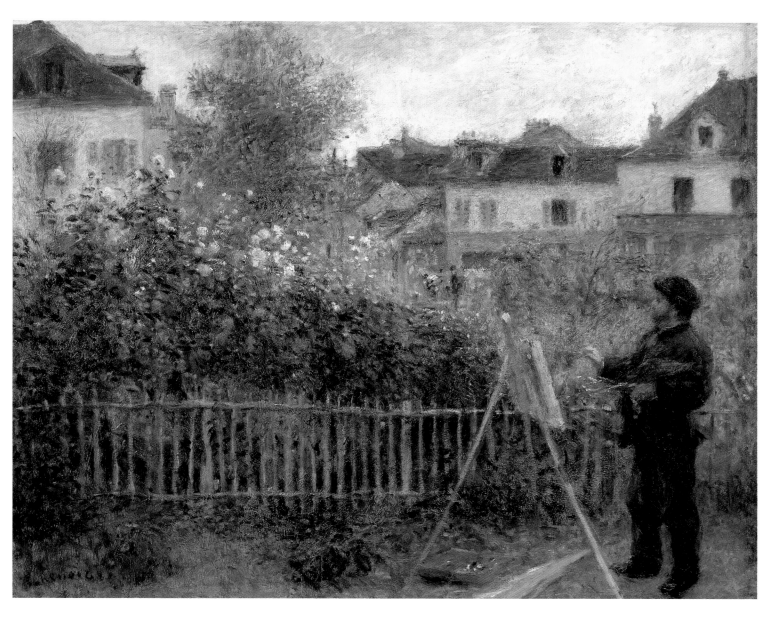

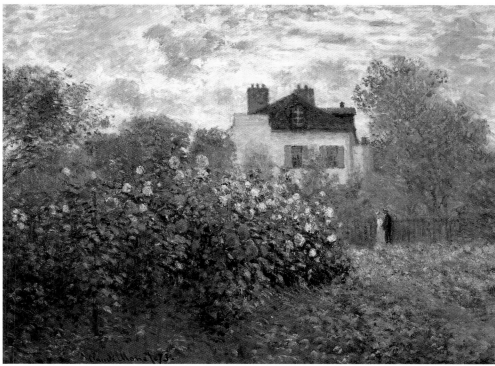

15 Pierre-Auguste Renoir, *Monet painting in his Garden at Argenteuil*, 1873

16 Claude Monet, *Monet's Garden at Argenteuil (The Dahlias)*, 1873

Two versions of Monet's garden at Argenteuil, one by the creator of the garden, the other by his guest, Renoir. The lightly touched brushmarks which delineate the dahlia blooms are, by implication, evocations of perfume as well as of texture and colour, reflecting 19th-century interest in synaesthesia.

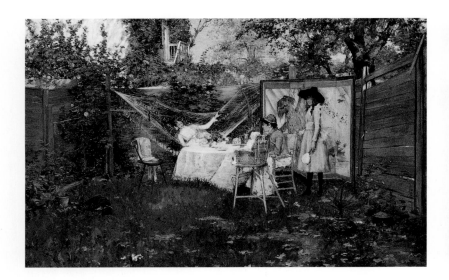

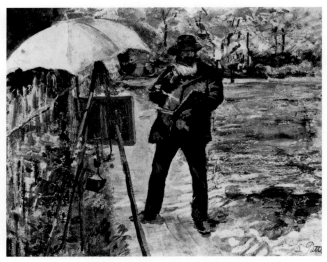

Just like Monet's suggestive mingling of his exotic pink, yellow, red and blue waterlilies with the clouds in his pictures of reflections in his pond at Giverny, such tactics were clearly conscious and deliberate, and they effectively transport us to worlds beyond the gardens shown – worlds of the imagination, through which we too may 'read' the shorthand brushmarks, enjoy the Moulin dancing, share the tempting repast, enjoy respite like Manet, or dream among the clouds. A number of Impressionist pictures in fact make the painter's act of personal creative response to the garden's 'sensations' their very motif. Pissarro's friend Ludovic Piette, for example, showed him painting in an unknown garden in a work of around 1874 now sadly lost, though known from a photograph. A pace or two from his portable easel, Pissarro himself already appears, as he dips his brush in the paint on his palette, like one of the sturdily rooted 'human plants' which Mirbeau would later call the figures in his paintings.[28] Pissarro's easel itself, meanwhile, is literally planted in the narrow flower border adjoining the garden fence at the left, so that the parasol shielding it from the sun seems to rise above its struts like some exotic flower. Monet likewise recorded Manet at his easel in the shade of his own garden at Argenteuil, in a picture considered in Chapter 5.[29]

Neither of these pictures, however, actually shows the precise motif which the artist portrayed is painting. It is Renoir's picture of Monet painting in his garden at Argenteuil of 1873 – one of the great icons of Impressionism as such – which provides this insight, and thus evokes still more vividly the actual process of making art out of what, for a painter, is a garden's most powerful sensory stimulus – its concentration of colours [15]. Standing as stockily before his easel as Pissarro, Monet squares up to a mass of pink, yellow, orange and red dahlias – flowers he has either grown himself, or (if we follow the logic of the low fence placed by Renoir before them) which grow in a neighbour's garden. Dahlias, with their 'infinite variety of dark, rich, splendid, dazzling colours', were felt able to 'vary and enrich a whole flowerbed',[30] and they would have been recognized by Monet's and Renoir's contemporaries as virtual emblems of the painter's business – the visual. For they were well-known as having no scent; their appeal lay entirely in their colour.[31] The creation of a blue dahlia was, indeed, something of a horticultural holy grail at this period – blue being the only colour not so far obtained in the species. In turn, the quest for the blue dahlia had become synonymous with pursuit of a dream or utopia, since blue is the colour of the sky itself, to which the soul traditionally aspires.[32] If Renoir, like Monet, chose to paint actual dahlias, rather than such intangibles, he nonetheless engaged in some revealing manipulations of the reality. The mass of flowers is so arranged that it diminishes in height, to reach a suggestive

17 William Merritt Chase, *The Open Air Breakfast*, c. 1888
Chase here shows some of the leisure activities associated with the private 'gardens of Impressionism'. A hammock and a decorative screen complement the outdoor meal enjoyed by members of Chase's family in their garden in Brooklyn.

18 Ludovic Piette, *Camille Pissarro Painting in a Garden*, c. 1874
This work, painted by a friend of Pissarro and now sadly lost, shows a garden whose location is unknown, but which serves Pissarro as an outdoor studio. The easel is steadied by a weight between its struts, since Pissarro is using a small-scale, readily portable canvas of the type preferred by the Impressionists for *plein-air* painting.

point of focus in Monet's tiny hand highlighted by the *plein-air* sunshine: despite their profusion, the flowers lie securely within Monet's artistic reach.

On one level, Renoir's painting thus reflects the traditional association between gardens or flowers and women, and the process imagined in the 19th century whereby, as Anthea Callen has described, 'Feminine colour needed the artist to structure its chaos'.[33] But Monet is painting colour which, of course, is already ordered, in that it grows in a garden. And as he deftly brushes his canvas, he seems, in fact, to take his colours from the actual flowers themselves, as they descend to the point where his brush is poised before the canvas. It is as though the garden itself were his palette, much as the critic Théodore Duret wrote of Berthe Morisot's 'light touches of the brush . . . as if she was lifting the petals from flowers'.[34] Something much more complex than cold mastery of feminine colour with masculine control is at stake; we witness an engagement with the garden's sensations by Monet which is palpably direct and therefore richly personal. As such, it clearly resonates with Geffroy's description of the Impressionists as 'thoughtful and self-willed artists',[35] who chose their subjects with discrimination.

The line of Monet's hat, the angle of the brushes in his left hand, and the thrust of his folded parasol on the ground, all serve, in fact, to focus our attention still more specifically on the nexus of his sunlit hand where 'sensation' so seamlessly turns into art. In this context, the low horizontal line of the fence – a feature which, more logically, appears beyond the dahlias in a painting of them by Monet himself [16] – becomes intelligible as a symbolic device, whose contrast with the wedge-shaped mass of the flowers quite literally underscores both the magnitude of Monet's artistic task and, by implication, of his skills as a painter. Read this way, the picture of course also pays tribute to Monet's horticultural skills, which have brought his motif into being in the first place. The towering size of the tallest dahlias, and their delicate pink colour, in fact suggest they were of the *imperialis* strain, which could attain heights of over two metres, and which had only recently been grown with success in the north of France. Tubers for both the *Dahlia imperialis* and its derivative, *Dahlia arborea*, were described in the horticultural press of 1872, the year before Renoir's picture, as being readily available for purchase.[36] With their giant size, these plants must have been 'sensations' in more ways than one. In the picture Monet himself painted in 1873 of the dahlias in his garden – perhaps even the one which Renoir shows him painting – he actually made the whole group of flowers, and not just the pink ones, dwarf a pair of figures who stroll beyond, albeit at a little distance.

If *cuisse de nymphe* (maiden's thigh) was the name popularly given to the pink colour of the *Dahlia imperialis*,[37] Renoir's feathery brushstrokes certainly look forward to the caress-like touches he would later deploy in his paintings of nudes in his garden at Cagnes, as if he was already seeking to make the visual also tactile, and, like Monet in his dahlia picture, thereby stretching the limits of simulation.[38] It is, likewise, the very instant at which Monet's colour becomes touch upon his canvas which Renoir highlights in Monet painting. The dividing line between reality and dreams or utopias in the gardens of Impressionism was perhaps rather less precise than their artists' dedication to sensation might at first suggest and we will encounter numerous revealing ways in which imagination – that cardinal Baudelairean faculty – interacted closely with reality. In *Monet painting in his Garden at Argenteuil*, the low fence can in fact also be read, as House has pointed out, as a device which 'makes it seem that the painter is standing on a stage'.[39] By this logic, Monet's simulation of his garden via painting becomes itself a further kind of art; a form of theatre or performance, in which reality is quite openly kept at one remove.

If Renoir shows colour and touch as one, it is, of course, but a short step from the 'concentration of sensations' offered by a garden to their synaesthetic interaction in the mind – the process whereby, as Baudelaire famously put it, 'perfumes, colours and sounds respond to each other'.[40] Synaesthesia – as it was later called – was keenly pursued not only by Baudelaire, who was inspired by the German Romantic E. T. A. Hoffmann's writing on the subject, but in turn by many later 19th-century French writers and artists, as well as musicians such as Debussy. It was felt to involve a state of heightened emotional or spiritual perception, enabling what Baudelaire called 'the language of flowers and of things which are mute' to become intelligible, and the banality of everyday life to be transcended.[41] In painting gardens, and in doing so *en plein air* (even if they frequently completed their work in the studio), the Impressionists were boldly substituting 'reality' for the 'artificial' stimuli, such as hashish, with which Baudelaire and the Romantics had often sought to induce synaesthesia. By the time the Spanish Impressionist Joaquín Sorolla painted the artist and designer Louis Comfort Tiffany before his easel in his Long Island garden in New York in 1911, the role of the garden as a gateway to 'inner' vision was still more vividly implied than even in Renoir's image of Monet. Sorolla had lived in Paris and fully absorbed the lessons of Impressionism. But instead of showing Tiffany actively engaged in painting the riot of yellow, white, pink and purple flowers around him, he depicts his colleague in seeming meditation at his easel, his brushes idle. Even Tiffany's dog appears in a parallel state of inactivity, its ears pricked and its step halted. Is Tiffany listening to an unseen voice – perhaps that of Sorolla, who must be seated where the viewer stands? Or is he, with his seemingly abstracted gaze, transported, with his dog, by the radiance and perfume of his garden – by the 'language of flowers and of things which are mute'? Sorolla's younger contemporary, the Spanish poet and dramatist Federico García Lorca, certainly called gardens 'a mosaic of souls, silences and colours, which spies on mystical hearts to make them cry . . . something that embraces you with love . . . a peaceful amphora of melancholies . . . a tabernacle of passions'.[42] And flowers and gardens were a favourite source of inspiration in Tiffany's innovative stained glass – the art for which, rather than his easel paintings, he is more often remembered today. The concentration of floral colour which Sorolla captures with palpably dynamic brushstrokes in his picture now seems a virtual emblem of the power of light itself which Tiffany harnessed in such glass. What matters here is not the species of flowers portrayed, but the way they 'concentrate' the brilliance of the summer light.

Simulation, sensation, synaesthesia . . . and now, psychological and even symbolic aspects too. One might be forgiven for thinking that the art of the gardens of Impressionism was actually more about what Proust called the 'internal garden' of the mind, than the 'here and now' of the actual gardens it illustrates. Many Impressionist garden pictures do, in fact, revealingly include the traditional visual emblem for the processes of thought – a person reading a book. Monet, for example, shows his wife reading in the protective shade of lilacs in their Argenteuil garden; Manet, more ambiguously, a young woman reading (but also coquettishly peeping past) an illustrated journal in a Paris café garden.[43] What we witness, in images like these or in pictures like Sorolla's, is an exploration of the affective power of gardens; the subtle interaction between a garden and the thoughts of those who use it, as mediated by the garden's 'sensations'. At the same time, pictures such as Renoir's *Monet painting* or Piette's of Pissarro, showing an artist actively responding to sensations in a garden, imply a certain equivalence between the work of painting and that of gardens or horticulture – the tilling of the soil and the planting of seeds, or even the work of the laundresses, using the garden's fresh air to dry their sheets, whom Morisot and Manet

19 Joaquín Sorolla, *Louis Comfort Tiffany*, 1911
The Spanish artist Sorolla here creates a fascinating synthesis of floral brilliance, psychological intensity and breezy Long Island air – for he shows Tiffany in the garden of the American's famous Arts and Crafts-style residence in New York. Tiffany's somewhat abstracted expression hints at what Proust called the *jardin intérieur* – the 'internal garden' – of the mind. Sorolla himself became a keen gardener, and used his own garden as a painting motif.

Chapter 1

If horticulturalists in mid-19th-century France were creating hybrid plants – notably the first hybrid tea rose, from which our modern roses derive[1] – then a not dissimilar process was simultaneously underway in art. The old 'hierarchy of genres', which placed history painting at the apex of artistic endeavour and relegated portraiture, genre and still life to its lowest levels, was being gradually but surely dismantled by 'Realists' such as Jules Breton and Gustave Courbet, the Impressionists' early idol.[2] Variously bringing into lively new interaction elements of landscape, domestic genre, portraiture and flower painting, the 'gardens of Impressionism' were a logical result. This chapter explores aspects of the earlier traditions which are of specific interest in relation to Impressionist garden imagery: the 'language of flowers', the work of the Lyons flower painters, the 'Rococo revival', and the reinvention of floral still life by Delacroix and Courbet, artists much admired by the Impressionists. It then goes on to discuss three pivotal works by Degas and Bazille which celebrate the results of the gardener's labours and look directly to Impressionist paintings of gardens (even if, as indoor subjects, they stand apart from the *plein-air* practices which came to characterize mature Impressionism). Read in relation to horticulture, these three pictures in fact take us to the heart of some of the key aesthetic debates, articulated by writers such as Gautier and Baudelaire, which surrounded the development of Impressionism as a movement.

How boldly traditions would be mingled in the 'gardens of Impressionism' can already be seen by comparing the early 19th-century artist Louis-Léopold Boilly's vision of the Tuileries Gardens in Paris with that of Manet in 1862. Where Boilly makes the Gardens primarily a backdrop for a genre scene of children at play, Manet deploys their lush green trees as an integral feature of his innovative, portrait-filled *Music in the Tuileries* [67]. The formal setting, with its monumental stone plinth and statue which offset Boilly's evocation of youthful rumbustiousness, is replaced by a fluid intermingling of trees and contemporary figures in Manet's scene of social intercourse, whose intimate correlation of the organic and the human is explored in Chapter 2. And where Corot had used the famous gardens of Rome or Florence essentially as vantage points for atmospheric topography, as in his *Florence, View from the Boboli Gardens*, the Impressionists, as we have already begun to see, would value gardens – and native ones at that – both for their own sake, and as central players in a rich diversity of scenes of 'modern life'.

As students at Charles Gleyre's atelier in Paris during the late 1850s, Monet, Renoir, Bazille and Sisley would have directly witnessed the emergence of the new 'mixing' of genres even in 'academic' art itself. Though they had left Gleyre's studio by the time he began what he regarded as his masterpiece, an evocation of the Garden of Eden called *The Terrestrial Paradise* [27], they would, for example, have noticed their teacher's interest in the domestic, 'everyday' aspects of mythology and antiquity, and his readiness to include flowers, plants and gardens – often sketched direct from nature [28] – in his historical and literary compositions.[3] Equally, though only Renoir of the future Impressionists is supposed to have had any good word for Gleyre, it is worth noting that both *The Terrestrial Paradise* and certain other 'history paintings' by the older artist involve a remarkably sensitive and naturalistic rendering of sunlight and its effects – the very phenomena, traditionally associated with landscape motifs, which would become such a central preoccupation of the Impressionists themselves.

24 Simon Saint-Jean, *The Gardener-Girl*, 1837
Perhaps the most famous of the 19th-century Lyons *fleuristes* (flower painters), Saint-Jean produced this spectacular painting in a bid for entry to the Paris Salon. The flowers and plants, including morning glory, roses, tulips, poppies, dahlias and acanthus, are chosen for their symbolic connotations, and construct a complex allegory of the transience of beauty and the permanence of art.

25 Louis-Léopold Boilly, *Outing in the Tuileries*, before 1845.
The Tuileries Gardens in Paris were reconstructed by André Le Nôtre in the 17th century, forming one of the most famous examples of the grand French formal garden. Here, they are essentially a foil for Boilly's genre motif, rather than a subject in their own right, or with specific import (as in later pictures by Manet, Monet and Renoir).

26 Jean-Baptiste Camille Corot, *Florence, View from the Boboli Gardens*, 1834
Corot uses the Boboli Palace garden in Florence as a *repoussoir* – a device to set off his principal motif, a view of the city. His atmospheric effects were nonetheless to exert considerable influence on the future Impressionists.

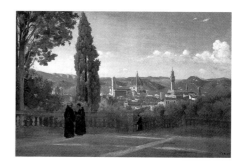

27 Charles Gleyre, *The Terrestrial Paradise*, c. 1870

28 Charles Gleyre, *Flowers and Head* (sketch), before 1874

Gleyre taught Monet, Renoir, Bazille and Sisley, and sits at a turning point between the polished, academic work of Saint-Jean and the much freer interpretation seen in the Impressionists. Here, his sunlight effects anticipate Impressionism.

29 Eugène Delacroix (with background by Paul Huet?), *Baron Schwiter*, 1826 Delacroix's admiration for the English artist Sir Thomas Lawrence's portraits, often set in 'landscape gardens', is evident in this depiction of a painter friend, though the prominence of the flowers is typically French and anticipates his own garden subjects of the 1840s and 50s.

While a number of the future Impressionists' fellow-students at Gleyre's atelier took up their master's predilection for the domestic and the naturalistic, and in so doing used garden settings, others combined gardens with motifs from contemporary life itself. These artists included Monet's cousin, Auguste Toulmouche (who had been responsible for advising him to study with Gleyre), and Marie-François Firmin-Girard, who both became known during the 1870s for their pictures of fashionably dressed women in well-stocked flower gardens.[4] Works such as Firmin-Girard's *Premières Caresses* (1875 Salon), showing a mother, baby and nurse within an idyllic summer garden, ultimately turned Gleyre's advice to Monet that 'style is everything' into a celebration of contemporary fashion, in which the pairing of flounces, frills and lace with the blossoms and foliage of cultivated nature quite literally updates the age-old poetic theme of woman as *flos florum* (flower of flowers).[5] If the 'gardens of Impressionism' were an overt rejection of the sugary artifice of such works, they were nonetheless thus born of a common inheritance. As Albert Boime has shown, Gleyre's vision of the past, placing mankind in harmonious coexistence with nature, is essentially at one with that of modern society in many Impressionist works; imagery of gardens – where humans cooperate with nature – was a logical form of its expression.[6]

Art and the *jardin anglais*

Gleyre himself had trained in Lyons as a designer for the fabric trade, which from the early 19th century had fostered and been influenced by the Lyons school of flower-painting. The popularity of flower painting and floral decoration in early 19th-century France went hand in hand with the emphasis given to flowers in the French version of the *jardin anglais* mode. It is thus helpful to consider some of the ways in which the new taste for the *jardin anglais*

was reflected more generally in French painting, and itself helped to foster the emergent 'mixing of genres'. 'English style' gardens were used, for example, as the setting for a number of early 19th-century French portraits, as well as – in a 'fantasy' form – in the work of the 'Rococo revivalists', such as Narcisse Diaz, Camille Rocqueplan and Eugène Lami, which extended from the 1830s well into the early years of Impressionism.

Delacroix's 1825 portrait of Baron Louis-Auguste Schwiter is a particularly interesting example of the 'English garden' in French portraiture, since it was was later owned by Degas himself. Echoing the kind of full-length outdoor portrait by Gainsborough, Reynolds and Lawrence which Delacroix had seen on his famous visit to England a year before, it already gives a distinctively French pre-eminence to flowers. Its somewhat melancholy subject, an artist friend of Delacroix, stands upon a terrace, apparently overlooking a landscape garden, and beside a large pink magnolia which grows luxuriantly in an Oriental vase. Many new varieties of magnolias were, of course, being developed in the early 19th century from specimens introduced from China. Coinciding with the contour of this shrub, Schwiter's lightly held glove and scarlet-lined soft hat seem but one of its larger-sized florets, and – since he himself was an artist – his painting hand is thereby joined with nature's own palette of floral colour. The flowers scattered in the foreground, which appear to be laburnum, surely offer yet a further commentary on the subject's (and Delacroix's own) dedication to art, for this flower, in the 19th-century 'language of flowers', signified a charm or spell.[7] Delacroix regarded Rubens, his artistic hero, as a 'magician'; painting itself would be described by Delacroix's admirer Baudelaire – who derived many of his ideas from Delacroix – as 'a magical operation'.[8] Cut suggestively by the picture frame, so that, by implication, they reach right into the viewer's space, the sprigs of laburnum become the literal agents of Delacroix's vision of art as 'a meeting place for the souls of all men', connecting Schwiter, himself and the viewer. In essence, the garden in which Schwiter stands is, as cultivated nature, a projection of the artist's soul: 'If you cultivate your soul it will find the means to express itself . . .', Delacroix had noted just before his visit to England.[9]

Flowers have similar prominence in Constant Desbordes's 1820s portrait *The Broken Wagon*. Less freely painted than Delacroix's picture, whose buttery facture so effectively evokes the waxy magnolia blooms, this portrays the family of a wealthy armaments manufacturer amid a more enclosed but still informal garden. A space not merely for relaxation and pleasure, but also for bringing up children, this garden clearly breathes the spirit of the great

30 Marie François Firmin-Girard, *Walk in the Park*, late 19th century
Fellow students of Monet, Renoir and Bazille at the Gleyre atelier, both Firmin-Girard and Toulmouche developed a highly detailed, anecdotal style of garden painting which became popular at the Salon. Firmin-Girard continued it even into the early 20th century, and made a speciality of portraits of wealthy women strolling in their country parks in the Paris region, as here.

31 Constant Desbordes, *The Broken Wagon*, 1820s
The obvious moralizing and academic poses stand in stark contrast to Delacroix's work at this period, but the relatively informal garden setting, with its hollyhocks and shady trees, is a reminder of the influence in early 19th-century France of Jean-Jacques Rousseau's advocacy of the freer style of the *jardin anglais* (English garden).

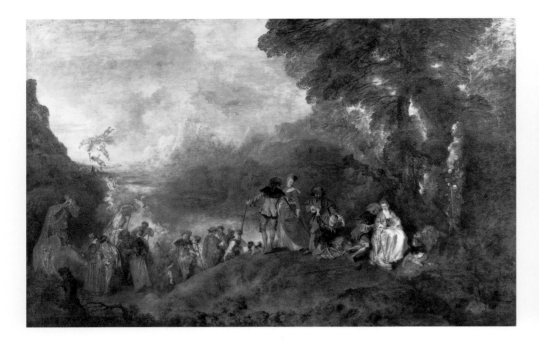

promoter of the *jardin anglais* in France, Jean-Jacques Rousseau. The adults are seated amid the cool shade of trees; the children are accompanied by (presumably) an older sister and a nurse, and have been playing with a wooden cart. This, however, has overturned, sending one of its occupants overboard, though seemingly to no harm. A gently waving pink holly-hock bends over the momentary mishap. If the hollyhock was traditionally an emblem of death, as in certain 17th-century *memento mori* paintings, it is worth remembering that in the new 19th-century 'language of flowers' it was ascribed the meaning of fecundity.[10] In this sense, the painting presents a positive message: family continuity will overcome misfortune, just as growing a garden is a defence against time.[11] Like the stiff postures, this moral note is still essentially Neoclassical, yet Desbordes's inclusion of a young woman reading a book in the background, within a rose-bower containing a statue of cupid, already looks forward to the garden as a realm of sensual pleasure which his niece, Marceline Desbordes-Valmore, who lived with him in Paris, would evoke in her expressive poems associating flowers with states of mind. Some of these were cited in the new 'language of flowers' books, and her work was to be much prized by the poet Verlaine, who was closely associated with the circle around Manet, Bazille and Fantin-Latour from the late 1860s.[12]

Portraits like these offer clear foundations both for the kind of intimate relationship of figures with setting to be found in Manet's *Music in the Tuileries*, and for the great flower gardens of Impressionism of the 1870s and 1880s exemplified by Monet's portraits of his family in his garden at Argenteuil. The shift in taste marked by the French adoption and floralization of the 'English garden' mode was, meanwhile, vividly encapsulated in the writing of Gérard de Nerval, one of the last – and most visually sensitive – of the Romantic poets, who made extensive symbolic reference to garden flowers.[13] In 1853, just a few years before the future Impressionists' arrival at Gleyre's, Nerval's novelette *Sylvie* took Ermenonville itself for inspiration – the 'English garden' park modelled on Rousseau's ideals, and the setting of Rousseau's tomb. For Nerval, like Rousseau, gardens were, in fact, ultimately important as much as places in which to walk, meditate, and recollect, as to grow flowers and trees. It is not surprising that Degas, who frequented gardens for similar purposes, and but rarely painted them, enjoyed reading Rousseau. Nor that both Nerval and Delacroix, as well as the poets Charles Baudelaire and Théophile Gautier, were closely

32 Antoine Watteau, *Embarkation for Cythera*, 1717
Watteau's painting, believed in the 19th-century to depict an imagined departure by his contemporaries for the garden of Venus on the island of Love, was much admired by later artists, and was Monet's favourite picture in the Louvre.

33 Camille Rocqueplan, *Rousseau and Mlle. Galley gathering Cherries*, 1851
In Rococo art, nature was equated with freedom from social and moral constraints. Rocqueplan, one of the 19th-century Rococo Revivalists, here combines this tradition with the influence of Jean-Jacques Rousseau; his motif is from Rousseau's *Confessions*.

associated with the literary circle called the Cénacle du Doyenné, which, during the 1830s and 1840s, looked back nostalgically to the ideal world of the Rococo *fête champêtre* with its fantasy parklands born of the English garden style.[14]

The members of the Cénacle tried quite to literally to 'step back' into such *fêtes champêtres* when Nerval devised a re-enactment of Watteau's *Embarkation for Cythera*. This is the painting, believed in the 19th century to show an aristocratic party setting off for a paradisal idyll-island, which Monet was famously in later life to name as the work in the Louvre he would most like to possess.[15] The Parisian headquarters of the Cénacle was meanwhile adorned with mural *jardins d'amour*, some painted by Corot and Rousseau, while in 1846 Diaz exhibited a *Garden of Loves* at the Salon which the critic Théophile Thoré described as:

a little like the famous *Jardin d'amour* by Rubens, and a great deal like the *Island of Cythera*, that delicious sketch by Watteau in the Louvre . . . You have the sky with its light illuminating all parts, the trees with their varied nuances, and the women capriciously reclining on the lawn, with their shimmering draperies mingled with the flowers, as fresh as dew, sparkling like the sun.[16]

Thoré's correlation here of women, flowers, reflections and light already clearly predicts that of many 'gardens of Impressionism'.

Numerous lithographs were published in the 1850s and 1860s of 'garden' paintings by Rococo revivalists such as Lami, Emile Wattier and Henri Baron, while original Rococo works were of course later collected by friends or patrons of the Impressionists such as the Goncourt brothers and Georges de Bellio.[17] The Rococo revivalists typically portrayed Watteau-style lovers in wooded parklands that are part 'English garden', part Versailles run to seed, and part Fontainebleau Forest planted with flowers and seen through Rousseau's eyes.[18] Camille Rocqueplan's *Rousseau and Mlle. Galley gathering Cherries*, an 1851 reworking of a garden subject he had first shown at the 1836 Salon, actually illustrates an episode from Rousseau's *Confessions*. Such works, as well as Verlaine's *Fêtes Galantes* poems of 1869 inspired by Rococo gardens, and Manet's infamous *Déjeuner sur l'herbe* of 1863 [71], which transposed the Rococo motif into a sharp new Realist key, form the immediate context for Monet's own experiment in 1865 with a modern *fête champêtre*. Also entitled *Le Déjeuner sur l'herbe* [70, 72], this was intended, like Manet's version, for the Salon.[19] We will look at the history and meanings of his picture in more detail later, when we explore the role of *pleinairisme* in the rise of the 'gardens of Impressionism'.[20] First, however, let us turn to the artistic context of the Impressionists' early garden works, and then, in particular, to flower painting and portraits of 'gardener-girls'.

'A flower is a living thing . . .'

One of the most prominent devotees of the new fashion for floriculture in early 19th-century France was the Empress Joséphine, wife of Napoleon I. She not only claimed that: 'My garden is the most beautiful thing in the world. More people go there than to my Salon',[21] but also employed the famous Pierre-Joseph Redouté to preserve in his renowned botanical volumes the beauty of the rose garden (the first ever) which she planted at Malmaison [34], and of her collections of lilies and other flowers there.[22] In 1822, after the Restoration, he became Professor of Botanical Drawing at the Musée d'Histoire Naturelle in Paris, where he painted the flowers and plants of the celebrated Jardin des Plantes. His work developed the tradition of *vélins* (botanical illustrations on vellum) established in the 17th century by the patronage of Gaston d'Orléans and Louis XIV,[23] and his many pupils both in Paris and at Malmaison formed a distinctive 'school' of floral painters. Some of them became decorators

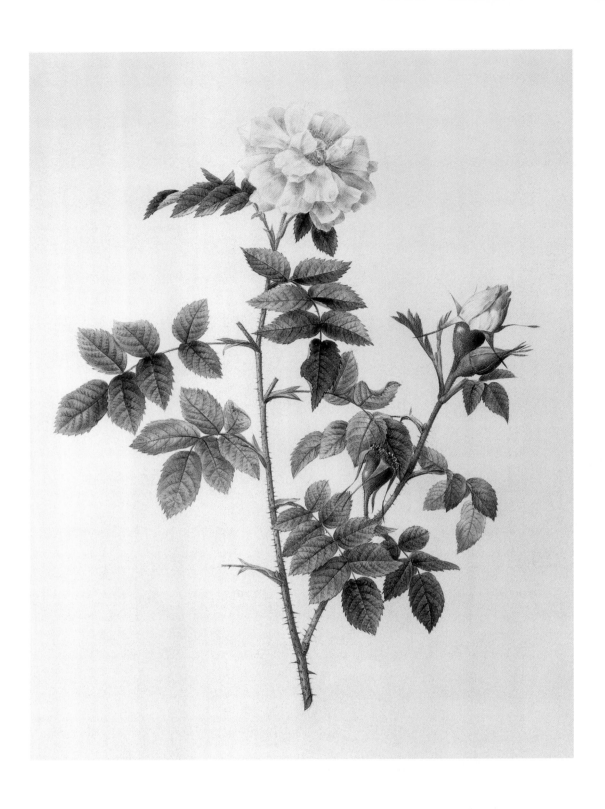

34 Pierre-Joseph Redouté, *Empress Joséphine Rose*, early 19th century
The precise yet elegant illustrations made by Redouté of the Empress Joséphine's rose collection in her garden at Malmaison document the astonishing range of roses developed in the wake of the introduction of the China or Bengal rose to France and England in 1792. Also recording other flowers grown by Joséphine, Redouté published over two thousand illustrations in total, covering 1,800 species. They were used not only for scientific study, but also by Sèvres porcelain designers.

and designers in the Sèvres porcelain works and Gobelins tapestry factory, and the Redouté style of flowers placed against a white background was consciously followed by the Lyons floral artists. Redouté's preferred medium was watercolour and although his own work is remarkable for its combination of botanical accuracy and colouristic subtlety, it was the exact, meticulous style which his pupils and emulators evolved that Delacroix, and in turn the Impressionists, were to revolt against.

Meanwhile both at Lyons and more generally in France, it was the symbolic meaning of flowers that emerged as an important element in their still-life representation. During the later medieval and renaissance periods, both gardens and flowers had, of course, played an important symbolic role in spiritual texts and paintings. Monastic writers and the Jesuits

described the *Hortus* or *Hortulus*, for example, in which plants or flowers were associated with specific religious ideas. In turn, floral emblems were a central feature of the art of the Low Countries which directly fostered the tradition of flower painting that had evolved from the late 18th century in France. Dutch paintings were acquired for the special 'Salon des Fleurs' opened in 1808 at the Musée des Beaux-Arts in Lyons. Along with the real-life contents of a new Jardin des Plantes in the city, this display was intended to provide a range of models for designers for the local silk industry; by 1844, it was claimed in the *Courrier de Lyon* that flowers, as the principal design motif for silk, 'are what 40,000 jobs rely on'.[24] The Lyons designers began, however, also to exhibit floral subjects as works in their own right both at the Salon in Lyons itself and at that in Paris. Flourishing schools of *fleuristes* meanwhile developed in other manufacturing centres, such as Dijon and Limoges. Born into a family of artisans in Limoges, it was in a porcelain manufactory (in Paris) that Renoir began his artistic career, ornamenting its products. If the propensity to associate flowers with ideas, feelings or virtues was a symptom of a heightened 'mysticism' which the historian Jules Michelet, writing in 1859, identified in the psyche of the modern industrial worker:

The sedentary life . . . of the artisan, seated at his trade, favours an internal fermentation of the soul. The silk worker, in the dank shadows of the streets of Lyons, the weaver of Artois and Flanders, in the cellar which has been his home, have created for themselves a world, a moral paradise of sweet dreams and visions . . .[25]

then Madame Charlotte de La Tour's 'language of flowers' manual, first published in 1819 and into its twelfth edition by 1876, made this in turn a pervasive social habit.[26]

Although, like the counterparts it inspired by writers such as Aimé Martin and Madame Anaïs de Neuville, Madame de La Tour's book was in a sense a reinvention of the Baroque emblematic tradition, it now offered a predominantly secular range of meanings for plants, trees and flowers, often derived from their characteristic forms of growth. The new meaning of fecundity for the hollyhock, for example, previously associated with 'autumn, death, and

35 Eugène Delacroix, *Overturned Basket of Flowers in a Park*, c. 1848
In contrast to Redouté's approach, Delacroix evokes the texture and vibrant colour of his flowers, often placing them, as if freshly cut, in a park-like garden. Georges Sand, who claimed to have witnessed Delacroix's first attempts at flower painting in 1845, nonetheless traced his success with the genre to his childhood study of botany. Many of Delacroix's 'flower portraits' – to be much admired by the Impressionists – were carried out at his country home at Champrosay.

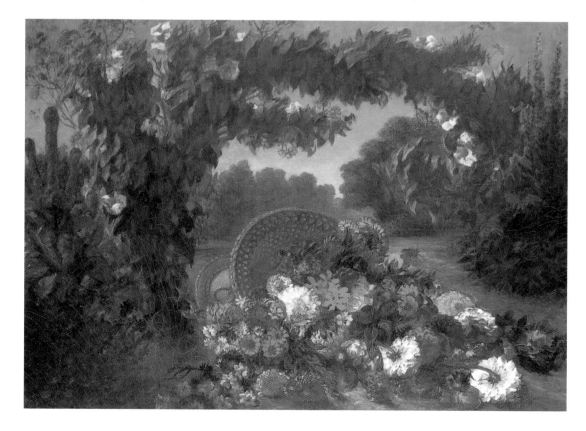

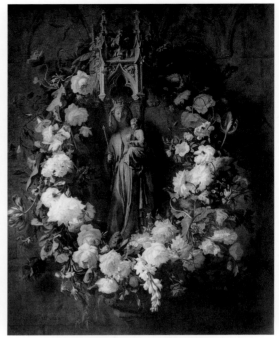

endings',[27] derived from the characteristic abundance of its florets. Recognizing this shift in meaning enables a work such as Courbet's *Hollyhocks in a Copper Bowl* of 1872 to be understood not as representing a 'sense of defeat' at his prison sentence for activities in the Commune, as has been assumed by art historians by reference to 17th-century symbolism,[28] but instead as a celebration of the fecundity offered by fruitful opportunity. Painted after Courbet had been transferred in 1872 from Sainte Pélagie prison to Dr Duval's clinic in Neuilly, it matches his ecstatic report in a letter to his family from his new address: 'I am in heaven. I have never been so comfortable in my life. I have a large park to walk in . . . there are guests almost daily, all old friends'.[29]

But we are jumping ahead. From the later 1840s, no doubt partly in response to Delacroix's example, a more painterly approach had begun to appear in the work of the *fleuristes* who showed at the Salon, while a lithograph after a painting by Régnier had even been published which offered a delightfully informal glimpse of the great Redouté's own garden itself at his home at Fleury-sur-Meudon, complete with a gardener watering the flowerbeds. The many flower painting manuals produced by artists trained in the Redouté manner, like the Gribbon brothers, still exerted a strong influence, however.[30] Baudelaire wrote bitterly in his Salon review of 1845 of the exhibits by the Lyons flower painters, whose leader in the 1840s and 50s, Simon Saint-Jean, had (albeit unsuccessfully) attempted to succeed Redouté himself at the Musée d'Histoire Naturelle. The Lyons school, he said, was 'the penitentiary of painting, the corner of the known world in which the infinitely minute and wrought is the best . . .'.[31] In 1859 the critic Paul Mantz was still complaining about Saint-Jean's work in the Salon of that year: 'A flower is a living thing . . . M. Saint-Jean cuts out the unhealthy-looking plants of an impossible flora in a material that is neither paper nor cloth'.[32] Baudelaire much preferred the art of Delacroix, who, from the 1840s, had been reinterpreting the Humanist and Biblical traditions of garden imagery in paintings such as *Christ in the Garden of Olives*, for the church of Saint-Paul-Saint-Louis in Paris. This spoke clearly of his Romantic vision of nature as at one with the human soul and its sufferings.

In turn, it was Delacroix's vigorously fresh, sensitive still lifes of freshly cut flowers [35], often placed alongside growing flowers in gardens, that were openly appreciated by the

36 Jean-Jacques Champin, after Régnier, view of Redouté's house and garden at Fleury-Meudon, early 19th-century
Redouté's bought his home at Fleury-Meudon, just outside Paris, at the height of his success. His most notable patron, the Empress Joséphine, visited him there and presented him with a chestnut and a cedar tree. In this picture we see his orangery at the right, near which a gardener waters plants.

37 Simon Saint-Jean, *Offering to the Virgin*, 1842
Depicting a wreathed statue of the Virgin Mary, this painting reflects the practice in Lyons of ornamenting such figurines with flowers during the Virgin's month of May. Warmly received by the critics, it secured Saint-Jean's reputation as a fine artist; his work was in turn chosen to represent the Lyons school in the 1851 Great Exhibition in London (held in the Crystal Palace). Though Baudelaire made stinging attacks on Saint-Jean's meticulous style, Durand-Ruel, the Impressionists' future dealer, sold his work and became his good friend.

Impressionists-to-be. Some were to be found in the collection of the Montpellier maecenas Alfred Bruyas, well-familiar to Bazille, while Degas is known to have admired Delacroix's 1849(?) watercolour *Flowerbed with Hydrangeas, Scillas and Anemones*.[33] Renoir, Cézanne and Guillaumin all later painted still lifes which include the crimson geraniums (zonal pelargoniums) particularly favoured by Delacroix – flowers which, after extensive development in Britain in the earlier 19th century, reached a zenith of popularity in the era of Impressionism.[34] Many of Delacroix's flower pieces were painted at Champrosay, the country retreat not far from Paris, where the artist had a studio with a garden from 1844 for the latter part of his life. In 1849 he exhibited two floral paintings at the Salon, of an intended group of five. While maintaining considerable botanical accuracy, he used open, suggestive brushwork to capture the brilliant colours and varied textures of his garden's generous growth, and with their abundant sprays of such flowers as dahlias, marguerites and peonies as well as geraniums, his pictures rudely burst the boundaries of conventional still life, as he himself described in 1849 to his artist friend Dutilleux:

I . . . wanted to get a bit away from the convention which seems to condemn all flower painters to do the same vase with the same columns or the same fantastic draperies to act as a background or contrast. I have been trying to do some pieces of nature as they appear in gardens, only bringing together within the same frame and in a fairly plausible manner the greatest possible variety of flowers.[35]

Champrosay did not, however, supply all Delacroix's needs. A note a few days later in his private journal records: 'I had a long talk about flowers after dinner with Jussieu in relation to my pictures. I promised to go and visit him in the spring. He will show me the hothouses and get me all permission required for study'.[36] New heating systems had enabled the creation of ever more ambitious 'winter gardens'; Jussieu, Director of the Jardin des Plantes in Paris, presided over some of the most splendid in France.

Did Delacroix perhaps also make use of photographs of flowers to achieve his 'effect of nature'? He was one of the first – and few – artists openly to support the new medium of photography, and in other letters to Dutilleux, he eagerly discusses its potential as an aid to painting. During the 1850s, when Delacroix produced the majority of his floral works, Adolphe Braun had in fact begun to publish his extensive series of flower photographs. Notable for their natural arrangements of specimens, these were intended for use especially by designers of textiles and fabrics, ceramic painters and wallpaper manufacturers, and became very popular.[37] Here was the ultimate paradox, for if the traditional object of horticulture was to make nature imitate art – as dramatically exemplified in the ever fancier tulips, dahlias and pansies being bred by the mid-19th century – then that art could now, through photography, be captured with unprecedented 'truth to nature', at least in terms of form. (The floral colour in which Delacroix so delighted was, of course, still beyond the camera's reach.) This is a paradox which, in a sense, runs through the whole enterprise of 'Realist' or 'Naturalist' flower-painting, whether as practised by Delacroix, Courbet or the future Impressionists. Painting living flowers just as they grew, in their garden setting, simply heightened it still further.

It was, meanwhile, the very relationship of art, nature and the creative imagination which the poet Baudelaire of course probed with iconoclastic irony in his notorious *Les Fleurs du Mal* anthology, first published in 1857, whose title played on the traditional conceit of poetry as the 'flower of art'. Equally, it was thus perhaps only logical that, as traditions of flower painting became mixed with other genres, and flowers began to be shown growing in a garden,

39 Claude Monet, *Spring Flowers*, 1864

Two reinventions by future Impressionists of the *préparatifs d'un fête* (festival preparations) tradition. Replacing the grand manner of Bony (*opposite*) with palpable domesticity – note the mud smeared on the pots in Renoir's picture – these show two phases of spring. In the Renoir, outdoor flowers such as crocuses are placed alongside lilacs, cineraria and the arum lily, which would have been brought on in a greenhouse. The plant trough at the left indeed contains a clump of the grass typically used in greenhouses to catch condensation. Monet's picture, thought to be the one which he felt had been poorly hung at the 'Rouen Exposition', shows flowers from later in the season – peonies, viburnum, hydrangea, and a sprig of wallflower as well as lilac.

40 Jean-François Bony, *Spring*, 1804
Much favoured as a model by Lyons silk designers, this is one of the earliest examples of the *préparatifs d'un fête* motif. Temporarily placed in water in an antique sarcophagus in the Italianate garden from which, by implication, they have just been cut, a rich array of flowers awaits formal arrangement in a vase, or perhaps as a garland. Like many of the Lyons *fleuristes*, Bony alternated grand Salon paintings with fabric and embroidery design.

these developments should become entwined with symbolic and philosophical purposes. We will, for example, meet more of Baudelaire's ideas on art when we explore Bazille's and Degas's 'gardener' pictures. Floral motifs had, however, even before these pictures, already prompted a suggestive encounter between art, nature and the imagination when Renoir, as an apprentice porcelain painter, decorated a coffee cup with a floral design of his own invention, instead of repeating the conventional motifs. This delighted its client until he discovered the liberty Renoir had taken. Only when the painter gave him a tale that he had taken his design from an old Sèvres model would the man buy the cup, and he then ordered two dozen more with the same decoration![38] If Renoir had access during his apprenticeship to Braun's flower photographs, it is clear that they did not prevent him from also using his imagination.

The emergence of garden painting
Though apparently different from both the Lyons tradition and the conventions of porcelain decoration so shamelessly flouted by Renoir, Delacroix's depictions of growing flowers in a garden context actually took up a trend already to be found in a number of works by artists associated with manufacture. In 1804, for example, Jean-François Bony, professor of flower design at the Ecole de Dessin in Lyons from 1809 to 1810, and a founder of Bissardon, Cousin et Bony which carried out many of Napoleon I's fabric orders for Versailles, had painted two exhibition canvases of *Spring* and *Summer* which each portrayed a bouquet of the respective season's flowers in gardens belonging to a villa.[39] In *Spring*, a lavish assemblage of cut flowers, awaiting arrangement for a festival or other special occasion and including yellow and pink hollyhocks, blue lilac, white lilies, brilliantly striped tulips and delicately tinted pink roses, rests in a water-trough made from an antique sarcophagus and

41 Edouard Manet, *Branch of White Peonies with Secateurs*, 1864

42 Antoine Berjon, *Peonies*, before 1843

It is tempting to see Manet's picture, one of several he painted of cut peonies, as a meditation on, or conscious reinvention of, the Lyons painter and designer Berjon's famous study of these flowers. While the techniques vary – Manet uses visible strokes of thick oil paint whereas Berjon creates a limpid delicacy with pencil and white chalk on tinted paper – both painters capture the distinctive waxy character of peony flowers. Peonies grew extensively on Manet's family's estate at Gennevilliers near Paris.

fed by an ornamental fountain. Life is made to blossom, metaphorically, from death; a trailer of scarlet nasturtiums suggestively tumbles over the edge of the sarcophagus and into the viewer's own space. In *Summer* fruit and ears of corn form an offering to a statue of Ceres beside a garden wall.

Bony's successor as professor of flower design at Lyons, Antoine Berjon, employed a fresher, less overtly symbolic style in which the subtle play of light likewise anticipates something of Delacroix's and the Impressionists' interests.[40] His study of peonies – one of his most famous works – shows petals as silky as the fabrics for which he taught his pupils to design, and though not explicitly portrayed within a garden setting, their delicately nuanced tones clearly imply the passage of outdoor sunlight, perhaps observed in the Lyons Jardin des Plantes. Given the fame of the Lyons painters and silks – the popular journal *L'Illustration* featured a picture of the Empress Eugénie herself attempting silk-weaving on a visit she made to the Lyons factories in 1860, for example – Manet's own series of peony paintings of the 1860s were surely in part a conscious update of Berjon's work. At least one includes the motif of a broken stem which Berjon, inspired by the 18th-century painter van Dael's *The Broken Tuberose*, had typically favoured, just as, around the same period, Manet was famously reinventing the figurative art of Old Masters through quotations from works by Titian and Raphael.

Renoir's *Still Life, Arum and Flowers* of 1864 [38], which depicts a casually assembled group of potted spring flowers – including daisies, arum lily, crocuses, lilac and cineraria – and similar works by both Monet [39] and Bazille [49, 50] from this period, certainly take up the *préparatifs d'une fête* (preparations for a festival) motif already employed by Bony, Berjon and other *fleuristes*. Even as late as 1885 we find the Lyons artist Castex-Dégrange, who had been exhibiting in Paris since 1874, and was newly appointed as professor of flower-design at the Lyons Ecole des Beaux-Arts, still using this motif in *My Table for Models*, though now with a loose Impressionistic feel. However, in *Still Life, Arum and Flowers* – which exists in two versions, one thought to be a trial run for the other[41] – and its counterparts by Monet and Bazille, the vigour of garden growth conveyed by the freshly assembled plants, whose

containers are still smeared with earth, is already projected through a palpably sketch-like handling. Art itself, and not just gardening or floristry, is here seemingly in progress even within the finished work. If the symbolism of Bony's 'preparations for a festival' has been discarded in such images, it is clear that they are nonetheless explorations of the larger theme of art's relationship to nature which – from the Renaissance disciplining of landscape to Rousseau's philosophy of free growth – had traditionally preoccupied the makers and painters of gardens. At the same time, the emphasis on process conveyed by Renoir's early *Still Life, Arum and Flowers* already contains in embryo the correlation between painting and cultivating that would be summed up in Monet's remark at the end of his life that his 'most beautiful work of art' was his garden. Indeed, Renoir's inclusion in the foreground of the grass that was typically grown in greenhouses to catch drips from condensation,[12] serves almost wittily to belie his 'still life' subject, by emphasizing its essential living character. His painting in this sense takes up a device employed already in the 1840s and 1850s by the 'primitive' photographer Bayard, whose similarly 'artless' arrangements of potted plants, often set alongside garden tools, had suggestively associated the camera's mechanical eye, so maligned by critics such as Baudelaire, with the vigour of natural growth.[13]

Renoir would later comment that, 'When I am painting flowers I experiment boldly with the tones and values without worrying about destroying the whole painting. I would not dare to do that with a figure because I would be afraid of spoiling everything. The experience I gain from these experiments can then be applied to my paintings'.[14] Already in 1864, likewise attempting a still-life subject, Monet in fact encouraged Bazille to 'do such a picture, because I believe it's an excellent thing to paint'.[15] Like Delacroix, these future Impressionists clearly recognized flower painting as a liberating experience, a genre in which they did not, in a sense, need to worry about the 'hierarchy of genres'. On one level, such a stance develops the aesthetics of 'art for art's sake', whose foremost advocate, the poet Gautier, is shown talking to Baudelaire beneath the trees in Manet's *Music in the Tuileries*. Gautier prized flowers as vital emblems of artistic freedom precisely because, unlike cabbages, they had no practical use.[16] The tactile, impastoed textures of the future Impressionists' early flower paintings suggest, however, that they had as much to do with the freedom of effect to be found in recent works by Courbet – a painter who had won notoriety for his 'political' meanings – as with theories such as Gautier's. For, during a visit in 1862–3 to his school-friend, Etienne Baudry, at Saintonge, in western France, Courbet had produced a series of vigorous flower paintings which gave a new Realist dimension to Delacroix's approach, and directly reflect the stimulus of Baudry's enthusiasm for horticulture.[17]

Baudry's library was, however, as well-stocked with books on esoteric botanical symbolism as were his conservatories with splendid flowers, and Courbet's Saintonge pictures also involve numerous allusive meanings. His *Still Life with Poppies and Skull*, for example, painted for the Republican lawyer and dabbler in the occult, Phoedora Gaudin, was exhibited in 1863 at Saintes with the caption: 'Death conquers law, and poppies still the cares of life'. Arranged in a cavity cut in the top of the skull, the poppies are mixed with marigolds, for which the French name is *souci*, also meaning 'care'; the skull itself stands on a law book. And in addition to these floral still lifes – from which Courbet happily found he was 'coining money',[48] and which, as such, would have naturally interested Monet, Renoir and Bazille – he painted a more ambitious floral subject in 1862 called *The Trellis* or *The Woman with Flowers* [45]. This shows a woman plucking a flower from a profusion that also includes primulas, ipomoeas, hollyhocks and stock, and is supported by a trellis. As in the examples by Delacroix, the traditional flower still life has here metamorphosed into a garden.

43 Hippolyte Bayard, *The Bottom of the Garden*, c. 1850
This early French photograph, with its comfortable chair placed out-of-doors beside artfully disposed garden tools and plant pots, presents horticulture as a form of recreation, and reflects growing bourgeois interest in 'cultivating one's own garden'.

44 Gustave Courbet, *Still Life with Poppies and Skull*, 1862
Courbet's floral still lifes were admired by his younger colleagues, the future Impressionists. Many have deeper levels of meaning, like this *memento mori*, exhibited with the caption 'Death conquers law, and poppies still the cares of life'. A skull sits upon a law book and is filled with poppies (traditional emblems of forgetfulness and sleep) mixed with marigolds, whose French name – *soucis* – means 'cares'.

45 Gustave Courbet, *The Woman with Flowers (The Trellis)*, 1862

46 Simon Saint-Jean, *The Gardener-Girl*, 1837

47 Edgar Degas, *Woman seated beside a Vase of Flowers* (detail), 1865

Women of bourgeois or higher social standing were not encouraged to engage in manual garden work such as planting or digging, hence the activities of gathering or arranging flowers shown in 'gardener-girl' pictures such as Saint-Jean's – a genre which Courbet and Degas here take up. Where Courbet's picture, painted at Saintonge, shows a woman engaged in plucking flowers, Degas's includes gardening gloves (on the table to the left: see the full work in ill. 48), implying that his sitter has just gathered the showy bouquet of chrysanthemums, cornflowers, marigolds and other flowers which dominates the composition. Like the flowers growing on the trellis in Courbet's painting, these reveal symbolic meanings, complementing the woman's pensive mood, when 'read' in relation to the 'language of flowers'.

The 'gardener-girl'

In *The Trellis*, Courbet's inspiration for the combination of a woman in the 'flower of youth' with flowers from various seasons 'symbolizing . . . the stages of her amorous life' could have been Dutch or Flemish 17th-century art.[49] Women plucking flowers were often illustrated during the Second Empire in the opulent murals modelled on Baroque sources which were popular forms of decoration in wealthy bourgeois dining rooms.[50] But Courbet's painting also presents the theme of woman as 'gardener' which is the subject of perhaps the most famous Lyons *fleuriste* work of all, Saint-Jean's *The Gardener-Girl* of 1837, showing a young woman with bouquets of flowers she has just cut from the garden.

Though so roundly denigrated by Baudelaire, Simon Saint-Jean was not merely a dry translator of botany onto silk; he illustrated an edition of the Abbé Delille's influential treatise on the 'English' garden, and his *The Gardener-Girl*, which made his name in 1837, expressed sentiments as personal as those of many works by Baudelaire's idol, Delacroix. Intended to demonstrate Saint-Jean's prowess as a *fleuriste*, its acceptance at the Paris Salon secured him the hand of Caroline Belmont, daughter of a wealthy Lyons silk merchant.[51] More than merely a portrait, however, it explores through symbolic imagery the very relationship of art to nature, time and mortality. The young, half-length gardener carries a basket of flowers on her head as she ascends balustraded stone steps in a garden; in the distance is a misty, 'wild' landscape. Just as cultivated and 'free' nature are juxtaposed, so the flowers in the gardener-girl's basket include both 'garden' and 'wild' species, and they also represent all seasons. Seemingly freshly plucked, they are thus a construct of art. The idea is reinforced by the bunch of flowers casually supported on the girl's right arm, including a prominent curling acanthus leaf, symbol of the arts in the 'language of flowers'. If the picture clearly alludes to Saint-Jean's own career aspirations, the prominence it gives to pink and white roses − emblems of beauty − refers to the prize he hopes to win in Caroline. A tulip,

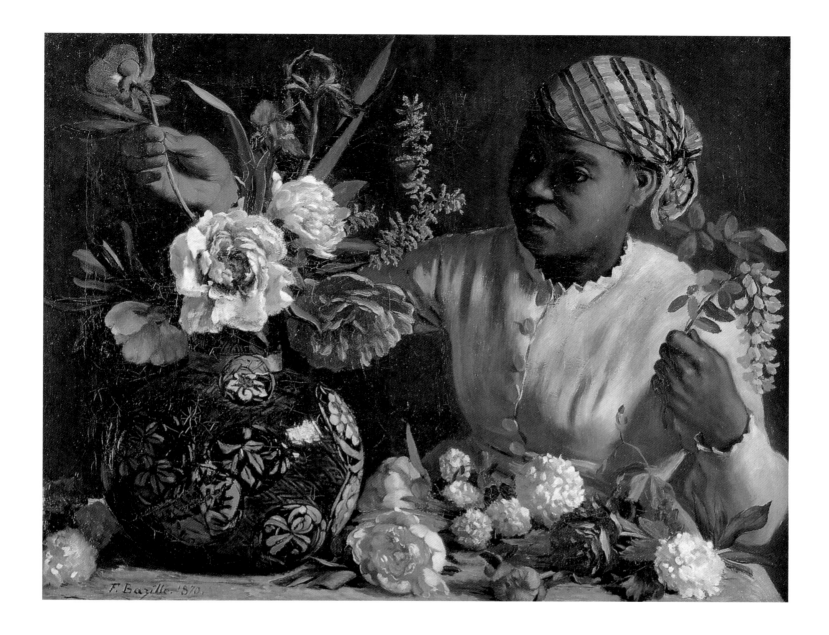

from the rest of the flowers in this way, as if an attribute of the African woman, this sprig of laburnum clearly expresses the sentiments to be found in Baudelaire's sensual paean to Jeanne Duval, his mulatto 'Black Venus', in *Les Fleurs du Mal*:

Bizarre deity . . . Faust of the Savanna,
Sorceress with ebony flanks,
Child of black midnights.[70]

Another name for the laburnum was in fact the 'ebony tree', on account of the colour of its wood. Held by the African woman to her left, the sprig of laburnum actually falls forwards towards the viewer, as if to draw us physically into her activity of filling the vase, and literally to 'bewitch' us. Since holding a flower to the left in this manner signified 'you' in 19th-century etiquette,[71] subject and object are once again here conflated. The viewer is 'bewitched' both by the African woman and by her flower.

 The flower which the African woman meanwhile places in the vase with her right hand is, however, a red peony. This is seen from the back, leaning away from the viewer, but is pre-sumably of the same double variety as those already prominently filling the vase with their

blowsy petals, or lying alongside, ready to be used. Showy and much favoured during the Second Empire, double peonies were flowers that symbolized 'splendour'.[72] Peonies in general were, as the horticultural press had recently noted, also believed in antiquity to annul spells.[73] In other words, we have beneficial as well as bewitching magic here, and as if to reinforce the point, a blue iris crowns the arrangement in the vase. Though in Baroque flower-paintings such an iris was often used to symbolize the Madonna, in the 19th-century 'language of flowers', it represented 'confidence'.[74] Vigorously brushed, in a manner reminiscent of Courbet, and illuminated with a strong shaft of light as if from a window, both this picture and its partner image hold the subjective and objective in that special moment of fusion of 'the world external to the artist and the artist himself' which Baudelaire had called 'evocative magic' – a state of sensory excitement which in turn calls into play the viewer's own powers both of imagination and of meditation. If Bazille's two paintings evoke a realm far removed from the sordid and unsettling scenes of civic unrest in the streets of Paris, following the death of the radical politician Rochefort, which he had witnessed and described with disgust in a letter to his mother but a few months previously,[75] they offer 'confidence' in the creativity of the human spirit, which, through art, consciously challenges death and destruction. In the 'first' version of the *African Woman with Peonies*, it is, in fact, a whole bunch of 'splendid' peonies, held up by the African woman as if for the viewer to admire, above her array of spring flowers in a basket, that is juxtaposed with her dark 'sorceress's' face and hand. The flowers and the woman become as emblems for that Baudelairean creative duality, whereby the encounter of opposites – peonies and 'sorceress'; 'object' and 'subject'; painting and viewer – works the 'evocative magic' which was felt to be 'modern art'.

Both Bazille's *African Woman with Peonies* paintings were completed (only a few months before his own death in the Franco-Prussian War) while he was lodging with Fantin-Latour. Fantin had recently painted his famous 'Betrothal Still Life', showing daffodils, strawberries and other motifs which, in the 'language of flowers', represent a declaration of his love and celebration of his lover (though this symbolism appears to have been overlooked by previous writers[76]). It is thus not surprising to find Bazille himself using floral symbolism at this period. His imagery, however, is perhaps still more complex. For in the painting which shows a basket of spring flowers, we find combined – again according to the 'language of flowers' – both love of self (subject), and of another (object). This is because, prominent among the spring flowers are not only narcissi, emblems of 'self-love',[77] but also tulips – the flowers which, as we saw in relation to Saint-Jean's *The Gardener-Girl*, symbolized a declaration of love to another person. There is a 'push and pull' of imagery here which matches that in Bazille's partner painting, where the 'intoxicating' woman with her 'magical' laburnum yet provides the means, with her peonies, to overcome the 'spell' represented by laburnum. What is now going on is not just a breaking of boundaries between different genres in art – portraiture, still life and so on – but an active, dynamic involvement of the viewer in the very process of the painter's interaction with his subject, so that, as in Degas's portrait of Madame Valpinçon or Renoir's evocative *Still Life, Arum and Flowers*, the painting becomes an 'impression' – something both subjective and objective at once.[78] It draws us into inner realms, while remaining bound to the physical realities of sensory experience, and conveying and inviting meditative thought.

In an age when the 'language of flowers' has long been forgotten, it is understandable that many of these layers of apparent inner meaning in Degas's and Bazille's paintings, as well as in work by Fantin-Latour, have been overlooked by modern writers. But Degas, after all, had made a close study of the contents of the Museé des Beaux-Arts at Lyons when he visited the

city in 1855, the year when Saint-Jean himself had won nine gold medals at the Universal Exhibition in Paris. Bazille, who painted alongside both Monet and Renoir in the later 1860s, and shared his studio variously with one or other at this period, had visited the Lyons Musée des Beaux-Arts from his family home in Montpellier, and, like Monet, also knew Courbet well. He would surely have noticed the 'submissions of remarkable pictures of flowers and fruits, the genre preferred by the Lyons School' which swept up most of the prizes in the Beaux-Arts section of the Concours Régional de Montpellier in 1860, given his father Gaston's prominent role in organizing such events for the Société Centrale d'Agriculture et des Comices Agricoles de l'Hérault.[79] And it is perhaps not without interest in that Monet's future wife, Camille, whom he portrayed in *Women in the Garden*, was herself originally from Lyons, and that one of Renoir's earliest surviving paintings shows a Lyons-style wreath of flowers.[80] The future Impressionists' use of floral symbolism clearly reveals, in fact, that they were already as much a part of the quest for new forms of non-verbal expression as were French poets at this period, whose fascination with what Mallarmé would call 'suggestion rather than statement' has been much discussed by literary and art historians.[81] While Degas's and Bazille's reinvention of the 'gardener-girl' theme in one sense develops the logic of Delacroix's Romantic belief that 'If you cultivate your soul it will . . . invent a language of its own', it thus also looks to the future; to the world of nuance and ambiguity of the late 19th-century Symbolists, who took Mallarmé as their leader. At the same time, Bazille's and Degas's 'gardener-girl' imagery gives a boldly original twist to the allegorical devices deployed by Saint-Jean and even by Courbet, by dynamically engaging the viewer. The scents, colours and textures of a garden, as concentrated in its flowers, are vividly thrust before our eyes, in ways which implicate us in their meanings. And though Bazille's 'gardener-girl', for all her exotic allure, is a more literal, even Courbetesque image than Degas's puzzling portrait with its strange perspective, his *African Woman with Peonies* pictures stand at a fascinating fulcrum. For he was simultaneously beginning to explore, in paintings to be considered in the next two chapters, the exciting new world of *pleinairisme* as found in gardens themselves. In these outdoor paintings, and in similar paintings by Monet, Renoir and Pissarro, we will find in evolution not only the new Impressionist 'language of art', but the garden itself as a place of inner meaning; a development which again points the way to the appreciation by turn of the century Symbolists of Monet's painting of his garden at Giverny.

Baudelaire's condemnation of Lyons as 'the penitentiary of painting' was perhaps as much a kicking over of his traces as genuine disgust; the city was, after all, where he first went to school. He did in fact find merit in the work of Pierre Chabal-Dussurgey, one of the younger Lyons *fleuristes* and the tutor of Philippe Burty, a close friend of Degas and one of the Impressionists' most loyal supporters. Yet where Burty had been taught by Dussurgey to see how, within a single nasturtium bloom, 'the masses of shadow created broad contrasts with the masses of light, drowning the details without, however, losing them',[82] it was, of course, nasturtiums within the whole environment of a contemporary flower-garden that would be shown in works such as Monet's *Terrace at Saint-Adresse* [87]. If this picture suggests that in the full-blown Impressionist garden links with tradition would become tenuous, it is worth remembering that gardens, as places of cultivated growth, have synthesis at their heart, uniting the organic and the ordered within the processes of time. It is thus only logical that, as we will discover, the Baudelairean interaction of 'the world external to the artist and the artist himself' became a prominent and productive theme in the 'mixing of traditions' represented by the 'gardens of Impressionism'.

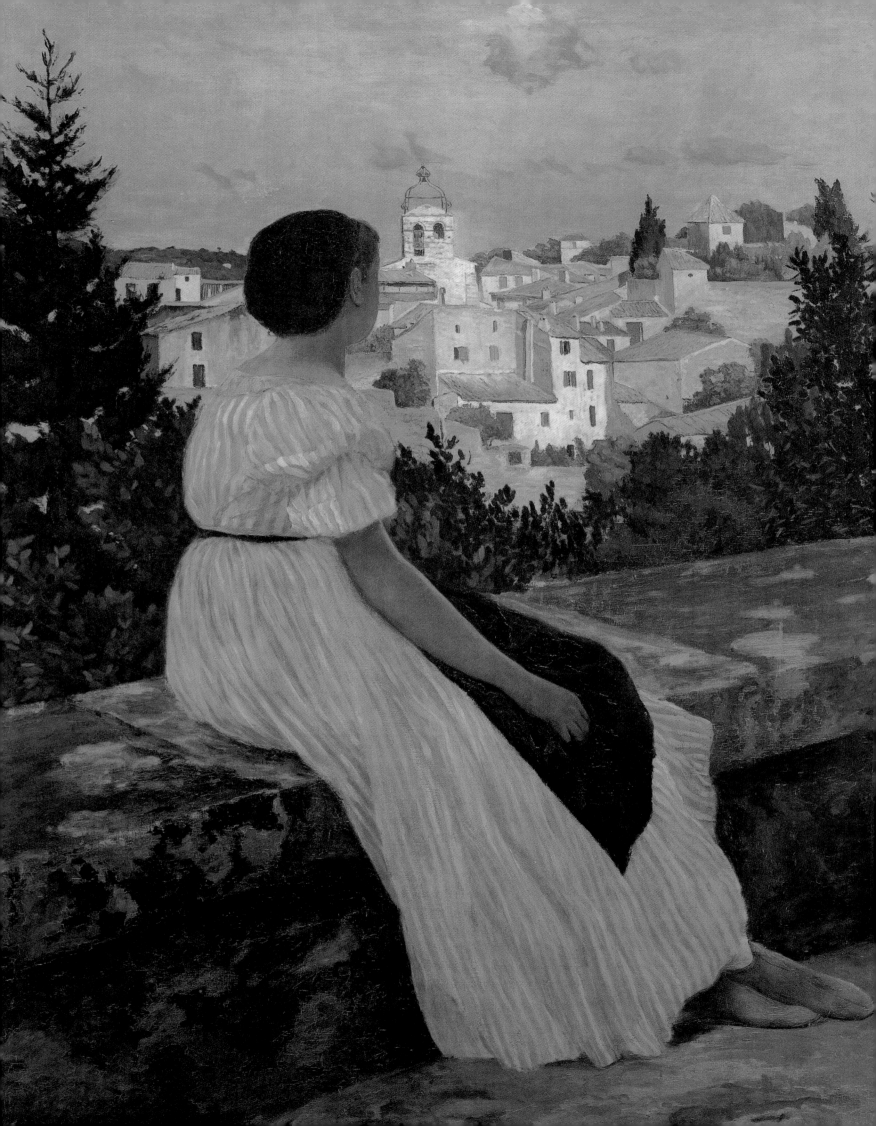

Chapter 2 Horticulture and *pleinairisme*

In December 1863, Bazille wrote excitedly from Paris to his mother in Montpellier:

We went with my friend Villa to look again at the studio we are to occupy from 15th January, it still pleases us greatly, the owner . . . has granted us a little piece of garden as large as the dining room at home, which contains a peach tree and some lilacs, it will be very pleasant for us in the summer, for painting figures in the sunlight.[1]

Louis-Emile Villa was a fellow artist from Bazille's native Montpellier; Monet also appears to have been present. The room and garden that so enthused the young artists were at 119 rue Vaugirard, on the Left Bank. Nearby was the Ecole des Beaux-Arts, where Renoir had been enrolled since 1862, as well as the Jardin du Luxembourg, the inspiration for many of Watteau's *fêtes galantes*. Also at hand was the Ecole de Médicine, where Bazille himself was still pursuing, though with little enthusiasm, the studies which his family hoped would secure him a profitable career as a doctor. Art had already won his heart, and by 1865, he would share a studio with Monet on the floor above the late Delacroix's own, at 6 rue Furstenberg, again not far from the Ecole des Beaux-Arts. Bazille's delight in his new garden brings together horticultural, aesthetic, and even social and scientific dimensions. This chapter shows how, concurrently with the transformations of flower painting and other genres discussed in the last chapter, the fashion for horticulture in Second Empire France joined with new *plein-air* trends and modern-life subjects to produce the conditions in which the 'gardens of Impressionism' would begin to take root. It also shows how this process, played out against the contentious rebuilding of Paris during the Second Empire by Napoleon III and his Prefect of the Seine, Baron Haussmann, became entwined with social, political and literary ideals through the influence of free-thinkers and radicals such as Baudelaire, Zola, Proudhon and Courbet. It then goes on to discuss Manet's *Music in the Tuileries* and his and Monet's interpretations of the *Déjeuner sur l'herbe* theme.

If Watteau's shade still hovered in the Luxembourg district when Bazille settled at rue Vaugirard, Delacroix's must have been still more tangible; he had died but a few months earlier, in August 1863. Bazille's project for painting figures out of doors directly recalls Delacroix's delight in observing the dappled sunlight on children splashing in the fountains before the nearby church of Saint-Sulpice when he worked in the last years of his life on his famous murals there. Already in 1846, Baudelaire had in fact named sunlight and 'air' the vital determinants of colour – the feature he so admired in Delacroix's art.[2] But where Delacroix, in his *Jacob and the Angel* at Saint-Sulpice, had portrayed Biblical figures amid sun-dappled woodland observed at Fontainebleau, just as Watteau before him had turned the spacious, tree-shadowed Luxembourg Gardens into shimmering, misty dreamscapes, the art of Courbet had by the 1860s put 'reality' firmly to the fore. In 1861, those sharp-eyed monitors of change the Goncourt brothers concluded that the 'future of modern art' lay in 'the reality of man and his costume transfigured by the magic of shadows and light, by the sun, a poetry of the colours which fall from the hand of the painter'.[3] As this comment makes clear, truth of atmospheric effect was now felt to demand its counterpart in terms of motif – the depiction not just of 'real' locations and lighting, but also of modern people, engaged in contemporary activities. It was only logical that Monet and Bazille were enthused just a few

LE JARDIN DU LUXEMBOURG
Dessin de M. Français, gravé par M. Rouget.

51 Frédéric Bazille, *The Pink Dress*, 1864
Seated on the boundary wall of the family estate near Montpellier, Bazille's cousin Thérèse des Hours looks out to the larger *jardin naturel* of the surrounding landscape, where the village of Castelnau-sur-Lez is bathed in summer evening light. One of Bazille's earliest attempts to capture *plein-air* effects, this picture invites us to share both his and Thérèse's enjoyment of the breeze which cools their Midi garden as the day draws to a close.

52 'Le Jardin du Luxembourg', from *Paris Guide*, 1867
The Luxembourg Gardens, surrounding the former royal Luxembourg Palace, were a favourite recreation place for students from the nearby Sorbonne and Ecole des Beaux-Arts, nannies with children – and future Impressionists. In the 1860s, Monet, Bazille and Renoir all enjoyed observing 'modern life' there, as coloured by the light and atmosphere of open air.

years after this not only by a private garden with its promise of concentrated sensation – warm sunlight, scented lilac, and the plenitude of a peach tree – but also by the 'spectacle of daily life' as found in the nearby Luxembourg Gardens itself. The original garden of the Luxembourg Palace, this was now the haunt of children playing while their nursemaids gossiped, and of Ecole and Sorbonne students reading and relaxing. It was all too lusty a bundle of 'daily life' – a crying baby, neglected while its nursemaid flirted 'with a trumpeter in the hussars, who was loitering nearby' – that, on one of Renoir's visits there with Bazille, actually resulted in his being chased by the park-keeper and a horde of mothers. Renoir had made so bold as to rock a baby's carriage to soothe it![4]

By envisaging his garden as a place for 'painting figures in the sunlight', Bazille was, of course, in one sense simply extending the established practice of *plein-air* landscape sketching.[5] Eugène Boudin, for example, to whom Monet later extravagantly credited everything he had learnt as an artist, believed that 'three strokes of the brush in front of nature are worth more than two days of work at the easel [indoors]'.[6] But even Boudin, like Manet, still held to the practice of sketching out of doors, rather than painting finished *tableaux* (pictures for exhibition) there. And Bazille now wanted to paint figures, and not just landscape, 'in the sunlight'. For if he saw the rue Vaugirard garden as an artistic 'laboratory' akin to that of the pioneering contemporary experimental scientist Claude Bernard, where he might explore in microcosm the combination of 'modern life' with light and atmosphere, its very nature as a private, readily accessible locale would also have facilitated the kind of labour over time involved in a *grande Salon machine* (finished subject picture). However, while a garden might serve as a *plein-air* laboratory, with all the objective study that the concept implies (or even just as a surrogate atelier), it could also carry rich and very personal associations involving a high degree of subjectivity. An early outcome of Bazille's expression of interest in painting figures out-of-doors, after all, seems to have been his painting *The Pink Dress* [51]. A portrait of his cousin Thérèse des Hours, this was carried out from sketches made on Bazille's family's estate at Méric near Montpellier in summer 1864, and as Thérèse sits on the boundary wall of its *parc à l'anglais*, with her back to the viewer, her gaze is that of Bazille himself. Artist and subject look together from their garden made in 'nature's image' to 'real' nature itself, the valley of the river Lez. In the distance is the southern, unmistakably French village of Castelnau-sur-Lez, its stone turned the colour of Thérèse's dress by the evening Midi sun. Bazille's 'sharing' of this view with his cousin is richly suggestive; the estate had been jointly inherited by the Bazille and des Hours families only five years previously. But we, as viewers, are also drawn into the elemental bond of blood, soil and sun, because we are given a privileged view over Thérèse's shoulder. As we will discover in later chapters, such a suggestion of inner meaning and intimate feelings recurs in many Impressionist works.

Metaphors of growth and cultivation

In charting the steps towards this development, it is worth remembering that the Faculty of Medicine in Montpellier where Bazille had begun his doctor's training before coming to Paris was still strongly influenced by the tradition of 'Vitalist' physiology developed there by Paul-Joseph Barthez, which saw the animal and vegetable kingdoms as sustained by a common vital principle.[7] A sense of intimate relationship between humanity, beasts and plants was also evident in the Republican historian Jules Michelet's popular works on philosophy and natural science which enjoyed a wide circulation in mid-to-late 19th-century France, and were especially appreciated by those sympathetic to left-wing ideas, as were Courbet, Manet and, in the main, the future Impressionists.[8] In Michelet's volume of 1859 on

Woman, an entire chapter is devoted to 'Sun, Air and Light' as vital forces linking human emotions and growth with the life of cultivated plants:

> The human flower is, of all flowers, the one that desires the sun the most . . . there must be a garden, not a park: a little garden. Man does not grow easily outwith its vegetable harmonies.[9]

Such association of child and plant growth has origins in Jean-Jacques Rousseau's Romantic philosophy, but Michelet also approvingly cited Froebel's more recent concept of the 'child-garden'.[10] And if Renoir saw nursemaids taking their children to the Luxembourg Gardens already in the 1860s, then by 1879, under a reforming Republican government, the Minister of Public Instruction and the Fine Arts, Jules Ferry, would actually decree that a *jardin clos* (enclosed garden) was to be part of every rural school.[11] For adults, of course, jaded by city existence, fresh air was looked upon as a restorative; a belief to which both Boudin's atmospheric, ozone-laden Normandy beach scenes populated by Parisians on holiday, and the rising popularity during the 1850s and 1860s of the Barbizon painters' 'natural' landscapes, bear vivid witness. As is well known, such paintings were a major influence on early Impressionism. But 'garden air' arguably had a special character, as a nutrient imbued with primal symbolism – whether of the Biblical Eden or Paradise, the Classical Hesperides, the Oriental legends cited by Michelet as placing 'the start of life in a garden',[12] or the new Darwinian ideas on evolution that inspired Zola, and showed humanity's ascent from beasts. Painting or sketching in a garden and tending or enjoying one were in this sense cognate activities, involving nostalgic, restorative or even visionary dimensions.

There was also a vigorous tradition of poetic association between humankind and plants and flowers. This derived in part, of course, from the description in the Psalms of man as but 'a flower of the field', and Baudelaire in turn drew upon the writings of the mystic Swedenborg when he wrote in his 'Invitation au voyage' (Invitation to the Journey) prose-poem of the perfect land as one where 'we must go to live and flower', and in his poem 'L'Ennemi' (The Enemy) of the human mind itself as a garden whose thoughts were flowers.[13] Baudelaire's friend Edmond Duranty, the founder of the journal *Réalisme* and a future champion of the Impressionists, likewise drew on the metaphor of the *plante humaine* (human plant, or plant of humankind). In Duranty's 1860 novel *Le Malheur d'Henriette Gérard* (The Unhappiness of Henriette Gérard), a private garden – the realm of Henriette and her clandestine lover – serves as an Eden-like enclosure of innocence, truth and purity, albeit at risk of despoliation from stones thrown by unenlightened elders. This image of the vulnerable garden is, of course, that which we have already met as a description of Impressionism itself in Duranty's famous essay of 1876 on 'The New Painting'. Zola too used metaphors of growth and cultivation when he called in 1866 for the modern artist to be someone who 'seizes nature herself in his hand and plants it upright before us, just as he sees it'.[14] In this sense the artist was not just a *plante humaine* but also a form of gardener.

Bazille's 'corner of creation'[15] at the rue Vaugirard must certainly have been a happy surrogate for his beloved family estate at Méric – a guarantor of emotional security amid the vast, unpredictable metropolis – and he clearly looked forward not just to painting there but also to to sharing its lilac and peaches with like-minded friends such as Monet and Renoir. Monet, as mentioned earlier, had grown up beside fine gardens at Le Havre, while Renoir would recollect in old age how when he was a child, prior to the reconstruction of Paris by Baron Haussmann for Napoleon in the 1850s and 60s, the city had been 'much more healthy than it is now. The streets were narrow and the central gutter stank a little; but behind every house there was a garden. There were plenty of people who still knew the pleasure of eating

freshly picked lettuce.'[16] Bearing in mind both such happy early memories of gardens on the part of the future Impressionists, and the 'Vitalist' and poetic traditions of association between humankind and plants or flowers, it is helpful to take a closer look at some of the ways in which, hand in hand with popular and scientific interest in 'sun, air and light', enthusiasm for horticulture was sweeping through France even as the future Impressionists took their first artistic steps.

Popular horticulture in France from the mid-19th century

Bazille's rue Vaugirard studio garden, providing a place where some produce could be grown for home consumption, along with a few flowers, was essentially the sort of modest cottage garden remembered fondly by Renoir, and, despite the programme of urban renewal, still to be found in some of the surviving older parts of Paris, such as the rue Vaugirard district on the Left Bank. And even though the uncompromisingly straight course being driven in the 1860s through the eastern part of the rue Vaugirard area by the new rue de Rennes, rue d'Assas and boulevard Raspail threatened to truncate part of the Luxembourg Gardens themselves, along with the traditional orchards and nursery bordering them, public petitions saved the gardens' core, along with the adjacent Allée de l'Observatoire. The nursery, however, was lost – to the sorrow of local inhabitants. A guide book of the period reveals how it had become a centre of gardening know-how:

53 A 'jardin artificiel' from Mangin's *Les Jardins Histoire et Description*, 1867 This period illustration presents the varied benefits and pleasures of the *jardin artificiel*. Cabbages at the right supply fresh food, while hollyhocks at the left – traditional rustic flowers – delight the eye. A woman draws water and a man digs the soil.

It contained, among other collections, one of every kind of vine. Skilled gardeners gave a course of public classes on horticulture in the nursery, and a professor taught apiculture with the help of some hives set up next to a little chalet.'[17]

In this context of the creation of 'new Paris', it may, in fact, seem something of a paradox that, just as Manet chose to paint a former royal garden in his Tuileries picture, a traditional garden in the rue Vaugirard should serve as midwife to new trends in art. The peach tree mentioned by Bazille brings to mind, for example, the 'trellis of espalier fruit trees and vines, whose pitted and dusty fruit is watched over anxiously by Madame Vauquer every year' which Honoré de Balzac had described behind the ancient 'Maison Vauquer', also on the Left Bank, in his 1834–5 novel *Le Père Goriot*.[18] But the lilac bush which also delighted Bazille in the garden of his new studio provides a reminder of the transformation into modern *agrément* (pleasure) which traditional horticulture was already undergoing. Where the peach tree at rue Vaugirard, providing food as well as shade, still spoke of what the 18th-century philosopher Diderot had praised as *nature employée* (nature turned to human profit),[19] its delicately scented lilac invited repose and *rêverie*, and in the 19th-century 'language of flowers', symbolized youth (if white-flowered) or young love (if purple-flowered). We might almost take the lilac in Bazille's garden as an emblem for the new enthusiasm for gardens as places for recreation and the delight of the senses which had been so dramatically fuelled by the discoveries of intrepid 'plant hunters' like 'Père David', a missionary in China.

VARIETES
1 Gloire de Corbeny.
2 Mistress Pollock.
3 Henri Lierval.

Syringa (Lilas) PRÉSIDENT MASSART.
Semis Belgique (Plein air.)

Hydrangeas, for example, which were much favoured by the Empress Eugénie, wife of Napoleon III, had been introduced around 1830; a specimen grown in a pot in fact appears at the left of Manet's *Balcony* of 1868, turning the window-front into a miniature garden, and inviting us to read the women seated on the balcony as themselves but further fashionable flowers. Prince Henri d'Orléans, grandson of King Louis Philippe, likewise returned from pioneering expeditions to Central Asia with new kinds of rhododendron and primula, among other plants, which also became staple ingredients in popular gardening.[20] Much effort was meanwhile given to the development of new varieties of flowers and plants through cross-breeding. Lilac itself had first been cultivated in the 1840s in the double-flowered form we know today, and which appears in Monet's *Spring Flowers* of 1864 [39].[21] The *Begonia Rex* was developed in the mid-19th century, and double geraniums from the mid-1860s; hundreds of varieties of the new *Gladiolus gandavensis* (introduced 1844) were similarly created.[22] The introduction of perpetual-blooming China and tea roses in the late 18th and early 19th centuries had given rise to the Bourbon and Noisette varieties, represented in the Empress Joséphine's famous collection at Malmaison; roses thereafter became a focus of intense development through artificial hybridization in both England and France. The first modern hybrid tea rose was created in 1867 by French nurserymen, and called, appropriately, 'La France'.[23] The smaller-flowered Japanese 'multiflora' rose was introduced in 1862, and new yellow and orange strains were bred later in the century from

54 *Pelargonium zonale iniquium*, from Alphand's *Les Promenades de Paris*, 1867–73

55 *Syringa (Lilas) Président Massart*, from *L'Illustration Horticole*, 1863

Two period illustrations of recently developed flower varieties – zonal pelargonium and a type of lilac – which were eagerly adopted in French gardens from the mid-19th century.

the 'Persian-Yellow', first introduced to the west from Iran by an English diplomat in 1837. Art in turn stimulated horticulture: camellias, introduced already in the 18th century, became all the rage after the publication of Dumas's *La Dame aux camélias* (The Lady with the Camellias) in 1848, which inspired both a play and Verdi's later opera *La Traviata*. By the 1860s, there were so many varieties of this flower that the gardening journal *L'Illustration horticole* proudly advertised itself as 'published by Ambroise Verschaeffelt, horticulturalist, editor of the *New Iconography of Camellias*'.[24]

Though agriculture also underwent modernization in mid-to-late 19th-century France,[25] it was ornamental and leisure gardening which caught the popular imagination, even among those of relatively modest means, as an essential expression of taste and fashion. As well as *L'Illustration horticole*, journals such as the *Revue horticole*, and the cheaper and very widely read *Le Bon Jardinier* and *L'Almanach du jardinier*, offered copious know-how and incentive. The grander journals were illustrated with attractive coloured engravings, often after images by Lyons *fleuristes*. The *Flore des serres et jardins de l'Europe*, published in Belgium, and one of those illustrated with colour plates, was widely circulated in France; Monet, whose second wife, Alice Hoschedé, had a Belgian father, would later own a set of its volumes at Giverny. Interestingly, however, all these publications typically mingled the moral, historical or social with the horticultural. The *Revue horticole*, for example, reflecting the concept of the *plante humaine*, in 1858 praised the introduction of a new course of elementary instruction in gardening at the College at Fontenay-le-Comte because, 'the soul needs to leave behind the nauseous atmosphere of life in the office to open out in the sun as does an etiolated plant . . .'.[26]

The horticultural societies, competitions and exhibitions which in turn proliferated throughout France were fed by rivalry with English and Belgian horticulturalists, who were frequent exhibitors − and prize winners − at them. The Lyons Société d'Horticulture was founded as early as 1832, that in Monet's home town of Le Havre in 1853, and the Société Centrale d'Horticulture in Paris in 1855.[27] By 1858, Daumier was making fun of the craze for horticulture in his caricatures. A typical example shows an amateur gardener scrutinizing his new fruit trees; boasting to some visitors 'I'm beating a new trail . . . just take a look for me at this tree . . . it's a cherry onto which, last year, I grafted an apple, I'm curious to see if it is bringing me anything this year . . .', he receives the answer: 'But of course it is . . . I already see caterpillars!' By 1860, the French journalist Eugène Chapus was writing that:

One of the pronounced characteristics of our Parisian society is that . . . everyone in the middle class wants to have his little house with trees, roses, dahlias, his big or little garden, his rural *argentea mediocritas*.[28]

If his phrase *argentea mediocritas* (silvered mediocrity) evokes the parvenu taste of such gardens by parodying Horace,[29] an illustration by Gustave Doré called *The Family at Auteuil*, published the same year, pokes still further gentle fun. This shows a *petit bourgeois* in a wide-brimmed hat hopefully pruning a leafless shrub from instructions in a gardening manual, as his wife watches anxiously, and his young daughter and son stand by with watering cans, the daughter obediently, and the son rather less so.

While in Paris, Bazille himself seems to have been something of a horticultural supplier and adviser to friends in Montpellier. One of these, the sculptor Auguste Bausson, wrote to him in March 1863 after a destructive storm there,

Send us seeds for summer plants. I will distribute them as you recommend to all [our friends'] gardens . . . [they] beg you to send them common plants that do well in these parts, balsamine,

chrysanthemums, above all chrysanthemums, and others of your choice. Méjan asks for . . . about fifteen dahlias of different kinds, especially pure white and canary yellow, we can get other sorts easily here, in short he does not need or want many of variegated hue, instead pure colours. Olivier Brun asks you to send some canteloupe melon seeds in Méjan's parcel. But as it is a bit late to sow these things down here, he begs you to send them speedily . . .[30]

Did Bazille go to the Luxembourg nursery itself for such seeds? His friends' requests certainly testify to the extent to which, despite the eventual loss of this old nursery, Paris was fast becoming a centre of horticultural excellence. Home to burgeoning dynasties of great commercial seedsmen such as Vilmorin, and Truffaut who would later supply Monet at Giverny, it boasted extensive new municipal nurseries at the Bois de Boulogne, where the thousands of plants for the city's parks and squares were grown. A lady in another caricature by Daumier displays a potted plant, still wrapped in paper, to a doubting gardener on her (somewhat bare) country estate: 'Look, my friend . . . it won't be said that we have no flowers this year in the country here . . . this is a rose-bush that I've brought back from Paris for you.' In turn, the free public lectures on gardening held in the Jardin des Plantes proved very popular; and in the Bois de Boulogne – another of the former royal parklands opened to the public by Napoleon (and in this case also substantially reconstructed by him) – the Paris gardeners held an annual ball. As one of the gardening periodicals pointed out in 1862, modern Frenchmen might no longer have the means and wealth of the noble ancestors to create estates for their 'great nephews', but they could seek,

nonetheless, to refresh [their] . . . years of maturity and old age, to embellish a plot of soil which after [them] . . . will pass on to other hands. Hence a new phase of picturesque gardening, that of the *petit parc* [domestic 'park' or garden], whose proportions accord with the limits of present-day incomes.[31]

Such *petits parcs* might range from the extensive policies of Caillebotte's family at Yerres, south-east of Paris, planted out in the 1860s and incorporating a Swiss cottage and other recommended features,[32] the Manet estate at Gennevilliers, where peonies apparently flourished in abundance, or the Bazilles' near Montpellier, to the more modest, but no less carefully tended lawns and *corbeilles* (display beds) of roses, geraniums, gladioli and nasturtiums shown in Monet's views of his family's gardens at Sainte-Adresse. The apotheosis of the Second Empire park, however, was the five-hectare horticultural display laid out on the Champ de Mars as part of the Universal Exhibition of 1867. The god of war, it was said, had allowed Flora to take over his military ground.[33] Described by the *Revue horticole* as a 'ravishing sight', the latest and rarest flowers and trees were planted out, from orchids to 'collections of hyacinths, on elevations of ground and on the slopes' and 'majestic clumps of Magnolias, Conifers, fruit trees and other vegetables'. Greenhouses 'of all sizes and heights' rose up 'as if by magic', and 'an English river' was created as if by a 'fairy wand', to meander amid spacious lawns.[34] This horticultural extravaganza was the starting point for ever more lavish successors at the international exhibitions of 1878, 1889 and 1900; by 1900, some 3,000 square metres (32,000 square feet) alone were filled by roses, as part of 'an immense Parterre of flowers, stretching from the [Place de la] Concorde to the Pont des Invalides, in an incomparable rainbow where all the colours mingle, all the perfumes blend, then domi-nate one by one, as one gradually moves through this Paradise of Flowers'.[35]

Gardens, in short, whether private or public, were virtually integral with 'modern life', the theme urged on artists first by Baudelaire, and then, from the mid-1860s, by Zola. The word *coin* (corner) employed by Zola in his famous definition of art as a 'corner of creation seen through a temperament' was itself frequently used in describing private gardens, evoking

59 'Universal Exhibition – horticultural competition: ornamental plants imported by Mr. Linden...' from *L'Illustration*, 1867
Ambitious horticultural displays and international horticultural competitions formed an integral part of the Paris Universal Exhibition of 1867. This illustration shows a submission from a British grower.

their character as a cultivated part of nature's larger realm.[36] At the same time, the emergence of the *jardin d'agrément*, with its heady appeal to smell and taste as well as sight, and its invitation to *rêverie* and private leisure, coincided absolutely with Zola's emphasis on subjective *sensation* (temperament), and its role in the artistic impression. By 1862 even the highly practical *Revue horticole* was calling a garden something 'which speaks simultaneously to the soul and the senses'.[37] A gardener from Montpellier itself, Bazille's home town, had even written in 1859 in this same journal of how the gardener's imagination, 'going before him in the realization of his efforts, already shows him the future through the enchanted prism of his fine dream'.[38]

Such sentiments in essence echoed a wider mood of Utopian idealism which found its origins in Charles Fourier's *phalanstères*,[39] and one of its most ambitious expressions in the socialist Pierre-Joseph Proudhon's dream of 'the splendid future of France':

We have the whole of France to transform into a vast garden where groves, copses of trees, tall forests, springs, streams and rocks are mingled, and where each new landscape contributes to the general harmony.[40]

Proudhon's vision was, in fact, part of a book called *On the Principle of Art and its Social Purpose* on which Courbet collaborated with him in 1863, but which was only published in 1865, after Proudhon's death. Courbet in turn portrayed the 'peaceful anarchist' philosopher meditating in his tree-shaded Paris garden, his books at hand as his daughters read and play, in a portrait of 1853–65.[41]

60 Gustave Courbet, *Portrait of P.-J. Proudhon*, 1853
Just as Proudhon urged that France itself should be made an enormous garden, so Courbet shows the anarchist philosopher working out his ideas in his tree-shaded garden in Paris. Proudhon's daughters in turn engage in creative play.

Haussmann: *Promenades et Plantations*

The *jardin artificiel* – the man-made garden – was, as mentioned earlier, often seen as continuous with the *jardin naturel* – the 'garden of nature' of the wider landscape, evoked in Proudhon's book, and closely related to the ideals of both Fourier and the social reformer Saint-Simon, who had decreed that 'The whole of French soil should become a superb English park, embellished with everything that the fine arts can add to the beauties of nature'.[42] It was, in fact, Saint-Simon's ideas, and his own experience of seeing the London parks, which had partly inspired Napoleon's programme to replace the ancient, disease-ridden streets of Paris with space, light and air. But we need to remember that Proudhon's vision of France itself as a garden was nonetheless couched as an explicit revolt against the new Paris of Napoleon III.[43] (His book concluded, in fact, with a vigorous denunciation of Napoleon's scheme to truncate the Luxembourg Gardens.) For despite Napoleon and Haussmann's admiration for the 'irregular' English garden style, it was a process of 'regularization', as Napoleon's Prefect Haussmann termed it, which they deployed in transforming Paris. *Plantations* (gardens, trees, and parks in the city) were tellingly linked with *promenades* (i.e. the new straight roads and boulevards) in Haussmann's new department of 'Promenades et Plantations', which was, indeed, entrusted to an engineer, Alphonse Alphand [63].[44] With the chief municipal gardener Pierre Barillet-Deschamps, Alphand organized the wholesale transplantation into the broad new boulevards and streets of fully grown trees from the woods around Paris, to serve as *arbres d'alignement* (edging trees) – a form of 'regularization' for which special wagons were deployed, as shown in a memorable period photograph by Marville. An article about these new trees in the popular journal *L'Illustration* poignantly tells how a cipher carved on one of them when it still grew in the country – the tryst of lovers on a holiday outing, just like that shown on the tree trunk at the right of Monet's *Déjeuner sur l'herbe* [70] – was now exposed to common gaze in a dusty Paris street.[45] By 1869, nonetheless, a British visitor to Paris was predicting that, 'before long Paris will be one vast garden', and by 1873, three years after the fall from office of Napoleon, some 102,154 *arbres d'aligne-ment* had, along with twenty-two new 'English'-style squares, the extraordinary new Buttes Chaumont park with its concrete rocks and pump-driven waterfall, and the renovated Bois

61 Edmond Hédouin, 'The Tuileries Gardens', from *Paris Guide*, 1867
Opened to the public by Napoleon III, the former royal garden of the Tuileries in Paris rapidly became a much-loved haunt of the young and old, whether native to the city or, as in the Universal Exhibition year of 1867, visitors from foreign countries.

62 Charles Marville, photograph, c. 1850s
Special horse-drawn machines were invented to transport and position the fully grown trees which Napoleon III's Prefect of the Seine, Baron Haussmann, transplanted to the capital from the woods around Paris.

de Boulogne, Bois de Vincennes and Parc Monceau, in effect turned Paris into a make-believe Eden, aided by Haussmann's new sewage system.[46] But did the new Eden have any heart? Where Haussmann viewed the city's new green spaces as its lungs, its new roads as its arteries, and its sewers as its mouth and digestive system,[47] Baudelaire, for one, had already lamented in his poem 'Le Cygne' (The Swan), published in 1861, that:

Old Paris is no more (the form of a city
Changes more quickly, alas, than the heart of a mortal).[48]

And it was in Baudelaire's company at this very period that Manet had made his *plein-air* sketches for his *Music in the Tuileries*. While the poet registered the Parisian *moeurs* which animate his *Petits Poèmes en prose* (Little Prose Poems), then in course of composition, Manet captured cameos in crayon – children playing under trees, mothers talking, upturned chairs. But the ways in which *plantes humaines* interact with nature in works such as Renoir's *In the Park at Saint-Cloud* (1866) [65], can be seen to subtly challenge and even subvert Napoleon's forms of horticulture. These pictures were painted, after all, against the backdrop of the displacement and 'uprooting' of whole neighbourhoods which Napoleon's urban renewal was causing (the displaced were termed *les déracinés* – 'the uprooted ones').[49] Manet's famous 'quotation' in his *Déjeuner sur l'herbe* of a pose from Raphael's *Judgment of Paris* indeed implicitly links its *jardin naturel* with the perfect but fateful pagan Paradise in which Paris's choice of Venus led directly to the terrible Trojan War – a kind of Classical mythological 'Fall' – as if to hint at a mode of existence which was doomed. Manet was no friend of Napoleon's Second Empire, even if his picture might at first be thought to show the kind of garden which, by artificial means, Napoleon was creating at the Bois de Boulogne.

63 Title page of Alphand, *Les Promenades de Paris*, 1867–73
Alphonse Alphand, the chief engineer of the City of Paris, recorded his renovation and creation for Haussmann of parks, gardens and tree-lined boulevards in a lavishly illustrated, two-volume album. Its title page shows the City's coat of arms on a decorative garden fountain, with views of several of the new parks and squares or their landmarks forming a composite 'garden' beyond – at the centre, for example, the Buttes-Chaumont park with its hilltop temple of love (see ill. 64); at the right, the winged figure of Victory from the Square des Arts-et-Métiers; and at centre left, the Tour Saint-Jacques, from the Square Saint-Jacques.

64 E. Grandsire, 'The Buttes Chaumont Park – View of the Cliffs', from *Les Promenades de Paris*, 1867–73
The most 'artificial' of the new Paris *jardins artificiels*, with its hillocks, cascades and lakes created from a former quarry, the Buttes Chaumont was later much loved by Seurat as a child, and, in the 20th century, became a favourite haunt of the Surrealists, but it is not known ever to have been painted by the Impressionists. They preferred more authentic 'nature'.

Another of the former royal estates made available for public use, Saint-Cloud lay just outside Paris. Renoir's image, with its feathery brushwork and party of Parisians enjoying an outing, is effectively a modern *fête galante* such as Watteau had painted in the 18th century. Its vision of harmony between humankind and nature looks forward to mature Impressionist garden imagery.

Meeting in the *jardin naturel*

The concepts of the *plante humaine* and *jardin naturel* came to a rich and many-layered synthesis in Manet's *Music in the Tuileries* [67]. In turn it is surely revealing that neither this picture nor Manet's and Monet's *Déjeuner sur l'herbe* paintings show the flower filled *jardins artificiels* which were becoming so popular in the 1860s, nor the English-style landscape garden into which Napoleon had converted the Bois de Boulogne by adding artificial lakes, hillocks and 'picturesquely' meandering paths. *Music in the Tuileries* instead shows trees spreading a canopy of green over the crowd as far as the eye can see: the ordered geometry of the Tuileries's 17th-century layout of tree-lined *allées*, clearly visible in a drawing of the period by Hédouin [61], has, in effect, been replaced by an essentially Proudhonesque *jardin naturel* (garden of nature) which is almost primal in its plenitude. Top hats merge imperceptibly with tree trunks; fashionable costumes are but fleeting glimpses amid the pervasive green; even the new rococo-style chairs, leaning somewhat drunkenly, seem like tangled and knotted stems.

The central motif of *Music in the Tuileries* is nonetheless one of modern social reunion as melodies waft through the trees from the band which played in the gardens on a Sunday afternoon. Intriguingly, as if subsumed by the greenery, this band is not itself portrayed. Manet included himself at the extreme left of his finished painting, while at the nearer left we see Baudelaire talking to the poet Gautier and the hispanophile Baron Taylor. Seated just in front of this group is the social hostess Madame Lejosne, wearing a blue-ribboned hat; she and her Republican-minded husband had recently welcomed Bazille into their literary and artistic circle on his arrival in Paris. The composer Jacques Offenbach, quizzing the world through his monocle, is glimpsed between a straw-hatted lady and the burly back of Manet's brother Eugène at the centre right. The painting is palpably a paean to the 'creative' strolling through Paris of the Baudelairean 'aesthetic being' or *flâneur*, whose powers of imagination

of course offered means to transcend the contentious physical 'Transformations' of the city. As such, it has long been recognized as an embodiment of the complex ideal of *modernité* that Baudelaire had argued should be the goal of the true artist – someone able to 'seize the eternal from the transitory', and show 'how great and poetic we are in our cravats and our patent-leather boots'.[50]

With its return of Le Nôtre's 17th-century formal garden to a vigorously 'natural' state, and its avoidance equally of Haussmann's horticultural artifice, Manet's picture is however, clearly very much more than just a hymn to modernity. Manet's close integration of his figures with their garden of trees and foliage is essentially at one with Baudelaire's theory of *correspondances*, where the heightened sensibility of the poet allows him to comprehend the 'confused words' that 'living pillars' (trees) let forth. Nature, we read in his poem 'Correspondances', is a 'forest of symbols'; the 'words' of the trees point to an inherent unity underpinning all human sensation and 'possess the expansiveness of infinite things'; and 'Perfumes, colours and sounds respond to each other', to 'sing the transports of mind and senses'.[51] We can see why Manet shows the crowd enjoying the garden to the sound of music. A contemporary critic, bemused by the medley of fragmented black, white and coloured patches with which Manet rendered the sun-dappled crowd, actually felt the painting 'hurts the eye as carnival music assaults the ear'.[52] But if the style embodies the music, that is surely what Manet intended; though the source of the music is not portrayed, the essence of it is – that essence whose 'universal' appeal, and power to evoke even colour itself, had been enthusiastically described by Baudelaire in his 1861 essay on Wagner.[53]

And, in 1861 also, Baudelaire had published a prose poem, 'Les Veuves' (The Widows), whose interpretation of public gardens as places of retreat offers some striking points of

66 D. Lancelot, 'Bois de Boulogne, View of the Great Lake', from *Les Promenades de Paris*, 1867–73
Though seemingly 'natural', the lakes in the Bois de Boulogne were another ingenious construct by Alphand, supplied with water pumped from artesian wells at Passy. Less theatrical in mood than the Buttes Chaumont, however, the Bois were later painted by a number of Impressionists, including Berthe Morisot [115].

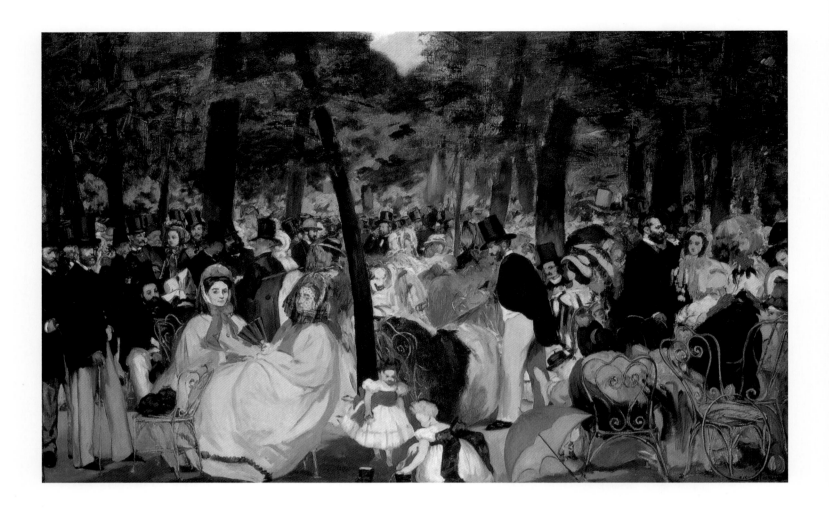

convergence with the imagery of Manet's painting. An elaboration of his poem 'A une passante' (To a woman passing by), also published in 1861, which deals with the psychological effects of time as witnessed in a public garden, Baudelaire's 'Les Veuves' evokes in half-pitying, half-cynical vein the people whom he encounters in the tree-lined *allées* of such gardens:

These shaded retreats are the meeting place of the rejected ones of life. They are above all the places towards which poets and philosopher like to direct their eager conjectures. They offer certain pasture land . . . An experienced eye never makes a mistake there. In those set or broken features, in those sunken, lustreless eyes, or those that still gleam with the dying embers of struggle, in those deep and numerous wrinkles, those steps so slow or jerky, he deciphers immediately the innumerable stories of love deceived, devotion scorned, effort unrepaid; of hunger and cold humbly and silently borne . . .[54]

Baudelaire's eye fastens in particular on 'widows on those solitary benches, poor widows', and he imagines their past, their disappointed hopes, their forgotten existences, and the history of the children who tag along beside them and make them pause before the merriment of a public concert in the gardens, which offers such contrast with their mourning attire. They are, in essence, poetic counterparts to the image of his own soul as a garden ravaged by the storms of time which Baudelaire had created in his poem 'L'Ennemi'.[55]

One of Manet's preparatory sketches made in Baudelaire's company in the Tuileries depicts a woman seen from the back and from a distance, seated in the shade of the Gardens' trees on one of the wooden benches which were later replaced by the fancy iron ones we see in the finished painting. She is dressed entirely in black, like the widow in Baudelaire's prose poem, whom the poet follows until 'beneath a charming autumn sky, one of those skies from

67 Edouard Manet, *Music in the Tuileries*, 1862
One of the icons of 'pre-Impressionism', this early work by Manet shows friends and contemporaries enjoying conversation and the music of an unseen band in the historic Tuileries Gardens. Baudelaire, in his top hat, appears just in front of the main left-hand tree-trunk; Manet's brother Eugène talks to a seated lady at the centre right; and the composer Offenbach, with his distinctive monocle, stands just to the right again. Shunning the garden's geometric *allées* – one of which features in Hédouin's view [61] – Monet suggestively creates a larger harmony of foliage and figures.

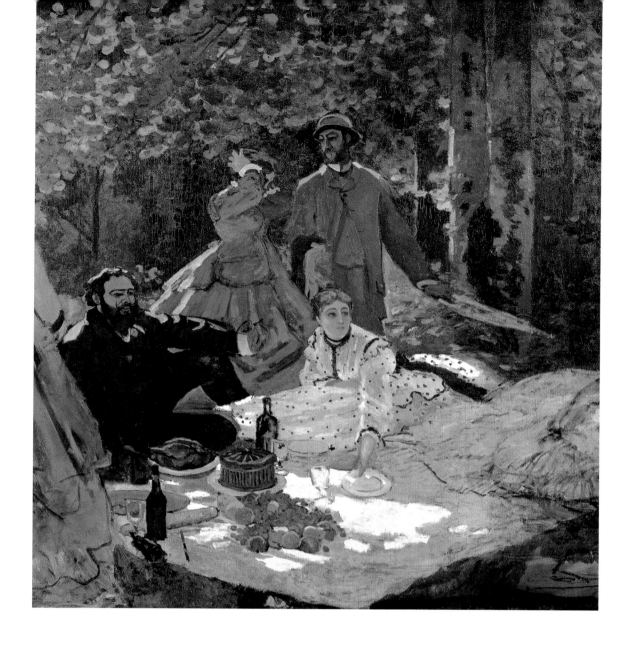

Monet's need to get his work accepted at the Salon, we can begin to understand not only why, having laid aside his *Déjeuner*, he next turned his hand to *Camille*, a more conventional portrait of his mistress in a green dress which met with Salon approval, but also why, for his next *grande Salon machine*, he chose women plucking and admiring flowers in a *jardin d'agrément* as his motif. Filled with fashionable standard roses, *Women in the Garden* [73] portrayed a form of horticulture which would not have been out of place in one of Haussmann's new *squares* – but which, of course, was now painted substantially *en plein air*, and, as the next chapter will show, was also a highly personal response to fashionable taste.

Monet had, nonetheless, made pictorial innovations in his *Déjeuner* which laid important foundations for his *Women in the Garden*. Just as his *Déjeuner* would have turned the viewer's world by implication into part of the socialist 'garden of France', so its colours 'correspond' with each other in a way that takes Baudelaire's theories into a new, still more vividly visual realm. And although, because of its size, the picture had had to be elaborated in Monet's studio from his *plein-air* sketches of his colleagues and friends at Chailly-en-Bière near Fontainebleau, its boldly dappled sun and shadow have a brilliance and immediacy which contrast decisively with Manet's more sombre colour-schemes. The shadows on the white tablecloth are blue and lilac, and equal in brilliance the patches of sunlight on the men's dark suits, contributing to an overall luminosity which puts into practice Monet's

72 Claude Monet, *Le Déjeuner sur l'herbe* (central portion of final work), 1865–6
In this fragment of the painting Monet intended to submit to the 1866 Salon (but in the end failed to complete on time), Courbet is the figure seated on the left, and the impasto paint application betrays Monet's admiration for his older colleague's style.

recent *plein-air* lessons from Boudin on the Normandy seacoast. At the same time, the notes of pure colour, such as the red costume trimmings which vibrate against the green grass, evoke a mood of hedonistic freedom. Here are carefree trippers who, having availed themselves of the expanding railway system, openly play at being plants and flowers. And they, or others before them, have correspondingly made their *jardin naturel* quite literally speak as if itself human: the tree at the right of the large preliminary sketch that Monet completed at Chailly (the clearest surviving guide to what the whole composition would have looked like had it survived intact) bears, as mentioned, a symbolic heart and arrow, along with an initial 'P'. Could this letter even be a witty homage to Proudhon, just as Courbet is shown 'centre stage'?

The painting certainly seems now to respond quite literally to the first stanza of Baudelaire's 'Correspondences':

Nature is a temple where living pillars
Sometimes allow confused words to slip out;
Man walks there through forests of symbols
Which observe him with glances of familiarity.[67]

Though Monet has replaced the mythological allusions of Manet's *Déjeuner* with a group of contemporary Parisians, his 'Realist' painting is thus still imbued with an essentially Romantic subjectivity. And as Gary Tinterow has noted, the 'lilting rhythm of tilting heads, acknowledging glances, and outstretched arms' in the large preliminary sketch is a clear homage to Watteau's *Embarkation for the Island of Cythera* [32],[68] just as its picnic theme evokes the Rococo tradition of hunting parties and *fêtes galantes*. As an emblem of human emotion, the cipher carved into living nature indeed parallels the carving of his name left by Jean-Jacques Rousseau on one of the trees at Rochecardon near Lyons, to mark his visit there in 1770.[69] Nature made literally temperament, Monet's 'growing' cipher embodies the very principle of vital life which echoes alike through Bazille's background as a medical student from Montpellier; the plant and garden images used by Michelet, Zola and Duranty; and the moralistic texts in horticultural journals of the day. But such a cipher, capable of surviving even when the tree bearing it was transplanted into Paris, as in the incident recounted in the press, is also perhaps a pointer to the inherent ambiguities of depicting modern life, and painting *en plein air*. For, as the critic Jules Castagnary noted in 1867, 'to paint what exists, at the very moment you see it, is not only to meet the aesthetic demands of contemporary people, *but, in turn, to write history for posterity yet to come.*'[70]

Painting *en plein air* seeks to capture the inherently transient – effects of weather, light and atmosphere. As we turn in the next two chapters first to Monet's *Women in the Garden* and *plein-air* paintings of private gardens at Saint-Adresse, and then to the Paris parks and squares painted *in situ* by the future Impressionists in 1867 and beyond, Baudelaire's exhortation to modern artists to 'seize the eternal from the transitory' will come readily to mind. In this connection, a remark by Bazille reinforces the possibility that the future Impressionists, no less than Manet in his *Music in the Tuileries*, were looking to past as well as present time in their garden works. Just as, in 1859, the *Revue horticole* had observed that 'a garden becomes as if the object of a cult by virtue of the memories it evokes',[71] so Bazille had written in 1864 to his mother, while visiting Honfleur with Monet: 'Ever since we arrived . . . we have been looking for landscape motifs. They have been easy to find because the country is a paradise.'[72] Here is a reference to a 'lost', perfect garden which again suggests that the Impressionist vision of nature had much in common not only with Proudhon's and Courbet's

socialist vision of a better, garden-like world, but also with Baudelaire's more bittersweet nostalgia. One of the purposes of Baudelaire's famous poem 'Correspondances' was, in fact, to show how perception of the secret, mysterious links between sensations – synaesthesia – may involve encounter with evil ('corrupt, rich and triumphant' scents) as well as innocence ('fresh perfumes like the flesh of children'); experiences at the heart of the Biblical story of the loss of the Garden of Eden. In the wake of Manet's juxtaposition of loss and delight in his *Music in the Tuileries*, as well as of Courbet's and Proudhon's Utopian ideals, we can, in this sense, view both Bazille's pleasure in the landscapes near Honfleur, and Monet's *Déjeuner*, as apprehensions of the 'perfect garden' that can only ever be simulated. The fleeting, ever-changing effects of light, weather and atmosphere that Monet and Bazille sought to capture *en plein air* become emblems of the impossibility of this dream, and we can see why Monet's *Déjeuner* should echo Watteau's *Embarkation for the Island of Cythera* – that scene believed to show departure for an imagined 'Garden of Venus'. With the dream of a perfect garden, we in turn arrive at something very close, though of course entirely different in its form of expression, to Ruskin's and Morris's retreat from modern industrial life in Britain at the same period.

In 1866, the year when Monet began *Women in the Garden*, Bazille also turned to subjects in private gardens, away from Paris. Both artists' new works, combining well-dressed women, top-hatted men and carefully tended flower-beds whose blooms would not be out of place in the pages of the *Revue horticole*, offer an intimate, seemingly sociable world that at first sight appears very different from the solitary 'rustic' retreat described by Proudhon as part of his vision of France as one vast garden: 'a home of my own in a little house made as I desire, which I would occupy alone, in the midst of a little tenth-of-a hectare plot, where I would have water, grass and silence.'[73] On seeing Monet's new paintings, Zola indeed concluded that 'In the countryside, Claude Monet will prefer an English park to a corner of a forest. He takes pleasure in rediscovering everywhere the mark of man, he wants always to live amid us. As a true Parisian, he takes Paris to the country, and he cannot paint a landscape without placing well-dressed gentlemen and ladies within it. Nature seems to lose its interest for him when it does not bear the mark of our ways of life.'[74]

But Monet, of course, though born in Paris, had spent his childhood in Le Havre. Rather than the celebrities shown by Manet in the tree-filled *Tuileries*, he was, in *Women in the Garden* and his subjects at Saint-Adresse, now painting his lover Camille or members of his family in the seclusion and harmonizing ambiance of a *plein-air* flower-garden. In linking the concentrated intensity of a sunlit, cultivated *coin* with that of blood or personal ties, he looks forward to the 'family gardens' of mature Impressionism which will be considered in a later chapter, yet also to his own eventual solitary concentration on motifs from his *paradis terrestre* at Giverny. Both types of subject, while horticulturally 'modern' in terms of the prominence given to flowers and decorative plants, can still be interpreted as an implicit retreat from, and even a rejection of, Haussmann's 'new Paris', just as had been offered by Manet's *Music in the Tuileries* and *Déjeuner*, and Monet's own early *Déjeuner*. Despite its championing by Zola, there are, in fact, important ways in which Monet's 'series' of palpably modern 'flower-gardens' of the late 1860s, and similar works by Bazille, Renoir and Pissarro, carry forward aspects both of Baudelaire's legacy, and of the vision of a perfect primal garden which is offered by their early pictures of *jardins naturels* considered in this chapter. In this process, the intimate interaction of 'subject' and 'object' that we discovered in the blurring of genre, portraiture and flower-painting traditions in Degas's *Woman seated beside a Vase of Flowers* or Bazille's *African Woman with Peonies* pictures moves yet further into prominence.

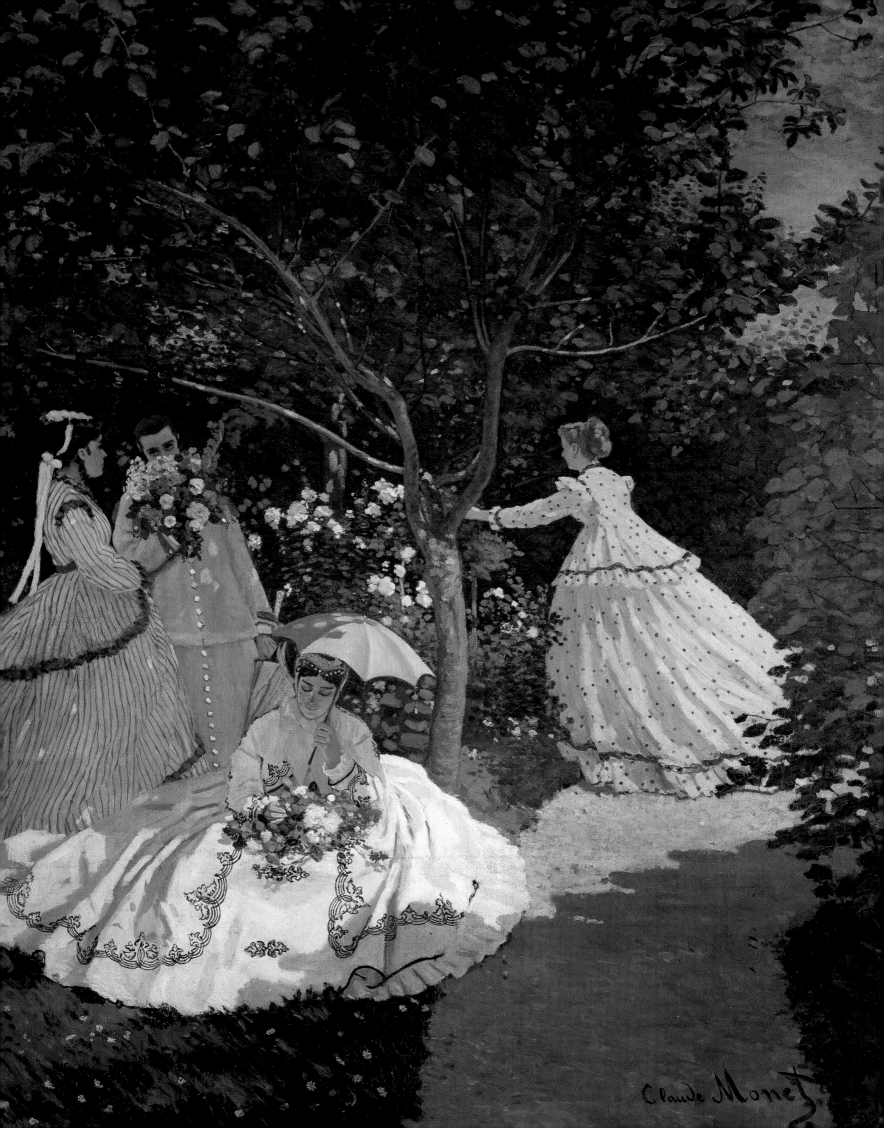

Claude Monet

Chapter 3 Private gardens before 1870

When Monet's *Women in the Garden* was rejected by the Salon jury of 1867, Zola was incensed. This, he protested, was a picture made of the artist's 'flesh and blood'; the work of an *actualiste* which had set before the viewer 'women in light summer dresses, picking flowers in the pathways of a garden; the sun fell directly into their skirts with a dazzling whiteness; the warm shade of a tree cut a broad, grey sheet across the paths and the sunlit dresses.'[1] Neither *jardin naturel*, nor public garden like the Tuileries, Monet's subject was the very apogee of modern popular horticulture: a private *jardin d'agrément* (garden for enjoyment), attached to a property he had rented during 1866 at Ville d'Avray near Paris. Planted with red and white roses, it is shaded by a fresh young tree, and enclosed by sheltering hedges. The women at the left admire the sight and scent of a fresh bouquet containing roses, a fiery gladiolus, and cultivated daisies; their companion in the foreground, seated on grass spotted with buttercups and daisies, rests a further bouquet in her lap, as she contemplates one of its roses, her face shaded by her parasol [79]. A fourth woman reaches towards the red and white standard rose-bushes in the background, to pluck one of their nodding sunlit blooms. Following the development in 1844 of the *Gladiolus gandavensis*, numerous new strains of this showy flower had been created, while among the hundreds of new roses were, for example, many red varieties, as well as a particularly impressive white rose tinged with pink and called the 'Impératrice Eugénie', and the splendid 'Gloire de Dijon' – a dullish-yellow, sweet-scented rose likely to be that in the bouquet whose perfume is enjoyed by the woman standing in the background at the left (varieties of yellow roses were still relatively limited in number).[2]

Within their blooming garden, the women of the picture's title are, of course, by implication the 'flower' of its flowers. *Women in the Garden* was, in fact, a clear attempt to update,

73 Claude Monet, *Women in the Garden*, 1866–7
The first major garden painting by a future Impressionist, this pays homage both to the traditional association of women and roses, and to Monet's mistress and future wife, Camille, who modelled all three women at the left. The woman at the right is portrayed in Monet's *Déjeuner sur l'herbe*. The garden was at Ville d'Avray near Paris, where Monet rented a house in 1866.

74 *Gladiolus gandavensis (Hybridus)*, from *Flore des serres et jardins de l'Europe*, 1846

75 Rose 'Impératrice Eugénie', from *L'Illustration horticole*, 1859

Developed in 1844, the *Gladiolus gandavensis* gave rise to innumerable varieties, one of which is clearly illustrated in the bouquet at the left of *Women in the Garden*. The 'Impératrice Eugénie' was a much admired, recently developed white rose which Monet – or his landlord at Ville d'Avray – might well have cultivated.

outdo and democratize – by means of a *plein-air* technique and a contemporary garden setting – the kind of idealized, fantasy images of the Imperial court at play with which academic painters such as Winterhalter had made their reputation, or the scenes of pastoral idyll in which Corot had come to specialize. Winterhalter's 1855 picture of the Empress Eugénie and her maids in waiting, for instance, had shown the women in their finery amid an imaginary, overgrown Watteauesque parkland, improbably clasping nosegays and bouquets which are *tours de force* of floral still-life. Monet's gladiolus and roses are, by contrast, clearly just gathered from the living garden itself, some from the flowerbed portrayed in the background. As such, the flowers portrayed are specimens of modern horticultural science which take their natural place in what Monet later remembered as an artistic 'experiment':

I was still far from having adopted the principle of division of colours which turned so many people against me, but I was beginning to experiment with it in part, and I was working at effects of light and colour which ran counter to accepted conventions.[3]

The picture, he explained, was 'painted on the spot and from nature, something not done at that time'; and for the purpose he 'had dug a hole in the earth, a sort of ditch, in order to bury my painting progressively in it, as I painted the upper part of it'.[4] Pools and patches of sunlight, filtered through the foliage, speckle the slender tree-trunk, the parasols, and the women's petal-like dresses, while glimpses of luminous sky fill the interstices between the leaves. The orange gladiolus and red roses glow against the complementary green of the grass and foliage, while the white roses echo the cool colours and creams of the dresses,[5]

76 Franz Winterhalter, *The Empress Eugénie and her Maids of Honour*, 1855 The fashionable society painter Winterhalter sets the Empress Eugénie and her entourage in a misty, imagined landscape to which the brightly sunlit garden of *Women in the Garden*, painted *en plein air*, offers an implicit counter.

themselves enlivened with greens reflected from the grass and bushes, and shadows made luminous with blue. Such coloured shadows, reflecting the hue of the sky, were an effect to which Monet's eyes had first been opened by his *plein-air* work for his *Déjeuner*. The heightened tonality in *Women in the Garden* now marked a still more decisive departure, however, from both Corot's delicate tonal values and Manet's Spanish-style chiaroscuro; Monet would later recall 'the outcry which that blue shadow precipitated'.[6] While the woman plucking a flower at the right is a reprise of the 'Gardener-Girl' theme which Courbet had illustrated in his *The Trellis* [45], Monet's quest for *plein-air* truth in fact caused him famously to reject the older painter's suggestion he might work on *Women in the Garden* even when the sun had been obscured by a passing cloud.

Zola noted, however, that Monet's 'experiment' was driven by an almost impassioned commitment – 'You have to be singularly dedicated to your own times to dare such a tour de force, the material of the dresses sliced in two by the sun and shade, finely clothed women in a flower garden which a gardener's rake has carefully groomed'[7] – and Monet himself also remembered the period when he painted *Women in the Garden* as one when 'I threw myself body and soul into the *plein-air*'.[8] His picture must in fact have had as much to do with emotion as with 'experiment', for it includes a multiple portrait, in the figures of the three women holding or admiring bouquets at the left, of his future wife Camille Doncieux, a Parisian seamstress who had recently become his mistress. (The red-headed woman in the background, reaching out to pluck a red rose, is the model whom Monet had portrayed in the same polka-dot dress, 'handing' a plate to the viewer, in his *Déjeuner sur l'herbe*). In effect we are presented with a secular *hortus conclusus* or a modern 'garden of love'. The sounds of music and chatter and enigmatic widows of Manet's *Music in the Tuileries* have been replaced by a private *coin* for a future wife, where the 'silent', intimate pleasures of sight, touch and scent reign supreme. Just as one of the 'Camilles' standing at the left smells her freshly picked flowers and the other gazes on their colours, so the woman at the right reaches out to touch and pluck a single rose – while the seated 'Camille' in the foreground simultaneously looks, touches and inhales the perfume of her bunch of red and white roses. In effect Monet's *pleinairisme* allows him to bring together for posterity the twin but transitory perfections of the loved one and her bower. His eventual use of a studio to finish off the picture during the winter of 1866–7 certainly suggests that his image involved rather more than mere fidelity to an instant of sunshine and shadow.

The picture was the first fully-blown 'garden of Impressionism', seamlessly joining the established tradition of flower painting with the emergent ones of *plein-air* technique, modern-life subject-matter and subjective impression. It directly prompted not only Monet's own series of private garden subjects at Sainte-Adresse in 1866–7, but also paintings of similar motifs by Bazille, Renoir and Pissarro in the years before 1870. While, within the context of Impressionism as such, *Women in the Garden* is generally agreed to have been 'catalytic for the young painters around Monet . . . setting the immediate agenda for Bazille, and Renoir, and even Cézanne',[9] it thus has a special and distinctive role in the evolution of the 'gardens of Impressionism'. It is, in fact, surely revealing that when Monet donated his famous panels depicting his waterlily garden to the State in 1920, he demanded that it should in return buy *Women in the Garden*, for the then extortionate sum of 200,000 francs. This was, on one level, a settling of old scores, for it was the State which, in the person of the Salon jury, had refused to accept *Women in the Garden* when Monet submitted it to the Salon of 1867. But the deal was surely also an index of a sense on Monet's part that *Women in the Garden* marked the point of origin of the 'gardens of Impressionism' which reached their apotheosis

in his paintings at Giverny. This chapter therefore takes a detailed look at *Women in the Garden*, before examining the works by Monet and his colleagues which stemmed directly from it in the later 1860s. In so doing it explores the intriguing ways in which the tradition of 'symbolic' representation, which was such an important aspect of earlier 19th-century flower painting, was reconciled with the seemingly divergent 'truth of appearance' involved in *pleinairisme*.

It is clear that the intensity and novelty of *Women in the Garden* were closely associated with a quest by Monet for seclusion and solitude: 'I have decided to retreat to the country; I work with a lot more resolution than ever', he wrote from his new home at Ville d'Avray.[10] Though Corot himself had already settled in this old village near Sèvres, as well as writers including Balzac whose large, landslip-prone garden there was described in contemporary guidebooks,[11] Monet was in effect putting into practice what he would argue in a letter to Bazille from the Normandy coast two years later: 'one does best alone with nature . . . I've always thought this and what I've finished under such conditions has always been best . . . one is too concerned with what one sees and hears in Paris . . . what I do here at least has the merit of not resembling anyone . . . because it will simply be the expression of what I personally will have felt.'[12] The critic and writer Gustave Geffroy, recalling the summer of 1866, certainly referred to 'that charming refuge of Ville d'Avray, where Monet was then living, continuing to flee the city', and called *Women in the Garden* 'that intimate paradise'.[13] The picture is in this sense the direct sequel to the 'Paradise' which Bazille had so delightedly recognized in 1864 in the countryside near Honfleur. But if it evokes an Eden already as seemingly escapist as what Zola in 1868 would term the 'piece of Elysian nature' in Corot's *Morning at Ville d'Avray*,[14] its almost hermetic self-containment is distinctive and suggestive. Its *hortus conclusus* contrasts tellingly, for example, with not only the open landscapes which, following Corot's example, both Monet and Bazille had painted near Honfleur, or the *jardins naturels* of Manet's and Monet's *Déjeuners sur l'herbe*, but also with the famous artificial *jardin paysager*, planted with such horticultural specialties as philadelphus, large-flowered spireas, white weigelias, American lime trees and even giant sequoias, which the garden designer F. Duvillers had created in 1841 'on the highest point of land at Ville d'Avray'.[15] Elevated sites were recommended by gardening treatises since they allowed the surrounding landscape to be viewed as a 'harmony'.[16] But Monet's garden at Ville d'Avray, at least as depicted in his painting, was now itself the 'harmony'. His painting was thus an implicit departure from the kind of topographical views of former royal parks – places such as Saint-Cloud, Marly, and Versailles itself, which were near to Ville d'Avray – which were commissioned by the Emperor from Daubigny and others.

The proximity of Ville d'Avray to former royal estates was of considerable appeal to many *nouveaux-riches* and *petits-bourgeois* of the Second Empire, who delighted both in the reflected glory it offered from the *ancien régime* and in the horticultural benefits of the pure water still supplied to the district by the royal irrigation schemes.[17] Just as Monet's picture presented what was regarded in Second-Empire France as 'one of our national glories'[18] – the rose – the very seclusion it celebrated was precisely what increasing numbers of Parisians were themselves now able to enjoy. Thanks to the railway, the region surrounding the capital – of which Ville d'Avray was part – had become so accessible that, as a chronicler of 'new Paris' put it, 'the employee, the landlord, the Parisian stockholder' could settle with ease 'during the summer in localities hitherto distant and abandoned. There they are awakened by the twittering of birds, drunk with the perfume of flowers, they enjoy the calm of rural life there.'[19] Monet's picture was thus at once both private – as an intimate portrait of his mistress

Chapter 4 Painting the Parisian 'bouquet'

If Monet sought to display the roses and freshly picked bouquets of his *Women in the Garden* in the very heart of Paris when he submitted it to the Salon jury in 1867, some felt that, as a result of Napoleon's and Haussmann's 'Transformations', the capital was virtually a floral gift itself. Already in 1863 the architect César Daly had declared that:

no city may today compare with Paris for gardens, elegant parks, rich greenery and ravishing flowers and plants; Paris, from the quarry of rubble, quarry stone and sandstone that it was, is transforming itself into a bouquet.[1]

Those hostile to Haussmann, however, only saw 'gardens . . . disappearing every day. Quarry-stone and hewn stone are chasing them pitilessly'. Louis Veuillot, one of his most forthright critics, even concluded in 1866 that 'the quarry-stone has killed the garden'.[2] Not only the truncation of the Luxembourg Gardens to make way for new roads, but also the sale of part of the 18th-century Parc Monceau for speculative building and the loss of the Tivoli garden to the expanding railway network near the Gare Saint-Lazare, for example, aroused keen regrets.[3] In defiance of such losses, the Parisians renewed their ancient tradition of *Rus est mihi in fenestra* – window-sill gardening.[4] A bittersweet caricature by Daumier shows a petit bourgeois and his wife rejoicing in the progress of their windowsill plant following the demolition of the opposite apartment block by Haussmann. As sun and air flood in, the husband exclaims 'I'll finally find out whether it's a rose or a carnation', pathetically oblivious to the fact that his home too will shortly suffer the same fate as the blocks and the ancient monuments which are trundled off ignominiously by cart in Gustave Doré's ironic frontispiece to a book of 1860 on the 'new' Paris (*Le Nouveau Paris*).

Writing in the *Paris Guide* of 1867, the former *Figaro* editor Alphonse Karr argued, however, that Haussmann's new squares and parks were a worthy compensation for the Parisians' loss both of their gardens or windowboxes and of the country fields formerly on their doorstep – fields that Renoir, of course, had enjoyed as a boy, and whose appropriation for building prompted him in old age to call Haussmann a 'vandal'.[5] A keen amateur gardener himself, Karr did much to foster the taste for horticulture in Monet's home town of Sainte-Adresse.[6] But, in contrast to private gardens, the public parks and squares of the new Paris were created for, rather than by, the city's inhabitants, and were intended equally for its visitors. Places to admire, and in which to be admired while walking, riding or carriage-driving, they were essentially a spectacle or backdrop. In place of Voltaire's famous defence of individual freedoms – 'you must cultivate your own garden' – it was a reward for obedience they offered; for the practice of 'plucking the flowers with the eyes only', as described by the horticulturalist André at the revamped Parc Monceau.[7] Napoleon's Parisian 'bouquet' was, in fact, in significant part a means to woo local, national and even foreign loyalties. Even Daly, generally sympathetic to Haussmann, argued that while the Parisian parks were purportedly for hygiene – to provide healthful light and air – what really lay behind them was a desire that Paris should: 'become the rendez-vous of literary, artistic and elegant Europe; a centre of attraction and seduction for the whole world; for this reason she has tried to complement the beauty of her monuments with that of their surroundings.'[8] Haussmann himself tellingly called his parks and gardens 'decorations'.[9]

94 Claude Monet, *The Garden of the Princess*, 1867
One of three views from a balcony of the Louvre which Monet completed in the early summer of 1867. See ill. 106

95 Honoré Daumier, 'There, my flower-pot will have some sunshine...I'll finally find out whether it's a rose or a carnation', 1852
The demolition of the surrounding buildings to make way for Haussmann's new boulevards brings sunshine to this Parisian's windowsill 'garden' – but he does not seem to realize that soon his apartment will be rubble too.

96 Gustave Doré, frontispiece to E. de La Bédollière's *Le Nouveau Paris*, 1860
Doré also mocks Haussmann, in this image of the ancient monuments of Paris being unceremoniously carted away as a workman brings stone for 'The New Paris'.

This chapter seeks to characterize the Impressionists' particular vision of parks and public gardens – not only in Paris, but also in London, where both Pissarro and Monet painted garden subjects – and to investigate the meanings their paintings of urban gardens would have held for them and their contemporaries. Against the backdrop of the contended and richly symbolic 'greening' of Paris, which continued well into the Third Republic as work begun by Haussmann was completed and the damage caused by the Prussian siege and the Commune made good, the act of painting parks, public gardens and squares in the city could, after all, involve a wide diversity of possible motives, from political propaganda to protest against Napoleon, declaration of solidarity with the new Third Republic which came into being in 1870, escape from the pressures of urban existence, or return to a surrogate nature in an increasingly sophisticated world. For the Impressionists, of course, Manet had provided an important lead in his *Music in the Tuileries* – a picture which, as we have seen, suggestively portrayed an old garden, rather than a new one, and where the close integration of the crowd with their milieu clearly stands at odds with the Haussmannesque concept of gardens as decoration, to be admired at one remove like a work of art or beautiful building. When, however, in 1867, the year of the great Universal Exhibition, Manet returned to the theme of 'green' Paris, and Monet and Renoir took it up, their pictures reveal a somewhat different emphasis from *Music in the Tuileries*. The city's gardens are now shown within their larger contexts – framed by buildings and streets, or themselves framing architecture, yet at the same time visibly spacious and open. This is an emphasis which persists even into work by Pissarro at the end of the century.

The Impressionists' very interest in painting urban parks and gardens, and their emphasis from the later 1860s on environment and milieu in so doing, were clearly on one level but the logic of their pursuit of 'modern-life' motifs and *plein-air* methods. Unlike Manet's *Music in the Tuileries*, their urban garden pictures were now typically begun, if not fully completed, *in situ* or from a vantage point or window overlooking the motif; even Manet himself now adopted this technique for his *Universal Exhibition of 1867* [101], working each morning 'before ten o'clock' in the Trocadéro garden, which had been created across the river from the Exhibition, and which occupies the foreground of its painting.[10] By choosing to work *en plein air* in a city as 'green' as modern Paris, the Impressionists could, of course, in a sense have hardly avoided painting parks or public gardens. But the distinctive conjunction of garden and city in the majority of their urban park and garden pictures from 1867 creates a particular dynamic – whether through choice or angle of viewpoint, or selection or balance of content – that in its day, as we shall see, could only have implied certain attitudes towards both gardens and the city. Though Manet shows a new park in his *Universal Exhibition*, his view of it, as we shall see, is not at all incompatible with the Impressionists' general avoidance, de-emphasis or otherwise selective rendering of the newly created parks and squares of the capital; tactics which suggest, as in Manet's *Music*, a deliberate turning away from the artifice that underpinned Haussmann's horticulture. Such an attitude superficially accords with the kind of polemic which was rife towards the end of the 1860s on the eve of Haussmann's fall from office; one critic of the Prefect, for example, writing 'from the heights of the Buttes Chaumont' (Haussmann's newest, and most extravagant and artificial park) cautioned mockingly that, ere long, carpets would be laid 'from one end of the city to another', while 'an immense artificial sun will set fire to the air with its rays and daylight will never end . . . [there will be] at every step, flowers, perfumes and spouting fountains . . . This will be Paradise.'[11]

But there are also continuities to be found in the Impressionist vision of nature in the city which transcend mere political dimensions, and in turn cut across the historical watershed

97 Encampment of Thiers's Government in the Tuileries Gardens, 1871, photograph When the Paris Commune challenged the government of Adolphe Thiers in 1871, Thiers stationed troops in several of the capital's gardens. Since the Commune began as a revolt against the royalist complexion of his government, this encampment in the Tuileries – a former royal garden – was particularly symbolic.

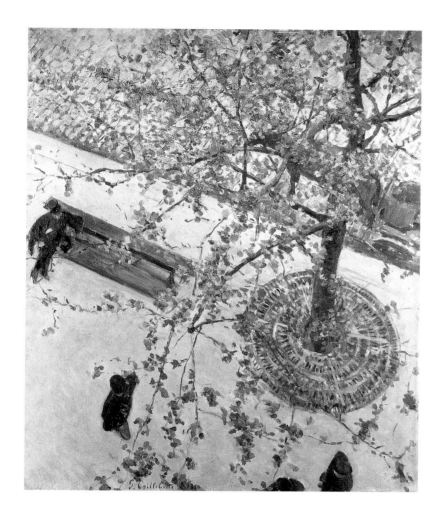

marked by the end of the Second Empire in 1870 and the Prussian siege and the Commune of 1870–1. Though a number of current writers regard the period after these events as one of greater engagement by the Impressionists with the modernity of urban life,[12] we will see that their images of gardens in the city actually carry forward strong elements of the interest in the 'old' which is evident in their city garden painting prior to 1870. The events of 1870–1, of course, saw the Tuileries and other parks used as military camps, while the Parc Monceau and many of the garden squares served as provisional cemeteries. But if *pétrole* stored in the artificial, 'picturesque' caves at the Buttes Chaumont during the siege was accidentally set alight at this time, creating 'a Dantesque vision of Hell' regarded by critics of Haussmann as a just vindication of their views,[13] then it is revealing that no trace of such events is evoked by the Impressionist vision of the *rus in urbe*. And that, as late as 1881, well after the rows about Haussmann's destruction of 'old Paris', we find Guillaumin using the colourful asters, zinnias and geraniums of his studio windowbox on the Quai d'Anjou [100] to guide the eye past angular chimneys and roofs to exactly the kind of view of a venerable old monument – the great Panthéon, whose dome suggestively echoes their rounded blooms and foliage – that the popular historian Michelet had recommended as the next best thing to having a garden of one's own in modern Paris.[14] Guillaumin, of course, was a warm admirer of Baudelaire – the great champion of both 'old Paris' and the imagination – and it is perhaps revealing that his picture was bought by Gauguin, who, fleeing modern urban life, was to paint Tahiti as a 'Post-Impressionist' Garden of Eden.

Equally, though Caillebotte's family had profited handsomely from property speculation in the 'new' Paris of the 1860s, his *Boulevard seen from Above* of 1880 explodes the ordered symmetry of the diagram of a 'Public road' in Alphand's *Promenades de Paris* – the great

98 Gustave Caillebotte, *Boulevard seen from Above*, 1880

99 Public street furniture, including 'Iron Grill for restraining roots of trees', and 'Double bench', in Alphand, *Les Promenades de Paris*, 1867–73

Caillebotte's viewpoint, presumably from a balcony, imaginatively reconfigures the 'New Paris'. In contrast to Alphand's meticulous record of the double-bench and pavement grill made so ubiquitous by Haussmann, Caillebotte asserts nature's primacy over human intervention: the tree seems almost to explode from its grill.

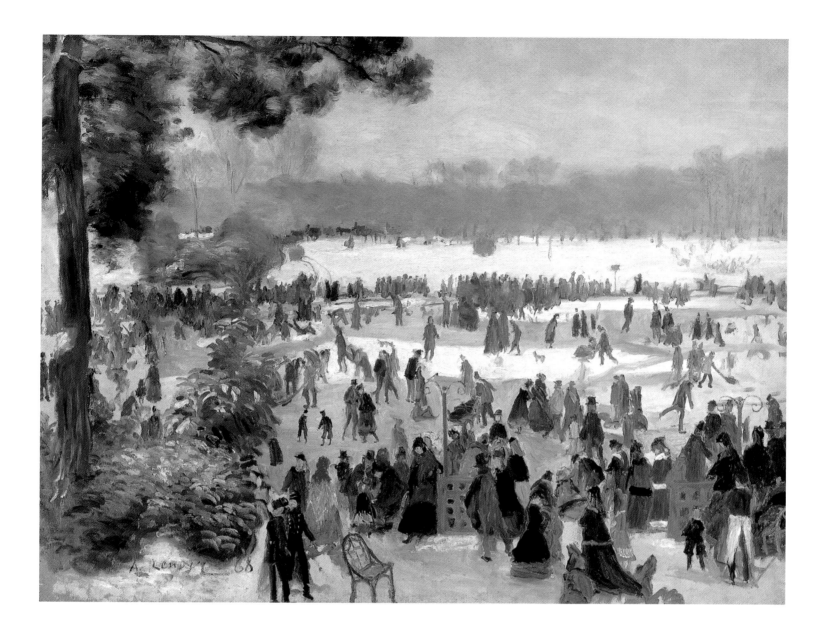

Haussmann's, and to explore the fragile boundary between shadow and substance which would later form the subject of Monet's 'series' of paintings of Rouen Cathedral with its similarly prominent rose window. Nature's metamorphosis into art – both through the rose window, and through Monet's painting of it – defies the hand of time. The correlation of nature and architecture which is embodied in the Gothic rose window is, of course, also at work in the way the trees of the Vert Galant Garden echo the form of the Panthéon in *The Garden of the Princess* and *The Quai du Louvre*. There is, in short, a sense of an almost organic continuity between past and present and gardens and buildings in Monet's three pictures from the balcony of the Louvre which reinvents the Romantic association between the forms of nature and those of architecture,[11] and, in its time, also surely carried intriguing implications.

For the decorative, 'Oriental' effect of the high viewpoint in both *Saint-Germain l'Auxerrois* and *The Garden of the Princess* makes their gardens visual thresholds to buildings which, in the later 1860s, were under threat of demolition. Achille Fould, Minister of State for palaces and museums, was urging Haussmann to demolish Saint-Germain l'Auxerrois, to create an even bigger square before the Louvre; the Prefect, being a Protestant, had so far reluctantly refused, fearing its demise would be seen as revenge for the St Bartholemew's

109 Pierre-Auguste Renoir, *Skating in the Bois de Boulogne*, 1868

110 Period photograph of skaters in the Bois de Boulogne, 1870s

The skaters' interweaving trajectories predict the principle of 'irregularity' which Renoir would later make his artistic credo. Likewise he tellingly omits the mock chalet seen in the period photograph, which Haussmann had installed.

Day massacres of Huguenots which had been signalled in 1572 by its bells.[42] And the two cream-coloured, mansard-roofed houses at the entrance to the Place Dauphine on the Ile de la Cité, which appear in *The Garden of the Princess* and *The Quai du Louvre* to the left of the Vert Galant garden, were likewise under threat. These, stated the *Paris Guide* of 1867, were 'going to disappear. They have hanging over their roofs the sword of Damocles. They will be replaced by a square.'[43] Here, in other words, was the threat of another of those modern apologies for a garden, as Zola saw them. In this context, the spring blossom, foliage or grass within both the new square before Saint-Germain and the old Garden of the Princess would – had Monet's pictures been shown at the Salon – have seemed a virtual emblem of survival, and a defence against loss. In *The Garden of the Princess*, the great green diamond of Marie de Medicis' garden, with its borders just coming into flower, in fact maps a bold magnification of the plan of the two condemned houses, orientated as they are at an angle to the viewer. This link is reinforced by the line of spreading green of the trees on the quays, which leads the eye from the garden to the Ile de la Cité. Was it mere coincidence that, similarly, the largest of the few puffs of cloud in the sky of *The Quai du Louvre* hangs Damocles-like above the two houses? The tip of the diamond formed by the Garden of the Princess in the picture named after it in turn coincides with the very point on the quayside where Haussmann intended to erect a new bridge – a scheme which would, of course, have clipped, if not actually destroyed, the ancient Vert Galant garden. How far Monet would have been aware of this particular project is unknown.[44] But, in contrast to tourist and topographical views in this period of the Ile de la Cité, the angled, elevated viewpoint of *The Garden of the Princess* locks the garden of its title into decorative unity with the fabric of the 'old' city with a tightness that certainly suggests a calculated rebuttal at least of the Place Dauphine project,[45] just as the very nature of its motif as a garden pits the enduring cycle of nature against the transient monuments of humankind. While photographers and graphic artists were often commissioned by Haussmann to create documentary records of areas of Paris due for demolition, this is clearly a far more complex image.

In the event, both the bridge scheme and the plan to replace the white houses with a square came to naught when Haussmann fell from office in 1869. But it is worth noting that, flanking as they did the Place Dauphine, and its entrance on the Pont Neuf, the two condemned houses occupied a spot of particular artistic interest. For it was here that, as had been described in 1864 in a substantial article from the *Revue universelle des arts*, the 'Exhibitions of Youth' had been held in the 18th century – annual outdoor displays of pictures by young artists.[46] Was this also why Monet, just such a painter in a later era, directed the viewer's gaze – and via green spring-garden growth – towards the two houses at the Place Dauphine? It was in April 1867, exactly as Monet began his views from the Louvre, that Bazille was drawing up his plans for what would eventually take shape as the 'Impressionist exhibitions' of 1874–86. Zola, meanwhile, had just the year before published his famous attack on the Salon jury which called for the 'rejected' painters to be allowed to present their works directly to the public.[47] Monet had, furthermore, chosen to stand not within the confines of the Louvre itself to paint his three pictures, but instead on one of its balconies. He was thereby forging his own new art alone, *en plein air*, and in resolute rejection of the conventional academic practice of copying the masters in the Louvre. Count Niewerkerke, Superintendant of Beaux Arts, who granted Monet permission to paint from the Louvre, had unwittingly advanced the 'modern' art which he denounced.

This is not to suggest, however, that we should interpret Monet's vision of the Saint-Germain and Princess gardens as merely 'political', whether in terms of reaction to

Haussmann or revolt against the Salon. The brilliant green of the lawn in *The Garden of the Princess*,[48] which anticipates Monet's interest in the decorative effects of strong colour in his *Terrace at Sainte-Adresse* of just a few months later, also balances, as we have seen, the limitless luminous sky – the Romantic emblem of freedom. Monet's line of view is, in fact, whether consciously or not, very nearly along the line of the Paris Meridian as it then was – an intriguing detail which suggests that his ultimate interest lay in cyclical, unending time, as encapsulated in the rhythms of cultivated nature, and marked by the play of sun and shadow and the passing of the seasons. Just as he defied his father in eventually establishing a home with Camille, it is the freedom to 'see' and act as he wished that his pictures powerfully assert.[49] Deconstructing Haussmann's vistas, by cutting boldly across them, and creating new forms of 'decoration', they also makes us reappraise the value and status of what we perceive. Are either gardens or buildings ultimately any more 'permanent' than the clouds which pass above them, and balance their forms and shapes? Captured on canvas, of course, they defy even Haussmann's 'Transformations', just as spring reigns eternal in the flowering horse-chestnuts and fresh green grass of Monet's pictures.

The year after Monet's pictures from the Louvre balcony had so boldly asserted 'visual freedom' through their garden imagery, Renoir evoked the random trajectories of skaters in the Bois de Boulogne in a painting which again presents an open panorama rather than a Haussmannized 'perspective' [109]. Framed within the larger rhythms of undulating pine branches and the soft grey-brown haze of bare trees on the horizon, both his skaters and his vision of the former royal park already embody the principle of 'irregularity' in art that he would famously later define.[50] The subtle 'winter effects' he described as his goal in the painting contrast forcibly with the artificial lighting laid on for skaters at the Bois and illustrated in Alphand's *Promenades de Paris*, and he likewise omits the new chalet-style pavilion erected by Haussmann by the lake [110].[51] Renoir's most telling representation of 'freedom' at this period is surely, however, his 1867 view of the Champs-Elysées gardens – the spot Haussmann had so carefully 'regularized' [112]. While the municipal gardener watering plants in the foreground parallels Manet's in *The Universal Exhibition*, he is subsumed, like the strolling visitors, within a larger, verdant idyll. And although the Parisian gardeners prided themselves on planting out the flowers grown in the city's greenhouses at La Muette just before they were ready to open, and on removing them immediately they had withered, those in the foreground *corbeille* (display bed) are, interestingly, not in bloom, as if Renoir did not wish the eye to be distracted by Haussmann's kind of 'decoration'. Likewise, even taking account of the fact that late frosts in 1867 delayed many flowers until the end of May, he offers little sign of the 'famous collections of Rhododendrons, Azaleas, Hollies, uprooted for a fee of gold' from Holland and Belgium for the garden, along with its magnolias, pampas grass, weeping sophora and clumps of eucalyptus.[52] Dappled shade, encroaching from spreading trees, instead blurs the forms of the foliage; the mature trees themselves not only screen out the Champs-Elysées Avenue, but also the garden's focal fountain (just out of the foreground to the right), and its toy-shop, circus, panorama and bandstand.[53] Only part of the Café de l'Alcazar is visible at the right, and of the Palais de l'Industrie at the left – 'landmarks' which effectively serve to point up the poetry of Renoir's image. With its panoramic sweep, his scene might almost, in fact, be an updated version of the mythical Elysian Fields illustrated in Mangin's 1867 history of gardens, whose inhabitants 'wander at will . . . in their immense terrain'.[54]

111 V. Foulquier, 'The Champs-Elyséens', from Mangin, *Les Jardins Histoire et Description*, 1867
In this illustration from what claimed to be the first historical account of garden cultivation, the inhabitants of the mythical Champs Elysées 'wander at will . . . in their immense terrain'. The Parisians enjoying Haussmann's Champs-Elysées gardens in a painting by Renoir of 1867 [112] are their modern contemporaries.

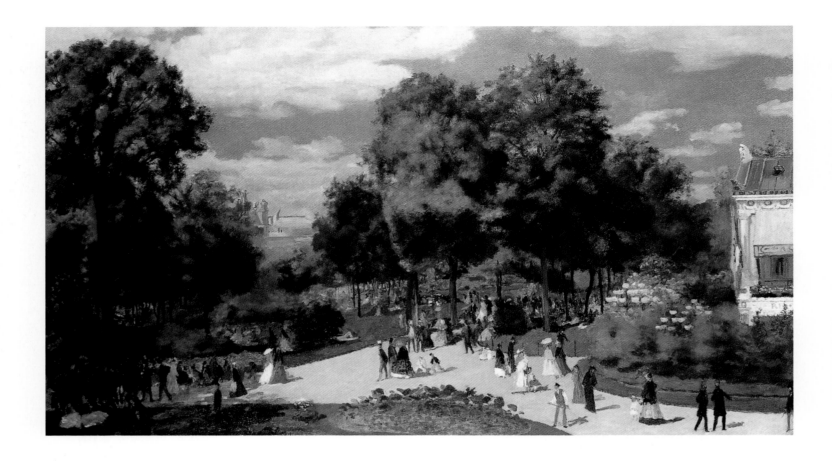

London and Paris after 1870

When the Prussians laid siege to Paris in 1870, the Elysian mode of existence must have seemed beyond even the power of an artist to conjure, as the trees in the Bois de Boulogne and the squares and streets were felled for firewood, and, by the end of the Commune in 1871, over a third of the 'garden' city's 8,428 outdoor benches were destroyed.[55] And when, having moved for safety during this period to London with their young families, Monet and Pissarro turned for motifs to some of the English parklands that had, of course, originally inspired Napoleon III's vision of Paris as a garden, they surely did so at least in part from a quest — either conscious or subconscious — for the principles of 'liberty' with which, as we have seen,[56] these were historically associated.

Pissarro later recalled how, 'Monet worked in the parks, while I, living at Lower Norwood, at that time a charming suburb, studied the effect of fog, snow and springtime. We worked from nature'.[57] Monet stayed first in Piccadilly and then in Kensington, and painted the view across the expanse of Hyde Park towards the distant line of houses in the Bayswater Road, and also that to the west across Green Park. The delicate light of a spring afternoon, colouring the sky below a veil of cloud, turns Hyde Park into a panorama of receding and criss-crossing paths, punctuated by figures who stroll freely and at leisure — polar opposites of their contemporaries in Paris enduring the Prussian siege, or facing or erecting the Commune barricades. A milky moisture likewise seeps across the spreading vista of Green Park, similarly dotted with freely moving figures. Pissarro's subjects included suburban streets with private gardens in the south of London where he had settled, and the grounds of Dulwich College with their pond reflecting the clouded but luminous sky, a tree in golden spring leaf, and the College's dusky pink buildings, recently completed by the younger Charles Barry. Ever changeful, the British weather perhaps intensified the artists' appreciation of atmospheric variation, which renders every moment unique. Turner and Constable,

112 Pierre-Auguste Renoir, *The Champs-Elysées during the Paris Fair of 1867*, 1867 The gardens portrayed were part of Haussmann's 'regularization' of the Champs-Elysées, but Renoir makes them look 'natural', even 'irregular'. Though a gardener like the one in Manet's *Universal Exhibition* is visible in the foreground, the picture virtually ignores the exotic plants for which the garden was famed, and likewise excludes its ornamental fountain and bandstand.

rather than Baudelaire's hero Constantin Guys (who had portrayed the fashionable London society promenading in Rotten Row), were now their spiritual mentors.[58] The figures who stroll through Monet's open panoramas are, in this sense, nodal points in a larger decorative transformation wrought by the moisture-laden atmosphere, which broadens and simplifies detail. The metamorphic power of sunshine is, in turn, explored in Pissarro's *Crystal Palace*. This uses the same basic compositional elements of highway, gardens, trees and figures as his *Versailles Road at Louveciennes* discussed earlier, but now presents them *contre-jour* (against the light). What is transparent – the glass of Crystal Palace – becomes 'visible', while things that are solid, such as houses, fences and tree-trunks, 'dissolve' at their edges. It is as if, through these transpositions, Pissarro explores the very principle of visual freedom. In winter, he similarly captured snow blurring the contours of garden walls and paths; in spring, he painted the 'snow' of blossom in suburban gardens at Lower Norwood.

It is possible that when in London Monet and Pissarro also saw French Rococo images of gardens, such as in Nicolas Lancret's *Four Ages of Man* (National Gallery); these would have contributed not only to Monet's interest in private garden subjects from the 1870s (discussed in the next chapter), but also to his and Pissarro's mature 'Impressionist' style of smaller, touch-like brushstrokes.[59] After they returned to France in 1811, it was certainly the 17th- and 18th-century parks of Paris – the Tuileries and Parc Monceau – to which Monet turned among the city's gardens; Renoir and later Pissarro also painted the Tuileries. Even the Grand Lac of Haussmann's Bois de Boulogne became a realm of private *rêverie* in Morisot's *Summer's Day* (1879) [115], one of a number of scenes she painted of the Bois, which was near her home in Passy. Ignoring the 'picturesque' views of the artificial lake afforded by Haussmann's hillocks, she 'sets' us in a boat upon it, beside two women taking one of the popular leisure trips to the islands on the lake. Painted in flickering strokes, their blue and white costumes shimmer *en plein air* like the water itself. If Watteau had portrayed what was believed to be *The Embarkation for Cythera*, here now was the voyage itself to that imagined isle; another Baudelairean 'departure' with 'hearts as light as balloons'. Even Manet, having offered (unsuccessfully) to paint murals of Paris including its 'parks, gardens and racetracks' for the new Hôtel de Ville,[60] was looking by the end of the 1870s to the great gardens of Louis XIV at Versailles for inspiration, though illness thwarted his project, as he wrote

113 Camille Pissarro, *The Crystal Palace, London* (detail), 1871
Seeking refuge during the Franco–Prussian War and Commune, Pissarro here delights in the visual pairings of transparent glass and luminous sky, and public park (around the Palace) and private gardens (at the right).

114 Claude Monet, *Green Park*, 1871
Also in London in 1870–1, Monet captures both the misty atmosphere which turns the cityscape into delicate tracery, and the freedom of movement of the strollers in Green Park – a freedom which, at this period, was denied to his contemporaries in Paris as they experienced the Prussian siege and the Commune.

115 Berthe Morisot, *Summer's Day*, 1879
Morisot often painted in the Bois de
Boulogne, which was near to her home in
Passy. Here, she deploys her mature, loose-
brushed style, vividly evoking a light
summer breeze upon the lake – the same
lake as Renoir had shown ice-bound [109].

regretfully to Eva Gonzalès from a villa he was renting in the district: 'Went away to make some studies in the garden designed by Le Nôtre, but had to make do with painting my own garden, a most frightful one.'[61]

If Manet's dream of return to Le Nôtre suggests, paradoxically, a Republican delight in 'taking possession' through art of gardens formerly royal or aristocratic, it was also part of wider tendencies in the 1870s which placed nature at a fulcrum between 'remembering' and 'forgetting'. Following the *débâcle* of France's defeat in the Franco–Prussian War, and the horrifying bloodshed of the Commune in Paris, nature was widely felt to offer both renewal for mind and body, and a moral antidote to the materialist excesses of the Second Empire – sins for which the events of 1870–1 were perceived as punishment. Not the showy artifice of a cut bouquet, but growing flowers, rooted in the soil, were the image for which the French now reached. The mood was captured in 1872 by Puvis de Chavannes, a friend of Berthe Morisot, in his painting *Hope* [118]. This shows an innocent young girl holding out the olive branch of peace among ruins where flowers have taken root and are beginning to bloom. The critic Armand Silvestre described this figure as 'living spring' herself, '. . . a flower hanging from the only surviving branch of green in this ravaged corner, a flower leaning over the earth, a flower of the sweet soil of the fatherland!'[62] In close touch with the Impressionists as they planned their first exhibition of 1874, Silvestre similarly recalled how this event took shape against 'deep yearning' in Paris 'for quietude and forgetfulness of the past', and as 'Flowers were . . . beginning to grow from the blackened ruins, and to show themselves from among the blood-stained cobbles . . . youth, infatuated with sunshine and spring, had asserted its rights'.[63] By implication, the Impressionists' colour-filled canvases at their first exhibition – 'gaiety, brightness, spring festivals, golden evenings or apple trees in flower', as Silvestre called them[64] – were themselves 'flowers' amid the ruins. Duranty's descriptions of

116 Claude Monet, *The Tuileries* (sketch), 1876

117 Claude Monet, *The Tuileries*, 1876

Both Monet and Renoir painted the Tuileries Gardens in the mid-1870s from the rue de Rivoli flat of the collector Victor Chocquet. Monet's sketch, capturing the hot pink and gold of late evening, reminds us that he had admired Turner's work when in London. Like Renoir, he avoids the part of the Tuileries Palace damaged by the Communards.

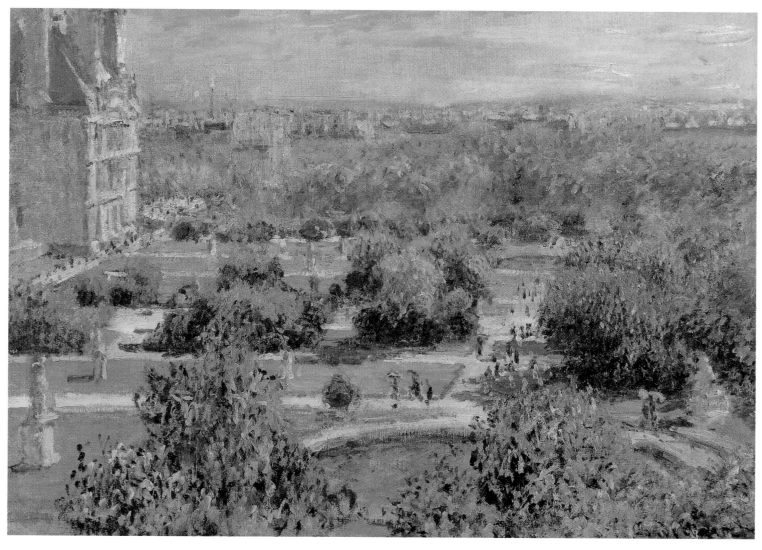

Impressionism in 1876 as 'little garden', and a 'young branch . . . on the trunk of the old tree of art' take their logical place within this context.[65]

Though he had had links with Communards, Renoir's *Place Saint-Georges* (painted in 1873 and shown in the 1877 Impressionist Exhibition) certainly disregarded 'one of the most memorable ruins of the Commune', the politician Thiers's mansion in this *place*, to give prominence instead to its towering, blossoming chestnut trees.[66] Monet's and Renoir's 1875–6 paintings of the Tuileries Gardens [116, 117] likewise excluded virtually all the part of the adjoining Palace burnt out by the Communards, while Degas obscured the statue of Strasbourg, one of the towns lost to the Germans, in painting the view towards the Tuileries Gardens from the Place de la Concorde.[67] Both Monet and Renoir similarly 'forgot' the brash new façades of the boulevards by masking them with spreading trees which turn these thoroughfares into virtual gardens.[68]

Selection or omission is, of course, itself a statement. And Duranty's call in 1876 for a fair wind to guide the 'new painters' in their journey to the Hesperides – the mythical gardens of antiquity where the sun set[69] – was essentially a challenge to 'remember'; to reinvent a lost perfection. His criticism of the attempts being made by others to despoil the 'little garden' of Impressionism likewise link it implicitly with the perfection of the Garden of Eden. These are powerful images, which, like the Impressionists' interest in Le Nôtre's gardens and Rococo art, imply that nostalgia, and the urge to 'reinvent' or 'preserve', still played as vital a role after 1870 as when Manet and Monet had portrayed 'old' Paris and its gardens in the 1860s. As Shiff has noted, the very term 'impression' – first adopted by the artists themselves for their 1877 exhibition – was regarded by Positivist thinkers of the day such as Littré and Taine as defining 'something that is primordial'.[70] The Impressionists' urban garden scenes in this sense clearly share in the restoration which followed the War and Commune, when renewal of the Parisian parks was given high priority. And their continuing interest in the 'old' combines from the 1870s with the transformatory power of light and atmosphere which had fascinated Monet and Pissarro in London, to suggest a still more urgent quest for a lost 'age of innocence', dreamlike realm of beauty, or elemental 'Paradise'. The Impressionist vision of the *rus in urbe* can once more be seen as anticipating Proust, who said that 'true Paradises are those one has lost', while the distinction between the public and the private in turn becomes ever more tenuous.[71]

Mary Cassatt, for example, shows her sister Lydia, wrapped in an 'Indian cashmere shawl'[72] after a serious illness, on a bench amid the healthful *plein-air* of a sylvan park, probably the Bois de Boulogne. She likewise paints her in the Bois with a young relative, driving in a trap, secure amid a form of nature which, as a *jardin irrégulier*, is free yet also disposed by mankind.[73] Degas portrays nursemaids and children in the Jardin du Luxembourg; Monet, returning to the vertical format of his *Garden of the Princess*, shows such figures protectively enfolded by arching boughs in the Parc Monceau [120]. The Second Empire houses glimpsed beyond Monet's trees – built on the land sold from the Parc Monceau under Haussmann, and described critically in Zola's *La Curée* (translated as *The Rush for the Spoils*) – merely render the scene, by contrast, the more Edenic. Does the sole gentleman in Monet's picture anticipate Maupassant's character Duroy in his novel *Bel-Ami*, as, alongside 'unconcerned nannies who seemed to be lost in dreams while the children tumbled about the sandy paths', he waits in the Parc Monceau for an illicit rendez-vous?[74] If so, this allusion to an impending 'Fall' of course makes the Parc Monceau seem yet more like a surrogate 'Eden'. Maupassant was, of course, to become a close friend of Monet. In turn, the Italian Zandomeneghi, in a painting shown at the Impressionist Exhibition of 1881 [122], portrayed two

118 Pierre Puvis de Chavannes, *Hope* (first version), 1872
Visions of a renewal of society in the wake of the events of 1870–1 are symbolized by this young girl who holds an olive branch of peace as flowers begin to bloom in a ruined landscape.

lovers amid the nursemaids and children in the modern Place d'Anvers. *Plantes humaines*, the figures in their white, blue and orange costumes merge into the larger decorative unity of striated golden sunlight, red and white flowers, and purple shadow. Similar association of the innocence of childhood with a haven-like public garden appears in Pissarro's *Garden at Pontoise* [121]. Here, the child's toy trumpet is perhaps also an allusion to the synaesthetic harmony which Baudelaire had described as perceptible to the receptive, child-like artist, since its bright sound is implicitly complemented by the 'notes' of red of the flowerbed in the sheltered municipal park – themselves echoes of the child's bright red costume.

119 Mary Cassatt, *Portrait of Mlle. C (Autumn)*, exh. 1881
Cassatt shows her sister Lydia, recuperating in the fresh air of a Paris park after a serious illness. The soft colours of her cashmere shawl complement those of the autumn trees.

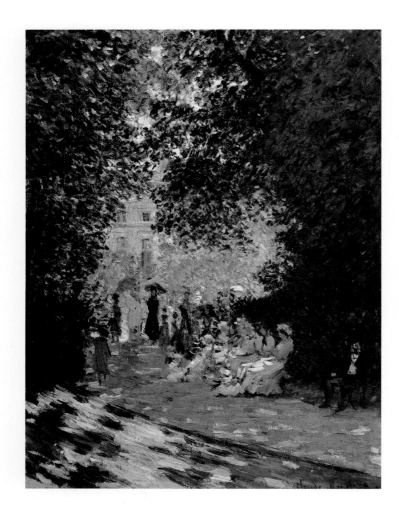

120 Claude Monet, *The Parc Monceau*, 1878
One of a group of paintings by Monet of this fashionable park, first constructed in the 18th century. The arching trees protectively enfold the adults and playing children.

121 Camille Pissarro, *The Garden at Pontoise*, 1877
The interest in creating public gardens spread from Paris to other cities. Pissarro painted the park at Pontoise, the small town north-west of Paris which was his home from 1872–82. Its floral harmonies, varied textures and effects of sun and shadow find natural expression in Pissarro's pure colours and multiple tiny brushstrokes.

Monet's views of the Parc Monceau – three in 1876 and three in 1878 – include what appear to be some of the exotic trees and shrubs planted there by Haussmann.[75] This of course echoes his Baudelairean interest in the beauty of the 'strange', as well as anticipating his enthusiasm for unusual plants at Giverny. But Monet made such 'beauty' also 'primordial', by labelling his Parc Monceau painting in the 1877 Impressionist Exhibition a 'landscape'. It shows no sign of Haussmann's gravel paths and picturesque *naumachie* (pond), and figures are virtually absent. Swathes of turquoise and blue-green shadow, punctuated with touches of yellow and white evoking wild buttercups and daisies, are cast by a canopy of branches in the foreground, to frame a sunlit vision of pink-flowered and orange-leaved shrubs and trees in the middle distance. Critics complained that 'the sense of reality is completely lacking in the Tuileries, Le parc Monceaux, and other landscapes by this artist'.[76] If such images, like Renoir's of the Place de la Trinité mentioned earlier, created Eden, Paradise or the Hesperides in modern Paris, they also fulfilled the ultimate logic of what the critic Ernest Chesneau was to define in 1882 as the Impressionists' goal. As artists in pursuit of 'fleeting' effects, it was, he claimed, 'memory that they wish to and know how to fix'. Light and atmosphere change so rapidly that the artist must rely on recollections of their appearance, and the creative imagination which enables their synthesis.[77] Both Morisot's flickering brushwork and Zandomeneghi's more disciplined, almost Pointillist strokes are thus mnemonic ciphers, born of the artist's memories of scenes observed, and in turn prompting 'memories' on the part of the viewer, who 'reads' them by reference to his or her own recollections of objects, people and phenomena.[78]

Of the range of urban park and public garden subjects painted by Impressionists after 1870, it was Monet's and Renoir's Tuileries Gardens views, and Pissarro's late views of both

In May 1870, on the eve of the Franco–Prussian War, Berthe Morisot persuaded Manet to use her parents' tranquil garden at rue Franklin in Paris as the setting for a portrait he wanted to paint of her pretty neighbour Valentine Carré. Situated in the fashionable suburb of Passy, a step or two from the Trocadéro park Manet had painted in 1867,[1] the Morisots' *coin* was tranquil and secluded: perfect for *plein-air* painting. Being herself one of Manet's favourite models, Morisot ensured her brother Tiburce was brought in too, lest the personable painter fell for Valentine. But Valentine's mother objected; a representation of her daughter with a man in a garden would have made a *scène d'amour*. So Edma, the sister of Berthe Morisot, sat instead, with her baby daughter Jeanne in her carriage at the left.[2] Tiburce lounges on the grass behind; pools of golden sunshine punctuate the shade from the spreading trees, and a glimpse of a red geranium border closes off the composition. A 'family garden' is shown, in an image which fuses the bonds of blood with the intimacy of a private demesne, and the nurture of a child with the culture of nature. These associations could already be found in certain earlier works such as Constant Desbordes's 'moral' painting, *The Broken Wagon* [31].[3] But in Manet's hands, a new, more spontaneous interplay between a growing family and a growing garden was created by his harmony of dappled sunlight and luminous shadows, which blended figures and environment. These effects prompted Manet's first biographer, Bazire, to proclaim the picture the first true Impressionist work: 'The landscape lives and

129 Berthe Morisot, *Hollyhocks*, 1884
The chair set slightly at an angle, like the abandoned basket, suggests someone has briefly gone away. Perhaps Morisot herself, her husband, or their maid, have been sitting out with the artist's young daughter Julie as she plays in the fresh summer air. Only the thrusting hollyhocks, rendered with lively swirls of paint, know the secrets of this intimate corner, probably at the Morisots' summer residence at Bougival.

130 Edouard Manet, *In the Garden*, 1870
Edma, one of Morisot's sisters who herself had studied painting, modelled for Manet here, along with her baby Jeanne and brother Tiburce. The garden is that of Morisot's parents at rue Franklin in Passy, and the picture marked the start of an important series of images of 'family gardens' by the Impressionists.

lights up, the air circulates . . . This revelation is a revolution. The school of *pleinairisme* is born with this canvas, which others will follow and complete.[74]

Manet's painting, called *In the Garden*, in fact heralded a sequence of Impressionist 'family gardens' through the 1870s and 80s, as Monet settled with his young family in a house with a garden at Argenteuil (which not only he, but other Impressionists also painted), and as Caillebotte and Morisot portrayed their relatives or families in their gardens. Monet, Manet and Renoir also painted the family estates or gardens of hospitable patrons, such as that of the department store-owner Ernest Hoschedé, at Montegeron, south of Paris, or of the diplomat Paul Berard, who had a château in Normandy with a fine rose-garden. It is this diverse but richly distinctive range of works which forms the subject of this chapter. Closely intertwined with their evolution is that, in turn, of the 'Impressionist family' itself, through its sequence of group exhibitions from 1874 to 1886.

Pissarro had, of course, already painted a 'family garden' in his *Versailles Road at Louveciennes* of 1870 [92]; Monet and Bazille had painted their parents and other relatives in their families' gardens during the 1860s [83, 86, 87, 88].[5] But all these were either monumental, grand-scale works intended for the Salon, or, in the case of Monet's 1867 Sainte-Adresse scenes, pictures of gardens grown by others – his relatives. Now, from around 1870, it was an essentially new kind of 'family garden' painting that emerged in Impressionism. On the one hand, it was often informal, small-scale, and palpably 'domestic' in character, as in many of Monet's subjects at Argenteuil, the small town on the Seine near Paris where he lived from 1871–8. On the other, it could be larger-scale and overtly decorative, as in Monet's *The Luncheon* of 1873–4 (first exhibited as *Decorative Panel*), showing his garden at Argenteuil, or the panels he and Manet did for Hoschedé's château in 1876, showing its estate [159, 158]. In both types of painting, the garden assumes a far more prominent role even than in *In the Garden*, while the interconnection between the world of the picture and that of the viewer is yet further developed. The potential of the garden as an equal, even dominant player in a figure-painting, first seen in Monet's work at Sainte-Adresse, was now more fully explored; so too was the liminal character of the domestic garden, linking the private world of the home with the public world beyond. Horticultural and personal imagery are entwined in ways that involve not only domestic, but also national or even political dimensions, making Impressionist 'family gardens' some of the most fascinating examples of symbolic expression within Impressionism, as well as some of the movement's most visually appealing works. As images of private realms, they are also reflections of the artist's mind, sometimes reshaping the real world's imperfections; sometimes, when representing children at play, bringing to mind the Baudelairean ideal of genius as 'childhood rediscovered at will'. At other times, they gratify parental pride, or nostalgia for lost innocence.

Only rarely does the Impressionist 'family garden' show other than leisure or light domestic activities like sewing; such imagery makes it a surrogate interior. When conceived as 'decoration', like Monet's *Luncheon*, of course, it literally came indoors. Because inherently private, however, the 'family garden' could often also be enigmatic. Manet's *In the Garden*, for example, has no horizon, so that the ground seems strangely 'tipped up', and Edma thrust into our space. Her baby's gaze 'fixes' us with a solemn intensity, while Tiburce is but a secondary presence. Manet seems teasingly to probe both his own and our motives in intruding on a mother and her child. In seeking to uncover the meanings which Impressionist 'family gardens' would have held for their creators or intended viewers, the very 'privacy' of their imagery (even when intended for public exhibition) often makes it possible only to surmise or infer its significance by reference to wider historical, social or personal contexts.

Intimate relationships in the 'family garden'

It was Manet who helped the Monets find the Maison Aubry at Argenteuil in 1871, after their return from 'exile' in London 1870–1. More affordable than living in Paris, but allowing ready access to the capital (it stood next to the station), it was a traditional, whitewashed Norman property. Its high eaves, shuttered windows, and cool, thick walls covered with rambling plants can be seen in a number of Monet's paintings. Its garden – some two thousand square metres in size – must have been one of the principal attractions for the Monets. Here, and later at the Pavillon Flament, their house in Argenteuil from autumn 1874,[6] Monet's son Jean could safely play with his hoop and toys [143], and Camille could walk, read, sew or meet with friends. And Monet himself could recreate the kind of flower-filled retreat which his own father and aunt – both deceased not long before – had grown at Sainte-Adresse. But while Monet's representations of this garden are, on one level, experiments with colour, light and form, in which Camille's dresses rival the flowers, and pools of sunshine are punctuated with luminous shadow, they also imply his own presence, as paterfamilias and gardener. Committing to canvas his pride in his wife's and son's well-being he shows, for example, Camille 'flowering' beside the hollyhocks that signified fecundity for 19th-century viewers, or Jean's progress through a demesne of flowers on his toy-horse tricycle.[7] Equally, such paintings celebrate Monet's own creation of the very environment in which both his family and art might flourish. And, even though the 'family gardens' portrayed by other Impressionists were not necessarily of their own cultivation, it is from the point of view of the artist as parent, spouse or sibling that we may often begin to 'read' their imagery too.

Caillebotte's large-scale *Portraits in the Country* of 1876, for example, set in the gardens at Yerres, evokes a realm imbued with colour and life which surely embodies the sense of psychological security he must have found there. Showing his mother, female cousins, and

131 Photograph of 21 Boulevard Karl Marx, Argenteuil, by Rodolphe Walter, c. 1965
Known as the Pavillon Flament, this was the newly constructed house at Argenteuil where Monet lived with his wife Camille and their young son Jean from 1874 to 1878. In its secluded garden, Monet painted, Jean played and Camille enjoyed – at least for a short time – something of the bourgeois lifestyle previously beyond the Monets' financial reach.

132 Gustave Caillebotte, *Portraits in the Country*, 1876
In the shade of the family estate at Yerres, near Paris, Caillebotte's mother and cousins are reading or sewing what are probably vestment trimmings for his half-brother, a priest in Paris. It is thought that the motif reflects Vermeer's *Lacemaker*, acquired in 1870 by the Louvre, but the sense of silent harmony, where the bonds of blood require no words, is characteristic of many Impressionist 'family gardens'.

his mother's friend seated peacefully sewing or reading in the shade, while bright green grass and a glowing bed of red geraniums fill the sunlit space beyond, this painting offers a converse to the impersonal, monochrome habitat of stone and asphalt he typically portrayed in Paris. Similarly, the estate of Berthe Morisot's sister at Maurecourt on the Seine, or the gardens grown or visited by her own family after her marriage in 1874 to Manet's brother Eugène, provided recurrent inspiration for *plein-air* figure subjects until her early death in 1895. Capturing the magic of her young daughter Julie at play in the 'little country garden' made by her husband behind their house in the rue Villejust in Passy,[8] or representing Eugène and Julie in the gardens of their rented summer property at Bougival [137], for example, Morisot linked her family's unity with that of flowering, cultivated nature. Far from being merely a background, the garden seems to enfold and embrace the sitters. Whereas Caillebotte's *Portraits in the Country* sets its family group amid a disciplined sequence of interlinked forms and zones – slatted bench and window shutters, yellow-striped awning, and massed flowers and meandering path – Morisot bound figures to garden with loose, calligraphic touches, so that the nodding hollyhocks themselves seem as members of the family.

133 Berthe Morisot, *In the Garden at Roche-Plate*, 1894
Painted just a year before Morisot's premature death, this rhythmically brushed picture shows her daughter, now a teenager, eating pears with her cousins in the garden of their holiday house in Brittany.

134 Claude Monet, *The Artist's Family in the Garden*, 1875
Sunlight filters through trees, dappling the grass where Camille, a friend, and young Jean are gathered in the Pavillon Flament garden at Argenteuil. The bed of geraniums arcs protectively around the figures in their wood-like sanctuary.

135 Claude Monet, *The Luncheon* (exhibited as 'Decorative Panel'), 1873
The most ambitious of Monet's Argenteuil garden paintings, this was a focal work in the Impressionist exhibition of 1876.

Photograph of Eugène Manet, Berthe
Morisot and Julie Manet in the garden at
Bougival, 1880
Berthe Morisot married Manet's brother
Eugène – the man talking to the widow in
Music in the Tuileries [67] – in 1874. In this
somewhat formal portrait with their
beloved toddler daughter, the garden is
that of their summer house at Bougival.

Some thirteen years later, in the garden of Roche-Plate, the property at Portrieux in Brittany where Morisot spent her final summer holiday before her death, she painted Julie, now in her teens, eating pears in the company of her cousins [133]. Here, the whole canvas seems alive with impasted, vibrant strokes which map bold symmetries between swelling pears, oval faces, spreading skirts, and curving bench. It is as though, within this garden's sanctuary, Morisot sought to seize for eternity the very pulse of life on which her brother-in-law was already losing grip; she herself would die the following year. Just as Julie, following her uncle Adolphe's death, sat down in the Roche-Plate garden before the 'alley blooming with red and white roses, the alley bordered with bushes' to 'pray for aunt Edma' and her cousins,[9] so the very act of representing the plenitude of life – both vegetable and human – as concentrated in a 'family garden' was in itself perhaps a defence against death. If Morisot merely hints at such meaning, it is surely overt in Monet's *Camille Monet on a Garden Bench*, painted at Argenteuil in 1873, where the mourning worn by Camille following her father's death is dramatically offset by the brilliance of the flowers. While such works reinvented

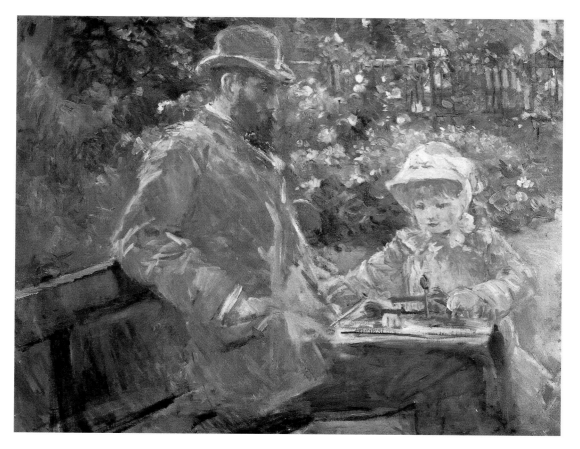

137 Berthe Morisot, *Eugène Manet and his daughter at Bougival*, 1881
A more sympathetic image of Eugène Manet's relationship with his daughter Julie – here playing with a toy train set on his lap – than the photograph opposite. Morisot's lively brushstrokes catch the sunlight as it glances off flowers, Julie's hair and face, and the light summer clothes.

138 Mary Cassatt, *Lydia crocheting in the Garden at Marly*, 1880
Cassatt, who did not marry, often painted her sister. This picture was shown in the same Impressionist exhibition (1881) as her portrait of Lydia in an autumn park [119]. The writer Huysmans commended Cassatt's work on this occasion for its 'charge of feminine sensibility'.

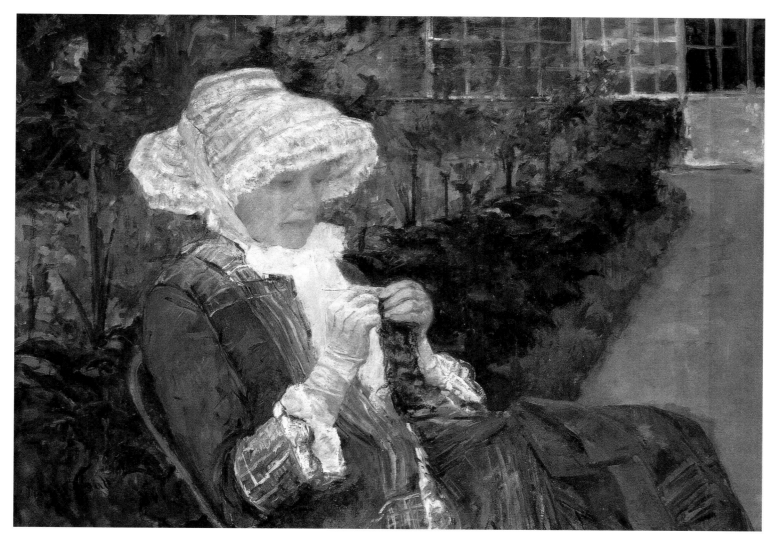

17th-century *vanitas* imagery, with its reminder that humans, like flowers, will wither and die, their *pleinairiste* rendering of sunshine and floral colour now created a keenly vigorous defiance of death. In a 'decorative panel' such as Monet's *Luncheon*, the very act of painting a family garden becomes a virtual emblem of faith in the future, since mural art is traditionally 'permanent'; imagery meant for posterity.

Where Morisot and Monet celebrated mother- and fatherhood in their 'family gardens', both Caillebotte and Cassatt (who did not marry) created a number of suggestive 'sibling' pictures. Caillebotte steals up on his brother Martial in *The Orange Trees* (1878), to look over his shoulder as he reads in the cool violet shadow of ornamental trees at Yerres, while his cousin Zoé stands, also reading. His own dog basks motionless in the high summer sun which floods across the grass and the geranium *corbeille* in the background. The brightness of the background brings it 'forward', giving the picture an almost heraldic, decorative effect, but also implicitly connecting us with Caillebotte, the observer who is related to his sitters.

Cassatt portrayed her sister Lydia seated in her garden at Marly [138]. Wearing an elaborate white bonnet whose diaphanous fabric is touched with soft pink, yellow and blue reflections, she seems herself a flower; at the same time, the line of the flowerbed and path behind her is echoed in the lengthening strip of crochet on which she solemnly concentrates, and the trimmings and ribbons of her dress, as if to articulate visually the bonds between artist and sitter. The close-toned harmony of blue dress, plum-coloured ribbons, red flowers and green grass, offset by Lydia's white bonnet and cream gloves, in turn creates a chromatic 'crochet' which further projects the sisterly relationship. As in Monet's *Camille Monet and a Child in the Garden*, showing his wife sewing before a mass of geraniums with variegated leaves, Cassatt links the artifice of cultivated nature and its painted image with that of costume and the needlecraft which fashions it.

Silence – both of the sitters' absorption in their activities and of the kinship that has no need of words – is, in fact, an almost palpable feature of many Impressionist family gardens.

139 Gustave Caillebotte, *The Orange Trees*, 1878
Another view of the garden at Yerres, its pools of violet shadow enjoyed this time by Caillebotte's brother, Martial, and his cousin, as they read on a hot summer's day. His dog, meanwhile, dozes on the path in the sun.

140 Marie Bracquemond, *On the Terrace at Sèvres*, 1880
Marie Bracquemond's sister Louise lived with the artist and her husband, and modelled both the women in this picture – a closely observed evocation of the play of garden sunlight on light gauzy costumes, offset by the dark suit of an unknown man. Despite their physical proximity, the figures each seem lost in private thought; the white rose on the foreground woman's dress, a traditional emblem of silence, encapsulates the mood.

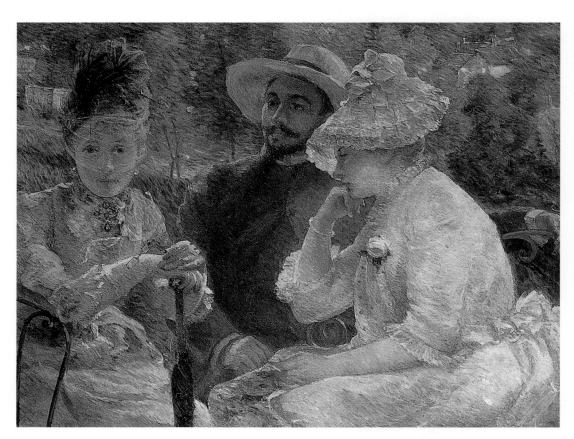

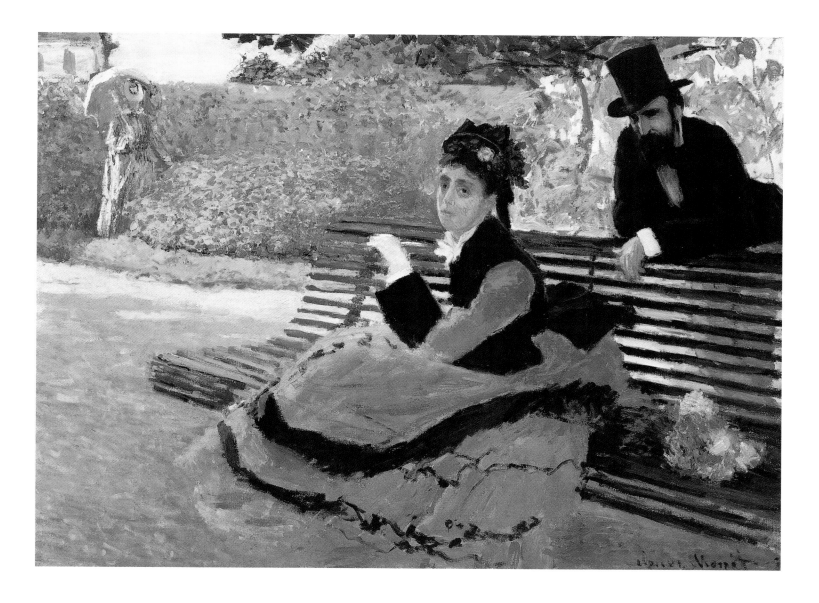

It serves to intensify the visual: the splendour of flowers, and the ordered or decorative arrangement of colours and forms. It is, for example, a white rose – the traditional emblem of silence as well as of innocence – that one of the women wears on her white dress in Marie Bracquemond's *On the Terrace at Sèvres*. Shown at the 1880 Impressionist exhibition, this portrays her sister Louise Quiveron (who modelled both the women), seated alongside a man in the garden of the Villa Brancas near Sèvres where Marie, her artist husband Félix, and Louise herself lived.[10] As if in obedience to the white rose, whose form is suggestively echoed in the ironwork whorls of the garden seats and the pattern of the sitters' clasped or cupped hands, the trio, lost in their thoughts, do not communicate with each other. Professional isolation was certainly largely Marie Bracquemond's lot. For although her husband Félix portrayed her painting on her garden terrace, he disapproved of her, as a woman, exhibiting her work. And though Louise as shown at the left stares intently towards the viewer, her eyes are lightly veiled, and she does not use the lorgnette idly balanced in her hand. The *plein-air* effects which, as a woman, Marie Bracquemond could most easily achieve by painting family and friends within her garden, here lead the viewer into realms beyond the visible. Some of the works she did exhibit were described by one critic as 'ethereal idylls . . . far from this world'.[11]

141 Claude Monet, *Camille Monet on a Garden Bench*, 1873
Wearing mourning bands after her father's death, Camille looks towards the painter, but in her evident grief, barely acknowledges either him or the visitor leaning on her bench (whom Monet later identified as a neighbour). The sun-filled background, where a woman (the neighbour's wife?) admires a bed of brilliant geraniums, is, at this moment, for Camille a world apart.

The family garden and the early Third Republic

As has already been suggested, the Impressionist 'family garden' is best seen as a historical phenomenon with a range of motives and meanings, often relating to the changes in the Impressionists' personal circumstances. For an artist such as Monet, setting up home with his wife and young son at Argenteuil in 1872, his garden was clearly a convenient and evocative subject. But domestic subjects such as women and children in gardens were also increasingly marketable in the new, supposedly more 'democratic', Third Republic which began in 1870. Academic painters such as Firmin-Girard and Monet's second cousin Toulmouche both did well from their polished, sugary images of the modern *hortus conclusus*, which answered Salon critics' pleas for more pictures of *paysage habité* (inhabited landscape) – nature seen 'in its relationships with man'.[12] This taste in part reflected the 'rediscovery' of Dutch 17th-century genre painting – itself created under a Republic, and something Monet must have seen when he stayed in Holland on his return to France from London in 1871.[13] 'Family garden' motifs were, in turn, an obvious expression for what the Impressionists' supporter Edmond Duranty in 1876 called their quest to 'eliminate the partition separating the artist's studio from everyday life'.[14] Boundaries between indoors and outdoors were also blurred in the way that Monet, for example, increasingly chose to finish pictures in his studio. Here, emphasis could be given to certain parts, and forms and colours consciously harmonized so that pure *pleinairisme* gave away to more deliberative art-making.

We also need to remember that the personal dimensions of Impressionist family gardens coincided not only with the self-definition of Impressionism as a movement, through its group exhibitions, but also with a moment of far-reaching self-scrutiny on the part of the France, following defeat in the Franco–Prussian War and the horror of the Commune in 1870–1. 'Putting down roots' by growing a garden and raising a family, and 'making connections' – between plant and human families, indoors and outdoors, and art and life – were, in this context, acts with deeper meaning. Many writers encouraged the turning of swords into ploughshares through gardening;[15] art, likewise, was a means to perpetuate human roots and connections for posterity. Although the year 1873, when Monet began his *Luncheon*, saw the departure of the last Prussian troops from France, memories of the separations and dislocations caused by the War and Commune remained vivid for much of the period of the Impressionist exhibitions (1874–86). In April 1874, as the first exhibition opened, buildings ruined by the Communards were still much in evidence in Paris, and when the Salon opened two weeks later, it was filled with mawkish paintings of the War.[16] France itself had been truncated, with Alsace and Lorraine now German territories; during the Prussian siege of Paris, the city had been cut off from the rest of the country, imposing extremes of privation on its inhabitants, including Berthe Morisot. Bazille had lost his life fighting as a soldier; Manet and Degas had served in the defence of the capital. Caillebotte had gone to Le Havre, visiting Yerres as conditions allowed. Monet and Pissarro, taking refuge in London with their young families, had been the most 'uprooted' of all the Impressionists.

Already around 1870, Caillebotte had shown national guardsmen using the estate at Yerres for rifle practice; bright dots of red and blue amid its green, even these 'friendly' soldiers seem a palpable intrusion, and one actually defecates beneath a tree.[17] On their return to France after the War and Commune, Monet and Pissarro would certainly have been as aware as the novelist Alphonse Daudet that their beloved Ile-de-France had been overrun by a foreign force, which had occupied and pillaged both the Parisians' 'summer palaces' and gardens there – the kind of place owned by the Caillebottes or Hoschedés – and more modest homes and gardens such as Pissarro's at Louveciennes.[18] 'Ah! if the

142 Engraving of Marie-François Firmin-Girard's *Grandmother's Garden*, 1876 Sentimental as it may seem to present-day eyes, this image conveys reactions in France to the twin humiliations of the Franco–Prussian War and the Paris Commune. If the woman gathering chrysanthemums for All Saints' Day implicitly remembers a soldier son or husband lost in battle, then her companions highlight the role of women as mothers – instead of the *pétroleuses* of the Commune – and of children as the nation's future strength.

Parisians, at the onset of the siege, could have brought into the city this adorable landscape surrounding it', wrote Daudet;

if we could have rolled up the lawns [and] the grassy paths turned purple by the sunset, lifted the ponds that shine in the woods like hand-mirrors, wound our little rivers around a bobbin like silver threads, and shut the whole up in the furniture-repository; what joy it would have been for us now to lay in place again the lawns and woodland, and to remake an Ile-de-France which the Prussians would never have seen![19]

When, on moving into the Maison Aubry at Argenteuil in 1871, Monet tore away the black paper screens with which the previous occupant had covered its studio windows, he visually reappropriated that 'lost' Ile-de-France mourned by Daudet. His paintings show that one of his first acts was to install and plant with flowers such as fuchsias the blue and white Oriental vases he had brought from Holland en route from London and placed outside in his new garden. In his portrait of *Camille at the Window* [146], the fuchsias include several mature specimens, trained in 'standard' formation, on which Monet must have spent some money. Many new kinds of fuchsias had been developed in the early to mid-19th century [145]; *Camille at the Window* shows some of the long-tubed varieties, derived from an American species introduced into France in 1835, as well as what appears to be a fine example of the strain with a white corolla first reported in the horticultural press in 1855.[20] It was at the Maison Aubry too that, as we saw in the Introduction, Monet appears to have delighted in growing magnificent dahlias [16].[21]

After the Monets moved to the newly constructed Pavillon Flament in 1874, Monet's horticultural activities actually reached a level that required the employment of a part-time gardener,[22] and must have been one of the reasons for his increasingly desperate pleas for loans from friends. His pictures now show carefully tended and lavishly planted *corbeilles* of geraniums, or of gladioli – those specialisms of his native town of Le Havre – as well as a fashionably curvilinear, flower-bordered central lawn.[23] Camille often strolls on the horse-

143 Claude Monet, *The Artist's House at Argenteuil*, 1873
One of Monet's first pictures of his Maison Aubry garden, showing the blue and white porcelain pots he had brought from Holland on his way home from London in 1871, and which he would again fill with flowers at the Pavillon Flament and in his garden at Vétheuil. Jean plays with his hoop; Camille stands in the doorway.

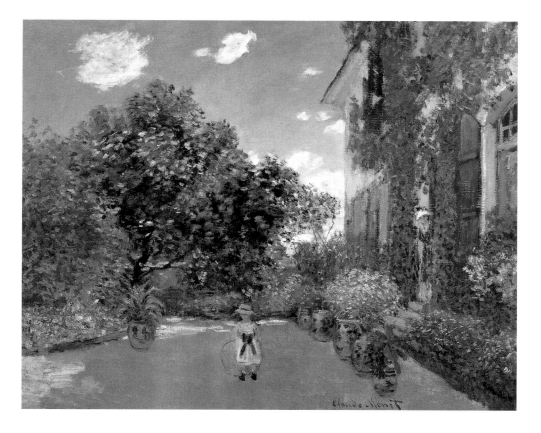

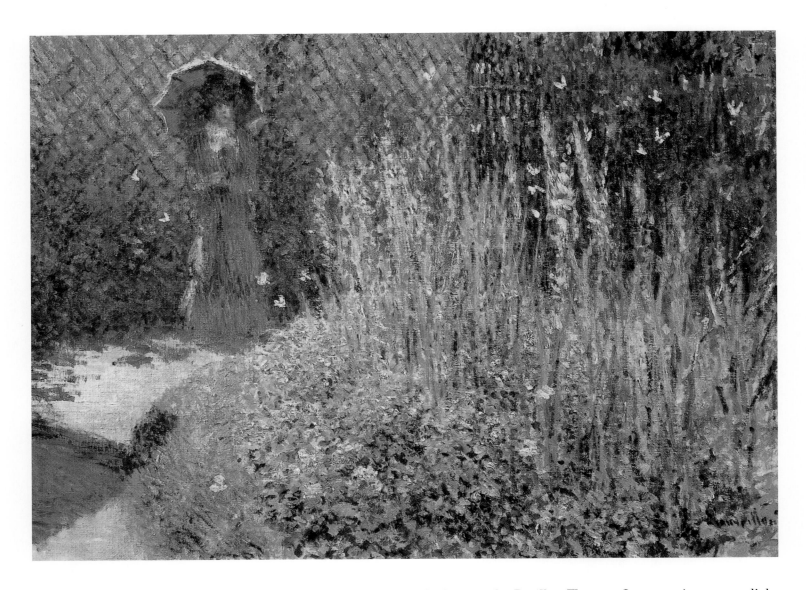

shoe-shaped path surrounding the lawn at the Pavillon Flament. In some pictures, sunlight sets the glowing beds of red and pink geraniums aflame, their brilliance enhanced by the complementary greens of the foliage and the trees. The ensemble seems almost to explode before our eyes. In others, more muted effects of dappled light dominate. But a number of Monet's scenes at the Pavillon Flament show secluded, even semi-wild areas of trees, through which stripes of golden sunlight straggle, and where Camille walks, or stretches out in the shade with one or two friends, sometimes with Jean. Camille's white dress is turned to violet in the reflected light, while in some pictures, an arc of glowing geramiums – part of the more formal section of the garden – fills the foreground [134]. Like a protective ring of fire it contains the family members and guests within a sanctuary of grass, at the fringe of the garden's 'wild' part. But in one intriguing painting, Camille pushes through undergrowth in some unkempt corner of the garden while Jean seems to play a private game, lying on his back on the ground.[24] Had Monet encountered in London the English gardener William Robinson's influential book on the *Wild Garden*, published just before he stayed there?[25]

If his Argenteuil gardens offered Monet a world in miniature which he could control, order, or deliberately leave to nature's way, they also contrast markedly with the elevated, even detached, panoramic viewpoints over the Tuileries and other public gardens which he and Renoir used in Paris in the 1870s [116, 117]. The ground-level, close-up viewpoint of *Camille at the Window* draws us directly into the heady mix of colours, textures and implied scents which surrounds Camille, and of which she is part. Indeed, the reclaiming of French

144 Claude Monet, *Gladioli, c.* 1876 Silhouetted against the light, Camille strolls in the Pavillon Flament garden beside a magnificent bed of gladioli – those specialities of Monet's native Le Havre. Butterflies hover, and even Monet's signature is harmonized in colour with the flowers.

soil and nationhood via horticulture is here almost fused with the intensity of sexual possession, as suggested by the open window and opened flowers. Fuchsias had become sufficiently widely grown already by 1863 to have acquired a gamut of meanings mainly to do with love in the 'language of flowers', while nasturtiums, those traditional emblems of 'the fire of love', climb suggestively up the walls with ivy (the symbol of friendship or attachment).[26] But if such imagery is inherently personal, it was, nevertheless, often shown at the Impressionists' group exhibitions, their innovative means of direct outreach to the public. Renewal of France as expressed by cultivation of a garden here converged with the goals of modern art. Although, in *Camille at the Window*, Monet in one sense 'guards' his wife by setting her within the house, the close-up viewpoint and closed-off background are typical of many Impressionist 'family garden' pictures and create a beguiling continuity with the viewer's spatial world. Composition and colour draw us in to the gatherings of family or guests, so that art becomes life – renewing France after its disgrace – and life becomes art, with Monet's 'Decorative Panel' (*The Luncheon*) pushing this interchange to its very limits.

145 *Fuchsia Varietates Hortenses* (Garden Fuchsia), from *L'Illustration horticole*, 1855
Fuchsias, like gladioli, underwent extensive development in France from the mid–19th century, and both were described in the horticulture press as 'plants whose culture is completely French'. Pictures such as 144 and 146, where they feature in Monet's garden, are in this sense inherently 'nationalist' images.

146 Claude Monet, *Camille at the Window*, 1873
Camille is implicitly a flower amid the riot of flowers before the window – notably splendid specimens of fuchsias, some in Monet's blue and white pots. In the contemporary 'language of flowers', the different kinds of fuchsia often had meanings to do with love, just as ivy (creeping up the wall on the right) signified 'attachment'.

The private and the political

When Monet painted his other favourite motif at Argenteuil, the river and its environs, he in turn often used bridges or lines of trees to 'contain' and 'enclose' the distant reach of the water and landscape, as if his inner eye were still programmed by a 'garden matrix' and the sailing boats before him were but flower blooms. So too, as Spate has observed, 'Monet's suburban countryside was an extension of the private garden'.[27] Camille sits tranquilly reading amid the long grass of *Meadow at Bezons* (1874) as if the field were her own; in *Poppies at Argenteuil* (1873), she and young Jean, sometimes accompanied by another adult and child, wander through the rolling fields, as if, despite the high grass and wild flowers, these were no different from their very own Eden behind the Maison Aubry or the Pavillon Flament.[28] Even Monet's portrayal in 1877 of the enclosing ironwork structure of the Gare Saint-Lazare in Paris, the departure point for travel to Argenteuil, in effect offers the artificial equivalent of the protective bower in which he placed his family in their Argenteuil garden. Light is filtered by the fretwork of its metal construction, just as arching, mature lilacs enfold Camille, sometimes alone and sometimes with friends, in a group of paintings of 1872 of a corner of the Maison Aubry garden [148]. If the meaning of lilacs as emblems of 'young love' falls heir to the imagery of *Women in the Garden*, however, small, touch-like strokes – the mature Impressionist style – have now replaced Monet's broader brushwork of the 1860s. And, since the Pavillon Flament was a new house, Monet must in some paintings have exaggerated the impression of its garden's maturity.[29] In *Resting in the Garden, Argenteuil* (1876), for example, surprisingly tall trees spread their shade across the lawn, so that we barely notice the figures of Camille and either a male friend or perhaps even Monet himself amid the shimmer of sunlight and shadow. Seated on the grass, they merge with it, so that, by implication, the garden itself embodies 'rest'.

Such effects are, of course, the logical sequel to Monet's and Renoir's fascination in 1869 with the play of light over the bathers on the tree-canopied riverside at La Grenouillère, a little further up the Seine. But it is significant that they are now explored in a private and 'family' realm. For Monet and Pissarro had chosen exile in London to safeguard their families – and it was the security represented by the family which the Commune of 1871, even more perhaps than the Prussian invasion, had shattered. With their *pétroleuses* – the working-class women of Montmartre who were blamed for the lead in the Communards' incendiary attacks on the Hôtel de Ville and other monuments of Paris – the events of 1871 had cruelly shaken the belief in 19th-century France that families were the backbone of society. Just as gardens were rebuilt in Paris after the Commune, so the restoration of women's 'proper' role as wives and mothers was seen as an urgent priority by the new Republic.[30] The phrase *terre maternelle*, joining motherhood and the land as one, was widely used. As even the leader of the nascent women's movement in France, Maria Deraismes, had argued as early as 1868, 'a people is nothing but several families . . . the sentiment best-suited to encourage enthusiasm and promote heroism is that . . . of the mother nation [*mère patrie*], as it is called, to emphasize its essentially familial origin and character'.[31] It was Deraismes, interestingly, whom Pissarro portrayed in 1876 in the garden of Les Mathurins, her property at Pontoise. His picture might actually be read as alluding to her advocacy of the Biblical Eve's curiosity as an essentially positive principle. It shows her standing beside a spreading tree – perhaps the tree of knowledge? She contemplates a Mexican silvered glass ball – a feature more usually found in Latin American gardens – as if perhaps an emblem of the world itself.[32] The delicate, interwoven touches of Pissarro's Impressionist brushwork, harmonizing orange nasturtiums and geraniums with the rich green lawn, red-roofed white

house, and blue cloud-swept sky, certainly seem vividly to project the mutual cooperation of humankind and nature which the carefully tended garden embodies. With its ordered *corbeilles* and paths, it echoes some of Monet's Argenteuil garden views,[33] but surely also pays tribute to Deraismes's dream of a perfected Republican society, born of the *mère patrie*.

More generally the Impressionists favoured less radical, though still firmly progressive forms of Republicanism.[34] Although they tried to avoid public association with politics by initially calling themselves an 'Anonymous Society', a pair of 'private' pictures painted by Manet and Renoir in Monet's Maison Aubry garden [149, 150] during the heatwave of July 1874, suggests that politics was sometimes in fact very closely linked with horticulture in the Impressionist 'family garden'. Manet had come to visit the Monets at the Maison Aubry. Inspired by the sight of Monet tending his flowers in the garden, watering-can at the ready, with Camille and seven-year-old Jean relaxing on the grass beneath a tree, he took up his brush. Renoir then dropped in; borrowing Monet's paints, he portrayed Camille and Jean as they sat for Manet in the shade of the tree. However, he took an even closer viewpoint than Manet, so that the figures and the lower trunk of the tree against which they lean form an almost decorative motif against the bright green grass. He allows no glimpse of the border to the left tended by Monet, or the red flowers in a second border in the background, which both appear in Manet's scene. On the same day or soon after, Monet in turn painted Manet at work at his easel in the Maison Aubry garden [152], seated beneath a small tree or woody shrub, beside a trellis. Manet's and Renoir's pictures pay tribute to Camille as wife, mother and lady of leisure, enjoying the fruits of her husband's labours – either explicitly (in Manet's version, where we see Monet gardening), or implicitly (in Renoir's). Manet wittily emphasizes the family dimension of his picture by placing a family of fowls – a cock, a hen and a chick – in the foreground; Renoir simply includes the cock. Both Manet's and Renoir's pictures, however, depict Camille's white dress fanned around her on the grass, enfolding Jean, so that it seems to 'root' the tree beneath which she sits with Jean to the very ground of the garden. Their images are thus almost literally of *terre maternelle* (native soil) and *mère patrie* (motherland). The paintings also bring to mind the ideas of the Republican historian

147 Camille Pissarro, *The Garden of the Mathurins, Pontoise*, 1876
With his radical political views, Pissarro found a natural friend in Maria Deraismes, an early campaigner for women's rights, who lived at Pontoise. Here, she is portrayed in her splendid garden, with its Mexican silvered glass ball which perhaps attracted Pissarro's interest on account of his upbringing in the Danish West Indies, and his early travel in Latin America with the painter Melbye.

148 Claude Monet, *Lilacs, Grey Weather*, 1872

An even earlier view of the Maison Aubry garden than *The Artist's House at Argenteuil* [143], this is one of several Monet painted of Camille with friends beneath its lilacs. The tall, mature shrubs create a natural – and richly perfumed – bower, making the garden seem more 'wild' than 'cultivated'.

149 Edouard Manet, *The Monet Family in the Garden*, 1874

150 Pierre-Auguste Renoir, *Camille Monet and her Son Jean in the Garden at Argenteuil*, 1874

Along with Monet's portrait of Manet [152], these pictures document a classic moment in the history of Impressionism, when three of its luminaries worked in each other's company in Monet's first garden at Argenteuil. Though Renoir later claimed he had painted his picture in the studio, its sense of spontaneity suggests otherwise, and Monet certainly remembered Manet whispering to him as he painted beside Renoir, 'He hasn't any talent, that boy there. Tell him, as his friend, to give up painting!' Despite such rivalries, both Manet and Renoir make striking – and probably political – play with the colours of Camille's tricolour fan, while Manet's version is believed to be the only painting of Monet actually gardening.

and writer Jules Michelet. Robustly anticlerical, Michelet had argued in his widely read 1869 book, *Nos Fils* (Our Sons), that a child should be brought up in a garden; should 'eat of both the fruits, life and knowledge' there; and should do so to the full, encouraged by its mother. Only then might 'paradise' come into being:

What joy to see in this garden that young Eve and her little Adam! To live in a garden, in the pure air, in communion with the heavens, with the good earth, our mother, that is true human life. Man is born a tree in several legends. In Persia, the spirit, life, the soul, these are all the sacred tree. The great educator of our century, Froebel, was a forester. 'The trees', he said, 'were my doctors'.[35]

We will look shortly at Michelet's reference to Froebel, the progressive educationist. Meantime, in considering Renoir's and Manet's motifs, it is worth remembering the Republican associations which lay behind Michelet's imagery of trees. 'Trees of Liberty' had been planted in the 1789 and 1848 Revolutions in France. 'At the foot of this tree, you will remember that you are French . . .' proclaimed the Republican *curé* who planted the first in 1790; the symbol had in turn been revived in the press in 1871.[36] In July 1874, it was surely not without significance that Manet and Renoir not only presented Camille and Jean as the 'roots' of a tree, but also gave emphasis to this motif through low, close-up viewpoints and tricolour colour-schemes – a red fan against a white dress and blue sailor suit in Manet's painting; a tricolour fan in Renoir's. In turn, in the right foreground of Renoir's picture, we see a proud 'Gallic' cock. The Gallic cock – distinguished by its upright, profile stance – was a traditional Republican emblem which had been suppressed under the Second Empire, but was reclaimed by the new Third Republic.[37]

The Third Republic which had come into being at the overthrow of the Second Empire in 1870 was, however, a rather uneasy coalition of Republicans, Imperialists and Monarchists,

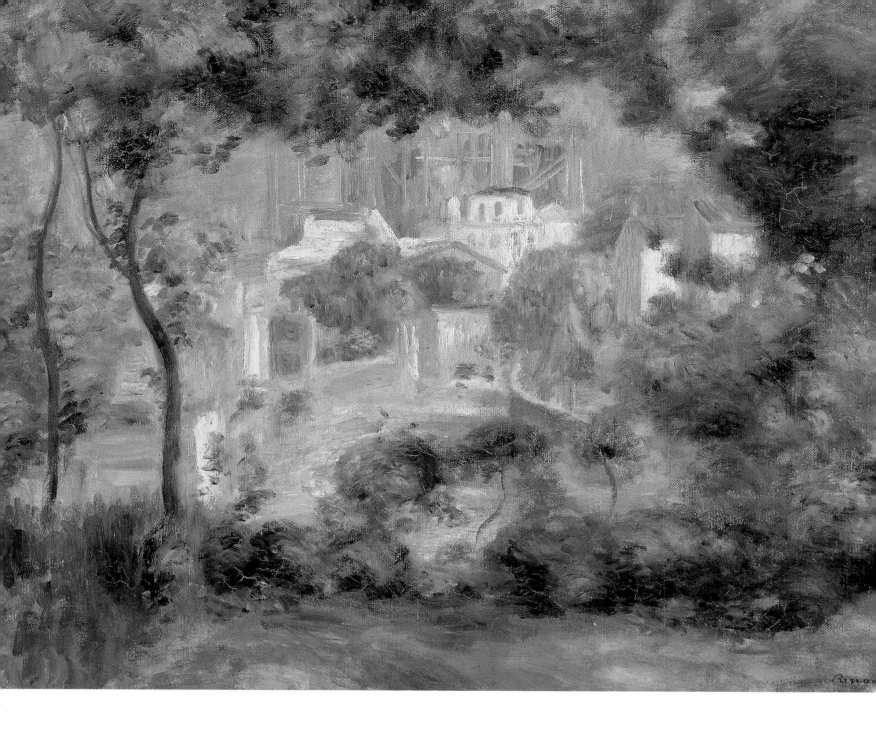

asymmetrically. Likewise, shadows reach freely across the *allée* from the trees, bisecting its white gravel with irregular zones of cobalt blue and violet. These in turn are punctuated by spots of yellow, pink and cream as the sun filters through the overhead foliage. The whole painting becomes a complex harmony in which forms are subtly deconstructed, and colours just as subtly linked, by the action of the sunlight. As in the *Moulin de la Galette*, the equation created between garden and figures by the action of the sun serves to project sociability and *égalité*.

Although Rivière believed that the Impressionists treated 'a subject for its colour and not for the subject itself', it is worth remembering that the critic Félix Fénéon, looking back on Impressionism in 1887, wrote of its artists' ability to reveal 'the emotional meaning of colours'.[53] The luminous blue shadows, golden straw hats, and harmonies of coloured light in Renoir's *Swing* are, in this reading, themselves the carriers of its significance as a 'Garden of Love'. It was certainly the emotions associated with such a garden that Zola evoked in the scene inspired by *The Swing* in his novel *Une Page d'amour* (A Page of Love), composed in

174 Pierre-Auguste Renoir, *The Gardens of Montmartre, with view to Sacré Coeur under construction*, c. 1896
With their interest in the contemporary, some Impressionist paintings are also spectacular historical records – like this view from Renoir's garden at the Château des Brouillards of Sacré Coeur under construction. Yet even here, the frame of trees turns Paris into a rural idyll, with the controversial basilica – intended as expiation for the events of 1870-1 – an integral part of it.

standing up on the seat [of her swing], her arms stretched out and holding onto the ropes . . . she was wearing a grey dress, decorated with purple knots . . . That day, in the pale sky, the sun was sending down a dust of blond light. It was, between the branches without leaves, a slow rain of beams. There were no flowers, only the gaiety of the sun on the bare earth announced the arrival of the spring . . . it was her enjoyment, these upward and downward swings, that made her so dizzy.[55]

1877 at a period when he was in close touch with a number of the Impressionists including Renoir.[54] The novel's heroine Hélène is described

Though Zola here transposed Renoir's picture into an earlier season, and substituted 'dizzy' movement for its figures' stasis, it is the mood evoked by its colour and brushwork to which his description clearly responds. The way Hélène's dress turns white in the sun in fact symbolizes her gradual liberation from the shadow of her husband's death: this is the first time she has not worn full mourning costume, and although the episode with the swing is to end in a minor accident, the attention she receives in consequence from the young Dr Deberle provides the opportunity for the pair to recognize for the first time their deep love for one another. In Renoir's picture it is arguably the very harmony of opposites – the 'regularity within irregularity', in terms of vibrant colour allied with restraint of pose; innocent child and knowing adults; and straight *allée* and swaying swing – that creates the 'Garden of Love' sensed by Zola.

With its dappled sunlight, grouped figures, and suggestion of a 'public' milieu, *The Swing* relates particularly closely both to *The Ball at the Moulin de la Galette*, and to studies such as *Under the Arbour at the Moulin de la Galette*, which shows a group of young people at one of the restaurant's garden tables.[56] Some of Renoir's other views of the rue Cortot garden were more domestic, such as *Nini in the Garden* [173]. This portrays Nini Lopez, another Montmartre girl, seated on a bench beside a patch of grass, with bushes, trees, and the glimpse of a building beyond. Perhaps set in an orchard or kitchen garden area of the rue Cortot site, Nini's casual pose certainly suggests that Renoir put her at ease. Renoir seems to have found her trustworthy and conscientious, but having 'a certain Belgian disingenuousness'[57] –

175 Martial Caillebotte, photograph of Renoir in the garden of his house in Montmartre, winter, with Sacré Coeur under construction in the background, c. 1891–2
This photograph, taken by Caillebotte's brother at the Château des Brouillards, and showing the view to Sacré Coeur just a few years before it was painted by Renoir [174], reminds us of the close friendship between Caillebotte and Renoir. Caillebotte, who died unexpectedly in 1894, named Renoir his executor.

comments that remind us that painting in itself was for him a social act; he apparently often conversed with his models as he worked. At the same time, both the absence of narrative in the painting and its domestic setting, bring to mind Renoir's revealing comment 'Give me an apple tree in a suburban garden. I haven't the slightest need of Niagara Falls'.[58] It is the decorative, rather than the dramatic, that again comes to the fore. Lines of violet shadow cross the grass, meeting the struts of the seat and the verticals of the tree trunks to create an almost abstract pattern, whose 'irregularity' is echoed by the vigorous, variegated brushstrokes. But there is also 'regularity', in terms of harmony and unity; the greenery is reflected in the viridian and violet shadows on Nini's face and dress, so that, like Anna in *Nude in Sunlight*, and the figures in *The Swing*, she becomes as one with her garden setting. The passage of sun and shadow which shapes these subtle harmonies is itself, of course, also a marker of the passage of time. The Mire du Nord (the siting mark in the northern part of Paris for the alignment of the Paris Meridian) was actually located in the Moulin de la Galette garden.[59]

By the time *The Ball at the Moulin de la Galette* was shown at the 1877 Impressionist exhibition, Renoir had probably given up his rue Cortot lodging. His pictures of boaters at the *plein-air* restaurant overlooking the Seine at Le Chatou, and his *Dance in the Country*, *Dance in the City* and *Dance at Bougival* panels, each showing a waltzing couple, are perhaps the most direct successors to his 'social gardens' in Montmartre.[60] He did, however, paint some views of the overgrown garden of the ancient Château des Brouillards in Montmartre when this became his home in the early 1890s. These include a painting in which Sacré Coeur is glimpsed under construction [174], shrouded in geometric scaffolding. Vigorously opposed by radical Republicans like Clemenceau, Sacré Coeur had been intended as expiation for the War and Commune, and its construction had begun while Renoir was at rue Cortot. It is revealing that he brought the Château's gardens to the fore, as if again portraying a *Paradou* before the 'Fall' of the War and Commune. In another evocative view of these gardens [172], he placed the teenage daughters of his neighbour at the Château des Brouillards, the writer Paul Alexis (one of Zola's closest friends), amid a self-contained realm of abundance; their dresses are softly-touched notes of cream and brilliant red offset by golden fruits or blossom, red flowers which may be geraniums, and surrounding strong viridians and deep greens. Despite the escapism of these images and his earlier work in Montmartre, it is worth remembering that even while painting *The Ball at the Moulin de la Galette*, Renoir had actually tried to persuade Madame Charpentier to fund a *pouponnat* – a crèche for the poor children of the working girls of the district.[61] This act, which implies he too may have been familiar with Froebel's 'child-gardens', suggests that his idyllic images of 'social gardens' at this period were in essence but the complement to the reform of modern society overtly demanded by the 'Naturalist' writers whom he met at Madame Charpentier's salons. 'Close down the taverns, open the schools . . . clean up the suburbs and raise wages', said Zola in response to criticism of his frank depiction of the evil wine-den in his *L'Assommoir*.[62] A 'regular' Republic (*République 'régulière'*) – as the necessary framework in which freedom could flourish – was, of course, a central ideal of the politician Jules Ferry, who in 1879, had also extolled the merits of *plein-air* painting.[63] Renoir, meanwhile, struggling to start his *crèche*, effectively created a vision on canvas of what he could not find in life.[64]

176 Period postcard showing 'the private gardens of Old Montmartre: alley of the Château des Brouillards, 13 rue Girardon', June 1904
This early 20th-century postcard shows Montmartre much as it would have been when Renoir lived there: a semi-rural village filled with gardens, not yet the haunt of Picasso, Dufy, Valadon, Utrillo, and the Surrealists.

Les Jardins privés du Vieux-Montmartre

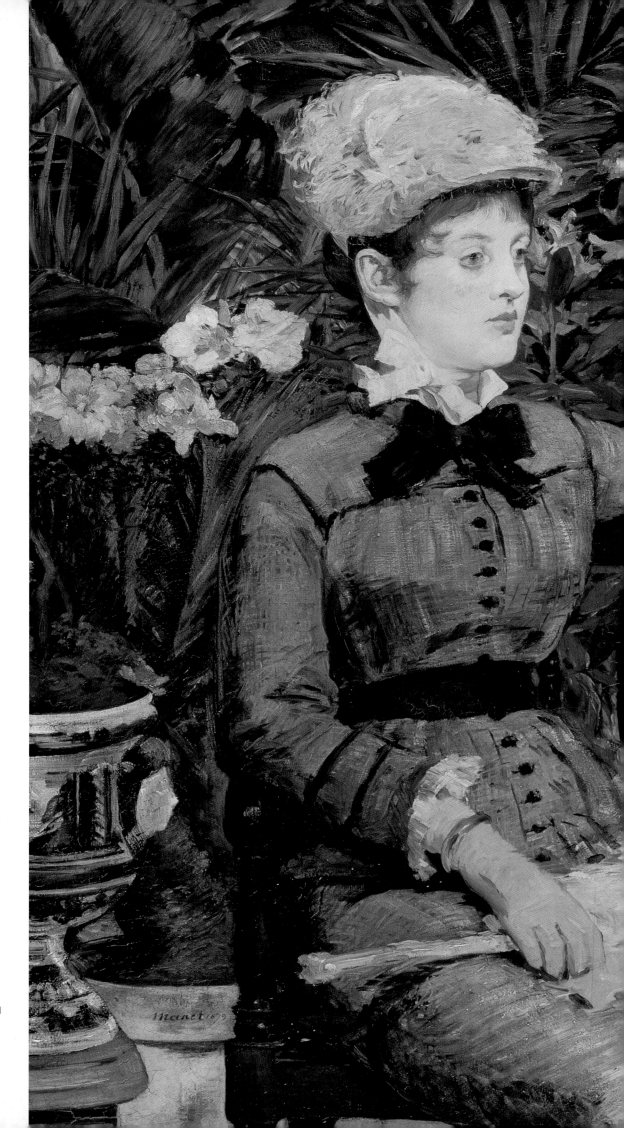

177 Edouard Manet, *In the Conservatory,*
1879
Private conservatories became status
symbols in later 19th-century France.
What more logical, therefore, than for
Manet to pose his friends Jules Guillemet
and his American wife – who owned a
fashionable clothing shop in Paris – in the
conservatory-studio owned by his
colleague Rosen? Yet the couple seem
abstracted; it is the burgeoning mass of
hothouse plants, whose leaves make
decorative liaisons with the bench slats
and dress-pleats, which seems almost
animate, suggesting affinities with the
conservatory described by Zola in his novel
La Curée.

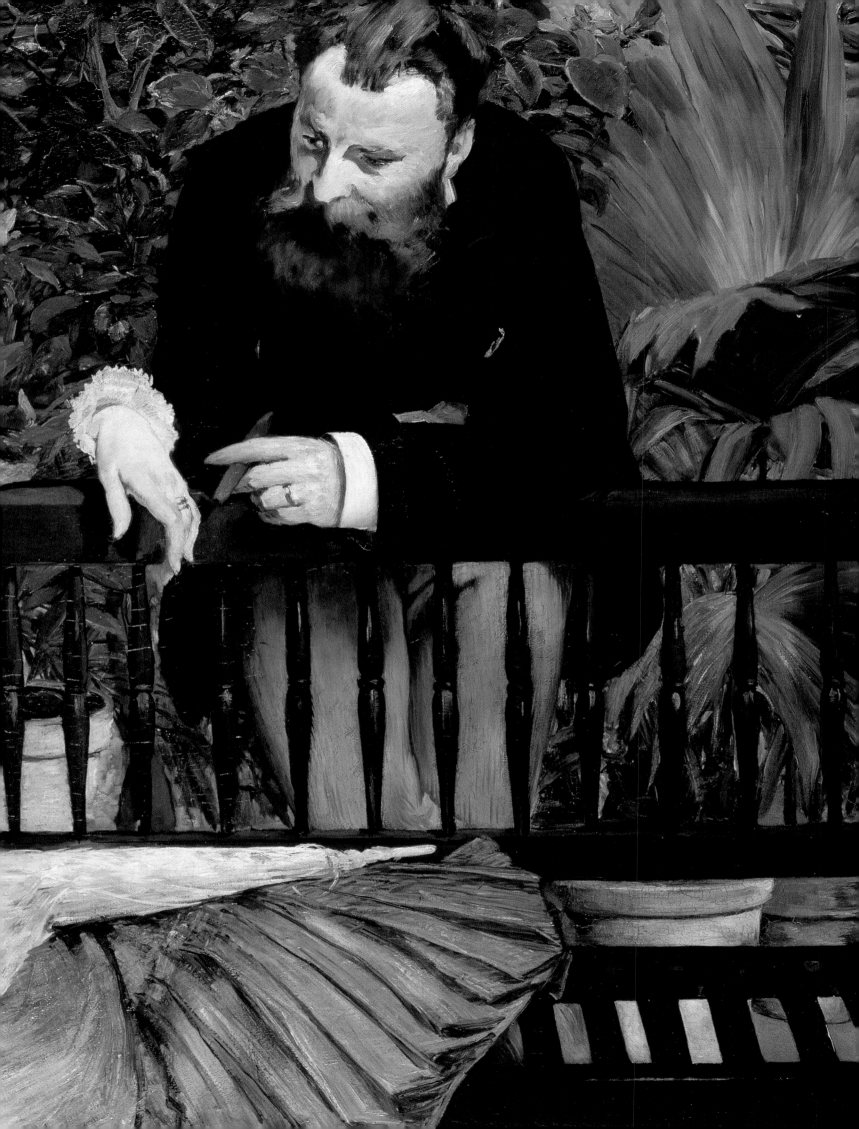

Manet's indoor gardens

If the 'good-luck' or 'happiness' bracelet worn by Anna in Renoir's *Nude in Sunlight* speaks of her 'free' existence in a *Paradou*-like garden, that of Madame Guillemet in Manet's *In the Conservatory* [177] has a very different function. As Crary has shown, it is part of a complex of 'binding' and 'enclosing' imagery in the painting which plays on the secondary meaning of *serre*, the French word for conservatory. *Serrer* means to squeeze or confine, as a bracelet does a wrist, and as rings 'encircle' the Guillemets' fingers. The narrow bench on which the fashionably dressed Madame Guillemet sits is, in turn, 'squeezed' right up to the picture plane, while M. Guillemet, leaning on its back and lightly holding a cigar, stands in an impossibly narrow space, virtually on top of the profusion of palms and exotic shrubs that fills the background.[65]

Manet's image, however, surely also plays on the implications of a *serre* as a place where plants themselves are 'forced', so that, thanks to modern 'progress', summer reigns in winter.[66] As constructions of iron, conservatories were at the forefront of 19th-century technology.[67] Given Manet's ambivalent presentation of 'progress' already in his *Universal Exhibition* (1867) [101], we can perhaps expect his witty correlation of fashion with the conservatory's contents – whereby the pleats of Madame Guillemet's dress, for example, echo the slats of the bench and the narrow-leaved palms – to involve some deeper dimensions. Conservatories were, after all, also *salons*: showcases as much for their owners and society guests as for the exotic flora they contained, which served essentially as status symbols. The Goncourt brothers, those literary socialites and friends of Degas, described that of the Princess Mathilde in their journal of 1867:

These conservatory-salons are an entirely new luxury . . . The Princess, with her somewhat barbaric taste, has furnished [her] . . . conservatory, which encircles the house, by mingling scattered articles of furniture of every possible country, every possible period, every possible colour, and every possible shape with the most exotic plants. It creates the bizarre impression of a display of bric-à-brac in a virgin forest.[68]

178 Sebastien-Charles Giraud, *Dining Room of the Princess Mathilde, rue de Courcelles*, 1854
The taste for conservatories grew out of the fashion for rooms ornamented with pot plants, like that recorded here by the fashionable painter Giraud. By 1867, however, the 'conservatory-salon' was born, and the Goncourt brothers could describe that of the Princess Mathilde, with its furniture now still more directly mingled with the plants, as looking like 'a display of bric-à-brac in a virgin forest'.

The Princess had already adorned her dining room in the rue de Courcelles with plants, as we see from Sebastien-Charles Giraud's painting of 1854. Here, however, she had kept garden and guests discreetly separate; the ornamental 'flower-beds' are fenced off with metal borders. Now, in the heady intensity of the conservatory-salons of the 1860s and 70s, heated by stoves and pervaded by the perfumes of orchids, giant lilies and other 'exotica', the forces of nature were encountered with a new, and even threatening, immediacy. The sheer number of 'new' plants in itself caused Georges Sand to comment by 1867 that 'The exotic vegetable world, which little by little has been revealing to us its treasures, is beginning to swamp us with its riches. Each year brings a series of unknown plants . . . of which we were in ignorance . . .'.[69] And by 1872, in Zola's ruthless revelation of Second Empire excess in *La Curée*, it was not just plant numbers that overwhelmed. As the novel's moral drama of lust and incest is played out by Renée, the wife of the speculator Saccard, and his son Maxime in the torrid conservatory of their luxurious *hôtel*, a pitch of symbolic suffocation is reached. The plants become almost animate, burgeoning extravagantly in the intense heat; in turn, in a frenzy of lustful anger, Renée bites a branch of tanghinia – the 'ordeal tree', reputed to poison the wicked and spare the innocent. From this point on she is doomed, both the victim and the personification of a sick and corrupted society.

One of the new mansions built on land formerly part of the Parc Monceau, the conservatory of Zola's novel is thus a garden that in turn literally devours the lives of its owners. It was well-known that La Pavia, a wealthy courtesan, had a splendid conservatory in Paris; Zola effectively laid bare the moral corruption of those who frequented such fashionable gardens. We can begin to see how the horticultural 'forcing' associated with a conservatory would have carried disturbing overtones for contemporary viewers when translated into the physical 'binding', 'squeezing' and 'enclosure' of Manet's *In the Conservatory*. Even a sympathetic critic, the writer J. K. Huysmans, described the lady as a 'lively flirt', when the picture was shown at the Salon of 1879,[70] while a cartoon of it published in *Le Journal Amusant* portrayed Madame Guillemet crouching *behind* the conservatory bench instead of sitting on it, with the caption 'An innocent young lady is taken into the clutches [*serre*, a play on the word for conservatory] of a perfidious seductor'. Placed behind the bench in this way, both Madame Guillemet and her husband also appear, of course, as if wild animals kept at bay, along with the exotic plants, by the 'bars' of its slatted back.

While the sitters' rings are juxtaposed in Manet's painting, it is, in fact, unclear which of Madame Guillemet's fingers bears hers[71] – despite the uncharacteristic precision and 'finish' of the painting which themselves suggest further kinds of 'forcing'. Though Herbert has interpreted the painting as a celebration of married love, others have noted its ambiguity.[72] The ring may not be a wedding ring, or even an engagement ring, but simply that normally worn with a 'good-luck' bracelet. And if, as was noted at the time, the man looks more like Manet himself than Jules Guillemet, Madame Guillemet is clearly represented as a visitor paying a social call. For the one ring that does not 'bind' is that on her fashionable parasol, implying that she has recently been using the parasol outdoors, and has not yet refastened it. At the same time, gazing fixedly yet impassively beyond the picture frame, she is a remarkably uncommunicative visitor. Is she in a trance, the kind of 'drugged dream' brought on by the scents of the conservatory in Maupassant's *Bel-Ami*?[73] Is she listening to music, so that the picture becomes an indoor variant of Manet's motif in his earlier *Music in the Tuileries*? Manet's wife, who apparently sat in on the creation of the picture, was a fine pianist.

As we look, we realize that what Manet shows is the winter garden stealthily but inexorably imposing its presence on the figures, as if 'forcing' their being to fuse with its own.

DANS LA SERRE.

Une pauvre jeune personne innocente est prise dans la serre d'un perfide séducteur.

179 Cartoon by 'Stop' of Edouard Manet's *In the Conservatory*, in *Le Journal Amusant*, 1879

This period caricature of 177 reveals the impact in France of Darwin's ideas: the Guillemets are depicted as wild animals, and the caption reads 'An innocent young lady is taken into the clutches of a perfidious seductor' – 'clutches' in French being *serre*, which also means 'conservatory'.

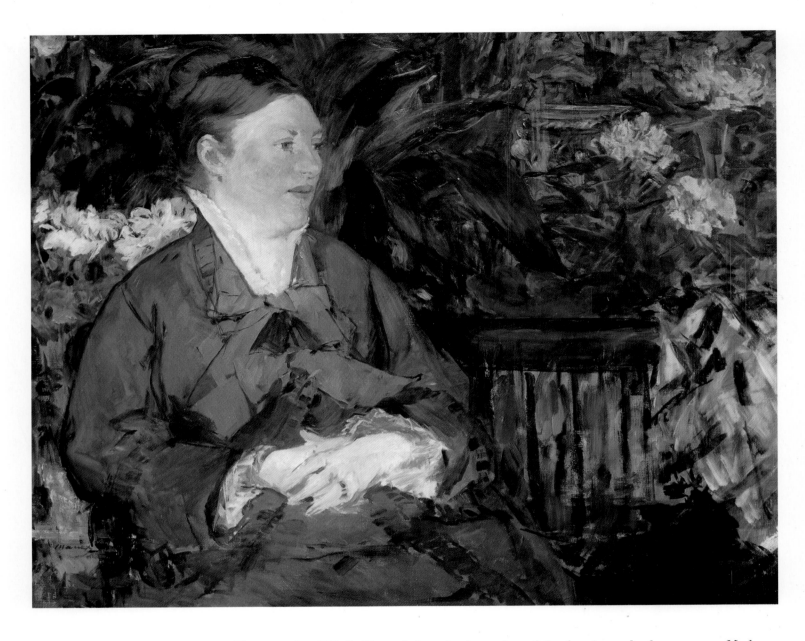

The growth of M. Guillemet's beard echoes that of the fanning palm leaves; even Madame Guillemet's eyes are green. Though the Guillemets' tranquil poses may at first seem very different from the frenzied embraces of Renée and Maxime in Zola's Saccard conservatory, there are in fact, parallels between Manet's and Zola's imagery which, in the context of the late 1870s when *In the Conservatory* was painted, enable us to see why *Le Journal Amusant* interpreted it as an image of wild beasts in a jungle. In turn, these correspondences suggest that Manet was not just making an indoor version of Monet's *Bench* [141] – that enigmatic image of a similarly abstracted woman in a garden, accompanied by a man who leans on her bench – nor a literal transcription of Zola's *La Curée*. Instead, *In the Conservatory* can be set within the context both of French debate about Darwin, which reached a critical moment in the late 1870s, and of the dialogue between artifice and nature which also engaged Renoir in his 'social gardens'. First, however, let us explore the parallels with *La Curée*.

In the conservatory of the Hôtel Saccard,

180 Edouard Manet, *Madame Manet in the Greenhouse*, 1879
This portrays the same conservatory-studio as *In the Conservatory* [177], but is far more sketchily-painted, exuding spontaneity. Manet's affection for his wife as his faithful friend and companion is suggested by the agapanthus in the background – a plant often grown indoors, and named after *agape* (empathetic, rather than erotic, love).

the thing that at every turn of the pathways struck your eye was a huge Chinese hibiscus, whose immense carpet of foliage and flowers covered the entire side of the mansion to which the conservatory was attached. The broad, purple flowers of such incredible mauve, endlessly coming into bloom, only lasted for a few hours. You would have thought they were the sensual mouths of women

Chapter 7

As we have seen so far, Impressionist gardens are most usually associated with leisure and recreation. They are *jardins d'agrément* – gardens for enjoyment – where flowers delight the eye and lawns invite relaxation. 'Work' is sometimes part of these – Monet tends his borders in Manet's picture at Argenteuil, for example, and a municipal gardener waters the plants in Manet's *Universal Exhibition* [101] – but it is not the main motif. There is, however, a small yet significant group of Impressionist garden pictures where 'work', or the evidence of it, does take centre stage. In some, the garden is effectively an extension of the domestic interior, where tasks such as washing or mending are performed amid the healthful open air and sunlight. In others, the work is that of cultivation itself – digging, planting, weeding, harvesting – and the plants portrayed are useful, rather than ornamental. The blue-green vegetables and scattered fruit trees in the 'working gardens' of Pissarro, Sisley, Guillaumin or Caillebotte are, nonetheless, typically part of inventive and even decorative compositions. We find rows of green beans striating pink soil, while pear and apple branches trace wintry silhouettes, bear drifts of blossom as in Japanese prints, or bend with ripened fruit. The girl in the foreground of Pissarro's *Apple-Picking* of 1882–6 [200] actually pauses to enjoy one of her newly gathered fruits even as her companions continue the harvest.

The boundaries between utility and decoration, and industry and pleasure are, in fact, often remarkably permeable in what we might call Impressionist 'working gardens', and they upset conventions and norms. Kitchen gardens were traditionally to do with necessity, not art, and were associated therefore with what was base and even bad. In George Sand's 1851 'country novel' *La Mare au Diable* (The Devil's Pond), for example – a book which Caillebotte tellingly disliked[1] – the climax includes an age-old wedding ritual in which the role of the kitchen-gardener is that of a priapic drunkard who presides over the symbolic uprooting of a cabbage, an emblem of fecundity. Even in 1872, just a couple of years before the first Impressionist exhibition, it was from a *jardin potager* (kitchen garden) that the evil genie 'King Carrot' was conjured by a wicked fairy in Offenbach and Sardou's operetta of that name. Though the Paris production of *King Carrot* included a lavish kitchen garden stage-set, and a ballet for black radishes, it was left to artists such as Pissarro, whom Zola approvingly dubbed 'a great blunderer', to challenge such caricature with his views of kitchen gardens at Pontoise.[2] And although the *Revue horticole* commented in 1862 on 'how many of our vegetables would, on account of their fine foliage or the brilliant colouring of their flowers, be prized as the equals of many of the choicest plants, if they were but rare or had come from afar!',[3] it was the Impressionists who put 'vulgar vegetables', as they grew in the soil, on the aesthetic map. This was a departure both from medieval Books of Hours, where kitchen gardens were an incidental backdrop for the 'Labours of the Months', and from the tradition of *Vanitas* still life, where cut fruit and vegetables were used as symbols of the brevity of life as, for example, in Diego Velázquez's *bodegón* pictures. Impressionist 'working gardens' were, nonetheless, as this chapter shows, far from devoid of meaning. Though the younger, Symbolist generation scorned Pissarro as an 'Impressionist market-gardener specializing in cabbages', he, in turn, mocked their motives – 'in truth, perhaps they don't like cabbages because . . . it's not everyone who can make a good cabbage soup with salt pork'[4] – and complained to his artist son Lucien: 'What would the Gothic artists say,

184 Armand Guillaumin, *Garden behind Old Houses, Damiette* (detail), c. 1882
During the 1870s, Guillaumin belonged to the group of like-minded artists and thinkers centred round Pissarro at Pontoise, and including Piette [18], Cézanne, Edouard Béliard, and the homeopathic doctor and future friend of van Gogh, Dr Gachet. From around 1882, however, Guillaumin developed his interest in peasant motifs by painting at Damiette, near Orsay in the Yvette valley. This characteristically high-keyed work shows a garden there in spring.

who so loved cabbages and artichokes and knew how to make of them such natural and symbolic ornaments?'[5]

On one level, painting 'working gardens' is, of course, the natural corollary of the tendency noted by Zola in 1868, whereby Monet preferred 'an English park to a corner of a forest', and delighted in finding 'everywhere the mark of man'.[6] Zola praised Pissarro's *La Côte de Jallais*, for example, with its neatly kept kitchen gardens, for its sense that 'man has passed though, carving up the soil, marking it out, shadowing the horizons'.[7] By painting 'working gardens', the Impressionists arguably broke even more decisively with Romantic, wild nature. For 'working gardens' present the very processes through which nature is shaped or used by humankind, whether in terms of digging or harvesting, or of the labour of the washerwomen painted by Manet and Morisot, whose linen is dried by the garden air. In so doing, they come as close as any Impressionist motif to what Richard Brettell has defined as a key feature of modern art: the belief that 'the more ordinary the subject, the more the viewer can appreciate the "fresh seeing" of the artist'.[8]

'Fresh seeing' is a key theme in this chapter. It is as though the very banality of beds of leeks or lines of washing freed the artist to take stylistic and interpretative liberties. Already in the 1860s, for example, Pissarro collapsed conventional perspective in his views of village vegetable plots, where bold slabs of paint laid on with a palette knife almost tangibly integrate the rows of blue cabbages with the houses and hillside beyond. We will find, in fact, that the aesthetic and the horticultural were closely intertwined in Impressionist 'working gardens' − not only with each other, but also with social and political factors. It is worth remembering that it was an article on 'Working Paris', written by a journalist for labour matters − Zola's friend Paul Alexis − that effectively triggered the first Impressionist exhibition.[9] It was no coincidence that the newspaper in which this article appeared, *L'Avenir nationale*, was radical and Republican. Work, just like families and sociability, was a key Republican ideal; as Gambetta put it, 'The Republic is the workers' friend'.[10] In the event, the constitution of the Society of Independent Artists which mounted the first Impressionist exhibition in 1874 was drawn up by Pissarro on the model of a bakers' union at Pontoise, and Zola in turn called the Impressionists 'the true workers of the century'.[11] The Republican sympathies which broadly united the Impressionists as they came together in the 1870s form, in fact, a vital context for their 'working gardens',[12] for working of the land had longstanding Republican overtones. Agricultural workers − the main component of the Third Estate − had played a key role in the French Revolution of 1789, and the 'right to work', especially among rural communities, had been a central slogan of the short-lived Republic of 1848−51.[13] In turn, during the 1850s and 60s, the call by Edmond Duranty − later a champion of Impressionism − for artists to paint not just the bourgeoisie but also 'working man',[14] had been answered in Courbet's and Millet's scenes of peasants at work.

These scenes, however, like the academic pictures of heroic agricultural labour included in official mural schemes from the late 1870s for the new Hôtel de Ville and Mairies, were quintessentially epic. They emphasized the vastness of the fields and the vigour of the peasant. Pissarro's frequent focus on domestic gardens[15] − or Caillebotte's pictures of gardeners in the walled vegetable garden on his family's estate at Yerres − find origins in Millet's 'intimate' pictures of the late 1850s and early 1860s, inspired by his garden at Barbizon. *In the Garden*, for example, shows a mother seated on the ground mending clothes in the shade of a tree, as her toddler daughter keeps the hens from the vegetables. While this perhaps betrays a latent association with the Republican symbolism of *terre maternelle* and the 'tree of liberty' already considered in Chapter 5, it essentially makes us witness to a reinvented

Eden, where work is turned into pleasure. Proudhon, the left-wing thinker and associate of Courbet, certainly dreamt of how, if education were available to all, 'the worker' might enjoy both 'the freedom of Eden and the benefits of labour', and argued that '[the] earth must become, through cultivation, like an immense garden, and work, through its organization, a vast harmony'.[16] Just as Millet's watercolour includes notes of pure colour which closely prefigure Impressionist technique, so Proudhon's ideals provided crucial inspiration for Pissarro already from the 1860s. A painting of 1870 by Pissarro actually juxtaposes 'education' (a schoolboy with his satchel, chatting to a neighbour) with a Proudhonesque 'Eden' (rows of neat kitchen gardens at Louveciennes).[17]

Pissarro painted 'working gardens' more frequently and systematically than any other Impressionist. Though latterly informed by, for example, Kropotkin's Anarchist ideal of communities sustained by market gardening, Pissarro's vision of 'working gardens' was resolutely individual; a product of his key belief in the freedom afforded by fidelity to 'personal sensation'.[18] While Cézanne, who painted alongside him during the 1870s, was amazed at Pissarro's own capacity for work, describing his colleague's dedication as that of one 'possessed', Pissarro himself found making pictures a form of liberation: 'Work is a wonderful regulator of mind and body. I forget all sorrow, grief and bitterness and I even ignore them altogether in the joy of working'.[19] In this sense his 'working garden' images compare with Renoir's celebration of freedom within order ('irregularity' within 'regularity') in the gardens of Montmartre.

If the paradox of work as 'freedom', and the traditions of association between cultivation of the soil, revolution, and liberty help explain why an artist of radical political persuasion such as Pissarro painted 'working gardens', they also form the context for Mallarmé's choice of a 'working garden' picture as the starting point for his landmark 1876 analysis of the practices and principles of Impressionism. Before exploring Pissarro's 'working gardens' in more detail, it is thus worth examining the picture which prompted Mallarmé's comments – Manet's *Laundry* [187] – as well as some 'working garden' paintings from the same period by Morisot and Caillebotte. Marking a moment when the ambitions of 'the New Painting' coincided with the rise to triumph of the Republican party in the elections of 1876 and 1877,

185 Jean-François Millet, *In the Garden*, c. 1860
One of a group of domestic garden subjects by Millet, with strong overtones of Virgil's celebration of the virtues of rural life. The woman sews as her child scares the hens from the vegetables, while beehives – traditional emblems of productive labour – are picked out in the sunshine at the right.

these paintings stand at a fulcrum in Impressionism, but, as Mallarmé recognized, they also reached beyond politics to deeper, even philosophical, dimensions of 'fresh seeing'. These not only complement Pissarro's approach, but also connect with the exploration of the power of the visual we have found in Impressionist 'family gardens'. In turn, they look towards the theme of 'visions' and even 'dreams' which is inherent in the *paradis terrestre* of the 'artist's garden' – the subject of the next chapter.

'Working gardens' by Manet, Morisot and Caillebotte

Mallarmé called Manet's *Laundry* nothing less than 'a work which marks a date . . . in the history of art . . . a complete and final repertory of all current ideas and their means of execution'.[20] Painted in 1875 in the tiny garden at 58 rue de Rome in Paris of Manet's friend the artist Alphonse Hirsch, its motif is almost shockingly banal: a washerwoman squeezing out linen in a tub placed on a chair, who is watched by a toddler and surrounded by foliage and flowers. Geraniums, marigolds, and what appear to be asters and perhaps some red zinnias, as well as the flat spears of iris leaves, and other foliage, hide the feet of the woman and child, while taller leaves and blooms thrust against and between the washing on the lines behind. Closing off the composition, and framed by the foliage, the flat shapes of the drying washing push the woman, tub and child right up against the viewer. Where, in his *Railway* of around 1873, Manet had looked *outwards* from Hirsch's garden, to dirty engine smoke in the Saint-Lazare railway cutting below, he now created a sanctum of purity: clean washing, clean floral colours, and the unsullied innocence of the young child. The yellows, reds and pinks of the flowers, vibrating against the green leaves, are in fact intensified by contrast with the reflective whites, tinged with violet shadows, of the laundry hanging on the line. It is as though the self-contained garden acts as refracting prism in which white light, bouncing off the bright patches of the linen, breaks in the flowers into its constituent colours. The process is echoed in the work of the laundress, who, squeezing out the clothes in the sunshine, causes the water dripping from them to shimmer and sparkle. The irony of Manet's image, excluding as it does the adjacent grimy railway, was not lost on Mallarmé, who himself lived in the rue de Rome; he praised the painting's 'witchery of art' in which 'open air' enacted a 'perpetual metamorphosis' of the visible, and noted Manet's and the Impressionists' 'dexterity . . . of cutting the canvass [sic] off so as to produce an illusion'.[21]

The Salon took a different view, and *The Laundry* was rejected by its jury in 1876. The picture's *facture* − abbreviated brushstrokes, incomplete forms, and unmodulated colour − was described by critics as 'brutal'.[22] Undaunted, Manet put the picture on exhibition in his own studio along with his other rejected work of that year, a portrait of his friend the etcher Marcellin Desboutin, and some of his earlier pictures. Issuing invitations printed with the slogan 'Faire vrai et laisser dire' ('Paint truthfully and let people say what they like'),[23] he laid out sheets of paper for his visitors' comments; a highly suggestive gesture in the wake of the elections just a few months before, in which the Republicans had won a decisive majority in the Chambre des Députés. Though he refused to participate in the Impressionists' exhibitions, doggedly persisting in trying to reform the Salon 'from within', Manet's exhibition was in effect an overt enfranchisement of the public in relation to art; an invitation to realize the Republicans' ideal of free speech. His visitors seized it. One wrote 'Superb!' but signed himself 'Bismarck', implying that Manet had betrayed French art; another, referring to *The Laundry*, wrote 'Your picture demonstrates that dirty linen should always be washed in private'.[24]

This last quip, which was repeated by another visitor, was a play on a well-known saying of Napoleon I, and therefore a mischievous double-entendre. For it was critics and writers such as Castagnary, Zola, Silvestre and, of course, Mallarmé, who praised Manet's pictures: people who, like Manet himself, supported the Republican party in its efforts to shake off the legacy of Imperial rule that still lingered under the young 'Third Republic', and who, at the same time, opposed the Royalists' efforts to restore the monarchy. A closer look at *The Laundry* in relation to its 'partner' Salon reject, *The Artist*, suggests that Manet's 'exhibition' was, in fact, an invitation to the public to weigh the respective merits not just of two kinds of painting, but

186 Edouard Manet, *The Artist*, 1875 Exhibited by Manet in 1876 with his *Laundry* [187], this shows the etcher Marcellin Desboutin. The Velázquez-style contrasts of light and sombre shadow, perhaps intended to allude to Desboutin's own black and white medium, would have thrown *The Laundry*'s *plein-air* colour into telling prominence, just as the depiction of bohemian leisure (Desboutin is filling his pipe) points up the laundress's 'honest' manual work.

also of two kinds of politics. It is the iconography and composition of *The Laundry* that point to this significance.

Manet's *The Artist* is an indoor subject featuring dramatic chiaroscuro in the style of 17th-century Spanish art. Its colour is almost monochrome. *The Laundry*, in contrast, is emphatically *pleinairiste*, a virtuoso response to the brilliance of sunlight as concentrated in the colour of a garden. *The Artist* shows Manet's friend Desboutin – who, as an etcher, worked in a black and white medium – as a sombre, brooding presence, ruminating as he fills his pipe, and only partially illuminated by a shaft of light which picks out the white coat of his dog. Drinking from a glass set on the floor, the dog dirties the water in it. *The Laundry*, however, not only juxtaposes the outdoor light, air and colour of a garden with manual rather than mental 'work', but also correlates these with the shimmering, cleansing water which seizes the child's attention as it drips from the linen being washed. Mallarmé certainly

187 Edouard Manet, *The Laundry (The Laundress)*, 1875
'Air reigns supreme and real' wrote Mallarmé, a close friend of Manet, of this summer garden with its laundress and wide-eyed toddler – figures who remind us that Mallarmé called the Impressionists 'the energetic modern workers' of the new Republic, and defined their art as 'vision restored to its simplest perfection'.
The picture was later owned by Morisot, who hung it with one of Manet's Bellevue garden paintings in her salon-studio in Passy.

conflated light, air and water in describing the painting as 'deluged with air. Everywhere the luminous and transparent atmosphere struggles with the figures, the dresses and the foliage, and seems to take to itself some of their substance and solidity . . . their contours . . . tremble, melt and evaporate into the surrounding atmosphere . . .'.[25] In turn, at the top right corner of the composition, as if a surrogate for the very origin of light itself, is the head of a giant sunflower. This marks the point of convergence of the lines bearing the washing, the peak of the washerwoman's 'Niniche'-style country hat, and the lines implied by her extended right arm, the back of the chair, and the arms of the child.

On one level, Manet's *Laundry* was thus clearly a reinvention of the traditional topos of the Elements: as the sunflower leans to the 'fire' of the sun, so the child gazes at the stream of water dripping from the linen, air dries the clothes, and earth is implied by the blooming growth. Juxtaposed with the portrait of Desboutin, however, the sunflower which lends its benison to the 'work' of the laundress and, in its bold *facture*, bears witness also to that of the artist, would have had distinctive political overtones, at least within Manet's circle of acquaintance. For it was the emblem in the popular press of Gambetta, the politician ever faithful to Republicanism, which itself was traditionally symbolized by the sun.[26] Desboutin, in contrast, was well known as a 'fanatical Royalist', who supported the Comte de Chambord in the lively discussions at the Café des Nouvelles Athènes where Manet, Degas and other Impressionists met during the 1870s.[27] It is hardly surprising if Desboutin's dog, as white as Chambord's contentious Royalist flag, sullies clean water by drinking from a glass. By 1876, when Manet unsuccessfully submitted *The Artist* and *The Laundry* to the Salon, Chambord's cause was increasingly vain; the washerwoman (painted from a model called Alice Legouvé) and the child (the concièrge's son) in contrast evoked the 'world of workers' to whom Gambetta proclaimed 'the future belongs'.[28] It was only logical that Manet should juxtapose the washerwoman and child, set amid the modern, *pleinairiste* sunlight of a reinvented Eden or *hortus conclusus*, with a portrait of Desboutin in a studio filled with Velázquez-style shadows.[29] This was a natural sequel to his own and Renoir's 'tricolour' portraits in Monet's garden in 1874, at the height of the Chambord threat.

A political interpretation of *The Laundry* must, for the moment at least, remain hypothetical. However, it would be entirely consistent both with Manet's well-known wit, and with the fact that he was a close friend of Gambetta – whom he had in 1871 called 'the only capable man we have'.[30] Mallarmé, himself a close friend of Manet, certainly ignored the portrait of Desboutin in his 1876 article, and instead used *The Laundry* as his key example in defining Impressionism as 'radical and democratic', and the Impressionists as 'energetic modern workers', whose art prefigured 'the participation of a hitherto ignored people in the political life of France'.[31]

If the sheer boldness of Manet's style forced his contemporaries into 'fresh seeing', as if themselves the child whose attention is captured by the water dripping from the laundress's washing, the motif of water shimmering in the sunlight is in itself worth a closer look. For, as we have seen, while the garden in Manet's picture frames a prismatic range of colour – red, yellow and blue, green foliage, violet shadows and orangey-pink – it is water specifically which acts as a prism when light shines through it. If something of this effect had already been captured in Delacroix's famous depiction of the water droplets on the figures in his *Barque of Dante* – a picture admired and copied by Manet in his youth – it was, in 1876, the power of a prism not only to refract but also to recombine the constituent colours of light which was being presented to the French Academy of Sciences by Manet's close friend Charles Cros in 'solution' to 'the problem of colour photography'.[32] Cros was a scientist, poet

188 Alfred Le Petit, *The Sun*, caricature of Gambetta from the series 'Flowers, Fruits and Vegetables of the Day', from *L'Eclipse*, 1871
The politician Gambetta, visionary of a Republic which he claimed would be 'the workers' friend', strides across the countryside, his face portrayed as a sunflower – a flower which turns to the sun, the traditional Republican emblem (compare 151). Since he wears stilts, traditionally used in marshy areas of rural France, he even towers above the sun – which therefore looks askance.

and Gambettist; colour reproduction a 'holy grail' of 19th-century photography. Just as Manet made a number of his paintings available as subjects for Cros's first colour photographs, he himself in fact made an intriguing 'painted photograph' when he coloured in a black and white photograph of his *Railway*. But within this context of evolving dialogue between science and art, the colours of the prism, 'sun'-like sunflower, 'ray'-like linear axes, and suggestive convergence of the sightlines of the woman and child in the drips of refractive water in *The Laundry* suggest that this picture in particular was, at least in part, a creative response to, and perhaps even an intended subject for, Cros's innovative photographic experiments.

Yet Manet, of course, maintained that 'imagination' was ultimately more important than 'science'.[33] In this sense, the toddler filled with wonder at the work of laundry in the garden is the artist's surrogate. And where Cros sought to extend the visual powers of the 'mechanical eye' – the camera – it was 'vision restored to its simplest perfection', as Mallarmé called the human sight of the Impressionists in his 1876 essay, that Manet sought.[34] As in his *Boy in Flowers* at Montgeron, painted just a few months after *The Laundry*, it is the garden, as a place of concentrated sensory appeal, which serves to point up the mysterious, primal vision described by Mallarmé, implying that painting itself, born of that vision, is ultimately more 'progressive' than mere 'photographic' reproductions.

While Cros and colleagues such as Edmond Becquerel were pushing forward the frontiers of photography in the 1870s, horticulture too was being reshaped by science, as Flaubert's notes for a projected novel, *Bouvard et Pécuchet* (Bouvard and Pécuchet), satirically remind us. Trying to master the latest horticultural techniques, Flaubert's two retired clerks meet only with disaster when, for example, they spread special kinds of fortified dung on their 'factory for produce' (i.e. garden).[35] Using waste products for fertilizer was only too topical in the 1870s and early 1880s. The City of Paris had begun a controversial scheme for irrigation of the plain of Gennevilliers, across the river from Argenteuil, with processed sewage. Even Cros had published a poem in 1876 which mocked '. . . the peninsula/Of Gennevilliers, where asparagus grows tranquilly under the stinking irrigation from the sewers'.[36] What, in such a context, were viewers meant to make of Morisot's *Laundresses Hanging out the Wash* [189], which shows this very area, with some of the market gardening and attendant commercial laundry work that were fast becoming established there as the irrigation scheme advanced? At the left, a few deft strokes define a gardener, his barrow, and a haze of spring shoots; at the centre are regularly pegged rows of washing, while, to the right, a tiny spot of red denotes a flower amid the dense green growth of a fenced-off private garden behind a house. Touches of pink and blue indicate the laundresses themselves. If, as Tucker has argued,[37] Monet's paintings of his garden at Argenteuil represent a refuge from the encroaching pollution, then Morisot's gardens, with their fluttering white washing, seem as much an emblem of purity as that in Manet's *Laundry*. The very sketchiness of her brushstrokes almost literally evokes the drying wind which completes the washerwomen's work; this is not the heavy laundry in sacks which had burdened Daumier's urban washerwomen, nor that which Degas's laundresses iron wearily in hot interiors. Rather, it complements the productive, healthful interaction of the gardener and soil at the left.

Morisot's image of invigorating freshness was, however, surely more than mere idealism. On one level it certainly reinvented the pastoral idyll tradition exemplified by a work such as Valenciennes's *Ideal Classical Landscape with Washerwomen around a Fountain* (c. 1807).[38] But the breezy brushwork which produces its Mallarméan 'witchery' of reality into art is underpinned by a compositional rigour that in turn calls attention to the artist's organizing,

189 Berthe Morisot, *Laundresses Hanging out the Wash*, 1875
The breeze is almost palpable in this freely brushed image, where small-scale market gardening and the commercial laundry work often undertaken with it are shown on the plain of Gennevilliers. Morisot gives no hint of the contentious irrigation scheme, using sewage from the Seine, which was already enhancing the plain's yield of produce, and which by 1878 would win the endorsement of the French Horticultural Society itself.

synthesizing eye. Horizontal zones – the line of foreground railings, strips of green vegetables against brown earth, row of trees and belt of clouds – create a counterpoint to the diagonals of the washing lines. In turn, the vertical forms of the railings and washing poles mark the image into sub-dividing parts, of which the plot at the left with the gardener is the largest. Balancing the mass of the house, this leads the eye to the open fields beyond; there is almost a zoom-lens effect, so that the zone of 'working gardens' in the foreground seems suddenly fragile, even vulnerable. Defined by its railing and poles, yet (unlike the private garden at the right) still open to the plain, it is ultimately subject to the wind and the atmosphere, a threshold to the spacious fields and sky. Morisot probes the very point of equilibrium where nature is *employée*, but yet remains free. Does she accept or reject her modern age? The very interplay of openness and closure in her image surely goes beyond the particularity of time, to invite an almost philosophical response, as do Mondrian's zones of ordered colour. Forced to complete in imagination the painting's sketchy forms, we ourselves are drawn into its creation; the free movement of air as signalled by the flapping laundry in turn becomes a virtual emblem both for artistic and for visual freedom. And it is the matrix of the garden, enclosing the laundry, yet open to the air, which again brings that freedom to focus.

Gothic and yet is modern and Impressionist'.[85] The old-fashioned kitchen garden had truly become the crucible for a new, distinctively decorative – yet richly symbolic – form of Impressionist art.

Just a week before the opening of the 1886 exhibition, one of the series of so-called 'Impressionist dinners' took place, attended by sympathetic writers as well as the artists themselves. The occasion in May 1886 was, according to Pissarro, 'a proper banquet', and he took the chance at it to talk at length with the writer Joris Karl Huysmans.[86] In relation to *Apple-Picking*, this is most suggestive. For in 1884, Huysmans had not only published his influential 'Symbolist' novel *A Rebours* (Against the Grain), which explored the interaction of mind and *milieu*, but also a collection of his recent reviews of Impressionism, much admired by Pissarro. Here, Huysmans had described the Impressionists' discovery that 'in a garden, for example, in summer, in the light filtering through green leaves, the human face turns violet', and he had rejoiced that the artists seemed at last to be shaking off their 'monomania' for blue and violet which made them like the neurotics in Dr Charcot's care, who could only see green as blue.[87] While *Apple-Picking* features a 'violet shadow', it is, in fact, the colour green – not the blue so bemoaned by Huysmans – which, reflected from the garden, shades the chin of the standing girl, while the other faces are noticeably ruddy in the warm low sunlight. It is also revealing that the woman eating the apple has her eyes closed.[88] Paris was full of debate in the early 1880s about Charcot's therapeutic use of hypnotism; the critic Philippe Burty, for example, one of those at the Impressionist dinner of May 1886, attended the public demonstrations of his method. The Irish painter and writer George Moore, another of the guests at the May 1886 Impressionist 'banquet', certainly described *Apple-Picking* some years later as a depiction of 'the garden that life has not for giving, but which the painter has set in an eternal dream of violet and grey'.[89] Despite his antagonism to the Symbolists' ideals, Pissarro was perhaps in fact not so far from them himself, and in a letter of 1882, he referred to contemporary debate about psychological suggestibility.[90] Is the girl

201 Camille Pissarro, *View from my Window, Eragny*, 1888
Pissarro moved to Eragny-sur-Epte in 1884. In this carefully ordered composition, painted in the Pointilliste technique he adopted at this period under Seurat's influence, the poultry-yard and garden lead smoothly into the larger landscape of the Bazincourt meadows, continuing Pissarro's interest in synthesis and connection.

eating the apple with her eyes closed in a state of trance, with her apple – that token of all-important 'sensation' – its agent, and the garden a projection of her dreams? In a few years Charcot and his colleagues would describe the 'visual hallucinations' experienced by female patients as 'paintings', often involving a 'happy' phase, in which 'the patient believes herself to be transported to a magnificent garden, a kind of Eden, where flowers are often red and inhabitants are dressed in red . . .'.[91] While the 'red flowers' in Pissarro's picture are those of bean plants, his garden is, from this point of view, a direct precursor to the red-coloured imagined space portrayed two years later in his pupil Gauguin's *Vision after the Sermon*, as well as to the symbolic apple-picker and eater in Gauguin's great summative painting of 1897 of the exotic 'garden' of Tahiti, *Whence Do We Come? What are We? Where are We Going?*[92]

A market garden scene, inspired by Pissarro's art, had actually been one of the very first works which Gauguin showed at an Impressionist exhibition, in 1880.[93] In 1886, in *Apple-Picking*, it is as though the 'liminal' nature of the vegetable garden or orchard, as a zone linking open fields or country with habitations or a town, now found its ultimate artistic counterpart, as a realm of potential and dream. At the same time, the kitchen garden of *Apple-Picking* is a telling inversion of that in Huysmans's novel *A Rebours* which rouses the neurotic 'hero' des Esseintes from a state of hysterical trance brought on by seclusion indoors.[94] Was Pissarro teasing the Symbolists – substituting a dream garden for Huysmans's real one, and a healthful trance for des Esseintes's sick one? Within a few years, he would abandon Neo-Impressionism for more naturalistic brushwork and compositions. Yet the matrix of the kitchen garden as a paradise on earth is still undeniably implicit in many of his later landscapes. Not only is the 'garden' activity of apple-picking transposed into the field setting of his Pointillist *Apple-Picking at Eragny* of 1887, but, as we have seen, the water meadows of Bazincourt appear as a direct extension of the kitchen garden and orchard of Pissarro's home at Eragny in his views from his window of the late 1880s and 1890s. Such images perpetuate the Proudhonesque vision of France itself as a garden. The Bazincourt series essentially finds its origin in the highly decorative, Pointilliste *View from my Window, Eragny* of 1886–7 [201], where the effect of the red roof of Pissarro's newly laid out poultry-

202 Armand Guillaumin, *Garden behind old Houses, Damiette, c.* 1882
See 184 for detail.

203 Camille Pissarro, *Woman washing Dishes, c.* 1882
One of a group of pictures of figures engaged in a variety of activities in gardens which Pissarro painted in the 1880s and 90s. It reflects his sympathy with the Anarchist vision of harmony between humankind and nature.

yard and vegetable plot against the green fields beyond takes up the complementary colour axis of *Apple-Picking*. Meanwhile, in his depictions of peasant gardens at Pontoise and Eragny, Pissarro developed his interest in figures at work – washing dishes, teaching a baby to walk, fetching water in cans – in ways which look back to Millet's garden scenes, but which also form part of a continuing fascination with 'synthesis'. For these late 'working gardens' are complemented in Pissarro's oeuvre by his series of 'leisure' gardens (Kew in London, the Tuileries in Paris, or Mirbeau's flower garden near Rouen) and of urban scenes (the streets of Paris, the market at Gisors, the docksides at Rouen). It is in this larger pattern of aesthetic and thematic complementarity that we surely find a logical sequel to the theme of 'harmony' which Pissarro had first explored in the humble imagery of the *jardin potager*.

During the 1880s, 'working gardens' were painted not only by Gauguin, but also by Guillaumin, an ardent Republican who had been part of the group around Pissarro and Béliard at Pontoise in the 1870s. Visiting the village of Damiette near Paris during the 1880s, he portrayed its orchards and *jardins potagers* in vivid colours and loose brushwork. Charles Angrand, whom Pissarro got to know in Seurat's circle, meanwhile painted his father, a former schoolteacher in Rouen, digging his garden in retirement in a painting of 1885 called *In the Gardener's Garden at Criquetot-sur-Ouville*. The complex 'synthetic' textures of the *jardin potager* here prefigure the effects Angrand would shortly achieve by means of Pointillist technique.[95] Whether in terms of Manet's, Morisot's or Caillebotte's 'Republican' images, or the more radical Anarchist overtones of those created by Pissarro and the Neo-Impressionists, it is clear that the Impressionist 'working garden' involved a potent and often multilayered interaction of art, horticulture and politics, in which a place of labour might become a modern paradise, and 'work' itself engender the creative 'freedom' of 'fresh seeing' on the part both of artist and of viewer. In turning to the theme of the 'artist's garden' in the next chapter, we will meet what is arguably the ultimate logic of the quest for personal 'sensation' on which such 'fresh seeing' was founded.

204 Charles Angrand, *In the Gardener's Garden at Criquetot-sur-Ouville*, 1885 Painted by a Rouen colleague of Pissarro, this shows Angrand's father at work in his garden. The interest in rich pictorial texture – juxtaposing logs stacked at the left, rough soil, near and distant foliage, and the house in the background – makes Angrand's subsequent adoption of Pointillisme quite logical.

Chapter 8 Monet in the south and at Giverny

Even as Pissarro was completing *Apple-Picking*, Monet was turning just such a garden – a place for growing fruit and vegetables – into a realm of floral *richesse*. For one of his very first acts on moving to the comfortable, thick-walled property at Giverny where he set up joint *ménage* with Alice Hoschedé in 1883 was to carpet with colour the *clos normand* (Normandy orchard) which formed a part of its policies, by planting flowers beneath its trees.[1] As time went by, he replaced its apples and pears with blossoming apricot and cherry trees, filling the air yet more abundantly with colour. And though he planted other flowers in rows of small square plots, set out in grid formation – 'just as in the market gardens of Grenelle or Gennevilliers', as the critic Arsène Alexandre put it in 1901[2] – and made an ornamental pool from a pond for watering cattle, the effect was still far from the ordinary, as will be confirmed by anyone who has visited either the restored Giverny demesne, or its recent recreation at Kochee in Japan.[3] Alexandre wrote of 'a palette of flowers', and noted that 'wherever you turn, at your feet, above your head, at the level of your chest, are lakes, garlands, and hedges of flowers'; Georges Clemenceau – himself a keen gardener, and Monet's dedicated supporter in the dark days after Alice's death and of the First World War – saw the water garden as quasi-elemental: a 'Garden of water and fire'. Monet himself was content to call his garden 'my most beautiful work of art'.[4] Dahlias, chrysanthemums, helichrysums and sunflowers, along with clematis, roses trained on iron supports, and the nasturtiums that trailed across the central *allée*, were just a few of the plants which, along with the blossom trees and 'every known kind of waterlily',[5] were skilfully juxtaposed or intermingled to produce the living, glowing colour which so impressed Alexandre and Clemenceau. Surrounded by rhododendrons, roses and tree peonies, and fringed with irises, agapanthus and weeping willows, the pond made the sky as one, through reflections, with the colours of the waterlilies and adjacent vegetation; it became Monet's near sole motif for the last twenty-five years of his life.

The garden at Giverny is the apotheosis of the 'gardens of Impressionism', and the most ambitious and influential example of the symbiosis of art and horticulture in the Impressionist movement. There were, of course, many Impressionists in the late 19th and early 20th

205 Claude Monet, *Under the Lemon Trees*, 1884
'While painting, I thought of you', Monet wrote to Alice Hoschedé, whom he was later to marry, as he created this picture in the famous Moreno Garden at Bordighera on the Italian Riviera. 'I have given myself up to the lemon trees in a delicious place . . . [imagine] something like a Normandy farmyard, with, instead of apple trees, orange and lemon trees, and, instead of grass, Parma violets; the ground is absolutely blue'.

206 Claude Monet in the Flower Garden at Giverny, *c.* 1920 in *L'Illustration*, 1927
Monet contemplates what the critic Alexandre called the 'lakes, garlands and hedges of flowers' in his garden at Giverny, which he began to cultivate soon after his move to the village in 1883. Roses are trained on metal supports amid beds of pelargoniums, and grow on the walls of the house.

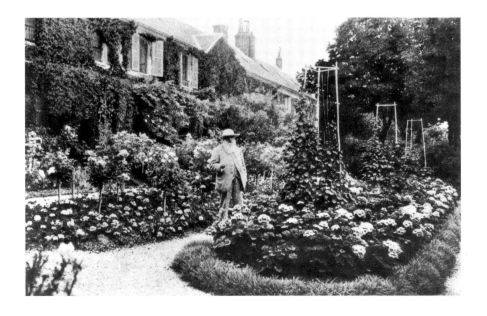

207 Gustave Caillebotte, *Dahlias, the Garden at Petit Gennevilliers*, c. 1886

208 Martial Caillebotte, photograph of the garden, greenhouse and house of Gustave Caillebotte at Petit Gennevilliers, late 19th century

Caillebotte and Monet visited each others' gardens, and also shared their interest in horticulture with their mutual friend the writer Mirbeau [209]. Though Caillebotte organized his garden far more strictly than did Monet his, reserving individual beds for different species [208], his paintings made richly decorative effects with their colours and forms. *Dahlias* contrasts the flowers' forms with the disciplined geometry, bleached in the strong summer light, of the house and greenhouse, and with the distant figure of Charlotte Berthier, Caillebotte's mistress.

centuries who grew the motifs which they painted. Renoir used the semi-wild rose and olive-planted grounds of Les Collettes [210], his home at Cagnes on the Riviera, as the setting for his late mythological paintings, while 'new generation' Impressionists such as Bonnard, Le Sidaner and Henri Martin likewise made their gardens both studio and subject. The latter, however, were at least in part responding to Monet's lead, and will be considered later, while at Les Collettes we find nature not so much made 'work of art' as simply left, as Renoir's friend Rivière put it, to 'keep in large measure her liberty'. Rivière described a 'multitude of plants, scattered all about'; more waspishly, the dealer Gimpel called the grounds at Les Collettes 'a poverty-stricken farmyard'.[6]

So, too, though Caillebotte developed his garden at Petit Gennevilliers around the same time as Monet began in earnest to shape his at Giverny, his premature death in 1894 prevented him from realizing its full potential as a motif; unlike Monet, he never exhibited his relatively small number of pictures of it. With its arrangement of flowers in beds devoted each to specific types or species − in contrast to Monet's intermingled plantings − Caillebotte's garden must, in fact, have been more akin to a botanical garden than a 'work of art'.[7] The silky-petalled bloom which Caillebotte's mistress Charlotte Berthier plucks from a bed of standard roses in one of his Petit Gennevilliers paintings [211] was perhaps a locally developed hybrid (the Paris region was known for its rose nurseries[8]); a flower as showily contemporary as her fashionable lap-dog and modish sailor dress. As in Renoir's case, though in a very different way, the 'work of art' here lay more in Caillebotte's interpretation of his motif, than in the garden as such. Caillebotte's enthusiasm for horticulture was, however, an inspiration to Monet, and he introduced him to horticulturalists such as Godefroy-Lebeuf, editor of *Le Jardin*, and visited horticultural exhibitions with him; they also swapped plants and expertise.

If Monet's Giverny garden was repeatedly termed a 'terrestrial paradise' by his friends and critics, it was the Italian-French Riviera for which he himself reserved this epithet.[9] Visiting this area for the first time in winter 1883–4 just as he was starting to shape his Giverny demesne, he found gardens filled with citrus trees, palms and flowers, and a 'magical light' which made everything 'pigeon's breast' and 'punch-flame'.[10] The deep impression which this profusion and glowing colour made on him is richly suggestive for his subsequent 'Garden of water and fire', and there are important links between Monet's ecstatic response to the Riviera and his achievements as gardener and painter at Giverny.[11] By looking at his garden in relation also to aspects of a wider range of stimuli – historical, literary and philosophical as well as artistic and horticultural – we can perhaps begin to understand why it became inspirational for so many later painters.

Designed, ordered and portrayed by Monet over nearly forty years, the gardens at Giverny were clearly in part an escape from urban life and modern industry; something between the 'art for art's sake' of Whistler, and the quest for a better world which led William Morris to grow gardens in Britain, Victor Horta to create his 'Bloemenwerf' home at Uccle in Belgium, or designers such as Charles Rennie Mackintosh and Hector Guimard to deploy organic motifs. It would be too limiting, however, to regard it simply as a 'sanctuary' – a concept which, following accounts in Monet's own lifetime, has been prominent in previous literature.[12] While Monet's 'most beautiful work of art' was undoubtedly on one level the logical sequel to the *hortus conclusus* of the garden at Ville d'Avray where he had painted Camille in 1867, or the private enclosures at Argenteuil and Vétheuil where he had shown his family at leisure,[13] the Giverny garden's diversity of plants makes it clear that it was also a form of 'collecting'. Yet although the Impressionists' literary colleague Edmond de Goncourt

209 Camille Pissarro, *The Terrace of Mirbeau's Garden, Les Damps (Eure),* c. 1892
Mirbeau was an eloquent supporter of Monet and Pissarro from the 1880s, though a misunderstanding later soured Pissarro's relationship with the writer. Pissarro painted a group of pictures of Mirbeau's garden at Les Damps, near Rouen, in 1892, finding that, with its lavish flower displays, it reminded him of his early years in the Virgin Islands. In keeping with Anarchist philosophy, espoused by both Mirbeau and Pissarro, the eye is led into the landscape beyond, as if this too were a garden.

210 Pierre-Auguste Renoir, *The Farm at Les Collettes, c.* 1915
Rivière recorded that Renoir bought Les Collettes near Cagnes because of 'the thousand-year-old olive trees which filled the policies, and which were in grave danger of being cut down to make way for flower growing' – commercial cut flower production. The painter refused palm trees or a *jardin anglais*, preferring the native olives and orange trees for his garden, as shown here.

had linked 'retreating' and 'collecting' as symbols of a modern quest for solitude in troubled times,[14] Giverny was surely something more than this. For Geffroy, after all, not only called Caillebotte the Impressionists' 'wise *amateur* of gardens' – using a word commonly applied to a collector of pictures or *objets* – but also termed his garden 'this vegetable world in miniature, labelled, cossetted, adored' by the painter, thereby emphasizing its emotional appeal.[15] And if Monet hated to see dead flowers at Giverny, and got his gardeners to remove them, the *dénouement* of his fusion of art and horticulture was, of course, his ensemble of *Grandes Décorations* at the Orangerie, given to the nation in the aftermath of the carnage of the First World War. Far from shutting the gate on the world beyond his garden, these images of his lilies in their pond implicitly placed faith in nature's regenerative lifeforce. Walter Benjamin concluded in 1930 that 'collecting' was actually a form of 'rebirth',[16] but Monet had already anticipated this.

In his Orangerie murals [231], Monet gave new life to the association of 'Impressionist gardens' and decoration – a recurrent theme in this book. In reflecting on Monet's creation and depiction of his garden at Giverny, we can, in turn, begin to see his 'most beautiful work of art' as a way of being or life-philosophy. It is telling, for example, that he chose to replace some of the wall which separated his new garden from the road with an openwork fence, over which he trained nasturtiums; a living membrane, through which passers-by could see his garden, and he could see the landscape.[17] And as his paintings of the lily pond developed from conventional views, framed by banks and bridge, into worlds without bounds where reflections of the sky are punctuated by star-like waterlilies, he made his garden quite literally burst forth from its boundaries. It is as though the *jardin naturel* he had portrayed in

he 'gave himself up' to Moreno's violet-studded lemon-grove, he was actually by this point also sending her regular gifts of Riviera flowers, sometimes almost daily, in a desperate attempt to salvage their relationship. For by March 1883, Alice's patience was near to breaking; his visit had significantly overrun the intended month; it looked as though she might leave him. Monet sent regrets – 'How happy we would be together here, and what a pretty garden we would make here' – and 'pink and red striped anemones' for her birthday.[38] Anemones traditionally allude to the absence of a loved one.[39] And his sentiments and gift pick up the great refrain of Romantic longing for the south – 'Do you know the country where the lemon-trees flower . . . That is where . . . I would like to go with you, O my beloved!'[40] In the 19th-century language of flowers, his very subject of the lemon trees in fact meant 'longing to be in touch'.[41] Unable to share the Moreno Garden itself with Alice, he sent her and the children 'manradines' (as he jokingly termed mandarins) from it, kindly provided by its owner.[42] And his efforts were rewarded. 'Thank you for your kind thoughts, and your violet which has brought me a little of yourself' he was able to write to Alice on 16 March. In return, he sent her 'wild flowers picked for you at Andore',[43] and gave M. Moreno 'a marvellous apple, a phenomenon of size and colour' he had been sent from Paris by his friend de Bellio.[44]

By late March, Monet was longing for 'these days of first spring' at Giverny.[45] In the event he returned, via Menton, in late April. His impassioned dispatch of fruit and floral gifts to Giverny, like his efforts to capture Bordighera's 'terrestrial paradise' in paint for Alice had, however, not only continued the association of flowers and plants with thoughts and feelings we have found in so many earlier 'gardens of Impressionism', but also re-enacted the plucking and offering of flowers of his very first garden painting, *Women in the Garden*. In this giving of flowers and fruit, and bringing of the south to the north through the plantings at Giverny, we find a purposeful dynamic which intriguingly parallels the prominence in Mallarmé's poetry of metaphors of *le don* ('giving' or 'gift'). These often involve flowers and Eden-like gardens.[46] Monet was in close touch with Mallarmé from the 1880s, and the poet's 'joyous response to the beauty of the Mediterranean coastline' may have spurred Monet's own visit to Bordighera.[47]

Monet's dedication to the depiction of his waterlily garden after Alice's death in 1911 has often been likened to Mallarmé's finding of presence within absence in his prose-poem *Le Nénuphar blanc* (The White Waterlily),[48] which describes his plucking of a white waterlily – an emblem of the absent woman of whom he dreams. At the same time, it is worth remembering that Monet's waterlilies were not the common wild *nénuphars* described by Mallarmé, but the cultivated *nymphéas* (*nymphaea*) which had been introduced by the grower Joseph Bory Latour-Marliac, or created by him through hybridization of hardy American with African and other exotic varieties.[49] In other words, they were part of Monet's dynamic of giving – his bringing of 'southern' light and colour to the shadows of the north. But while we might draw parallels with van Gogh's famous attempt to synthesize 'north' and 'south' in his paintings of 'Dutch' motifs at Arles from 1888,[50] there is an essential difference between van Gogh's correlation of the sunshine of Provence also with a 'Japanese' purity of line, and the sheer profusion of growth in Monet's garden. Rather than the elemental juxtapositions of water and rocks shown in the painting made by Monet's American pupil Lilla Cabot Perry of a real Japanese garden, it was the traditional concept of Paradise as a gathering together of many flowers which Monet surely reinvented at Giverny.[51] The multiple touches of colour-istic Impressionist brushwork with which he would in due course represent his garden of course simply reinforce this lineage.

215 Lilla Cabot Perry, *Japanese Garden (Japan)*, c. 1900
Where Perry, one of the American artists who came to Giverny in the late 19th century, recorded a real Japanese garden, on a visit to Japan, it was the decorative compositional strategies of Japanese print and screen makers which Monet imaginatively reinterpreted in his images of his flower and water gardens at Giverny.

The concept of 'Paradise' had originally guided the creation of botanical gardens – collections of many species – but was still very much alive in late 19th-century France. Bruno's immensely popular elementary schoolbook *Le Tour de la France par deux enfants*, for example, first published in 1877, noted that 'The most beautiful garden is the one which contains the most beautiful and the most numerous species of flowers'. Bruno indeed called France itself 'a garden. Its provinces are like flowers of every kind.'[52] Although the Giverny garden included numerous Oriental species, from peonies obtained from the Mikado to Japanese anemones and chrysanthemums and wisteria, its fusion of the south with a corner of northern France becomes in this sense part of the wider preoccupation with French motifs which has been identified in Monet's *Rouen Cathedral* and other series paintings,[53] and which reached its final logic in his gift of the Orangerie murals to the State. He tellingly denied that he had intended his waterlily pond to look 'Japanese',[54] and consistently used the word *bassin* for it – a term which evokes the great formal tradition of water-gardens such as that at Versailles.[55] Though constructed shortly after he had visited an exhibition of Japanese prints in Paris, Monet's pond was in fact positioned as the climax of the formal tree-lined *allée* [228] which led from his house through the flower garden. The 'Japanese' bridge he built over the pond continued this *allée*'s axis. The pond itself was originally much smaller than it is today, and it was only in 1910, following the terrible floods that year which swamped it and other parts of his garden, that Monet gave it the irregular, curving edge which makes it appear more 'Oriental' than 'formal'. So too, while the cascades of purple and scented white wisteria with which Monet eventually adorned his bridge in one sense bring to mind the curtain of flowers in Hiroshige's famous image of a drum-bridge and wisteria,[56] they ultimately speak more of the generosity of *le don* than of the lean, spare, idiom of Japanese prints – not least because wisteria stands for 'friendship' in the language of flowers.[57] Monet indeed often used the bridge as the setting or backdrop for photographs of himself with guests, framed by its wisteria. As we will see, it is in his late paintings of his water-garden that we perhaps find his real dialogue with Japanese art, as these move from traditional perspective to evocations of space via surface. Yet even in his Orangerie *Décorations*, whose conception owes much to Japanese screens,[58] there persists a palpable sense of *le don* in the encrusted, layered paint surfaces, and the open, generous rhythms of the almost calligraphic brushwork.

But this is to look ahead. Already at Bordighera in March 1884 Monet concluded a letter to Alice and the children at Giverny with the comment '. . . what a lot of gardening I will have to do!'[59] Though he told Durand-Ruel in May 1885 that he was busy gardening 'in order to prepare some fine motifs of flowers for the summer, whenever it comes',[60] and painted his peonies under their protective straw awnings in 1887, it was to be the late 1890s before he painted his garden in earnest. 'You need to live in a country for a certain time in order to paint it' he had, after all, written from Bordighera.[61] It was perhaps this recognition which, after the challenge of painting stormy Breton seas – while Alice faithfully marked out with bits of wool the best-coloured chrysanthemums at Giverny[62] – led Monet back to the south in 1888, and only after this into the burst of concentrated horticultural activity that would culminate in his Giverny garden paintings proper.

On his 1888 visit, Monet stayed at Antibes. For one of his first 'series' there, he positioned his easel to look over the sea from the La Salis market gardens; he was therefore just beneath the magnificent botanical gardens of the Villa Thuret. These included special collections of the plants of the region, as well as hundreds of rare species and a wood of parasol pines.[63] It was surely these gardens to which Monet referred when he described to Alice a visit to 'a

marvellous property where the most beautiful plants of the region are grown and exploited. What flowers we brought back! It was splendid: branches of mimosa bigger than I am! If only you had been [there] to enjoy it all!'[64] Soon after this, he wrote of the arrival of 'M. Vilmorin who has a pleasure boat' – a reference presumably to Henri Vilmorin of the famous dynasty of horticulturalists, who knew the garden well.[65] Since it was the *jardin potager* section of the Villa Thuret gardens which most directly adjoined Monet's Salis painting site, he surely saw the notable collection of bulbs – ranging from twenty-five types of narcissi through to gladioli – which grew there under fruit trees.[66] Growing narcissi in an orchard is, of course, precisely what he did at Giverny. If the 'terrible' cold which Monet described as decimating 'all these fine flowers, the orange trees, everything' barely a fortnight into his stay at Antibes explains why did not paint the Villa Thuret gardens, his apparent encounter with them surely found its sequel at Giverny.[67] They included, for example, a special collection of bamboos; plants which he would cultivate around his pond. They also boasted collections of irises and roses – further future glories of Giverny – which Monet could have seen in bloom before his departure from Antibes in May 1888.[68] And it was certainly the quest for variety and rarity, so luxuriantly exemplified at the Villa Thuret, which now combined with the dynamic of *le don* as Monet took his own garden in hand from around 1890.

'A fury of horticulture'

Already some months before Monet found he had the means to purchase (instead of rent) the property at Giverny in 1890, he was, according to Mirbeau, 'in a fury of horticulture'.[69] By March 1891 he was telling Geffroy he was 'deep in workmen right up to the neck, in plantations and removals of all sorts'.[70] And Mirbeau – who became Monet's 'favourite critic' – published an article that same month on his friend which tellingly dealt first with the garden, and only secondly with Monet's paintings. Listing some thirty different flowers, Mirbeau described a 'perpetual feast for the eyes', from wallflower and hyacinths in spring through to 'omnicoloured nasturtiums', 'saffron-hued eschscholtzias', and irises whose 'complicated undersides' evoked 'mysterious analogies, tempting and perverted dreams'. These were followed by hollyhocks, 'Texas sunflowers', 'the enchantment of poppies', and, by late summer, dahlias, asters, 'antirrhinums with the sheen of striped velvet', Japanese anemones, phlox, and gladioli. Mirbeau presented this profusion as contiguous with the landscape at Giverny, and called Monet's painting itself a form of 'growth'.[71]

Mirbeau's article ended with a poetic image of Monet 'in his shirt sleeves, his hands black with earth, his face haloed with the sun, happy to be sowing seeds, in his garden constantly dazzling with flowers, against the cheerful and discreet backdrop of his little pink mortar-plastered house'.[72] But by 1892, Monet had no less than seven gardeners, and was also building greenhouses. And by spring and summer 1893, having purchased land beyond the railway and road at the end of his garden, he was in tortuous negotiation with the Prefect of the Eure for permission to route water from a tributary of the Epte to create his waterlily pond there – 'for the pleasure of the eye and also for motifs to paint', as he put it.[73] Though at one point almost giving up – 'I don't want any more to do with it, what with . . . all these Giverny people, and then the engineers and diggers . . . Nothing must be rented, no sluices bought and the aquatic plants should be thrown in the water; they'll grow there anyway', he had written to Alice from Rouen, where he was working on his Cathedral series – he persevered.[74] Throwing individual budded stems into the water, each with a small stone attached, was, in fact, exactly the recommended means to plant waterlilies.[75] In Rouen, meanwhile, Monet made friends with the Director of its Jardin des Plantes – 'He told me to

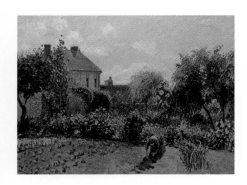

go around as if I was at home', he reported delightedly to Alice – and from him obtained plants for both his garden and 'the young botanists'. His son Michel and Alice's son Jean-Pierre had begun to compile a local *Flora*.[76]

We can interpret all this horticultural activity as a 'fury' of Goncourt-style collecting – it was 'a collection' of forest orchids and 'a collection of chrysanthemums', for example, which Mirbeau offered Monet in 1890, just as he sent special sunflowers to Pissarro[77] – presumably the stock from which the flowers surrounding the vegetable plot in Pissarro's *The Artist's Garden at Eragny* (1898) were derived. If Monet in turn helped Mirbeau obtain what the writer suggestively described as a 'series of crown-headed dahlias' and one of 'carissas',[78] his 'collecting' was, however, clearly already cognate with a larger creative process. 'Simply by standing in his garden', the critic Gillemot noted in 1898, Monet 'continues . . . his work; his eye contemplates, studies, stores up' (*emmagasine*).[79] *Emmagasiner* describes accretion over time; Monet, after all, had taken a close interest while at Antibes in the progress of Mallarmé's translation of Whistler's 'Ten O'Clock Lecture', in which the artist is described as one who 'looks at' nature's 'flower, not with the enlarging lens, that he may gather facts for the botanist, but with the light of he who sees, in her choice selection of brilliant tones and delicate tints, suggestions of future harmonies'.[80] It was thus entirely logical that, despite all the digging and planting of the 1880s and early 1890s, Monet deferred systematic painting of it until the later 1890s.

Before we turn in detail to the pictures which resulted, it is worth taking note of several further factors which must have fed Monet's 'fury of horticulture'. During his lengthy stay with the melancholy poet Maurice Rollinat while painting in the bleak Creuse Valley in 1889, Monet had greatly enjoyed hearing him read his verse in the evenings, while later that year, Monet had held his celebrated joint exhibition with Rodin. And both Rollinat and Rodin saw nature as imbued with soul and sentiment; the artist was therefore its tributary. 'In the plant which flowers/I circulate like sap', wrote Rollinat; Rodin had 'no doubt but that the beauty of flowers and their movement expresses thoughts'.[81] This emphasis on the artist's empathy with his motif would have been reinforced for Monet if, as his correspondence implies, a Japanese gardener visited Giverny in 1891. Japanese principles of gardening were based on the Zen

216 Camille Pissarro, *The Artist's Garden at Eragny*, 1898
While Pissarro's Eragny garden, kept mainly by his wife Julie, had a vegetable plot as its most prominent feature, its sunflowers may well have included the *harpoliums* and *Helianthus loetiphorus* (perennial and autumn varieties) which Mirbeau had sent Madame Pissarro in 1890. Pissarro invited Mirbeau himself, as well as friends such as Monet and Rodin, to visit him and his wife at Eragny.

217 Claude Monet, *Wisteria*, c. 1919–20
Monet grew purple and white wisteria on his 'Japanese' bridge at Giverny, and began this and other panels of the flower – which traditionally signified 'friendship' – as decorations to surmount the waterlily mural scheme he planned for a pavilion in the grounds of his late friend Rodin's home, the Hôtel Biron. This project, never realized, was the prototype for the *Grandes Décorations* scheme in the Orangerie [231].

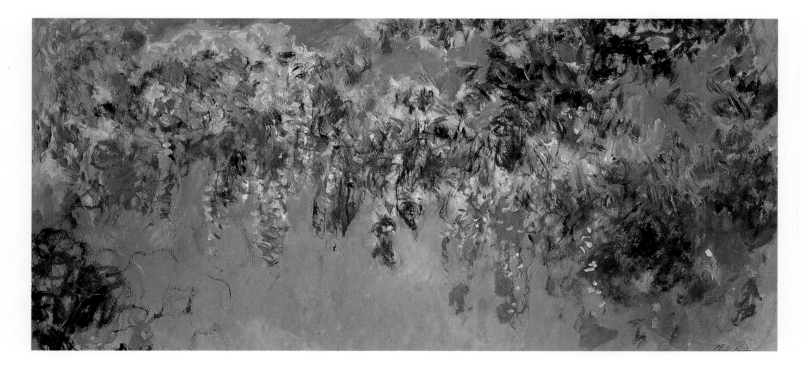

Buddhist ideal of union of self with nature.[82] The waterlilies which Monet grew from 1893 are botanically related to the sacred 'lotus' flowers of Oriental culture, symbolic of 'the true nature of beings . . . unstained by the mud of the world'.[83] As Spate and Bromfield have suggested, the waterlilies within Monet's garden were thus quite literally the alter ego of the haystacks he had painted in 1889–91 in the field immediately beyond it, since these are believed to have been inspired by Hokusai's *Thirty-Six Views of Mount Fuji*.[84] The waterlilies in the pond would have been emblems, through association with Eastern culture, of the very principle of regenerative wholeness and unity which had produced the original Utopian and socialist vision of France itself as a garden. Once again it seems clear that Monet's cultivation and portrayal of his garden had 'nationalist' implications, figuring an ideal France.

Rodin's correlation of 'flowers' and 'thoughts' appears, in fact, in his famous book on French cathedrals. Though not published until 1914, Rodin had begun the 'fieldwork' for this as far back as 1877.[85] The coincidence of Monet's 'fury of horticulture' with the painting of his Rouen Cathedral series certainly offers suggestive resonances both with the association between 'stone' and 'flowers' which Rodin would draw in *Les Cathédrales*, and with Rodin's view that the Gothic masons who created the great French cathedrals took their inspiration from flowers and plants.[86] This train of thought, was, of course, part of the same veneration for medieval art which Renoir and Pissarro had expressed. Critics in the 1890s were also quick to see Monet's 'Cathedrals' as quasi-organic, while Monet himself, struggling to seize the nuances of light as it played over the façade of Rouen cathedral, noted that 'everything changes, even stone'.[87] If we remember, in turn, that, as would be pointed out in Charles Morice's introduction to *Les Cathédrales*, a cathedral itself was traditionally conceived as a type of paradise – an embodied garden connecting earth with the 'heavens' as does a living tree[88] – then Monet's 'fury of horticulture' becomes the literal partner to his 'Rouen Cathedrals' and 'Poplars'. We can also begin to understand why Monet would later plan his Waterlily *Décorations* as murals for a pavilion in the garden of the Hôtel Biron – Rodin's former home, which had become the property of the State on his death. Here, he intended to surmount them with panels depicting wisteria – that floral emblem of 'friendship'. The scheme would thus have formed an explicit tribute to his colleague. (In the event, the

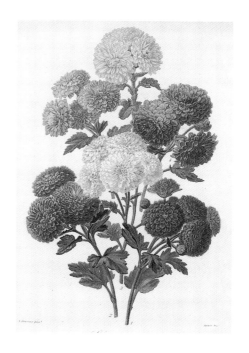

218 Riocreux, *Chrysanthemums*, from *Revue horticole*, 1862

219 Gustave Caillebotte, *White and Yellow Chrysanthemums in the Garden at Petit Gennevilliers*, 1893

220 Claude Monet, *Bed of Chrysanthemums*, 1897

Chrysanthemums, originally from China and Japan, were extensively developed in the 19th century, and both Monet and Caillebotte grew and painted a number of the new varieties. Here, they use close-up viewpoints to create decorative effects, partly inspired by Japanese prints [221]. Caillebotte's picture may be related to his scheme of floral decorations for his home at Petit Gennevilliers [213].

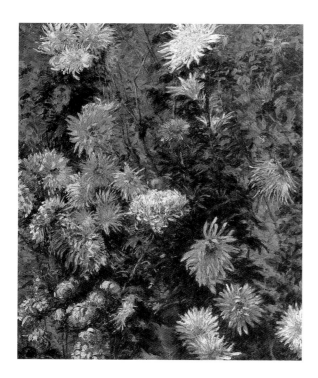

government decided the Hôtel Biron pavilion would be too costly, causing Monet, urged on by Clemenceau, to revise and extend his scheme for installation in the Orangerie).[89]

Such connections and relationships enable the garden at Giverny to be recognized as a vital nexus of Monet's mature creative output. Itself a place of growth and renewal, it was interlinked with the rest of his oeuvre; expressive of personal feelings, it was also a physical meeting point, at the heart of northern France, for southern profusion, eastern plants, and the gardens of western tradition – whether of Paradise or the Hesperides. Nature – as concentrated in Monet's garden – had in this sense truly become his 'studio'; a notion he repeatedly passed on to journalists and reviewers.[90] The small group of paintings of a bed of chrysanthemums which Monet produced in 1896–7 [220], for example, in which the tousled, multicoloured flowerheads entirely fill the canvas, are works of art in their own right, perhaps even elegies – given the association of chrysanthemums and mourning – for Caillebotte and Morisot who had died in 1894 and 1895 respectively. But they are also studies for future pictures. Their ultimate sequel lies in Monet's paintings from around 1905 of the surface of his waterlily pond, where, as in the *Chrysanthemums*, the flowers 'float' free of apparent spatial context. This effect of course reflects Monet's interest in Oriental art – he owned Hokusai's *Chrysanthemums and Bee* – and it departs from the more naturalistic portraits of flowers which Caillebotte had painted at Petit Gennevilliers [219].

If the introduction and cross-breeding of new Oriental species of chrysanthemum which had brought these flowers to a zenith of colouristic diversity by the end of the century [218] made them an obvious choice for painter-gardeners such as Monet and Caillebotte, Monet's 'fury of horticulture' had clearly set in motion a complex process of artistic and even philosophical cross-fertilization. To understand his paintings of his garden, however, we surely also need to bear in mind that Monet recalled at the end of his life that gardening was 'a *métier* I learnt in my youth . . . when I was unhappy' – implying that he understood it as a consoling activity.[91] Already at the turn of the century he had, in fact, taken issue with Mirbeau's admiration for van Gogh's vibrant irises of 1889 – whose plants, growing in the garden of the asylum at Saint-Rémy, appear to writhe and twist – on the grounds that, if van Gogh had really grasped the true character of nature, he should have been a happy man.[92]

Monet's personal view of horticulture meshed, of course, with the wider interpretation at the period of gardens as 'healing' places. Albert Besnard, for example, in his murals at the Ecole de Pharmacie in Paris, begun in 1882, had shown the drying in a garden of plants for medicinal use, and a garden as the place where a sick young woman (perhaps one of Charcot's neurasthenics) takes her first steps to recovery. Monet's own 1895 painting of his daughter-in-law Suzanne plucking a flower from a bed of golden, red and orange dahlias or chrysanthemums at Giverny [223] – virtually his last figurative picture – can in turn be regarded as symbolic, for Suzanne was ill with the disease which would 'pluck' her own life in 1899. A latter-day 'gardener-girl', her action echoes that of the woman picking a rose in Monet's early *Women in the Garden*; a 'flower' herself, her red jacket and blue scarf match the colours of the nearby petals and leaves as if Monet, through art, sought to infuse her ailing being with the garden's healing life-force.

When, shortly after this, Monet began to paint his garden as such, it was, of course, against the backdrop of the national trauma caused first by the moral crisis of the Dreyfus Affair, and then, from 1914–18, by the First World War. Critics certainly saw the results in terms of 'healing'. Roger Marx, for example, in 1909 quoted Monet as having had an earlier idea for a room decorated with waterlily murals, where 'nerves weighed down by work would be relaxed . . . following the soothing example of these still waters . . . for whoever used it, this

221 Hokusai, *Chrysanthemums and Bee*, c. 1832, from Monet's collection
Monet's collection of Japanese prints, displayed on the walls of his house at Giverny, would have complemented the garden outside, with its actual chrysanthemums, poppies, Japanese anemones, and many other types of Oriental flower.

222 Albert Besnard, *Drying of Medicinal Plants*, 1882–90
One of the murals from the series painted by Besnard, a younger contemporary of the Impressionists, for the Ecole de Pharmacie in Paris. These illustrate plant, animal and human evolution, botanical education, and the therapeutic use of plants, here being dried in a garden for medicinal use. The scheme reflects the wider association of gardens with healing.

room would have offered the asylum of peaceful meditation in the midst of a flowered *aquarium*.[93] In Huysmans's famous novel *A Rebours* – a book which Monet had requested from Pissarro back in 1884 – the neurotic recluse des Esseintes had created a room in which a fish *aquarium* formed a part of the wall. But speaking through Roger Marx in 1909, Monet now tellingly refuted any correlation with this precedent, and instead recollected his *aquarium* project as intended to embody 'blooming health'.[94] The act of growing a garden – and, in turn, of recreating that garden in paint – was for Monet firmly one of giving 'life'. By the later 1890s, this expression of *le don* would have been closely intertwined with the status of Impressionism itself. For, just as Pissarro had spoken of Impressionism as a 'healthy' art based on 'sensations', so Monet's decorative project presented an implicit riposte to former Impressionists who had embraced the principles of Symbolism, such as van Gogh's colleague Gauguin. Even more explicitly than Pissarro's *Apple-Picking*, it reunited 'the decorative' – a key element in the Symbolists' repertoire of means to embody abstract thought – with the sensory, healthful immediacy of garden growth. Mirbeau had mocked the Symbolists in an article of 1895, much admired by Pissarro, which drew implicit contrast between their art of 'knock-kneed Christs whose crossed arms ended in bleeding lily-blooms' and the burgeoning April plenitude of the Tuileries Gardens.[95] He had nonetheless described Gauguin's departure for Tahiti in 1891 in search of a new symbolic art as the logic of the artist's quest for 'a sacred abundance of Eden' in Martinique a few years previously.[96] In this context, Monet's creation and painting of his garden at Giverny proclaimed that Impressionism could enable just such an Eden to exist within, and even be synonymous with, France itself.

223 Claude Monet, *Monet's Garden at Giverny*, 1895
Virtually the last figurative garden subject by Monet, this shows his daughter-in-law Suzanne Hoschedé Butler beside chrysanthemums or dahlias, and perhaps alludes to the tradition of gardens as places of healing, since Suzanne was already suffering from the illness of which she died in 1899. At the same time, the portrait is clearly also a reminiscence of the woman picking a rose in Monet's early *Women in the Garden* [73].

The 'work of art' made works of art

In the wake of Gauguin's second departure for Tahiti in 1895, Monet's first true garden 'series' at Giverny was itself an engagement with the 'exotic', for it focused on the pond area of his 'most beautiful work of art'. Not only had the colourful waterlilies there been derived by Latour-Marliac from crosses with exotic species, but the term *aquarium* which Monet, speaking via Roger Marx, used with reference to his early idea for waterlily murals was one which denoted the whole environment – typically a plant-filled glasshouse – in which a man-made pond was situated.[97] In 1886, for example, the *Revue horticole* had reported on the magnificent *aquarium* at the Jardin des Plantes in Paris, with its specimens of 'Nymphaea, Nelumbium, Pontederia [around which] grow vigorous climbing Aroïdes, Caladium and Nepenthes pell-mell, the whole encircled with lianas and giving the impression of a little creek on the banks of the Amazon'.[98] Both Monet's pond and his projected mural *aquarium* would in this sense have offered a direct counterpart to the southern profusion of his flower garden and the orchids and tigridia in his greenhouses, much as Caillebotte had turned his very home at Petit Gennevilliers into a 'virtual' greenhouse, through his murals there of his orchids.[99]

Monet's first pictures of his water garden certainly suggest that he saw it as a place where cultivated nature might enfold the viewer with the generosity of *le don*. Three painted between winter and early summer 1895 show the pond within its larger setting, with the arched bridge answered by its reflection, and the surrounding mass of trees and shrubs providing protective enclosure. The sky is barely visible, either in reality or reflection, and it is too early in the season for any waterlilies, though brilliant yellow flag irises enliven the summer picture. Though Caillebotte had painted a study of wild waterlilies on the water surface at Yerres in the 1870s, and Guillemot had in 1898 described Monet's projected mural scheme in terms of 'an expanse of water dotted with [aquatic] vegetation',[100] Monet seems in 1899–1900 to have wanted to present his waterlilies as an integral part of their *aquarium* setting. In a series of these years, he showed them covering the water almost totally, and again framed by weeping willows and irises, their burgeoning profusion intensified by the

224 Gustave Caillebotte, *Yerres, on the Pond, Waterlilies*, before 1879
Monet perhaps knew of this painting by Caillebotte of wild waterlilies on his family estate. He certainly appears to have experimented with a number of close-up views of his own pond in the late 1890s following Caillebotte's death, though at this stage to have abandoned these for views of the pond in its environs [225].

225 Claude Monet, *Waterlily Pond*, 1899
Monet exhibited a series of views at Durand-Ruel's gallery in 1900 of the waterlily pond surmounted by its bridge, including two groups painted in 1899 and 1900. The 1899 group emphasizes green tonalities; that of 1900 takes the red undersides typical of the leaves of Latour-Marliac's new scented hybrid waterlilies as its key. Monet grew these flowers extensively.

slender arc of the bridge. The 'carpet' of flowers is literally such; vertical strokes representing reflections from the surrounding foliage form a 'weft' to the 'web' of horizontal lozenges which denote the lily pads. Pink, white, yellow and red touches – the lily flowers – meanwhile spark like miniature explosions from the surrounding greens, browns and occasional notes of blue. A greater contrast with the strict, geometric mosaiculture which was popular in many fashionable gardens of the period – plants and flowers organized into intricate formal 'carpets' of contrasted colours – could hardly be imagined. Rather, the pond was in tune not just with an exotic *aquarium*, but also with the kind of 'wild' or 'natural' plantings which, following the publication in Britain in 1870 of William Robinson's influential book *The Wild Garden*, had begun to find echoes in France.[101] Some of Latour-Marliac's new hardy waterlilies had, in fact, been displayed in a stream at the 1889 Universal Exhibition, as if growing wild, and the way Monet's waterlilies cover the water surface is exactly similar to *Le Jardin*'s description of how, in this display, 'the water plants struggle with each other to find space in the sun', with 'the water . . . barely visible'; a 'picture which should have tempted all the artists [who saw it]'.[102]

The dark reds and warm purples interwoven through the surface of the pond and reflected in the underside of the bridge in Monet's 1900 paintings suggest, in fact, that many of his waterlilies were new scented varieties, since these typically had purple-red undersides to their leaves.[103] Contemplation of the pond via Monet's art was, therefore, just like the vicarious enjoyment of taste offered earlier by Pissarro's *Apple-Picking*, a form of intensified sensation – that cardinal focus of Impressionist attention. Indeed, the 1900 images almost literally fulfilled Mirbeau's characterization already in 1891 of Monet as an artist who 'made intoxicating pictures that can be inhaled and smelled'.[104] If the origins of this synaesthesia perhaps lay in Monet's delight at the 'delicious perfume' he had found 'everywhere' at Bordighera in 1884, and the 'extraordinary pink' of the light there,[105] its *dénouement* was surely reached in the impromptu concerts which took place in 1922 both in Monet's studio

226 Line illustration of a corner of the river-garden at the Trocadéro, in *Le Jardin*, 1889
This shows Latour-Marliac's display at the Universal Exhibition, Paris, as if in a natural environment, of his acclaimed new hybrid waterlilies. Monet in turn seems to have adopted a similar closely massed arrangement of his waterlilies, at least until he enlarged his pond in 1901.

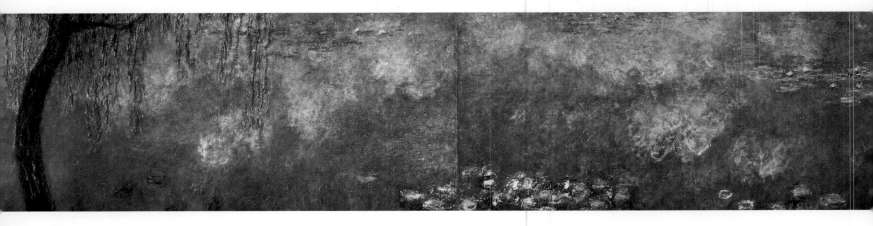

of sky reflected in it, which spread life and movement within it.'[127] The lotus of Indian mythology was, of course, 'the flower of life and light' – something Monet could surely have learnt from Clemenceau, who visited India in the early 1920s.[128] The dynamic, vigorous brushwork and intensity of colour of the pictures of the wisteria-clad bridge and its reflection which Monet painted while his vision was impaired certainly suggest some quasi-primal union of 'life and light', as if in symbolic defiance of his struggles to see. If Clemenceau referred to Monet's 'Garden of water and fire', some of the *Paysages d'eau* exhibited in 1909 already seem almost alight, bisected by reflected sunset colour as if by a pillar of fire [227]. Such images, translating the 'heat' of the formal, flower-bordered *allée* of the 1900–2 pictures into the changeful intangibility of water and clouds, reinvented the Garden of the Hesperides in ways which even Duranty could hardly have foretold.

Confessing in 1925 to having literally burnt a group of paintings he felt unsuccessful, Monet added 'All the same, I do not want to die before saying everything which I have to say, or at least having tried to say it . . .'.[129] It was, of course, 'the colour of the sky' which, according to Rollinat, itself created 'the colour of thought'.[130] In these terms, what more natural than to render the 'celestial garden' in a format – mural painting – which was traditionally a vehicle for messages and ideas?[131] It was the sky to which, through the 'emotive' device of reflecting what lies beyond the picture frame, Monet increasingly gave emphasis in his *Grandes Décorations*. In his original project for the Hôtel Biron pavilion, he had organized his water garden motifs essentially by plant type, with three of the scheme's four sets of panels devoted each to a different form of growth – irises, agapanthus, waterlilies, and the reflections of willows and bamboo. Only the fourth set was called 'The Clouds'. In Monet's ultimate scheme for the Orangerie, however, developed in the early 1920s and itself arranged as a 'double garden' in that it decorated two conjoined room – it was effects of different times of day – sunset and early and later morning – which dominated. There was thus a subtle shift from the earth-based garden with its growing plants and trees to an apprehension of the universe itself as implicit in the larger rhythms and processes of time.

If Monet's reluctance to declare his murals finished made Clemenceau irate, we can see his portrayal of the photosensitive waterlilies – yellow, blue, red, pink and white – as a literal depiction of 'the colour of time'.[132] Equally, the palpably unfinished character of the Orangerie panels – with their layers and encrustations of paint and their almost disconcerting combination of Japanese 'vertical' perspective with implicitly 'rooted' plants and trees – is essentially cognate with Rodin's vision of sculpture as 'design from all sides'. Such design Rodin called 'the incantation which permits the soul to be made to descend into the stone . . . this gives all the contours of the soul at the same time as those of the body'.[133] If it offers

231 Claude Monet, *The Two Willows*, four panels from the *Grandes Décorations*, third wall of second room, Orangerie, Paris, 1920–6
Accompanying two morning scenes with willows, and one of reflections of trees, these panels portray reflected clouds of subtle pinks mingled with the pink, orange and yellow notes of partly opened waterlilies, and they occupy the far wall of the second of the two ellipse-shaped 'Waterlily' rooms at the Orangerie. The first room contains a sunset scene, one of clouds, 'Green Reflections', and the first morning scene of the entire ensemble.

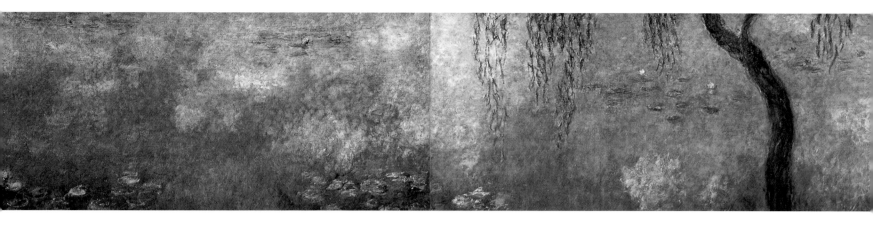

an Impressionist answer to the simultaneous viewpoints of Cubism or of Duchamp's *Nude descending a Staircase*, it was, in the Orangerie scheme, surely also the culmination of the personal engagement with nature which lies at the heart of Impressionist garden-painting. For, arranged in continuous sequence on the walls of its elliptical rooms, the scheme re-enacts Monet's walk around the waterlily pond which, with Alice and the children, had been a well-loved ritual on fine summer evenings at Giverny; at the same time, it encircles us as viewers, transporting us by implication to the mythical island of Cythera. It puts us again in mind of Mallarmé's discovery that 'Eden' – understood as perfection – lies in the 'real' gardens of this world; it is the artist's gift of creative, metamorphic vision which recognizes its presence. The anguished, writhing strokes which shaped Monet's 1918–19 *Weeping Willows*,[134] painted in the immediate aftermath of the war, have now been replaced by delicate touches and strokes; the leaves of the bending willows, forming screens of undulating colour, link the floating, multicoloured waterlilies with the drifting, inverted clouds. With its multidimensional implications, whereby the surface of the pond is simultaneously a continuous pattern on the walls, a 'view' to a virtual 'garden' through them, and a reflection of the celestial 'garden' far above, Monet's panels were clearly now intended both to synthesize and to transcend. Propagated from cut budded stems, the waterlilies were themselves an embodiment of nature's regenerative powers; painted in 'permanent' murals, they perpetuated those powers for posterity. It is in this sense that, despite their palpably unfinished and even unresolved appearance, the Orangerie murals represent the apotheosis of the gesture of *le don* which was contained in Monet's very planting of his garden so as to enfold the viewer with perfume and colour. Reaching forwards to future generations, they lead us, in turn, to the subject of the next chapter, which explores some of the paintings of gardens produced by latter-day Impressionists, both in France and beyond.

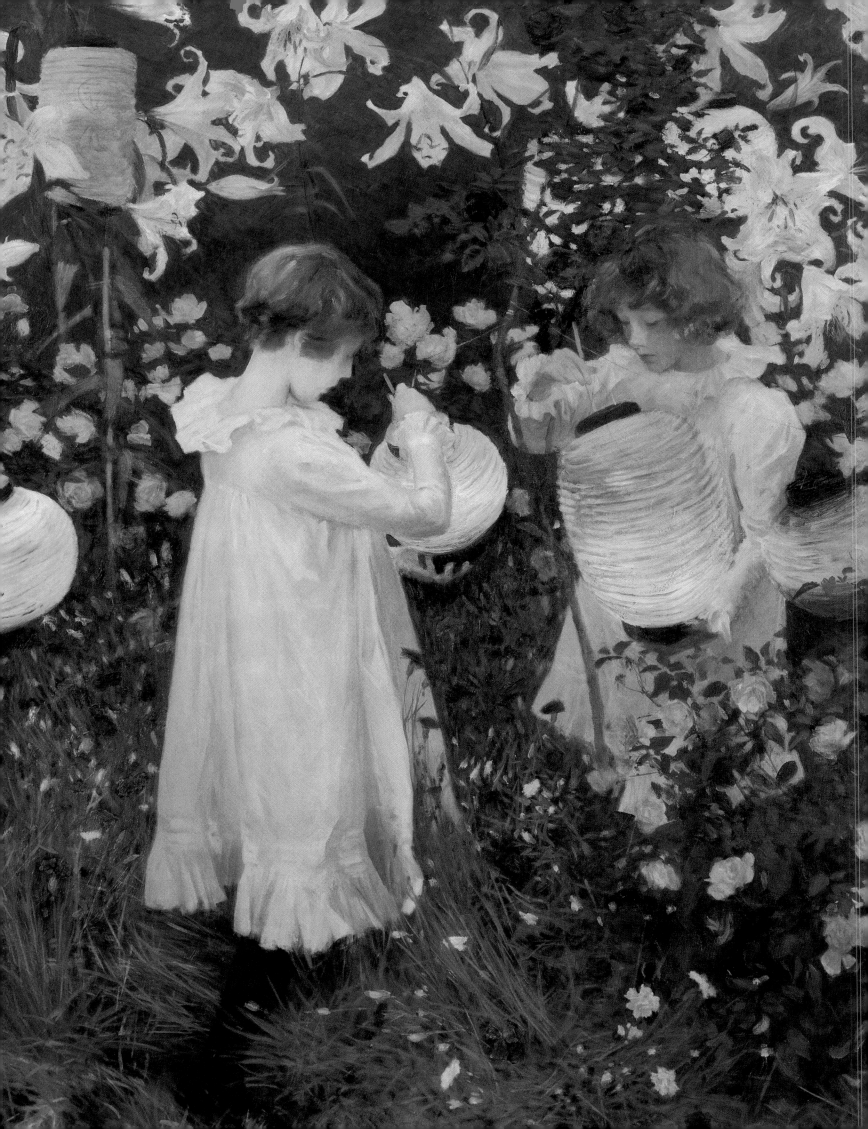

Chapter 9 The fruits of the gardens of Impressionism

I saw a most paradisiac sight at the end of September . . . Children lighting paper lanterns swung from rose trees and in the middle of flowers, at dusk, when the lanterns just begin to glow.[1]

So wrote the American painter John Singer Sargent in 1885 of the inspiration for a picture he had just begun in a private garden at Broadway in the English Cotswolds. Called *Carnation, Lily, Lily, Rose*, its modern *hortus conclusus* follows clearly in the tradition of Monet's *Women in the Garden* [73], just as its children echo the absorption in pleasurable activity of Jean in Monet's *Luncheon* [135]. It was at the 1876 Impressionist exhibition, where *The Luncheon* was the focal work, that Sargent had first made Monet's acquaintance. And as summer faded in 1885 and he tired of using flowers 'from a friend's hat' instead of real ones, with 'ulsters [long overcoats] protruding from under my children's pinafores',[2] Sargent had in turn renewed contact in Paris with the Impressionists in general, and Monet in particular. After completing *Carnation, Lily, Lily, Rose* the following summer, he must have been gratified that Monet was one of its many admirers. His method of painting the picture – in 'two or three minute sessions' – actually anticipated Monet's own description of his goal as 'instantaneity', for the writer Edmund Gosse described how, each evening, 'at a certain notation of the light', Sargent had stopped playing tennis to run 'forward over the lawn with the action of a wagtail, planting at the same time rapid dabs of paint on the picture, and then retiring again, only with equal suddenness to repeat the wagtail action'.[3]

An American artist; a British garden; a French Impressionist technique. If Pissarro commented already in 1889 that 'the Impressionists have had an enormous influence, above all in the north of Europe', then the modern art historian Brettell has noted that Impressionism's 'effect on the practice of representation was virtually global by 1900'. Brettell goes as far as to say, in consequence, that Impressionism 'as a term' is 'all but useless'.[4] With gardens as our focus, however, it is possible to trace a seam of Impressionist-type art from the late 1880s to the 1920s, and in some cases even beyond, which is distinctive as well as substantial. While continuing key features of the original 'gardens of Impressionism' – *plein-air* effects; emphasis on suggestion and evocation, and delight in the experiences of the senses, for example – it takes them in subtly new directions. This chapter offers some examples which illustrate this development, both from France and beyond. If the creation of the gardens of later Impressionism was fuelled by the role of Paris as the 'art capital of the world' in the late 19th century, and the prominence given to Impressionist painting by dealers such as Durand-Ruel (who showed work in America and London as well as Paris), it was, of course, also given particular impetus by the increasing fame from the 1900s of Monet's garden and work at Giverny.

In this context, Sargent's use of the word 'paradisiac' is also richly telling. For the spread of Impressionist techniques coincided at the fin de siècle with a widespread quest for 'paradise on earth'. It was a 'Paradise' which the first American artists who found their way to Giverny said they had discovered in its environs[5] – and which was effectively given expression in their eventual concentration on garden subjects there. As a new century approached, a quest for 'better worlds' was perhaps only logical. Industry was threatening rural ways; urban life was increasingly disrupted by strikes and political unrest. The urge to renew and regenerate to be

232 John Singer Sargent, *Carnation, Lily, Lily, Rose* (detail), 1885–6
An American artist who became a prominent member of the New English Art Club, Sargent met Monet at the 1876 Impressionist exhibition. This painting, named after a popular song, was carried out in gardens at Broadway, in the English Cotswolds. Along with Sargent's subsequent work alongside Monet near Giverny, it was catalytic in the spread of Impressionism in Britain. See also ill. 247.

found in the original Impressionists' post-Franco–Prussian War garden imagery was ripe itself for reinvention. Images of gardens – whether as places of leisure or productive cultivation – could offer an implicit defence against the morbid 'degeneration' identified by the Paris-based Hungarian physician Max Nordau, or ills like the 'American Nervousness' described by George Beard of the New York Academy of Medicine, whose sufferers found 'quick relief on getting into the open air'.[6] It is hardly surprising that, of the pictures shown by Durand-Ruel in New York and Boston in the 1880s and 90s, it was Monet's views of his gardens at Argenteuil and Vétheuil which attracted particular enthusiasm, just as garden subjects by Manet and Monet were some of the first Impressionist works to be purchased by collectors and galleries in Germany, fast becoming a major industrial power.[7]

The English designer William Morris's vision of an 'Earthly Paradise', recreating a lost pre-industrial harmony between mankind and nature, had particularly widespread influence. If Candace Wheeler, friend of Louis Comfort Tiffany and a prominent advocate of Morris's 'Arts and Crafts' ideas in North America, wrote that 'There is a possible Eden in every garden',[8] then similar ideas fed into Belgian 'social art', and Scandinavian and German 'back to nature' trends at the end of the 19th century. It was Morris himself who had recommended Broadway to the 'colony' of American artists whom Sargent joined there when he painted *Carnation, Lily, Lily, Rose* – and it was Morris's admirer, the British artist-gardener Alfred Parsons, who helped develop the garden at Russell House in the village where Sargent completed this picture. Parsons was a close friend in turn of William Robinson, the influential horticulturalist inspired by Morris. Robinson's ideal of the 'natural' or 'wild garden', with flowers growing *en masse*, is surely reflected in Sargent's dispatch of no less than fifty lily bulbs for the Russell House garden to Lucia Millet, sister of the American painter Frank Millet who owned the property.[9]

At the same time, it is revealing that Sargent instructed Lucia Millet that twenty were to be 'put in pots and forced' at Russell House.[10] Late 19th- and early 20th-century horticulture was as much to do with 'artifice' as 'nature'. Not just techniques such as forcing, but the sheer variety of plants introduced by plant collectors and hybridizers had produced a situation

233 Period photograph of 'The Terrace in the sun' in Henri Le Sidaner's garden at Gerberoy
Le Sidaner settled at Gerberoy, near Beauvais, in the early 1900s and developed his partly formal, partly 'natural', garden there over nearly forty years. The terrace was inspired to some extent by those of the Baroque gardens at Isola Bella in Italy.

78 See R. Schiff, 'The End of Impressionism' in Moffet et al., *The New Painting*, pp. 61–89 for discussion of the 19th-century definition of an 'impression' as reflecting subjective as well as objective experience.

79 See *Bulletin de la Société Centrale d'Agriculture et des Comices Agricoles du Département de l'Hérault*, 47th Year (1860), p. 300.

80 The format persisted as late as 1894, in the Lyons painter André Perrachon's *Hommage aux poètes du siècle*, Musée des Beaux-Arts, Lyons. Renoir's 1858 painting *Couronne des Roses* (sold Sotheby's London, 25 June 2002) uses the wreath format.

81 Mallarmé, 'Nommer un objet, c'est supprimer les trois quarts de la jouissance du poème . . . le suggérer, voilà le rêve (quoted in M. Braunschvig, *La Littérature française contemporaine*, Paris, 1929, p. 25). Cf the attempts by French 19th-century poets to rival the 'language of flowers' by means of 'a synaesthetic code' (see Knight, *Flower Poetics*, p. 53), and cf Baudelaire's strategic placement in *Les Fleurs du Mal* of his 'Correspondances' poem (which deals with this synaesthetic code) as the sequel to his 'Elévation', a description of the ecstasy of the person who 'effortlessly understands/The language of flowers and of things which are mute'. Mallarmé's search for a 'supreme language' (Knight, *Flower Poetics*, p. 245) is exemplified in his synoptic phrase 'Je dis: une fleur! . . . ' ('I proclaim: A flower! . . . ') which evokes the features of every potential flower (Mallarmé, *Poésies*, pref. Y. Bonnefoy, Editions Gallimard, 1992, p. xviii).

82 Burty, 'Etudes et compositions de fleurs et de fruits. Cours gradué pour l'enseignement par M. Chabal-Dussurgey', *Gazette des beaux-arts*, 24, 1868, p. 102.

Chapter 2: Horticulture and *pleinairisme*
pp. 53–73

1 Letter from Bazille to his mother, 8 December 1863, in D. Vathone (ed.), *Frédéric Bazille: Correspondance*, Montpellier, 1992, pp. 68–9.

2 E.g. 'The air plays such an important part in the theory of colour' ('Salon de 1846', in Baudelaire, *Art in Paris*, p. 50; see also p. 51).

3 E. and J. de Goncourt, *Journal*, 12 November 1861, quoted in Tinterow and Loyrette, *Origins of Impressionism*, p. 132. In their novel of artistic life, *Manette Saloman* (1867), the Goncourts would elaborate this idea still further.

4 J. Renoir, *Renoir, my Father*, p. 105.

5 Claude, for example, had sketched out of doors; the practice became firmly established in the late 18th and early 19th centuries by artists such as Valenciennes, Desperthes, Michallon and Corot; see Clarke, *Lighting up the Landscape*, pp. 13–14.

6 Quoted in V. Hamilton et al., *Boudin at Trouville*, Glasgow, 1992, p. 16.

7 See P. Gachet, *Deux amis des impressionistes: Le Docteur Gachet et Murer*, Musées Nationaux de France, 1956, p. 24, and *Encyclopaedia Britannica*, 1911, 3, p. 449. The homeopathic doctor Gachet, gardener, patron and friend of many of the Impressionists from the 1870s, himself trained at the Faculty of Medicine in Montpellier in the 1850s, when he is thought to have encountered the young Bazille (Gachet, *Deux Amis*, p. 27).

8 See Nord, *Impressionists and Politics*, pp. 3, 21, 27–35.

9 Michelet, *La Femme* (1859), pp. 428–31.

10 Ibid., p. 436; see also Michelet's tribute to Froebel in *Nos Fils*, 1869, discussed in Chapter 5 below.

11 Galiègue et al., *Henri Le Sidaner*, p. 170.

12 Michelet, *La Femme* (1859), p. 431.

13 'c'est là . . . qu'il faudrait aller vivre et fleurir' (Baudelaire, 'L'Invitation au voyage', in *Le Spleen de Paris*, p. 75; for Baudelaire's image of the human mind as a garden, see Introduction, n. 45 (cf also n. 55, below).

14 Zola, 'Le Moment artistique', *L'Evénement*, 4 May 1866, in *Ecrits sur l'art*, p. 108.

15 Zola, 'Les Paysagistes', *L'Evénement illustré*, 1 June 1868, in ibid., p. 217.

16 Quoted in J. Renoir, *Renoir, my Father*, p. 63.

17 *Guide de l'étranger dans Paris et ses environs*, p. 101.

18 H. de Balzac, *Old Goriot* [1834] (trans. M. A. Crawford), Harmondsworth, 1976, p. 29.

19 Diderot's phrase is quoted in F. Cachin, 'Le Paysage du Peintre', p. 465.

20 For the missionary priest Jean Pierre Armand David, who collected specimens for the Musée d'Histoire Naturelle in Paris in 1861 and made various expeditions to China during the 1860s, and for Prince Henri d'Orléans, see J. Reynolds Green, *A History of Botany 1860–1900*, New York, 1909 and 1967, p. 180 and p. 176; see also E. M. Cox, *Plant Hunting in China*, London, 1945, and A. M Coats, *The Quest for Plants*, London, 1969, for these and other plant collectors of the period.

21 'Lilas Président Massart' by 'Ch. Lem.' in *L'Illustration horticole*, X, Ghent, 1863, notes that lilac is grown 'everywhere in the parks, shrubberies and flowerbeds of the rich and the poor alike'; is 'one of the plants most amenable to forcing during the winter, so as to furnish the balls and soirées of society at that season with its beautiful and scented flowers', and is 'the subject in Paris of an extensive trade'.

22 See Decaisne and Naudin, *Manuel de l'amateur des jardins*, II, p. 237, for the *Gladiolus gandavensis* with its distinctive 'vermillion colour, with pinkish reflections, and large yellow macula on the lower petals' and 'intense violet-blue' stamens, from which the new varieties were developed. The English horticulturalist William Robinson reported in his *Parks, Promenades and Gardens of Paris*, p. 253, that M. Souchet, the Emperor's gardener at Fontainebleau, had been growing gladioli for over thirty years, and his father before him, but now had 'the finest collection in the world' of this flower. Robinson also observes, p. 257, that 'In France the Gladiolus is cultivated much more abundantly than with us'. See n. 62, Chapter 3, and n. 23, Chapter 5, below, for further references to gladioli in period horticultural literature.

23 See Chapter 1, n. 1.

24 The popularity of camellias was reflected, for example, in the creation of no less than 'two greenhouses for camellias' at the Jardin du Luxembourg in 1862 (*Guide de l'étranger dans Paris et ses environs*, p. 101).

25 See Brettell et al., *A Day in the Country*, pp. 242–3, which notes the slow take-up of progressive agricultural practices in 19th-century France, and Brettell, *Pissarro and Pontoise*, pp. 31–2. Cf also the ironic presentation in Duranty's *Le Malheur d'Henriette Gérard*, 1860, of the heroine's father's attempts to engage in agricultural innovation and Flaubert's satirization of the tide of agricultural and horticultural invention in *Bouvard et Pécuchet*, 1881.

26 'L'Horticulture au Collège', *Revue horticole*, 1858, p. 277.

27 By 1865 the 'Société Centrale d'Horticulture' in Paris had more than 2,500 members and mounted its annual exhibition in the Palais de l'Industrie itself, where, in art, the Salon took place; see *Revue horticole*, 1865, p. 73 and p. 107.

28 Eugène Chapus, 'La Vie à Paris: le caractère de la Société parisienne actuelle; les maisons de la campagne', *Le Sport*, 5 September 1860, quoted in Tucker, *Monet at Argenteuil*, p. 125.

29 I am grateful to Janet Webster for identifying 'argentea mediocritas' as a modification of the phrase 'golden mediocrity' which appears in Horace's *Odes*.

30 Letter from Bausson to Bazille, 17 and 23 March 1863, in Schulman, *Frédéric Bazille*, p. 324.

31 'Parcs et jardins paysagers', *Revue horticole*, 1862, p. 327.

32 For a detailed account of the Caillebotte family garden, see Wittmer, *Caillebotte*.

33 Bossin, 'Visite à l'Exposition Universelle', *Revue horticole*, 1867, p. 148.

34 Ibid., p. 148; p. 149.

35 *1900 Paris Exposition: Guide pratique du visiteur de Paris et de l'exposition*, quoted in Galiègue et al., *Henri Le Sidaner*, p. 173.

36 Zola, 'Les Paysagistes', p. 217; cf the extract from the *Magasin pittoresque* on 'Les Joies du jardinage', pp. 230–1 ('The effect of a *coin de terre* (corner of land) intelligently organized . . . '). Cf also the discussion of the term *coin* in Brettell, *Pissarro and Pontoise*, pp. 103–5, ('a fundamentally elusive and informal landscape term which was used widely throughout the middle and late nineteenth century', meaning 'an odd framed portion of an environment . . . [which] is, by definition, part of a larger whole').

37 'Parcs et Jardins paysagers', *Revue horticole*, 1862, p. 326.

38 Sahut ('Horticulteur à Montpellier'), 'L'Horticulture au dix-neuvième siècle', *Revue horticole*, 1859, p. 89.

39 See L. Nochlin, *Realism*, Harmondsworth, 1982, pp. 107 and 257, which includes discussion of D. Papety's 1843 painting *Le Rêve de bonheur*, showing figures in a garden, and 'replete with the timely message of Fourierist felicity'. Papety, interestingly, was a member of the circle in Montpellier around the art collector and patron of Courbet Alfred Bruyas, whom Bazille knew in his early years.

40 Proudhon, *Du Principe de l'art*, p. 281.

41 This shows Proudhon seated on the steps of his house in the rue d'Enfer, Paris, in his tree-sheltered garden, where he was accustomed to do his writing when weather permitted. It originally also showed his wife. Courbet also portrayed Proudhon in his *The Painter's Studio*, 1855, Musée d'Orsay, Paris.

42 Quoted in Grad and Riggs, *Visions of City and Country Prints and Photographs of 19th-Century France*, exh. cat., Worcester, Mass., 1982, p. 190. For the continuity of the *jardin artificiel* with the *jardin naturel*, see Mangin, *Les Jardins*, p. 4, and Introduction to the present book.

43 See Proudhon, *Du Principe de l'art*, p. 281.

44 See Willsdon, '"Promenades et Plantations"'. See also the distinction drawn by George Sand in 'La Rêverie à Paris', in *Paris Guide*, II, p. 1199 between Haussmann's artificial *jardins paysagers* and actual 'nature'.

45 E. Frébault, 'Paris pittoresque: le transportation des arbres', *L'Illustration*, LIX, 1872, p. 235.

46 Robinson, *Parks, Promenades and Gardens of Paris*, p. 89; for Napoleon III's introduction of parks and gardens into Paris, see Alphand's detailed and lavishly illustrated *Promenades de Paris*; E. André, 'Les Jardins de Paris', in *Paris Guide*, II, pp. 1204–1216 (André was 'Chief Gardener of the City of Paris'); Chapter VI, 'Promenades et Plantations', of Haussmann's *Mémoires*, III; the chapter on 'Buildings and Parks' in Pinkney, *Napoleon III*; Grad and Riggs, *Visions of City and Country*, pp. 188–228; Choay, 'Haussmann'; Herbert, *Impressionism*, Chapter 1 ('Paris Transformed', pp. 1–32) and Chapter 5 ('Parks, Racetracks, and Gardens', especially pp. 141–61); and Willsdon, '"Promenades et

Plantations'". For the Buttes Chaumont, see 'Le Parc des Buttes Chaumont', *L'Illustration*, XLIX, no. 1264, 18 May 1867, p. 311.

47 See Choay, 'Haussmann', p. 93.

48 Baudelaire, 'Le Cygne' (The Swan), in *Les Fleurs du Mal*, p. 95.

49 Cf the journalist Louis Veuillot's description of Paris as a 'city of uprooted multitudes' (*ville des multitudes déracinés*) in his *Les Odeurs de Paris*, 1867 (quoted in Morizet, *Du vieux Paris*), p. 352.

50 Baudelaire, 'The Painter of Modern Life' [1863], in *The Painter of Modern Life*, p. 12; 'The Salon of 1845' in *Art in Paris 1845–62*, p. 32.

51 Baudelaire, 'Correspondances', in *Les Fleurs du Mal*, p. 13.

52 Paul de Saint-Victor, quoted in Tinterow and Loyrette, *Origins of Impressionism*, p. 266.

53 Baudelaire, 'Richard Wagner et Tannhäuser', 1861, in *The Painter of Modern Life*, p. 115–16.

54 Baudelaire, 'Les Veuves', in *Le Spleen de Paris*, pp. 56–7. H. Lemaître notes in his edition of Baudelaire's *Petits poèmes en prose* (Paris, 1958, p. 68), that Baudelaire himself recommended the subject of *Music in the Tuileries* to Manet.

55 Ibid., p. 57; 'L'Ennemi', in *Les Fleurs du Mal*, pp. 18–19. Cf the lines in the latter which describe how, 'Now that I am nearly at the autumn of inspiration/And have to use shovel and rakes/To tidy anew the flooded soil,/Where the water hollows holes as big as tombs//Who knows if the new flowers of which I dream/Will find in this ground washed like a seashore/The mysterious sustenance that would give them vigour?'.

56 Baudelaire, 'Les Veuves', p. 58.

57 'Règles de deuil', *La Mode illustrée*, 15 June 1863, p. 192; cf also 'Modes', in *La Mode illustrée*, 1864, p. 188.

58 See L. Taylor, *Mourning Dress: A Costume and Social History*, plate 65.

59 See P. Guiral, *La Vie quotidienne en France à l'age d'or du capitalisme 1852–1879*, Paris, 1976, p. 178.

60 This social geography is described in A. Joanne's *Le Guide parisien*, Paris, 1863, p. 119; it was still current in 1874 (see *Guide de l'etranger dans Paris et ses environs*, p. 98). Both sources record that a military band played between 5–6 pm each day in the gardens; the *Guide de l'étranger* says this did so between the Allée des Orangers and the central *allée*.

61 Baudelaire, 'Le Cygne', p. 95.

62 Morizet, *Du vieux Paris*, p. 182.

63 Baudelaire, 'The Salon of 1846', in *Art in Paris 1845–62*, p. 118.

64 Zola, 'Edouard Manet étude biographique et critique', Paris, 1876, first published as 'Une nouvelle manière en peinture: Edouard Manet (1867)', in *La Revue du XIXè siècle*, 1867, in *Ecrits sur l'art*, p. 153; his rejection of similarities between Manet's art and Baudelaire's work is on p. 152.

65 Courbet is thought to be the bearded figure seated on the grass in the central fragment of Monet's *Déjeuner sur l'herbe*; see Tinterow and Loyrette, *Origins of Impressionism*, p. 424.

66 Quoted in ibid.

67 Baudelaire, 'Correspondances', p. 13.

68 Tinterow and Loyrette, *Origins of Impressionism*, p. 135.

69 For Rousseau's visit to the estate and château of Rochecardon, which belonged to his Swiss friend Daniel Boy de la Tour, see M. Régnier, *Jardins et maisons des champs en Lyonnais*, Vourles, 1999, p. 54.

70 Castagnary, 'Salon de 1867', quoted in Cachin, 'Le Paysage du peintre', p. 476.

71 'Chronique horticole', *Revue horticole*, 1859, p. 337 (referring to the intended truncation of the Luxembourg Gardens).

72 Letter from Bazille to his mother from Honfleur, 1 June 1864, quoted in Tinterow and Loyrette, *Origins of Impressionism*, p. 420.

73 Proudhon, *Du Principe de l'art*, p. 268.

74 Zola, 'Les Actualistes', *L'Evénement illustré*, 24 May 1868, in *Ecrits sur l'art*, pp. 207–8.

Chapter 3: Private gardens before 1870
pp. 75–95

1 Zola, 'Les Actualistes', *L'Evénement illustré*, 24 May 1868, in *Ecrits sur l'art*, p. 209.

2 For the *Gladiolus gandavensis* and its development, see Chapter 2, n. 22, above, and Chapter 5, n. 23, below. For the 'Rose Impératrice Eugénie', see the text accompanying the plate of this name in *L'Illustration horticole*, September 1859; it was first put on the market in 1859, having been developed by Pierre Oger, a Caen horticulturalist, and noticed at the 1858 exhibition of the Central Horticultural Society of Caen and Calvados by the Empress, who allowed it to bear her name. For the strong tradition of rose-growing in 19th-century Normandy – where Monet was brought up – see D. Lemonnier, 'La Normandie, grande région de création de roses anciennes', *Hommes et plantes*, no. 31, Autumn, 1999, pp. 2–3. 'Gloire de Dijon', a rambler, was bred by Jacotet in 1853 and flowers almost continuously through the summer; its scent is 'Tea-like and powerful' ('Old Roses', at http://www.mc.edu/campus/users/nettles/rofaq/rofaq-or.html, consulted 3.7.03).

3 Comment recorded in Thiébault-Sisson, 'Claude Monet, les années des épreuves', *Le Temps*, 16 November 1900, quoted in House, *Monet*, p. 111.

4 Quoted in Duc de Trévise, 'Le Pélerinage de Giverny' (2), 'L'Atelier des "figures en plein air"', *La Revue de l'art ancien et moderne*, LI, 1927, p. 122.

5 Such contrast was discussed in Chevreul's influential *Principles of Harmony*, p. 262ff ('Application of the law of contrast of colours to horticulture'). This notes the way that colour contrasts between flowers are enhanced by their green foliage (p. 268). For the popularization of these principles in horticulture, see, e.g. Decaisne and Naudin, *Manuel de l'amateur des jardins*, II, pp. 53–7. Chevreul was Director of the Museum of Natural History and the Jardin des Plantes in Paris from 1863.

6 Recorded in F. Crucy, 'Le Peintre de l'air', *L'Aurore*, 12 June 1904, quoted in House, *Monet*, p. 114.

7 Zola, 'Les Actualistes', p. 209.

8 Comment recorded in Thiébault-Sisson, 'Claude Monet', quoted in House, *Monet*, p. 135.

9 Tinterow and Loyrette, *Origins of Impressionism*, p. 138.

10 Letter from Monet to Armand Gautier, 22 May 1866, no. 26, p. 423, WI, quoted in ibid., p. 429.

11 See E. de La Bédollière, *Histoire des environs du nouveau Paris*, pp. 31–2; the garden of Balzac's 'Maison des Jardies' at Ville d'Avray was too steep for trees, and Monet's comfortable, shaded, modern bourgeois *coin* at Ville d'Avray would have contrasted as much with this Romantic 'pic de Ténériffe' (Tenerife peak) (ibid., p. 32) as with the landscapes of pools and woods painted by Corot in the region. Interestingly, it was the Utopian ideals of Saint-Simon which apparently inspired Balzac to move to Ville d'Avray.

12 Letter from Monet to Bazille, December 1868, no. 44, pp. 425–6, WI; transl. based on that in Spate, *The Colour of Time*, p. 55.

13 Geffroy, *Claude Monet*, p. 47.

14 Zola, 'Les Paysagistes', *L'Evénement illustré*, 1 June 1868, in Zola, *Ecrits sur l'art*, p. 216.

15 Description of the garden created in 1841 of 'the property of M. Pivot-Faguet', in F. Duvilliers, *Les*

Parcs et jardins créés et exécutés par F. Duvilliers, architecte, ingénieur, paysagiste, dessinateur et ordonnateur de parcs et jardins, I, Paris, 1871, p. 103.

16 Ernouf and Alphand, *L'Art des jardins*, p. 125.

17 There was a famous spring of pure water at Ville d'Avray, which had been piped to Versailles for the exclusive use of Louis XV. Louis XVI had in turn constructed a château at Ville d'Avray. See de La Bédollière, *Histoire des environs du nouveau Paris*, pp. 31–2.

18 André, 'Exposition horticole internationale de Londres', *Revue horticole*, 1866, p. 234; André in fact makes the dramatic claim here that 'All or nearly all the varieties [of roses] currently grown in the gardens of Europe were born in France and bear French names'.

19 De La Bédollière, *Histoire des environs du nouveau Paris*, p. 2.

20 'A private letter' by Baudelaire, quoted in Lloyd, *Mallarmé: The Poet and his Circle*, p. 83.

21 Herbert describes the seated woman's face as 'mask-like' (*Impressionism*, p. 177). Cf Spate, *The Colour of Time*, p. 42, who also notes that the 'distancing' created by the simplified *taches* which compose the forms in turn engenders 'intimacy', in that the viewer becomes engaged by having to decipher these marks.

22 See M. Roskill, 'Early Impressionism and the Fashion Print', *Burlington Magazine*, CXII, June 1970, pp. 391–5. Roskill also compares figures in Monet's *Déjeuner sur l'herbe*, and *Camille*, with fashion plates.

23 See Chapter 2, n. 50.

24 Review of the fourth edition of Madame Millet's *Maison rustique des Dames*, in *Revue horticole*, 1859, p. 619.

25 'Chronique du mois', *La Mode illustrée*, February 1865, p. 46.

26 Chevreul in *Principles of Harmony* notes that white flowers 'accord . . . perfectly' with 'rose or red' ones (p. 264). In a list of 'Examples of plants which may be associated together under the relation of the colour of their flowers', he includes groups of 'Blood-red Bengal Rose (*Rosa semperflorens*)', 'Pink Bengal Rose' and 'White Bengal Rose' for the month of May (pp. 275–7).

27 De La Tour, *Le Langage des fleurs*, p. 73; cf also de Neuville, *Le Véritable Langage des fleurs*, p. 202, where a white rose with a red rose is identified as meaning 'Fire of the heart'.

28 Ibid.

29 Ibid.

30 Cf Goody, *The Culture of Flowers*, pp. 313–14. Goody also notes that by tradition the gift of a white rose is a 'particularly intimate gesture'; hence the frequent use of white roses as wedding flowers (p. 293).

31 Both de La Tour and de Neuville (see note 28) in fact cite the poet Bonnefons who 'sent, to the object of his affection, two roses, the one white and the other of the brightest pinky-red: the white one in order to imitate his pallor, and the pinky-red one in order to represent the fires of his heart; with his bouquet, he sent the verses: For you, Daphné, these flowers have just come into bloom: /See, the one is white, and the other coloured with vivid brilliancy: the one depicts my pallor, the other my ardour: both my unhappiness' (de La Tour, *Le Langage des fleurs*, p. 73). The red rose about to be plucked by the woman in the background of the painting in this sense 'completes' Monet's 'gift' of a white one.

32 Proudhon, *Du Principe de l'art*, p. 282.

33 See Chapter 1, n. 59.

34 The power of gardens to enchant or alter mood was a central theme of 19th-century horticultural treatises such as Boitard's *Traité de la composition*

et de l'ornement des jardins, which went through many editions. Michelet's *La Femme* (1859), p. 94 also describes the 'sweet enchantment' of a garden, which causes a woman to be 'fascinated, bewitched by the place'.

35 De La Tour, *Le Langage des fleurs*, p. xi.

36 See Chapter 1 and ibid., p. xii.

37 Though a yellow rose could in some circumstances symbolize infidelity, Goody points out that its meaning was dependent on the context in which it appeared or was used (*The Culture of Flowers*, p. 317). In Monet's painting it is closely associated with appeal to the senses.

38 Michelet, *La Femme*, pp. 430–1.

39 T. Reff, in *Manet: Olympia*, London, 1976, pp. 105–6, notes that the bouquet in *Olympia* probably features red and white roses. Though he states that it was in the 1860s that 'interest in the language of flowers was at its height' (p. 103), he does not, somewhat surprisingly, identify the 'sufferings of love' meaning of the pairing of red and white roses. The repetition of this choice of flowers by Monet a few years later in *Women in the Garden* was surely not coincidence, and suggests that greater weight should be placed on a symbolic reading of both *Olympia* and *Women in the Garden* than has hitherto been envisaged.

40 Though the de-petalled flower in the White Girl's hand has sometimes been interpreted by modern writers as a lily, its leaves accord with those of orange blossom. For the 'chastity' and wedding associations of orange blossom, see de La Tour, *Le Langage des fleurs*, p. 255.

41 Castagnary, quoted in Tinterow and Loyrette, *Origins of Impressionism*, p. 202.

42 See, for example, R. Spencer, 'Whistler's "The White Girl": Painting, poetry and meaning', *The Burlington Magazine*, CXL, 1142, May 1998, pp. 300–11.

43 Cf the preoccupation of literary 'Realism' with the 'underbelly' of Paris in novels such as the Goncourts' *Germinie Lacerteux*, 1864, and Zola's *Thérèse Raquin*, 1867.

44 See the discussion of this concept in Bullock-Kimball, *The European Heritage of Rose Symbolism*, p. 96.

45 Cf R. Lloyd, *Mallarmé: The Poet and his Circle*, p. 50 ('The poem becomes an exploration . . . of the artistic transposition of the world's beauty, and of the existential question of whether we have any proof that the external world exists').

46 Letter from Monet to Geffroy, 7 Oct, 1890, no. 1076, p. 258, WIII.

47 Goethe, letter to Eckermann, 13 February 1831, quoted in P. Wayne, *Goethe Faust, Part II*, Harmondsworth, 1959, p. 12.

48 Bullock-Kimball, *The European Heritage of Rose Symbolism*, pp. 51–2.

49 Comment by Monet quoted in Tucker, *Claude Monet*, p. 103.

50 Zola, 'Les Actualistes', p. 210; see G. Poulin, 'L'origine des *Femmes au Jardin* de Claude Monet', *L'Amour de l'art*, XVIII, March 1937, pp. 89–92.

51 Letter from Monet to Bazille, 25 June 1867, no. 33, pp. 423–4, WI.

52 Quoted in WI (1996), p. 10.

53 By 1868 Monet was obtaining portrait commissions from an Havrois industrialist, Louis-Joachim Gaudibert, while his sea subjects had appeal at the Paris Salon, as illustrations of places known to Parisians from holidays (cf Tucker, *Claude Monet*, p. 30). Garden subjects would have been cognate with the trend at the Salon noted by the critic de Lostalot: 'classicists and romanticists are throwing themselves into genre . . . [there is] an almost complete absence of what is commonly called High Art . . . artists no longer wish to avoid

what has to do with the soil' (*L'Illustration*, 11 June 1870, p. 423).

54 'Dr. L.', 'Prologue', 28 December 1853, in *Bulletin du Cercle Pratique d'Horticulture et de Botanique de l'arrondissement du Havre*, 1854.

55 'Rapport sur la visite faite aux Jardins de la Ville du Havre', p. 63.

56 X-ray analysis has shown that Monet appears originally to have included another figure in *Jean-Marguerite Lecadre in the Garden*; see entry for W68 in WI (1996), p. 38. Since this figure wears a panama hat, he was presumably Adolphe Monet; his deletion allows the emphasis to fall on the correlation of flower and woman in the painting.

57 Quoted in WI (1996), p. 67.

58 Spate, *The Colour of Time*, p. 49.

59 See entry for W95 in WII (1996): the painting 'shows the terrace of a property situated just below what is now known as the Alphonse-Karr Path, at Sainte-Adresse'. The Alphonse Karr Path joins the Promenade François Lebel, which directly overlooks the sea.

60 Letter from Monet to Bazille, end of December 1868–beginning of January 1869, no. 45, p. 426, WI. 'Chinese' and 'Japanese' were terms often used synonymously.

61 Baudelaire, 'The Exposition Universelle 1855' in *Art in Paris 1845–62*, p. 124.

62 See 'Ch. L.', text for Plate 1, *Gladiolus gandavensis (hybridus)*, in *Flore des serres et jardins de l'Europe*, II, March 1846, and Chapter 2, n. 22. The catalogue for 1867–8 for *Ognons à fleurs, plantes bulbeuses et fraisiers* produced by the seedsmen Vilmorin-Andrieux lists well over 100 varieties of gladiolus for sale, including 23 hybrid *gandavensis* varieties, described as 'novelties of 1867', and 'Semis Souchet' (seeded by Souchet).

63 Cf the comments on the difficulties of growing trees in the strong winds from the sea in 'Rapport sur la visite faite aux Jardins de la Ville du Havre' (*Bulletin du Cercle Pratique de l'Horticulture et de Botanique de l'arrondissement du Havre*, 1862), p. 63, and the discussions on whether or not the salt water borne in on such winds was detrimental to gardens, in the same journal in 1857, p. 43.

64 Lechevallier, 'Rapport sur la collection de Glayeuls de Monsieur Lefrançois par la commission des visites', *Bulletin du Cercle Pratique de l'Horticulture et de Botanique de l'arrondissement du Havre*, 1863, p. 87. M. Lefrançois's garden is described here as 'situated on the most preeminent part of the hill of Graville, at the top of rue Joly'. Was Monet already familiar with it from his sketching visits to the Graville quarter of Le Havre in 1856 as a 16-year-old (cf D.43, WV)? In 1866, the *Bulletin du Cercle Pratique* reported on a similar inspection visit undertaken by the members of the Cercle to 'one of the nurseries of M. Fauquet', to see his 'magnificent collection' of gladioli 'grown from seed' (p. 117).

65 See 'Fleurs lumineuses', extract from the *Indépendance belge*, in *Flore des serres et jardins de l'Europe*, XIV, 1861, p. 96, which discusses the 'phenomenon' of 'luminous flowers', whereby certain flowers, including nasturtiums, appear to give off 'little flashes of light . . . from quarter past ten to quarter past eleven at night'. The article attributes the phenomenon to the presence of phosphorescence. See also de La Tour, *Le Langage des fleurs*, p. 115. If the effect Monet evokes is not precisely 'flashes of light' amid darkness, he certainly captures the high colour temperature characteristic of nasturtiums even in shadow.

66 See the chapters on these series in Tucker, *Monet in the 90s*.

67 This is portrayed in Bazille's *The Studio in the rue La Condamine* (1869–70), Musée d'Orsay, Paris,

which is thought to include portraits of Monet, Renoir and possibly Sisley.

68 De Neuville, *Le Véritable Langage des fleurs*, 'Geranium', p. 163; 'Capucine', p. 130.

69 Letter from Monet to Bazille, 25 June 1867, no. 33, p. 424, WI.

70 Zola, 'Les Actualistes', p. 210.

71 *The Terrace at Méric* (1866–7), 97 x 128 cm, Musée du Petit Palais, Geneva.

72 See *Bulletin de la Société Centrale d'Agriculture et des Comices Agricoles du Département de l'Hérault*, 1864, p. 388 ('M. G. Bazille notes the results obtained against oleander fumagine . . . the oleanders have been washed, on their lower parts, with a solution of sodium sulfate, to which quicklime was then applied. The success was complete . . . ').

73 *Lise with a Parasol* (1867), 182 x 113 cm, Folkwang Museum, Essen.

74 Quoted in D. Cooper, 'Renoir, Lise and the Le Coeur Family: A Study of Renoir's Early Development – II: The Le Coeurs', *The Burlington Magazine*, CI, nos 678–9, September–October 1959, p. 326.

75 See ibid..

76 See House et al., *Renoir*, p. 189.

77 Homer's works were painted in gardens at Belmont near Cambridge, Mass. Pre-Raphaelite garden subjects include Ford Madox Brown, *An English Autumn Afternoon* (1852–4), Birmingham Museum and Art Gallery; W. H. Deverell, *The Pet* (also known as *Lady feeding a Bird*) (1852–3), Tate Britain, London; J. E. Millais, *Autumn Leaves* (1856), Manchester City Art Gallery; and A. Hughes, *Fair Rosamund* (1854), and *April Love* (1856), both Tate Britain, London. Since Fantin introduced Dante Gabriel Rossetti to Manet in 1862, and Baudelaire had referred sympathetically to Pre-Raphaelite work at the 1855 Universal Exhibition, it is possible that word of such pictures had reached the future Impressionists; Fantin-Latour himself planned in 1865 to paint a picture of his English patrons the Edwardses in their garden at Sunbury-on-Thames, though does not appear in the event to have done so.

78 Brettell, *Pissarro and Pontoise*, p. 212, n. 16.

79 Cf the period photographs of these gardens discussed by Brettell et al., *A Day in the Country*, p. 86.

80 Duret, 'Le Salon de 1870, les naturalistes: Pissaro (sic)', in *L'Electeur libre*, 12 May 1870, quoted in J. Pissarro, *Camille Pissarro*, p. 58.

81 See Tinterow and Loyrette's study by this name of the work of the Impressionists prior to their first group exhibition.

82 Quoted in J. Newton, 'French Literary Landscapes', in R. Thomson (ed.), *Framing France*, p. 49.

83 Ibid.

84 Gallé's lecture ('Le Décor Symbolique'), given in 1900 to the Académie de Stanislas, is reprinted in P. Garner, *Emile Gallé*, London, 1976; see p. 154 in this for his reference to the rose with thorns and leaves. For Rilke's 'rose poems', see Bullock-Kimball, *The European Heritage of Rose Symbolism*; for Le Sidaner's rose garden and paintings of it, see Galiègue et al., *Henri Le Sidaner*.

85 Entry for W1959 (*The House seen through the Roses*, 1925–6), in WIV (1996), p. 942.

Chapter 4: Painting the Parisian 'bouquet'
pp. 97–125

1 Daly, 'Promenades et Plantations. Parcs, jardins publics, squares et boulevards de Paris', *Revue de l'architecture*, XXI, 1863, p. 249.

2 Cristal, *Le Jardinier des appartements*, p. 2; L. Veuillot, *Les Odeurs de Paris*, 1866, quoted in

M. Braunschvig, *La Littérature française contemporaine*, 3rd edn, Paris, 1929, p. 246. Veuillot's phrase derives from Hugo's famous 'Ceci tuera cela' ('This will kill that') passage in *Notre Dame de Paris* (see ibid., p. 245).

3 The Parc Monceau was created in 1778 by Louis Carmontelle for the Duc de Chartres (later Duc d'Orléans); the Scottish designer Thomas Blaikie developed a *jardin anglais* there in 1783. Part of the park became State property in 1852. When the City of Paris acquired the entire park in 1860, the central portion was revamped and the periphery was sold off to building speculators, whose efforts were satirized in Zola's *La Curée*. See Elisseeff (pref.), *Grandes et petites heures du Parc Monceau*. For the 18th-century Tivoli garden, a popular complex of pleasure gardens near the rue Saint-Lazare, part of whose site became the Place Vintimille in 1846 (later painted by Vuillard), see Hillairet, *Dictionnaire historique des rues de Paris*, I, p. 454. Nostalgia for the garden is expressed in, e.g., F. Duvilliers, *Les Parcs et jardins créés et exécutés par F. Duvilliers, architecte . . .* , II, Paris, 1871, p. 143. For the protest at the truncation of the Luxembourg gardens (a petition signed by 12,000), see Chapter 2 and Fournel, *Paris et ses ruines*, p. 6.

4 A. Karr, 'Les fleurs à Paris', in *Paris Guide*, II, p. 1225.

5 See ibid.; J. Renoir, *Renoir, my Father*, p. 44. Jean Renoir records that, as a child, his father accompanied a neighbour when the latter went hunting in the fields subsequently covered by the 'Europe' quarter. For Haussmann as a 'vandal', see ibid., p. 63; Hugo had in 1832 already called the demolition of old buildings in Paris 'vandalism' (see Morizet, *Du vieux Paris*, p. 147).

6 Karr moved to Sainte-Adresse in 1841, where he became a municipal councillor, but from 1860 he gardened in Nice, where he fostered the development of commercial market-gardening and cut flower production (see Chapter 7). His down-to-earth *Voyage autour de mon Jardin* (1845) debunked the poetic descriptions of flowers in popular romantic literature.

7 André, 'Le Parc de Monceaux', p. 395. The Latin phrase is 'Oculis tu lege, non manibus'.

8 Daly, 'Promenades et Plantations' (op. cit.), p. 249; p. 128.

9 See, for example, Haussmann, *Mémoires*, III, p. 202, where he describes trees and shrubs 'garnishing and decorating' pavilions and buildings in the Bois de Boulogne. Georges Sand similarly characterized the kind of garden to be found in the new Paris as *le jardin décoratif par excellence* ('the decorative garden par excellence') ('La Rêverie à Paris', *Paris Guide*, II, p. 1199). See also the discussion of 'The politics of "embellishment" of Napoleon III' in M. Mosser, 'Jardins "fin de siècle" en France', p. 44.

10 Quoted in Tinterow and Loyrette, *Origins of Impressionism*, p. 413.

11 *Paris désert: Lamentations d'un Jérémie Haussmannisé*, Paris, 27 August 1868, pp. 6; 7; 10–12.

12 E.g. Loyrette in Tinterow and Loyrette, *Origins of Impressionism*, p. 288, who revises interpretations by Herbert and Reff of the Impressionists' pre-1870 city subjects as celebrations of 'modern Paris'.

13 Fournel, *Paris et ses ruines*, p. 77; p. 78.

14 Michelet, *La Femme* (1859), p. 431. Michelet – who was left-wing and Republican, like Guillaumin – also recalls here that 'nothing in my early childhood made a greater impression on me than the sight of the Panthéon on one occasion between me and the sun' – an effect not dissimilar to Guillaumin's silhouetting of the Pantheon against the glow of pinky clouds. The sun, of course, was a symbol of radical Republicanism and it was in 1881, the year of Guillaumin's painting, that Renoir, courting Salon sanction, famously refused to exhibit with him because to do so would be 'like exhibiting with any Socialist' (White, *Renoir*, p. 121).

15 See, for example, the discussion of the picture in Reff, *Manet and Modern Paris*, p. 36.

16 *Paris Guide*, II, p. 2025 ('Promenade à l'Exposition Universelle'). See also Chapter 2 above, and Fournel, *Paris et ses ruines*, pp. 20–2, which describes the *parc* occupied by the Universal Exhibition as 146,588 metres large, of which 5 hectares were the *jardin réservé*, dubbed 'the triumph of artificial nature' (ibid., p.22). The first International Horticultural Exhibition, held in London the previous year, was perhaps an influence; for this event, see Taylor, *The Victorian Flower Garden*, p. 187.

17 See Alphand, *Promenades de Paris*, I, pp. 128ff. and the section on 'Flore ornementale des Promenades de Paris' in II.

18 Herbert, *Impressionism*, p. 5, Clark, *The Painting of Modern Life*, p. 66 and Reff, *Manet and Modern Paris*, all identify the balloon as Nadar's, but its tether and position at the right of Manet's picture make it almost certainly one of the balloons described in W. de F, 'Le Grand Ballon de l'Exposition Universelle', *L'Illustration*, 1867, L, pp. 219–21, as making captive ascents in 1867 from avenue Suffren, beside the Exhibition, in commemoration of the first balloon ascent. They were each anchored by a 300m long cable.

19 Fournel, *Paris nouveau et Paris futur*, pp. 395–6.

20 1867, Städtische Kunsthalle, Mannheim.

21 Herbert, *Impressionism*, pp. 4–5.

22 Cf Baudelaire's attack on photography in his 'Salon de 1859', in *Art in Paris*, pp. 149–55, and his comment that 'Poetry and progress are two ambitious men who hate each other with an instinctive hatred, and when they meet upon the same road, one of them has to give place.' (ibid., p. 154). His description of 'Le Voyage' is in a letter to Maxime Du Camp, 23 February 1859, quoted in *Les Fleurs du Mal*, p. 429. For his antagonism to *le progrès*, see Willsdon, 'Baudelaire's "Le Voyage"', pp. 247–63.

23 Baudelaire, 'Le Voyage', in *Les Fleurs du Mal*, p. 155.

24 Comment to Georges Jeanniot (1881), in J. Wilson-Barreau (ed.), *Manet by Himself*, London, 1991, p. 261.

25 Baudelaire, 'Le Voyage', p. 160.

26 *The Burial*, c. 1867, The Metropolitan Museum of Art, New York.

27 Baudelaire, 'The Painter of Modern Life', in *The Painter of Modern Life*, p. 8. (Genius is 'childhood recovered at will').

28 Fournel, *Paris nouveau et Paris futur*, p. 42.

29 Hugo, 'Les Embellissements de Paris', in *Les Années funestes*, quoted in Morizet, *Du vieux Paris*, p. 352.

30 See Haussmann, *Mémoires*, III, pp. 91–2 and Choay, 'Haussmann', p. 90 and p. 99, note 26. Since, as noted in A. Picon, 'Le naturel et l'efficace: art des jardins et culture technologique', in Mosser and Nys (eds), *Le Jardin*, pp. 390–1, Haussmann's principle of 'regularization' was a function of Napoleon III's attempts at 'social pacification', it is clear that, in its time, the Impressionists' emphasis would have had subversive implications.

31 Haussmann, *Mémoires*, III, p. 517. According to Fournel, *Paris et ses ruines*, p. 10, the Square de la Trinité cost 4 million francs, and extended over 'a vast space' of 2,500 metres in front of the church; its garden was adorned with statues of Faith, Hope and Charity.

32 Théophile Thoré (W. Bürger), one of the early supporters of Millet and Courbet, had 'rediscovered' Vermeer (see his *Musées de la Hollande*, Paris, 1860, and J. Rosenberg, *On Quality in Art*, London, 1967, pp. 83–9); though Monet would not himself visit Holland (including the Rijksmuseum) until 1871, Thoré's important series of articles on Vermeer had been published in the *Gazette des Beaux-Arts* only the year before Monet's three views from the Louvre (1st period, XXI, 1866); he particularly admired Vermeer's *View of Delft* (Mauritshuis, The Hague), in which the sky fills more than half the composition, and a narrow panorama of buildings runs across the middle of the painting as in Monet's *Quai du Louvre* and *Garden of the Princess*. In 1891 Octave Mirbeau certainly described Monet's *Saint-Germain l'Auxerrois*, one of the 1867 views from the Louvre, as 'of the kind of fine classic form which makes you think of the purest Canaletto' ('Claude Monet', *L'Art dans les deux mondes*, 7 March 1891, in Mirbeau, *Correspondance avec Claude Monet*, p. 257).

33 Cf Fournel's description in *Paris nouveau et Paris futur*, p. 220, of a walk in old Paris as 'a voyage of exploration through worlds always new'.

34 Mangin, *Les Jardins*, p. v.

35 The *Paris Guide*, 1867, for example, contained extensive sections on the history of Paris and its gardens, architecture and monuments; more luxurious publications (with numerous plates) included Delvau et al., *Paris qui s'en va et qui vient*, 1859, and Audiganne and Bailly, *Paris dans sa splendeur*, 1861. Given Duranty's involvement in the former, it would be surprising if Monet had not either seen this volume, or heard discussion of Paris history through the gatherings at the Café Guerbois.

36 See 'Le Square du Vert-Galant' (the present name of this garden) in Soprani, *Paris jardins*, p. 47–9.

37 See *Paris Guide*, I, 1867, p. 563.

38 Zola, 'Les Squares', pp. 298–9. Although he in due course conceded that Alphand's *Promenades de Paris* was a fine publication ('Livres d'aujourd'hui et demain' in *Le Gaulois*, 8 March 1869, in *Oeuvres complètes*, X, pp. 801–5), Zola stated he would 'willingly pick a quarrel with M. Haussmann' (ibid., p. 802), and of course famously did so in 1872 in his novel *La Curée*.

39 Zola, 'Les Squares', p. 297.

40 Alphand, *Promenades de Paris*, I, p. 245.

41 Cf Chateaubriand's description of a cathedral as a 'constructed forest' (*forêt bâtie*), cited in the introduction of C. Morice, *Rodin: Les Cathédrales de France*, Paris, 1914, p. 17, and Baudelaire's metaphor of trees as 'living pillars' in his poem 'Correspondances'. Discussion of the relationship of nature and architecture with reference to Chateaubriand, and with the Gothic rose window as a key example, had in fact appeared in the *Revue horticole*, 1860, p. 282.

42 Morizet, *Du vieux Paris*, p. 188. There had already been proposals to demolish the church in 1809, and in 1832, when Victor Hugo protested strongly. Monet's view tellingly avoids the adjacent modern belfry and Mairie, just as he allows the trees of the garden square to obscure the new frescos and replacement statues, so despised by Fournel (*Paris nouveau et Paris futur*, p. 297), in the church's portals. Renoir certainly loved the church, preferring it even to St Mark's in Venice (letter to Madame Charpentier, 1881, quoted in White, *Renoir*, p. 112).

43 J. Clarétie, 'Les Places publiques, les quais et les squares de Paris', in *Paris Guide*, II, p. 1383; Clarétie goes on to assert that Paris will be 'defaced' if these two houses are demolished: 'This tip of the island is the nose of the capital.

42 E. Zola, *La Faute de l'Abbé Mouret*, in *Oeuvres complètes*, vol. 3, pp. 109–10.

43 Ibid., p. 120. See also Lemirre and Cotin, 'D'un paradis l'autre: la mort-fleur', p. 129. This article includes a detailed discussion of the phases and symbolism of the 'Paradou' episode in the novel.

44 Lhote, 'Mademoiselle Zélia', p. 708. A further layer of dark–light symbolism lies in the fact that Georges Dengadine, Mlle. Zélia's new lover, is an etcher – i.e. an artist who works in a black-and-white medium, whereas Resmer (Renoir), as a painter, uses colour.

45 Renoir, letter to Paul Berard from Venice, 1 November 1881, quoted in White, *Renoir*, pp. 108–9.

46 See White, *Renoir*, p. 81.

47 Comment to A. André, quoted in House et al., *Renoir*, p. 14.

48 Quoted in J. Renoir, *Renoir, my Father*, p. 217. In a letter of 1884 to Durand-Ruel, Renoir proposed the formation of a 'Society of Irregularists'; see White, *Renoir*, pp. 145–6. For Renoir's comments on 'irregularity', see also his *Grammar* (1883–4) as reprinted in Herbert, *Nature's Workshop*, pp. 139–41.

49 See Herbert, *Impressionism*, p. 192; and *Nature's Workshop*, p. 22; and House et al., *Renoir*, p. 13.

50 J. Renoir, *Renoir, my Father*, p. 177; though this source records 'the restaurant at the top of the Rue des Saules' in Montmartre as the site where Renoir painted *The Swing*, the picture is nowadays generally believed to have been carried out in Renoir's rue Cortot garden or its precincts (cf House et al., *Renoir*, p. 210).

51 Rivière, *Renoir et ses amis*, p. 130.

52 Posner, 'The Swinging Women of Watteau and Fragonard', pp. 78, 80.

53 Rivière, 'L'Exposition des impressionistes', p. 179. The word *tons* ('treating a subject for its *tons* . . .') is translatable either as 'colours' or 'tones', but in the context of Rivière's text, 'colours' makes most sense). Fénéon's comment is in 'L'Impressionisme', *L'Emancipation sociale, agricole, industrielle et commerciale*, 3 April 1887, reprinted in Riout (ed.), *Les Ecrivains devant l'impressionisme*, p. 420.

54 See Newton, 'Emile Zola impressioniste', part 1, p. 45, n. 20, which cites the recollection by Paul Alexis that, around this time, Zola 'did the rounds of the studios, above all the studios of the "Batignolles" school, which was the cradle of Impressionism. Thus it was that he became close to Edouard Béliard, Pissarro, Monet, Degas, Renoir, Fantin-Latour'.

55 E. Zola, *Une Page d'amour*, quoted in ibid., pp. 45–6.

56 c. 1876, Pushkin Museum, Moscow.

57 Quoted in Bailey et al., *Masterpieces of Impressionism and Post-Impressionism*, p. 30. Nini Lopez also posed for Renoir's *Mother and Children* (1874), The Frick Collection, New York, a formal portrait of a fashionably-dressed mother and her two young daughters taking a walk in a park, whose sale paid for the rent at rue Cortot; *Nini in the Garden* provides an informal opposite to this work.

58 J. Renoir, *Renoir, my Father*, p. 129.

59 See A. H. Brodick (ed.), *Paris*, London, 1950, pp. 439–40.

60 *Oarsmen* (known as *Luncheon by the River*) (c. 1879), The Art Institute of Chicago, and *Luncheon of the Boating Party* (1880–1), The Phillips Collection, Washington, D.C.; *On the Terrace* (1881), The Art Institute of Chicago, is a related subject. The *Dance* panels each show a waltzing couple. A drawing by Renoir based on *Dance at Bougival* (1882–3), Museum of Fine Arts, Boston, was used to illustrate Lhote's 'Mademoiselle Zélia' in *La Vie moderne* (1883). *Dance in the City* and *Dance in the Country* (both 1882–3, Musée d'Orsay, Paris) show Lhote himself, with Suzanne Valadon in *City* (set in a conservatory-salon) and Aline Charigot, Renoir's future wife, in *Country*. The latter, like the Bougival panel, is set in an outdoor restaurant garden; the freedom of rural life is thereby implicitly contrasted with the artifice of the city conservatory.

61 See F. Fosca, *Renoir his Life and Work*, London, 1964, pp. 91–3; to raise money for the venture, Renoir masterminded a theatrical presentation at the Moulin de la Galette, whose scenery, painted by Franc-Lamy and Cordey, portrayed a garden. Though the Pouponnat project came to naught, Madame Charpentier later founded a child-garden establishment of her own, 'La Pouponnière' (see Octave Mirbeau's eulogy of this in *Le Journal*, 12 December 1897, in P. Michel (ed.), *Octave Mirbeau: Combats pour l'enfant*, Vauchrétien, 1990, pp. 192–4).

62 Zola, letter to Yves Guyot, 13 February 1877, quoted in A. Schom, *Emile Zola: A Bourgeois Rebel*, London, 1987, p. 66.

63 For Ferry's 'Regular' Republic, see O. Ruelle, *Jules Ferry: La République des citoyens*, I, Paris, 1996, p. 37. For his praise for *plein-air* painting, see his speech at the Salon prize-giving of 1879, published in *Salon de 1880*, p. vi, and quoted in Cachin, 'Le Paysage du Peintre', p. 475).

64 The difference between Renoir and the 'Naturalist' writers is aptly summed up by Renoir's comment on Maupassant – 'He always looks on the dark side' and Maupassant's on Renoir 'He always looks on the bright side' (reported in J. Renoir, *Renoir, my Father*, p. 210).

65 J. Crary, *Suspensions of Perception*, pp. 90–4.

66 Forcing under glass in hothouses was widely used by horticultural establishments to bring on plants 'to provision the covered markets and principal mansions of Paris' ('Nouveaux Principes de la Culture Forcée', *Revue horticole*, 1870, p. 53); the flowering plants in particular in Manet's painting may well have been 'forced' in this way, and then purchased as ready blooms for Rosen's conservatory.

67 Following the innovative use of iron construction for conservatories such as De Mistel and Rohault's at the Jardin des Plantes, Paris (1833–6), Hector Horeau's at Lyons, and Joseph Paxton's at Chatsworth, the technique was deployed in other buildings, notably Paxton's Crystal Palace (1851), and Les Halles and stations such as the Gare St-Lazare in Paris. In 1852, the *Flore des serres et des jardins de l'Europe* had even advertised a proposal for a greenhouse to cover the entire Place de la Concorde in Paris ('Miscellanées', 1852, p. 139).

68 E. and J. de Goncourt, *Journal*, vol. 8 (1867–70) (ed. R. Ricatte), p. 70. Interestingly, the Paris 'Salon' itself (the official art exhibition, held at the Palais de l'Industrie), appears by 1874 to have become virtually a 'conservatory-salon': Zola recorded its 'great nave transformed into a garden You would have thought yourself at some princely reception, in a gigantic conservatory.' (*Le Sémaphore de Marseille*, 3 and 4 May 1874, in *Ecrits sur l'Art*, p. 272). By the late 1870s the Société d'Horticulture's own annual exhibition was being held at the Palais de l'Industrie (under the 'protection' of the Ministry of Fine Arts (see A. Truffaut, 'Exposition d'Horticulture en 1879' in *Revue horticole*, 1879, pp. 254–6); a conjunction of art and gardening with which Manet's image, as a Salon submission, perhaps also made play.

69 G. Sand, 'La Rêverie à Paris' in *Paris Guide*, 1867, vol. 2, p. 1199.

70 Huysmans, review of Salon of 1879, quoted in Heard Hamilton, *Manet and his Critics*, p. 216.

71 See Crary, *Suspensions of Perception*, pp. 106–7.

72 Herbert, *Impressionism*, p. 182; Crary, *Suspensions of Perception*, p. 106.

73 See note 29, above.

74 Zola, *La Curée* (pref. C. Duchet), Paris, 1970, p. 74. Zola based his description of the conservatory in *La Curée* on visits to that at the Jardin des Plantes in Paris; it is thought he also took inspiration from the conservatory of the mansion owned by the chocolate manufacturer Menier, beside the Parc Monceau.

75 Zola, review of *La Mère* by Eugène Pelletan, *Le Salut public* (7 July 1865), in Zola, *Mes Haines*, in *Oeuvres complètes*, 10 p. 89.

76 Cachin et al., *Manet*, p. 435, call these flowers oleanders. Dr Eric Curtis, former curator of the Botanic Gardens, Glasgow, has suggested to the author, however, that, as far as they may be discerned, the size of the flowers in proportion to the leaves, and the shape of the florets themselves, are in fact consistent with azalea or with *Hibiscus rosa-sinensis*.

77 Zola, *La Curée*, p. 74.

78 See T. F. Glick (ed.), *The Comparative Reception of Darwinism*, Austin and London, 1972, pp. 146–9.

79 *Boating*, 1874, Metropolitan Museum of Art, New York.

80 Quoted in Cachin et al., *Manet*, p. 437.

81 Because agapanthus does not withstand frost, it was often grown in pots indoors.

82 Truffaut, 'Exposition d'Horticulture . . .', p. 253. It is possible that, though grown indoors, the rhododendrons apparently shown in Morisot's *Young Woman Dressed for the Ball* of 1879 were already a reflection of the fashion for this flower which Truffaut predicts here.

83 See Chapter 5.

84 See Bailey, *Renoir's Portraits*, p. 202.

Chapter 7: The working garden *pp. 179–201*

1 See Caillebotte's letter to Monet, 18 July 1884, in Berhaut, *Caillebotte*, p. 252, where he calls Sand's *La Mare au Diable* (The Devil's Pond) one of her 'peasant nonsenses'.

2 For *King Carrot*, see A. de Lostalot, 'Une répétition du "Roi Carotte" à la Gaieté', *L'Illustration*, LIX, 13 January 1872, p. 22, and M. Savigny, 'Les Théâtres', ibid., 20 January 1872, p. 38. (Lostalot, interestingly, was editor at the *Gazette des Beaux-Arts*, and reviewed the Impressionists' 1876 and 1879 exhibitions in broadly favourable terms). Zola's comment on Pissarro is in 'Adieux d'un critique d'art', *L'Evénement*, 20 May 1866, in *Ecrits sur l'art*, p. 133, as transl. in Cachin et al., *Pissarro*, p. 46.

3 Ch. Martins, 'Parcs et jardins paysagers', *Revue horticole*, II, 1862, p. 327. Martins's article is a review of *Les petits Parcs et les jardins paysagers* (Small and Landscape Gardens), by R. Siebeck of Vienna, which included diagrams showing 'the clever combinations' whereby 'vulgar vegetables' such as certain types of cabbage, beetroot, tomato and aubergine might be partnered for decorative effect with 'luxury plants'.

4 The Symbolist opinion of Pissarro – 'Maraîcher impressioniste. Spécialité de choux' ('Impressionist market-gardener. Speciality in cabbages') – was expressed in *Le Petit Bottin des lettres et des arts*, 1886, p. 109, to which Félix Fénéon, Paul Adam, Oscar Méténier and Jean Moréas contributed. Pissarro's comment about the Symbolists is in his letter to Octave Mirbeau, 17 December 1891, no. 732 in C. Pissarro, *Correspondance*, III, p. 169.

5 Pissarro was responding to the sympathy towards the Symbolists shown by Camille Mauclair, editor of the *Mercure de France*. Letter to Lucien Pissarro, 29 May 1894, in C. Pissarro, *Camille Pissarro: Lettres à son fils Lucien* (ed. J. Rewald), Paris, 1950, p. 241. It should be noted that this letter is not included in C. Pissarro, *Correspondance*. Although in his letter to Mirbeau of 17 December 1891 cited above (n. 4), Pissarro had written that 'Our admirable ancestors, the Gothic artists, did not disdain this vegetable [i.e. the cabbage] either from the point of view of ornamental art, or from the point of view of culinary art' (C. Pissarro, *Correspondance*, III, p. 169), his use of the word 'culinary' rather than 'symbolic' here is readily explained by his reference in the previous sentence to the Symbolists' inability to make cabbage soup. For discussion of Pissarro's relationship with, and attitudes towards, Symbolism, see B. Thomson, 'Camille Pissarro', and Schiff, 'The Work of Painting'.

6 Zola, 'Les Actualistes', *L'Evénement illustré*, 24 May 1868, in *Ecrits sur l'art*, p. 207.

7 Zola, 'Les Naturalistes', p. 205.

8 R. R. Brettell, *Modern Art 1851–1929*, Oxford, 1999, p. 89. The phrase 'fresh seeing' is quoted by Brettell from the title of a lecture of 1930 by Emily Carr, a Canadian painter (see ibid., p. 83).

9 It was following a letter by Monet, published in the same newspaper (*L'Avenir national*), in which he expressed appreciation of Alexis's support in his article for the idea of an exhibition outwith the Salon system, that the charter for the first Impressionist exhibition was drawn up. See Nord, *Impressionists and Politics*, pp. 51–2.

10 Quoted in L. Daudet, *Souvenirs des milieux littéraires, poetiques, artistiques et médicaux*, Paris, 1920, p. 3. Léon Daudet, who trained as a doctor, was the son of the novelist Alphonse Daudet. Alexis's *L'Avenir national* article in fact called for the creation of an association of artists independent of the Salon, to be part of the 'great workers' organizational movement' (*grand mouvement ouvrier*) which he hoped would come into existence with the Third Republic. For this see Nord, *Impressionists and Politics*, p. 52 (author's translation).

11 Zola, 'Le Naturalisme au Salon', *Le Voltaire*, 19 June 1880, in *Ecrits sur l'art*, p. 423.

12 For discussion of the Impressionists' sympathies with the Republican party, see Nord, *Impressionists and Politics*, pp. 36ff, which notes (p. 38) that 'two movements, impressionist and republican, intersected in the 1870s. The new painters were in the main men and women of republican conviction, a *parti pris* that deepened as the decade wore on . . .'; see also S. F. Eisenman, 'The Intransigent Artist *or* How the Impressionists Got Their Name', in Moffett et al., *The New Painting*, pp. 51–9.

13 For the importance of work in Revolutionary philosophy, and agricultural workers as a 'political force' in the Revolution of 1789, see V. Mainz, *Women at Work, Men in Labour: Work and Image in the French Revolution* (ed. R. Williams), exh. cat., University of Leeds, 1998.

14 Duranty, 'Pour ceux qui ne comprennent jamais', *Le Réalisme*, 15 December 1856, in Nord, *Impressionists and Politics*, p. 26.

15 Though Pissarro did paint a number of views of the fields near Pontoise, and later, Eragny, Brettell notes his predilection for the domestic, enclosed area of nature called the *coin* (corner) in French, and typified by the domestic kitchen garden. Brettell, *Pissarro and Pontoise*, pp. 103–6.

16 Proudhon, *Justice*, III, as transl. in S. Edwards (ed.), *Selected Writings of Pierre Joseph Proudhon*, London, 1970, p. 83; *Du Principe de l'Art*, p. 258.

17 See A. R. Murphy, *Jean-François Millet*, Boston, Mass., 1984, p. 131; Murphy makes direct comparisons with Impressionist colour effects in discussing Millet's *Training Grape Vines*, c. 1860–4, another garden scene (p. 129), and *Sewing Lesson*, 1874 (p. 225) (both Museum of Fine Arts, Boston, Mass.). In the latter, the high-keyed luminosity of the garden view through the window suggests that Millet in turn had been influenced by Impressionism. Pissarro himself was reluctant to lend credence to the many comparisons which were made in his lifetime between his own and Millet's peasant subjects, but, as Thomson notes, 'There are instances in Pissarro's work when Millet's example seems to resonate' (R. Thomson, *Camille Pissarro*, p. 51). Brettell draws attention to Pissarro's reading of Proudhon's *Du Principe de l'Art* in 1865, and argues that 'he had been a confused, purposeless artist before this book inflamed his imagination and gave direction to his work' ('Camille Pissarro: Problems of Interpretation', in Lloyd et al., *Retrospective Camille Pissarro*, p. 16). Pissarro's painting is his *Landscape at Louveciennes (Autumn)* (1869–70), The J. Paul Getty Museum, Malibu (P&V 87).

18 For Kropotkin, see note 52, below. For 'sensation', see Pissarro's advice to his son Lucien that 'it is necessary to have persistence, will-power and free sensations, not dependent on anything but one's own personal sensation'. Letter from Pissarro to Lucien, 9 September 1892, in C. Pissarro, *Correspondance*, vol. III, p. 256. This letter was, interestingly, written from Les Damps, Octave Mirbeau's home, while Pissarro was in course of his group of paintings of Mirbeau's garden there (see ill. 209); his comment is followed immediately by a reference to these paintings, suggesting that he felt them to be an illustration of his principle of truth to 'personal sensation'. The French word *sensation*, which I have translated here by the English word 'sensation', embraces 'feeling' (i.e. emotional or subjective response) as well as sensory and physical experience. For discussion of the importance to Pissarro of the concept of 'personal sensation', see J. Pissarro, *Camille Pissarro*, p. 105.

19 Cézanne's comment is quoted in ibid. Pissarro's comment on work is in Octave Mirbeau's preface to *Catalogue de l'exposition de l'oeuvre de Camille Pissarro* (Galeries Durand-Ruel, Paris, 1904), as quoted and transl. in Cachin et al., *Pissarro*, p. 36. Mirbeau himself, writing in 1891 to thank Pissarro for one of his paintings, had already commented 'What a poet you are, my dear Pissarro, and what a worker!' Mirbeau, *Correspondance avec Camille Pissarro*, p. 51.

20 Mallarmé, 'The Impressionists and Edouard Manet', pp. 93–4. This was published in English.

21 Ibid., p. 94; p. 95. Manet's *The Railway* (1873) is in the National Gallery of Art, Washington.

22 See Tabarant, *Manet et ses oeuvres*, pp. 282–88; the critic Albert Wolff, hostile as ever, wrote an article on 17 April 1876 in *Le Figaro* in which he addressed Manet as 'condemned always to paint brutally what you see' (quoted in ibid., p. 283).

23 Ibid., p. 279.

24 Quoted in ibid., p. 280.

25 Mallarmé, 'The Impressionists and Edouard Manet', p. 94. For the history of the 'dirty linen washed in private' quip, and its Napoleonic use, see 'Linge' in Larousse, *Grand Dictionnaire universel du XIXè siècle*, 10, p. 537.

26 See Chapter 5, note 42.

27 P. Courthion, *Manet*, London, 1962, p. 120.

28 Gambetta, speech at Grenoble of 1872, quoted in D. Thomson, *Democracy in France The Third Republic*, Oxford, 1946, p. 41. If Gambetta saw his 'world of workers' as composed primarily of those whom Gildea has termed 'tradesmen, small manufacturers and farmers' (R. Gildea, *The Third Republic from 1870 to 1914*, London, 1988, p. 6), it was nonetheless a world he believed should be shaped by the dynamic of upward social mobility, and one in which, therefore, a concierge's son such as the boy portrayed by Manet might one day himself own property.

29 One hostile critic in fact likened *The Artist* to a picture of a miner, so dark was the colouring. See Heard Hamilton, *Manet and his Critics*, p. 198.

30 Comment by Manet recorded in a letter from Berthe Morisot's mother to her sister Edma, 29 June 1871, quoted in Nord, *Impressionists and Politics*, p. 43.

31 Mallarmé, 'The Impressionists and Edouard Manet', p. 97.

32 C. Cros, *Solution générale du problème de la photographie des couleurs*, in *Oeuvres complètes de Charles Cros* (ed. Forestier and Pia), p. 459. Manet was in especially close touch with Cros from around 1873, when they met at the bohemian salons of Nina de Callias, Cros's lover and the subject of a portrait by Manet. Cros had actually produced his 'solution' in 1869, but the French Academy of Sciences only opened his sealed account of it in June 1876, on his request – a request which would have closely coincided with Manet's exhibition of *The Laundry*, and which was prompted by Cros's awareness of rival techniques being developed by Edmond Becquerel, for example (see ibid., p. 628).

33 See note 24, Chapter 4. Manet had from the 1860s had photographs made of his work, and he used these and photographs of other artists' work as a technical aid and artistic starting point for some of his etchings. His painted photograph of *The Railway* (1873–4) is in the Durand-Ruel collection, Paris; see Cachin et al., *Manet*, pp. 342–3.

34 Mallarmé, 'The Impressionists and Edouard Manet', p. 97. In this context, the frequency with which the Impressionists were credited by their supporters with having advanced powers of physiological as well as imaginative vision is worth noting; their art was accordingly seen as making new demands on the viewer's faculty of sight. See, e.g., Ephrussi on Mary Cassatt (in Riout (ed.), *Les Ecrivains*, p. 242–3; Duret in ibid., p. 212; and J. Laforgue's comment (1883) that 'the Impressionist eye is the most advanced eye in the history of human evolution', in ibid., p. 336.

35 G. Flaubert, 'Scénarios de *Bouvard et Pécuchet*', in *Oeuvres complètes* (ed. Société des Etudes littéraires françaises), Paris, 1972, p. 648.

36 C. Cros, 'Songe d'été' (Summer Dream) (first pub. 1876 in *Paris à l'Eau forte*), in *Oeuvres complètes*, p. 114. Forestier and Pia, *Oeuvres complètes de Charles Cros*, p. 566, note Verlaine's similar disgust at the irrigation scheme in his 'Paysage' (Landscape), in *Jadis et Naguère*: 'Towards Saint-Denis the countryside is ugly and dirty.' For the history of use of sewage for irrigation in the Paris region at this period, see Philipponneau, *La Vie rurale*, pp. 73–4 and (especially for the Gennevilliers scheme), pp. 484–94; see also Clark, *The Painting of Modern Life*, pp. 161–2 and Tucker, *Monet at Argenteuil*, pp. 149–53.

37 Tucker, *Monet at Argenteuil*, p. 149–53.

38 Private collection. Both Millet's *Washerwoman* (1853–5, Museum of Fine Arts, Boston), and the

work of Daubigny (e.g., *View on the Oise with a Boat and Laundress*, 1872, National Gallery, London) had continued the ideal pastoral tradition, but Morisot's image of the *drying* of washing, with its delight in atmosphere, represents a distinctive shift in emphasis.

39 Zola, 'Exposition des oeuvres d'Edouard Manet' (*Préface* to catalogue of the retrospective exhibition of Manet's work at the Ecole des beaux-arts, Paris, January 1884), in *Ecrits sur l'art*, p. 456. Zola's image of 'departure for the unknown' echoes the final line of Baudelaire's 'Le Voyage' in his *Les Fleurs du Mal*, in which the travellers describe desire to plunge 'To the depths of the Unknown to find the *new*!'.

40 Though later than Morisot's painting, a particularly telling example of Mallarmé's 'white' imagery is his 1893 poem 'Salut' of the poet as a solitary mariner, facing 'the white care of our sail [or canvas]' (*Le blanc souci de notre toile*). This plays on the double meaning of the word *toile*, as either 'sail' or 'canvas' (see the commentary on this image in R. Lloyd, *Mallarmé: Poésies*, London, 1984, p. 39). Mallarmé's creative use of *blancs* (literally 'whites', i.e. the blank spaces between letters, words and lines) in his *Un Coup de dés* draws the reader even more directly into the 'work' of art, as a device intended to elicit meditation or dream (*faire rêver*); see ibid., p. 57. The most famous example of his imagery of whiteness is 'Le Nénuphar blanc' (The White Waterlily), published in 1885 and illustrated at his request by Morisot.

41 Caillebotte, *The House-Painters* (1877), private collection; and *Floor-Scrapers* (1875), Musée d'Orsay, Paris (another version of this subject was painted in 1876 and is in a private collection).

42 1850, Museum of Fine Arts, Boston

43 1877, The Art Institute of Chicago.

44 See Philipponneau, *La Vie rurale*, p. 142. Caillebotte's *Pont de l'Europe* (1876) is in the Musée du Petit Palais, Geneva.

45 'Progrès de l'arboriculture fruitière', *Revue horticole*, 1864, p. 213.

46 Castagnary, 'Exposition du boulevard des Capucines', p. 16.

47 J. Renoir, *Renoir, my Father*, p. 188. Pissarro's *Orchard in Bloom, Louveciennes* was originally known as *The Orchard*.

48 Philipponneau, *La Vie rurale*, p. 23.

49 Carrière, 'Sur la nomenclature des pêches et brugnons', *Revue horticole*, 1862, II, p. 394. Export of produce to England by rail from the Paris region was occurring as early as 1866; see ibid., p. 71.

50 See Karr's account of his role in the development of market gardening on the Riviera in *Le Jardin* (1888) [unpag.]. Philipponneau, in *La Vie rurale*, p. 67, notes that packets of flowers were first sent to Les Halles in Paris from the Midi in November 1871; for statistics by 1902, see p. 65.

51 Cf 'Nouveaux principes de la culture forcée', *Revue Horticole*, 1870, p. 53. The writer on Montreuil is Emile de La Bédollière, *Histoire des environs du nouveau Paris*, p. 192.

52 Kropotkin saw the intensive practices of market gardening as the logical sequel to the 'working in common of the soil' which had occurred in the Festival of the Federation during the French Revolution, and predicted that they would result in a more economical use of workers' time, so that 'hours of work' would become 'hours of recreation'; it would 'again be by the working in common of the soil that the enfranchised societies will find their unity and will obliterate the hatred and oppression which has hitherto divided them' (*The Conquest of Bread and other Writings*), pp. 194 and 197. Pinchon's painting

was exhibited in Rouen in 1921, but may have been painted in the 1900s; see C. Pétry et al., *L'Ecole de Rouen*, p. 94.

53 See Brettell, *Pissarro and Pontoise*, pp. 31–3. For the 'Belle de Pontoise' apple, developed in 1869 but not marketed until 1879, see 'Fruits nouveaux', *Revue horticole*, 1879, p. 189. This was one of many new apples born of the enthusiasm for 'pomology' which developed in France from the mid-19th-century – the science of cultivating fruit with pips or stones; cf. 'Sur la nomenclature des pêches' (1862), which reports the creation of the 'Congrès Pomologique de France', p. 394; and 'Progrès de l'arboriculture fruitière', *Revue horticole*, 1864, p. 213.

54 Castagnary, 'Exposition du boulevard des Capucines', p. 16.

55 T. Gautier, *La Préface de Mademoiselle de Maupin* (ed. G. Matoré), Paris, 1946, p. 31.

56 Letter from Pissarro to Théodore Duret (20 Oct. 1874), no. 37 in *Correspondance*, I, p. 95, announcing his imminent departure from Pontoise to visit his friend Ludovic Piette on his farm in the Mayenne: 'I am going there to study the figures and animals of the true countryside'. For the tradition of gardens on the periphery of settlements, see X. de Planhol and P. Clavel, *An Historical Geography of France*, Cambridge, 1994, p. 225.

57 Letter to Lucien Pissarro, 25 July, 1883 (actually written in June), no. 164 in C. Pissarro, *Correspondance*, I, p. 225; for Pissarro's ideal of 'synthesis', see R. Thomson, *Camille Pissarro*, p. 10.

58 In an 1892 letter to Mirbeau (21 April, no. 774 in *Correspondance*, III, p. 217), Pissarro wrote with reference to Kropotkin's *Conquest of Bread*, 'You have to admit that while it's utopian, it's nonetheless a beautiful dream and since we have often had examples where utopias have become reality, nothing stops you from believing that it may be possible one day, at least as long as mankind does not succumb and return to complete barbary.'

59 Kropotkin, *The Conquest of Bread*, p. 186.

60 The phrase *avoir du bien au soleil* is discussed in A. Frémont, 'The Land', in Nora (ed.), *Realms of Memory*, II, p. 31.

61 Shikes and Harper, *Pissarro*, p. 67.

62 See Chapter 5. The second picture of the seasonal pair is *Snow at l'Hermitage, Pontoise*, 1874, P&V 238, private collection (reprod. no. 64 in Brettell et al., *A Day in the Country*).

63 Proudhon regarded 'Progress' as, 'In the political order . . . synonymous with *liberty*, that is to say individual and collective spontaneity evolving unconstrained, by means of the gradual participation of the citizens in sovreignty and government'; he also saw 'progress' as involving the dynamic of 'series'. In this the 'fusion' of opposites produces 'synthesis' (Proudhon, *Philosophie du progrès*, 1853, in *Oeuvres complètes* (introd. Th. Ruyssen), Paris, 1946, pp. 79–80).

64 Nord, *Impressionists and Politics*, p. 47.

65 Proudhon, *Philosophie du progrès*, p. 96.

66 Ibid., p. 81.

67 Pissarro himself would, of course, later portray the market at Gisors in a group of works of the 1880s; these might, similarly, be interpreted as the 'omega' to his pictures at the same period of peasants working in gardens or in the fields.

68 See Philipponneau, *La Vie rurale*, p. 69, for the continued use in the 19th century of the *hotte* and *bât* for local transport of produce.

69 J. Vallès, *L'Enfant* (1879), p. 164.

70 'He firmly believes that the painter "exists within [ordinary] humanity", just as the poet, the farmer, the doctor, the blacksmith [and other workers] . . . Paintings should no longer constitute inaccessible treasures or sacred religious fetishes, but contributions to society valued like all other productions of human labour [*travail*] or genius.' Mirbeau, 'Camille Pissarro', *L'Art dans les deux mondes*, 10 January 1891, as quoted and transl. in Shiff, 'The Work of Painting', p. 309.

71 Vallès, *L'Enfant*, p. 174. For Zola's comment on Pissarro's art as that of an 'honest man', see Zola, 'Les Naturalistes', p. 204.

72 Duranty, *La Nouvelle Peinture*; Duret, *Les Peintres impressionistes Claude Monet, Sisley, C. Pissarro, Renoir, Berthe Morisot* (May 1878), in Riout (ed.), *Les Ecrivains*, p. 219 ('Just imagine, he has sunk to the depth of painting cabbages and lettuces, and, even, I believe, artichokes. Yes, in painting the houses in certain villages, he has portrayed the kitchen gardens which were dependent, in these gardens there were cabbages and lettuces, and, along with everything else, he has reproduced these on the canvas.').

73 Pissarro, letter to Lucien, no. 661, 13 May 1891, in *Correspondance*, III, p. 82.

74 Cf the comment in 'Les joies du jardinage', p. 231: 'There is nowadays no peasant who does not know the advantages of an orchard and who does not seek them . . . His sustenance is improved, and his morals themselves are sweetened through contact with a table at which disorder and misery no longer reign.'

75 R. Thomson, *Pissarro and Pontoise*, p. 10, notes that Pissarro 'came to find it difficult to respond to the summer, "with its fat green monotony", saying that "the *sensations* revive in September and October."' (Pissarro's remarks are quoted here from C. Pissarro, *Correspondance*, III, letter 930, to Lucien, 15 September 1893, p. 368).

76 See R. R. Brettell, 'The "First" Exhibition of Impressionist Painters', in Moffett et al., *The New Painting*, pp. 194–5. The deliberation with which the painting was created is apparent from its overlaid paint, indicating reworking in the studio (see J. Pissarro, 'Pissarro's doubt: Plein-air painting and the abiding questions', *Apollo*, 136, Nov. 1992, p. 324.)

77 Mirbeau, article in *Gil Blas*, 14 May 1887, quoted in C. Pissarro, *Correspondance*, II, p. 171. For Pissarro's paintings of Mirbeau's garden, see Chapter 8 and note 18, above.

78 Duranty, *La Nouvelle Peinture*, p. 76.

79 Zola, 'Lettres de Paris Une Exposition de tableaux à Paris', IV, *Le Messager de l'Europe*, June 1875, in *Ecrits sur l'art*, p. 296.

80 See Ward, *Pissarro*, pp. 34–7. Pissarro's comment appears in his letter to Lucien, no. 211, 21 January 1884, in C. Pissarro, *Correspondance*, I, p. 276.

81 E.g. letter to Lucien, 14 April 1887, no. 412 in ibid., II, p. 151 (' . . . I still don't know how to frame my *Apple-Eaters* . . . '); and letter to Lucien, 15 May 1887, no. 423 in ibid., p. 166 ('grouped around my *Apple-Eaters*, my exhibition would have been much superior' – a reference to an exhibition at the dealer's Georges Petit in Paris in 1887).

82 G. Simmel, 'Sociology of the Meal' (*Soziologie der Geselligkeit*), opening speech at the first meeting of the German Sociological Society, October 1910, in Frankfurt am Main, in D. Frisby and M. Featherstone (eds), *Simmel on Culture*, London, 1997, p. 130. Simmel's method as a sociologist has itself been termed that of an 'Impressionist'.

83 J. Ajalbert, 'Le Salon des impressionistes' (1886), p. 432.

84 Draft letter from Pissarro to Hugues Le Roux, prior to 16 May 1886, quoted in Ward, *Pissarro*, p. 282, n. 3.

85 L. Pissarro, quoted and transl. in ibid., p. 46. Pissarro particularly admired the Gothic sculpture of Chartres cathedral. In this context it is perhaps relevant to note that Proudhon valued Gothic art as 'the product of a power of social collectivity' – a power he wished modern France to emulate (*Du Principe de l'art*, p. 83).

86 See Pissarro, letter to Lucien, 8 May 1886, no. 334 in C. Pissarro, *Correspondance*, II, pp. 44–5.

87 Huysmans, 'L'Exposition des Indépendants en 1880', from *L'Art moderne*, 1883, in Riout (ed.), *Les Ecrivains*, pp. 254–5. In his review of the Impressionists' 1881 exhibition, also published in *L'Art moderne*, Huysmans gave lavish praise to Pissarro's paintings, and concluded that ' . . . one great fact dominates, the blossoming of Impressionist art as it has come to maturity with M. Pissarro'. Ibid., p. 295.

88 This was noted by Jean Ajalbert, one of the new generation of critics associated with Symbolism, in his sympathetic review of Pissarro's contribution to the 1886 Impressionist exhibition, 'Le Salon des Impressionistes', p. 432 ('her large eyes were closed').

89 G. Moore, *Reminiscences of the Impressionist Painters*, Dublin, 1906, p. 40, quoted in Cachin et al., *Pissarro*, p. 126.

90 Letter from Pissarro to de Bellio, 26 March 1882, no. 104 in *Correspondance*, I, p. 162; Pissarro's comment here that 'the academy is beginning to occupy itself with it [magnetism], while denying the power of the magnetizer' implies that, although he used the term 'magnetism' rather than the word 'hypnotism' which was associated with Charcot's experiments, he was familiar with the debate about suggestibility surrounding the latter. Though Charcot's colleague and rival Dr Hippolyte Bernheim of Nancy challenged Charcot's belief that only subjects with neuroses were capable of being hypnotized, both men saw the suggestibility of the subject, rather than the actions of the hypnotizer, as determinant. Ward, in *Pissarro*, p. 43, certainly notes the similarity between the angular, 'primitive' poses of the figures in *Apple-Picking* and those of certain figures by Degas at this period which have been likened to the illustrations of hysterical patients published by Charcot.

91 Quoted from G. Guinon and S. Woltke, 'De l'influence des excitations sensitives et sensorielles dans les phases cataleptique et somnambulique du grand hypnotisme', *Nouvelle Iconographie de la Salpêtrière*, 4, 1891, p. 79; and from J.-M. Charcot's and P. Richer's *Les Démoniaques dans l'art*, Paris, 1887, pp. 92 and 102, in Silverman, *Art Nouveau*, p. 85. Pissarro was perhaps also aware via Duret (who had visited Japan), of Zen Buddhist ideals of trance-like self-absorption (see Spate et al., *Monet and Japan*, pp. 28–30, for French awareness of Buddhism in this period).

92 Museum of Fine Arts, Boston. Though he felt that Gauguin was wrong in eventually placing emphasis on imagination rather than observed reality, Pissarro played an active part in seeking support for his younger colleague's first visit to Tahiti.

93 Gauguin, *The Market Gardens of Vaugirard*, (c. 1879), Smith College Museum of Art, Northampton, Mass.

94 Huysmans, *A Rebours* (pref. H. Juin), Paris, 1995, p. 263. Pissarro lent Monet a copy of this novel in 1884 (see Pissarro, *Correspondance*, I, letter no. 262, to Monet).

95 For the history of this painting, see Pétry et al., *L'Ecole de Rouen*, p. 74.

Chapter 8: Monet in the south and at Giverny
pp. 203–229

1 Truffaut, 'Le Jardin de Claude Monet', p. 56. The 'Maison du Pressoir' where Monet settled had originally been a cider farm. Monet did grow vegetables at Giverny (cf letters such as no 462, 26 March 1884, WII, p. 247, re. planting out onions) – but, in contrast to the Pissarros at Eragny, separately from his flowers. His *jardin potager* at the Maison Bleue in Giverny (purchased c. 1913) supplied the field hospital set up in the village during the First World War.

2 Alexandre, 'Le Jardin de Claude Monet'.

3 For the Kochee copy, created to commemorate the millennium, and emulations of parts of Monet's garden in the USA and elsewhere, see Holmes, *Monet at Giverny*, p. 185.

4 Alexandre, 'Le Jardin de Claude Monet'; Clemenceau, *Claude Monet par Georges Clemenceau*, p. 35. Since Clemenceau puts the phrase 'Garden of water and fire' in quotation marks, it may even be Monet's own. For 'my most beautiful work of art', see Introduction, n. 4.

5 Truffaut, 'Le Jardin de Claude Monet', p. 55.

6 Rivière, *Renoir et ses amis*, p. 250; R. Gimpel, *Diary of an Art Dealer*, introd. H. Read, London, 1966, p. 11 (comment from 1918). Rivière (p. 250) recounts that Renoir purchased Les Collettes on account of its 'thousand-year old olive trees, which filled the policies, and were in great danger of being cut down to make for floral cultivation' [i.e. market gardening]. With their narrow leaves which filter the sunlight, olives would have created the same effects of dappled light and shade as the acacias which had inspired Renoir in Montmartre. For Les Collettes, see also Geffroy, *Claude Monet*, pp. 168–9.

7 For Caillebotte's garden at Petit Gennevilliers, see Distel et al., *Gustave Caillebotte*. His brother Martial's photographs clearly show the garden's dedicated beds.

8 *Le Journal des Roses*, for example, was published in Melun, 'at the very heart of these huge nurseries where Roses are counted by the million; one could not find a more sumptuous crade for the birth of the Journal des Roses' (1877, p. 1).

9 Cf Monet's letter to Thérèse Janin, 24 February 1914, no. 2109, WIII, p. 390 ('what you call my paradise'); Geffroy, *Claude Monet*, p. 327 ('you believe . . . you are entering a paradise' when you open the garden's gate); Clemenceau, *Claude Monet par Georges Clemenceau*, p. 67 ('a paradisical repose'); Gillet, 'Après l'Exposition Claude Monet', p. 671 ('this little paradise of water'); and Forestier, 'Le Jardin de Claude Monet', p. 13 ('In the middle of the garden is Eden, Paradou . . . ' [an allusion to Zola's reinvention of Paradise in *La Faute de l'Abbé Mouret*]); cf also Hoschedé's refusal of such analogies (*Claude Monet*, I, p. 65). For Monet's own use of the term at Bordighera, see his letter to Alice, 11 February 1884, no. 415, WII, p. 237.

10 Letter to Durand-Ruel, 11 March 1884, no. 442, WII, p. 243.

11 Although Stuckey notes that the Moreno Garden which Monet painted at Bordighera in 1884 was 'surely an inspiration for the lavish Giverny garden' (Stuckey, *Claude Monet*, p. 210), relationships between the latter and Monet's visits to the Mediterranean coast of Italy and France in 1883, 1884 and 1888 do not appear to have been explored beyond this.

12 See, e.g. Levine, *Monet, Narcissus and Self-Reflection*, p. 215 ('Like Alexandre, Thiébault-Sisson [in 'Choses d'Art', 1909] repeats the saga of Monet's "cloistered" seclusion at Giverny . . . '; and Geffroy, *Claude Monet*, p. 326 ('his retired life among his flowers [at Giverny]'). Holmes draws attention to Giverny's nature as 'an oasis' for Monet and 'sanctuary' for Clemenceau during the First World War, and describes Monet in later years as 'deliberately cut off from the unrecognizable world' beyond the garden (*Monet at Giverny*, p. 53 and p. 59); Spate places Monet's work at Giverny in the context of the mood of 'retrospection and interiority' of the fin de siècle (*The Colour of Time*, p. 233; see also p. 201). Monet undoubtedly became more reclusive in his later years, but this is readily explained by the physical limitations of his cataracts, eventually operated on in 1922, and by his depression after the death in 1911 of Alice Hoschedé, whom he had married in 1892, and of his son Jean in 1914; see Joyes et al., *Monet at Giverny*, pp. 38–9.

13 See chapters 3 and 5.

14 E. de Goncourt, 'Préambule' to *La Maison d'un artiste*, 1880, in E. and J. de Goncourt, *Oeuvres complètes*, XXXIV–XXXV, Geneva and Paris, 1986, pp. 8–9 ('this passion which has become general, this pleasure in solitude to which almost an entire nation is giving itself up, owes its emergence to emptiness and boredom of the heart, and, it must be recognized, to the sadness of the present times, the uncertainty of our tomorrows, the birth, feet first, of the new society It is these reasons . . . which at the present moment, make everyone collectors and me in particular the most passionate of all collectors.').

15 Geffroy, *Claude Monet*, p. 176; p. 175. Caillebotte in fact had two gardeners to help tend his garden.

16 Benjamin, 'Unpacking my Library: A Talk about Book Collecting', 1931, in H. Arendt (ed.), *Walter Benjamin: Illuminations*, London, 1979, p. 61. See also Monet's step-son Jean-Paul Hoschedé's insistence that Monet was not a '"solitary egotist"', 'living . . . for his sole pleasures: paintings and gardens' (*Claude Monet*, I, p. 87).

17 See Hoschedé, *Claude Monet*, I, p. 61; Holmes, *Monet at Giverny*, p. 90; and the descriptions of passers-by looking in on the garden in Alexandre, 'Le Jardin de Claude Monet' and Kahn, 'Le Jardin de Claude Monet'.

18 Among the first of these was the engraving after a photograph by Theodore Robinson of Monet wearing clogs in what appears to be the *clos normand*, in Guillemot, 'Claude Monet', 1898.

19 Letter to Geffroy, 7 October 1890, no. 1076, WIII, p. 258.

20 Letter to Monet, c. 27 Sept., 1890, no. 47 in Mirbeau, *Correspondance avec Claude Monet*, p. 111. Mirbeau suggestively transferred this affection for dung to the painter hero of his novel *Dans le Ciel* (In the Sky), 1892–3 (see ibid., n. 3).

21 Alexandre, 'Le Jardin de Claude Monet'; Marx, 'Les Nymphéas de Claude Monet', p. 527. Cf Geffroy, *Claude Monet*, p. 326 ('It is at Giverny that you must have seen Claude Monet in order to know him, to understand his character, his style of existence, his intimate nature.').

22 See Chapter 1, n. 59.

23 Schopenhauer's idea appears in his *Die Welt als Wille und Vorstellung* (The World as Will and Representation), 1819. See Duret, 'Arthur Schopenhauer', in *Critique d'Avant-Garde*, Paris, 1885, pp. 300–12. Kahn's 'Le Jardin de Claude Monet' notes that *Critique d'Avant-Garde* was in Monet's library.

24 Duret, 'Arthur Schopenhauer', p. 312. This article was, in fact, first published in *Le Siècle*, March 1878 – the year when celebrations took place to mark the centenary of Voltaire's death, and it was Duret to whom Monet wrote just after moving to Giverny that it was 'a splendid place for me' (no. 354, WII, p. 229). As a free-thinker, Voltaire had

famously concluded in his poem 'Le Mondain' ('The Man of the World') that paradise lay not in some remote garden of Eden, but 'where I am' (see R. H. Williams, *Dream Worlds: Mass Consumption in late 19th-century France*, Berkeley, Los Angeles and Oxford, 1982, p. 39).

25 Hoschedé, *Claude Monet*, II, pp. 28 and 90–123.

26 Letter from Monet to P. Durand-Ruel, 1 December 1883, no. 383, WII, p. 232.

27 Letter to Alice, 9 February 1884, no. 412, WII, p. 237; for the 'terrestrial paradise' comment, see n. 9 above.

28 'E. Renoir, 'L'Etiquette', *La Vie Moderne*, Paris, 15 and 29 Dec., 1883'. R. Walter notes that Charles Garnier, architect of the Paris Opera, who lived at Bordighera (and whose Villa Bischoffsheim there appears in Monet's *Villas at Bordighera*, ill. 214), had described the Moreno Garden as 'the pearl of Bordighera' in *Les Motifs artistiques de Bordighera* in F. F. Hamilton, *Bordighera et la Ligurie occidentale*, Bordighera, 1883; this source could also have alerted Monet to the possibilities of the garden as a motif. See Walter, 'Charles Garnier et Claude Monet à Bordighera', *L'Oeil*, 258, 1977, p. 27.

29 E. Renoir, *L'Etiquette*, p. 831.

30 Letter to Alice, 29 February 1884, no. 434, WII, p. 242.

31 Truffaut, 'Le Jardin de Claude Monet', pp. 57–8; this in fact describes the flower-filled *clos normand* at Giverny as 'this former Normandy yard' (*cour normande*). Truffaut became a close friend of Monet's in the later 1900s and 1920s. The 'blue' flowers described by Truffaut include aubretias, violas, iris and wisteria; the yellow ones wallflower, aquilegia and laburnum.

32 Chevreul, *Principles of Harmony*, p. 264 ('Yellow flowers, especially those which incline to orange, accord very well with Blue flowers'). For the 'disagreeable' effect of 'leopard's bane (doronica), of a brilliant golden yellow, side by side with the narcissus, which is of a pale greenish-yellow', see pp. 262–3.

33 Letter to Alice, 29 February 1884, no. 434, WII, p. 242.

34 Ibid.

35 For Monet's ordering of these and other waterlilies from the great French grower and hybridizer of waterlilies, Joseph Bory Latour-Marliac, see Holmes, *Monet at Giverny*, p. 97, and Russell, *Monet's Waterlilies*, pp. 32–42. For a period description of the *Nymphaea zanzibarensis* ('one of the most beautiful and easily grown of all the tropical waterlilies . . . [with] flowers . . . of a rich deep blue . . . [which] when well grown will measure fully 10 inches in diameter') and *Nymphaea stellata* ('from tropical Africa . . . a free-blooming and desirable species, with large, bright blue flowers'), see *The Garden*, 44, 1893, p. 507 (an issue dedicated to Latour-Marliac). The *N. zanzibarensis* had been mentioned in 1891 in an account of recent developments in waterlily culture in *La Revue horticole* (Vilmorin, 'Les Nymphaea rustiques', p. 22). Though Monet created a special cement tank within his pond in 1901 for exotic waterlilies, and overwintered them in containers in his greenhouse, he apparently had more success with Latour-Marliac's new hardy and half-hardy hybrids; he removed the tank when he further enlarged the pond in 1910 (see Gordon, 'The Lily Pond at Giverny', pp. 161 and 164).

36 The Romantic quest for the 'blue flower', emblem of mystical love and aspiration, is most famously exemplified in Novalis's *Heinrich von Öfterdingen*, 1800, (see J. Gage, 'Mood Indigo' in K. Hartley (ed.), *The Romantic Spirit in German Art 1790–1990*, exh. cat., Edinburgh, London and

Berlin, 1994, p. 122); it influenced French 19th-century flower-imagery in literature (see Knight, *Flower Poetics*, pp. 23–4).

37 De Neuville, *Le Véritable Langage des fleurs*, p. 220; letter to Alice, 3 March 1884, no. 436, WII, p. 242.

38 Letter to Alice, 5 March 1884, no. 438, ibid., p. 243.

39 The anemone serves as reminder of the beautiful Adonis, killed by a boar, whose absence was mourned by his lover Aphrodite. See Lemirre and Cotin, 'D'un paradis l'autre: la mort-fleur', pp. 112 and 116; see also Gubernatis, *La Mythologie des Plantes*, n. 2, p. 151.

40 Goethe, 'Mignon', in L. Forster (ed.), *The Penguin Book of German Verse*, Harmondsworth, 1966, p. 216.

41 De Neuville, *Le Véritable Langage des fleurs*, p. 137.

42 Letter to Alice, 12 March 1884, no. 444, WII, p. 244.

43 For Alice's gift of a violet and Monet's return gift of 'wild flowers', see his letter to her, 16 March 1884, no. 447, ibid. Monet's and Alice's exchange of flowers is in essence cognate with age-old courtship customs involving symbolic tokens; for some French examples of these, see D. Hopkin, 'Love Riddles', *Family History*, 28:3, 2003, pp. 339–63.

44 For the 'fine Norman apple' from de Bellio, see Monet's letters to Alice, 3 and 4 March 1884, nos. 436 and 437, ibid., p. 242.

45 Letter to Alice, 18 March 1884, no. 449, ibid., p. 244; Monet adds here that 'more than ever I want to share your life, to be at your side, to garden, to look after our poultry'.

46 J. Starobinski, 'Sur quelques Apparitions des fleurs' in Y. Peyré (ed.), *Mallarmé un destin d'écriture*, pp. 21–35.

47 Lloyd, *Mallarmé: The Poet and his Circle*, p. 138. Mallarmé had visited the Riviera in 1866.

48 See, e.g. Spate, *The Colour of Time*, pp. 237; see also her discussion (p. 203) of Mallarmé's 'aesthetic of absence' in his 'Nénuphar blanc' in relation to Monet's work more generally.

49 See Holmes, *Monet at Giverny*, pp. 93–100 and p. 109 for Monet's purchases from Latour-Marliac and his visit in the early 20th century to the grower's renowned waterlily nurseries at Temple-sur-Lot near Bordeaux; see also Russell, *Monet's Water Lilies*, pp. 32–42; Latour-Marliac, 'Hardy Water Lilies and Nelumbos' (transl. and adapted by J. M. Berghs), *The Garden*, 1888; Vilmorin, 'Les Nymphaea rustiques'; L. W. Goodell, 'Aquatic Plants and their Culture', *The Garden*, 44, 1893, pp. 506–9; F. W. Burbidge, 'New Hardy Waterlilies' in ibid., pp. 297–8. Latour-Marliac obtained three gold medals at the 1889 Universal Exhibition in Paris for his innovatory hybrid waterlilies.

50 E.g. See D. Druick and P. Zegers, *Van Gogh and Gauguin: the Studio of the South*, Chicago and New York, 2001, p. 102.

51 See Goody, *The Culture of Flowers*, p. 153; cf the Van Eycks' representation of Paradise in the *Adoration of the Lamb* in S. Bavon, Ghent, where, according to Lemirre and Cotin, over fifty species of flowers are shown ('D'un paradis l'autre: la mort-fleur', p. 117).

52 Quoted in X. de Planhol and P. Clavel, *An Historical Geography of France*, Cambridge, 1994, p. 293.

53 See Tucker, *Monet in the 90s*, and 'The Revolution in the Garden: Monet in the Twentieth Century' in Tucker et al., *Monet in the 20th Century*, pp. 14–85 (see p. 17 in ibid. for period interpretations of Monet's late work as 'expressing' France).

54 See Kahn, 'Le Jardin de Claude Monet'.

55 See Hoschedé, *Claude Monet*, I, p. 48, n.1.

56 Utagawa Hiroshige, *Inside Kameido Tenjin Shrine*, 1856. This was not actually in Monet's collection of Japanese prints, displayed around the walls of his house at Giverny.

57 See de La Tour, *Le Langage des fleurs*, p. 316 (wisteria means 'Your friendship is sweet and agreeable', in accordance with Chinese tradition).

58 See A. Mabuchi, 'Monet and Japanese Screen Painting', in Spate et al., *Monet and Japan*, pp. 186–94.

59 Letter to Alice, 4 March 1884, no. 437, WII, p. 242.

60 Letter to P. Durand-Ruel, 27 May 1885, no. 566, ibid., p. 259.

61 Letter to an unknown recipient, 25 March 1884, no. 460, ibid., p. 246.

62 See Monet's letter to Alice, 10 November 1886 from Kervilahouen, no. 742, ibid., p. 288.

63 For the Villa Thuret Gardens, originally established by Gustave Thuret in 1856 and taken over in 1877 by the State as a centre for advanced botanical instruction annexed to the Jardin des Plantes and Natural History Museum in Paris, see H. Vilmorin, 'La Villa Thuret', pp. xxvi–xlix. The gardens are still extant.

64 Letter to Alice, 9 February 1888, no. 832, WIII, p. 229. Vilmorin called the Thuret Garden 'for the botanist, a precious casket containing treasures' ('La Villa Thuret', p. xix).

65 Henri Vilmorin, representing the Société Botanique de France, had led its 1883 field-visit to Antibes, which included a detailed study of the Villa Thuret Garden. See 'Séance du 12 mai 1883' in *Bulletin de la Société Botanique de France*, 30, 1883, p. v, and Vilmorin, 'La Villa Thuret'.

66 See ibid., pp. xlvi–xlvii. This arrangement was, of course, also reminiscent of the kind of 'natural' planting advocated by William Robinson's *The Wild Garden*.

67 Letter to Alice, 1 February 1888, no. 824, WIII, p. 227. It is possible that the gardeners' cottages and the unidentified site planted with parasol pines which Monet painted at Antibes were in fact those of the Villa Thuret gardens; cf Vilmorin's description of such cottages in the *jardin potager* leading down to the sea at the 'Salis side' ('La Villa Thuret', p. xliv), and of the pines which grew there against a backdrop of the Gulf of Nice and distant Alps (ibid., p. xxvii).

68 Ibid., pp. xlvi and xlviii.

69 Letter from Mirbeau to Geffroy, 1890, quoted in Mirbeau, *Correspondance avec Claude Monet*, p. 98, n. 4.

70 Letter to Geffroy, 6 March 1891 (former Barbier collection), quoted in ibid., p. 124, n. 6.

71 For Mirbeau as Monet's 'favourite critic', see R. Schiff, 'To move the eyes: Impressionism, Symbolism and well-being. c. 1891', in Hobbs (ed.), *Impressions of French Modernity*, p. 196. During the late 1880s and early 1890s, Mirbeau kept a fine garden at Les Damps near Rouen (cf Pissarro's series of pictures of this of 1892; see ill. 209); from 1893–1904 he continued his horticulture at Carrières-sur-Poissy, a few kilometres from Giverny. His descriptions of Monet's flowers are in 'Claude Monet', in *L'Art dans les Deux Mondes*, 7 March 1891, in Mirbeau, *Combats esthétiques*, I, pp. 428–33.

72 Ibid., p. 433.

73 Letter to the Préfet de l'Eure, 17 July 1893, no. 1219, WIII, p. 275.

74 Letter to Alice, 20 March 1893, no. 1193, ibid., p. 271.

75 M.-L. de Vilmorin, 'Les Nymphaea rustiques', p.21.

76 Letter to Alice, 16 February 1893, no. 1175, WIII, p. 269. For the *Flora* by Jean-Pierre Hoschedé

and Michel Monet, in which the local priest and botanist Abbé Toussaint collaborated, see Joyes et al., *Monet at Giverny*, p. 25; the boys' experiments in hybridization produced the *Papaver Moneti* (a poppy).

77 Letter to Monet, May 1890, no. 40 in Mirbeau, *Correspondance avec Claude Monet*, p. 95. For Mirbeau's gift to Pissarro of 'some harpoliums – a sort of perennial sunflower which flowers in June' and 'Helianthus loetiphorus, that fine autumn sunflower', see his letter to Pissarro, 11 February 1893, no. 61 in Mirbeau, *Correspondance avec Camille Pissarro*, p. 142; cf also his letter to Pissarro, July 1892, no. 40 in ibid., p. 102, re. his dispatch to Mme. Pissarro of 'several kinds of hollyhock'.

78 Letter to Monet, September 1891, no. 54 in ibid., p. 54, implies that Monet had put Mirbeau in touch with the grower Crozy who supplied these to him.

79 Guillemot, 'Claude Monet'.

80 Whistler, 'Mr. Whistler's "Ten O'Clock Lecture"' (1885), in J. C. Taylor (ed.), *Nineteenth-Century Theories of Art*, Berkeley, Los Angeles and London, 1989, p. 506.

81 Rollinat, 'La Journée divine', in *La Nature: Poésies*, Paris, 1892, p. 248; Rodin, 'Les Ornements' in *Les Cathédrales de France* (first pub. 1914), p. 191.

82 For the projected visit of the Japanese gardener, see Monet's letter to P. Helleu, 9 June 1891, no. 111bis, WIII, p. 261. For the Zen Buddhist conception of nature, see Spate et al., *Monet and Japan*, pp. 30 and 49; Monet could have become aware of this through direct contact e.g. with the Japanese gardener mentioned in 1891, the dealer Hayashi, or, later, M. Kuroki and his wife (née Princess Matsukata), who visited Giverny. Japanese gardens also formed part of the 1878, 1889, and 1900 Universal Exhibitions in Paris; see e.g. Geffroy, 'Les paysagistes japonais' in *Le Japon artistique*, 3, no. 32, December 1890. A number of private Oriental or Indian-inspired gardens were created at this period, e.g. Albert Kahn's at Boulogne; Les Moutiers and Les Communes at Varengeville (by Lutyens and Gertrude Jekyll); and Maulévrier (Maine-et-Loire) (see Mosser, 'Jardins "fin de siècle"', pp. 55–8), but it is not known whether Monet ever visited any of these.

83 Fischer-Schreiber, 'Lotus', in *The Encyclopaedia of Eastern Philosophy and Religion*, 1994, quoted in Spate et al., *Monet and Japan*, p. 52.

84 Ibid., p. 51. (Bing's description of Mount Fuji's peak in *The Thirty-six Views of the Fuji-yama*, 1898).

85 Rodin undertook a tour of northern French cathedrals in 1877, to which L. Bénédite traced the origin of his ideas in *Les Cathédrales* (introd.).

86 Rodin, *Les Cathédrales*, pp. 180–1 ('the flowers produced the cathedral').

87 Letter to Alice, 5 April 1893, no. 1208, WIII, p. 273. It is perhaps not a coincidence that Clemenceau – who would be instrumental in the realization of the Orangerie scheme – had in 1895 proposed that Monet's Rouen Cathedral series would make a good mural ensemble (Clemenceau, *Claude Monet par Georges Clemenceau*, p. 126); an idea seconded by Pissarro (see Stuckey, *Claude Monet*, p. 228).

88 Rodin (introd. C. Morice), *Les Cathédrales de France*, Paris, 1914, p. 60 ('Entering into [a cathedral] . . . is this not into paradise?'). For traditions which interpret trees as linking earth and heaven, see Gubernatis, *Mythologie des plantes*, I, pp. 93–5.

89 For the plan to house the *Grandes Décorations* in a pavilion in the gardens of the Hôtel Biron, near the Invalides, see Stuckey and Gordon, 'Blossoms and Blunders', pp. 110–11. Monet had suggested

the Musée des Arts Décoratifs as a potential home for the two panels he gave the State immediately following Armistice Day in 1918, but as his work developed into a mural ensemble, this idea was abandoned for the Hôtel Biron scheme (see ibid., p. 109). The latter would, in fact, have partnered sculptures by Rodin which, along with several antique statues, had been installed in the grounds of the Hôtel prior to the War.

90 This notion reaches from, e.g. Guillemot, 'Claude Monet' ('His studio is nature') to Clemenceau, writing shortly after the painter's death (Clemenceau, *Claude Monet par Georges Clemenceau*, p. 58: his garden is 'an extension of the studio into the open air').

91 Quoted in Spate, *The Colour of Time*, p. 253, from R. Delange, 'Claude Monet', in *L'Illustration*, 15 January 1927, p. 59.

92 Schiff, 'To move the eyes', in Hobbs (ed.), *Impressions of French Modernity*, pp. 202–3.

93 See, e.g., Guillemot, 'Claude Monet'; Marx, 'Les Nymphéas de Claude Monet', p. 529.

94 Ibid., p. 529. Monet's positive emphasis departs also from Verlaine's typically Symbolist equation of waterlilies (*nénuphars*) and private sadness in his poem 'Promenade sentimentale' (for which see Knight, *Flower Poetics*, pp. 185–6).

95 Mirbeau, 'Des Lys! Des Lys!', in *Le Journal*, 7 April 1895, reprinted 1917, in Mirbeau, *Combats esthétiques*, II, pp. 81–2.

96 Mirbeau, 'Paul Gauguin', in *L'Echo de Paris*, 16 February 1891, in ibid., I, p. 421.

97 See *aquarium* in Larousse, *Grand Dictionnaire du dix-neuvième siècle*, I, 1866, p. 534.

98 J. Sallier, 'Nymphéacées et Nélombonées', *Revue horticole*, 1886, p. 35.

99 The soul was equated with a hothouse of flowers in Maeterlinck, 'Aquarium', in *Serres Chaudes*, Ghent, 1889; cf also G. Rodenbach's 'Aquarium mentale' in *Les Vies encloses: Poèmes*, Paris, 1896, and Levine's comment that 'The image of the flowering aquarium is one of the period's chief metaphors for the introspective life of the mind' (*Monet, Narcissus and Self-Reflection*, p. 236). The exoticism of Monet's Giverny *aquarium*, however, makes it simultaneously part of his process of 'reaching out', beyond the confines of his northern garden site.

100 Guillemot, 'Claude Monet'.

101 See, e.g. J. Batise, 'Les Jardins sauvages', *Revue horticole*, 1882, pp. 546–8, which, as noted by Galiègue et al., *Henri Le Sidaner*, p. 170, uses the term 'Wild Gardens' even though it does not refer to Robinson by name.

102 'Un coin de rivière au Trocadéro', *Le Jardin*, 1889, p. 258.

103 See the description of Latour-Marliac's new hybrid nymphaea, in Vilmorin, 'Les Nymphaea rustiques', p. 20.

104 Mirbeau, 'Claude Monet', 7 March 1891, in Mirbeau, *Combats esthétiques*, I, p. 429.

105 Letters to Alice, 13 February and 5 March 1884, nos. 417 and 438, WII, p. 238 and p. 243.

106 See especially Gillet, 'L'Epilogue de l'impressionisme'; the tendency of reviewers of Monet's waterlily paintings to draw 'musical' analogies is discussed in Levine, *Monet and his Critics*, pp. 311ff.

107 See Chapter 7, n. 91.

108 See, e.g. Baudelaire's 'Parfum exotique', 'Harmonie du Soir', 'La Chevelure' and 'L'Invitation au Voyage' in *Les Fleurs du Mal*, and the discussion of the evocative role of scent (often floral) in Baudelaire's imagery in Knight, *Flower Poetics*, pp. 82–4 and 110–15.

109 For the Dreyfus Affair and Monet's support for Zola's and Clemenceau's response to it, see Tucker et al., *Monet in the 20th Century*, pp. 20–6, in

which Monet's comment, in his letter to Geffroy, December 15 1899, no. 1482, WIV, p. 339, is quoted (p. 25).

110 Alexandre, 'Le Jardin de Claude Monet'. This alchemical analogy echoes the Romantic poet Nerval's description in his *Voyage en Orient*, 1851, of a garden of fire at the centre of the earth where 'metals become "flowers" through the application of fire' and 'the dreams of art are realized' (Knight, *Flower Poetics*, pp. 144–5).

111 See Guillaud, *Claude Monet at the Time of Giverny*, p. 10, and Holmes, *Monet at Giverny*, pp. 74–6. Monet covered the stumps with climbing roses.

112 Letter to Alice, 1 February 1888, no. 824, WIII, p. 227.

113 Letter to Geffroy, 22 June 1890, no. 1060, WIII, p. 257, quoted in Spate, *The Colour of Time*, p. 203.

114 For Monet's 'preferred authors', see Hoschedé, *Claude Monet*, I, p. 76. Maeterlinck, *Le Double Jardin*, Paris, 1904 (also published in English and Dutch).

115 Gubernatis, *Mythologie des Plantes*, I, Preface and pp. 93–8.

116 Rollinat, 'Du Ciel', in *La Nature*, p. 119; Mallarmé, 'Les Fenêtres', in B. Marchal (ed.), *Stéphane Mallarmé Poésies*, Paris, 1992, p. 11. In 'Soupir' (ibid., p. 23), Mallarmé actually evokes 'the azure . . . /Which reflects its infinity in the great ponds' (*bassins*)).

117 Letter to Geffroy, 11 August 1908, no. 1854, WIV, p. 374.

118 Alexandre, 'Le Jardin de Claude Monet'; Mirbeau, letter to Monet, June 1903, no. 109 in Mirbeau, *Correspondance avec Claude Monet*, p. 109.

119 See Silverman, *Art Nouveau*, pp. 235–8. For Monet's interest in Gallé, see Wildenstein, *Claude Monet*, 1996, I, p. 390 and cf Marx's comparison of the two artists (and Maeterlinck) in 'Les Nymphéas de M. Claude Monet', p. 524.

120 De Goncourt, *Hokusai* (first pub. 1895), p. 265, in Forrer, *Hokusai*, p. 371. Goncourt interestingly refers to two Hokusai screen panels in the possession of 'M. Monnet' (sic), a landscape painter (ibid., p. 374).

121 Marx, 'Les Nymphéas de Claude Monet', p. 528.

122 De Goncourt, *Hokusai* in Forrer, *Hokusai*, p. 321.

123 Clemenceau, *Claude Monet par Georges Clemenceau*, pp. 92–3. Gillet (whose writing was much admired by Monet) had emphasized the parallels between Monet's waterlily motifs and Watteau's painting already in 1909 ('L'Epilogue de l'impressionisme', pp. 413–14).

124 Mirbeau likens the artistic process to the planting of a lily bulb by a gardener who 'brings towards the soil the bulb which is as powerful and beautiful as a sexual organ' (*Dans le Ciel*, 1892–3, ed. P. Michel and J.-F. Nivet, Tusson, Charante, 1989, p. 121). Gillet wrote of 'the liquid, multiple, feminine element of water' ('Après l'Exposition Claude Monet', p. 670).

125 See E. Apter, 'The Garden of Scopic Perversion from Monet to Mirbeau', in *October*, 47, Winter 1988.

126 See Thiébault-Sisson, 'Un nouveau musée Parisien', p. 48.

127 Cf. Levine's discussion of allusions to the legend of Narcissus by Marx, Geffroy, Gillet and others, in *Monet, Narcissus and Self-Reflection*, chapters 14 and 15; cf also Alexandre's analogy with the Flower Maidens of Wagner's *Parsifal*, in 'Le Jardin de Monet'. Monet's description of his 'essential motif' is quoted in Thiébault-Sisson, 'Un nouveau musée parisien', p. 44.

128 Gubernatis, *Mythologie des plantes*, I, p. 145. Clemenceau wrote from Benares to Monet 'saying he had discovered paradise'. (G. Dallas,

Clemenceau and his World 1841–1929, London, 1993, p. 585.).

129 Delange, 'Claude Monet', p. 54, quoted in Stuckey, 'Blossoms and Blunders II', p. 120.

130 Rollinat, 'La Couleur du Temps', in *La Nature*, p. 176.

131 In Paris, Monet would have known Delacroix's Saint-Sulpice Biblical murals; in Venice in 1909, he in turn admired Tintoretto's murals at the Palazzo Ducale on the theme of divine light, and brought photographs of these back to Giverny.

132 'The Colour of Time', used by Rollinat (see n. 130 above)was in turn used by Gillet in relation to Monet's art ('Après l'Exposition Claude Monet', p. 667); it is also the title of Spate's 1992 book on Monet.

133 Rodin, *Les Cathédrales*, p. 220.

134 W1868–1877.

Chapter 9: The fruits of the gardens of Impressionism *pp. 231–255*

1 Letter from Sargent to R. L. Stevenson, 1885, quoted in Olson et al., *Sargent at Broadway*, p. 67. In one account, Sargent identified the original location of his lilies and lanterns motif as Pangbourne in Berkshire; in another, Broadway (see ibid.). The children are Dorothy and Polly, daughters of the artist Frederick Barnard.

2 Letter from Sargent to Stevenson, 1885, in ibid.

3 For Monet's goal of 'instantaneity', see his letter to Geffroy, 7 Oct 1890, no. 1076 in WIII. For Gosse's description, see E. Charteris, *John Sargent*, London, 1927, pp. 74–5, as cited in Olson et al., *Sargent at Broadway*, p. 67.

4 Pissarro, letter to Esther Isaacson, 30 June (?), 1889, no. 528 in *Correspondance*, II, p. 274; R. Brettell, *Modern Art 1851–1929: Capitalism and Representation*, Oxford, 1999, pp. 18–19.

5 Memoir by Edward Breck, brother of the painter John Leslie Breck, March 8, 1885, quoted in Gerdts, *Monet's Giverny*, p. 26, re. the reaction of their colleagues Louis Ritter and Willard Metcalf to the countryside at Giverny.

6 Nordau, *Degeneration*, London and New York, 1895 (first pub. as *Entartung*, 1892); G. M. Beard, *American Nervousness: Its Causes and Consequences. A Supplement to Nervous Exhaustion (Neurasthenia)*, New York, 1881, p. 174.

7 See 'Germany, Austria and Switzerland' below, and von Hohenzollern and Schuster, *Manet bis Van Gogh*.

8 Morris's 'Earthly Paradise' poem was first published in 1868–70 and republished in 1898; his celebrated account of his ideal Utopian society, *News from Nowhere* (1892) in turn employed a photograph of his garden at Kelmscott as its frontispiece. See also J. Duchess of Hamilton, P. Hart and J. Simmons, *The Gardens of William Morris*, London, 1998. Candace Wheeler, 'Content in a Garden', *The Atlantic Monthly*, vol. 86, 1900, p. 234.

9 See 'T', 'The Abbot's Grange and Russell House', p. 61; and Olson et al., *Sargent at Broadway*, p. 68. By 1886, Robinson had obtained a collection of hardy border carnations from France; 'by 1887 he had planted out 2,000 of them' (Hadfield, *A History of British Gardening*, p. 380).

10 Letter from Lucia Millet, April 27, 1886, quoted in Olsen et al., *Sargent at Broadway*, p. 68.

11 See 'T', 'The Abbot's Grange', p. 61. Henry John Elwes's landmark *Monograph of the Genus Lilium*, 1880, incorporating many new varieties, was compiled not far from Broadway, at Colesborne in Gloucestershire; see Hadfield, *A History of British Gardening*, pp. 376–7.

12 The Baroque garden of Isola Bella in the Borromean Islands inspired the balustrades which Le Sidaner added to his terraces after 1910 (see Galiègue et al., *Henri Le Sidaner*, p. 21). For the 'formal' vs 'natural' debate, see Helmreich, *The English Garden*, especially pp. 135–88, and Hadfield, *A History of British Gardening*, pp. 365–8. Le Sidaner owned French editions (1908 and 1911) of *The Studio*'s special numbers on *The Gardens of England* (1907–11) and is believed to have referred to these when constructing his Gerberoy garden (see Galiègue et al., *Henri Le Sidaner*, p. 177). He had visited Holland House, Kensington, London in 1904, whose garden these illustrated, (ibid., p. 175), and he was a close friend of the Arts and Crafts enthusiast and *Studio* contributor Gabriel Mourey, who designed the garden of *The Studio*'s editor, Charles Holmes (1908; see Helmreich, p. 148 and p. 202ff) also designed or advised on several French gardens (see Mosser, 'Jardins "Fin de Siècle" en France', pp. 55–6), just as 'Arts and Crafts' principles guided the French horticulturalist J. C. N. Forestier (designer of the Bagatelle garden in the Bois de Boulogne); see Galiègue et al., *Henri Le Sidaner*, p. 179).

13 Jekyll, *Some English Gardens*, London, 1904, p. 122, quoted in J. B. Tankard and M. A. Wood, *Gertrude Jekyll at Munstead Wood. Writing. Horticulture. Photography. Homebuilding*, Thrupp, 1996, p. 149. For Jekyll's association of gardening and painting, see also Hobhouse and Wood, *Painted Gardens*, p. 20.

14 Morris, 'Hopes and Fears for Art' ('Making the Best of it'), in Sieveking, *In Praise of Gardens*, p. 293.

15 For Henri Bergson, see McConkey, *Memory and Desire*, p. 183, and 'France and Belgium' in the present chapter. Edmond de Goncourt had discussed the interaction of the mind and its environs in *La Maison d'un artiste* (see especially 'Le Jardin' in this, pp. 307–15).

16 For the Caillebotte bequest, see Distel et al., *Gustave Caillebotte The Unknown Impressionist*, Appendix III, pp. 218–36. It included, e.g. Renoir's *Ball at the Moulin de la Galette*, *Swing* and *Place Saint-Georges*; Monet's *Luncheon* and one of his Tuileries paintings; and two Pissarro Pontoise kitchen garden scenes. For Durand-Ruel's Impressionist exhibitions (e.g. *Renoir*, 1896 and *Tableaux de Monet, Pissarro, Renoir et Sisley*, 1899), see Groom, *Vuillard*, pp. 107, 113.

17 See D. Derrey-Capon, '"Vie et Lumière." Prémices sur un air nationaliste et débuts prometteurs' in Block (ed.), *Belgium the Golden Decades*, pp. 99–138.

18 See Boime, *Art and the French Commune*, p. 146 and p. 161.

19 Mallarmé, 'Brise Marine', first pub. 1866 ('Rien, ni les vieux jardins reflétés par les yeux/Ne retiendra ce coeur qui dans la mer se trempe/ O nuits! . . . Je partirai! Steamer balançant ta mâture./Lève l'ancre pour une exotique nature'). Bonnard in particular was a life-long enthusiast for Mallarmé's poetry.

20 *Woman reading on a Bench* (also known as *In Front of the House*) and *Woman seated in a Garden*, 1898, private collection, reprod. in Groom, *Vuillard*, pls 165 and 166; further panels for this scheme were painted in 1901 (see ibid., pls. 177, 178 and 180).

21 *Foliage: Oak Tree and Fruit Seller*, 1918, The Art Institute of Chicago; see cat. 84 in Groom et al., *Beyond the Easel*.

22 *Comedy*, 1936–7, Palais de Chaillot, Paris, reprod. B. Thomson, *Vuillard*, pl. 137.

23 Quoted in Groom et al., *Beyond the Easel*, p. 149.

24 Quoted in Newman (ed.), *Bonnard*, p. 136.

25 See Groom et al., *Beyond the Easel*, pp. 145–7. Perhaps the most famous 'Mediterranean' works of the fin de siècle are Signac's *Au Temps de l'harmonie* (In the Age of Harmony), 1893-4, Mairie, Montreuil, and Matisse's *Luxe, calme et volupté*,1904, private collection, and *Bonheur de vivre* (The Joy of Life), 1905–6, The Barnes Foundation, Merion, Penn.

26 See Newman (ed.), *Bonnard*. Cf also Bonnard's illustration of the ancient Greek romance *Daphnis and Chloë*, 1902.

27 1916–20, The Art Institute of Chicago; see cat. 52 in Groom et al., *Beyond the Easel*.

28 *Décor at Vernon* is also known as *The Terrace at Vernon*. For its allusions to antique sculpture, see ibid., pp. 197–8, where the similarity of pose between the figure of Marthe and pre-Classical Greek *kore* statues is also noted; and the entry on the painting in Newman (ed.), *Bonnard*.

29 Groom et al., *Beyond the Easel*, p. 198; see also N. Watkins, 'The Death of Renée Monchaty, Bonnard's model and lover', in *The Burlington Magazine*, CXL, May 1998, no. 1142, p. 327.

30 Newman (ed.), *Bonnard*, p. 18.

31 For Martin's garden at Marquayrol, a house in the village of Labastide-du-Vert near Cahors near Toulouse, where he settled in 1900, see Coustols, *Henri Martin*, pp. 73–4. For his interest in Bergson, see J. Martin-Ferrières, *Henri Martin, his Life, his Work*, Paris, 1967, p. 80. Bergson's *Matière et Mémoire* was published in 1896.

32 *L'Atelier au Mimosa*, 1939–46, Musée National d'Art Moderne, Centre Pompidou, Paris, pl. 65 in Newman (ed.), *Bonnard*. For Bonnard's comment about yellow, see ibid., p. 148.

33 Interview with Le Sidaner by *Lecture pour tous*, c. 1911, quoted in Galiègue et al., *Henri Le Sidaner*, p. 21. It was on Rodin's advice that Le Sidaner went to live in the Beauvais region (see ibid., p. 13).

34 Ibid., p. 21.

35 De Goncourt, 'Le Jardin', in *La Maison d'un artiste*, p. 308, as transl. in Sieveking, *The Praise of Gardens*, pp. xx.

36 Ibid., p. 308, as transl. in Sieveking, *The Praise of Gardens*, pp. 277–9; *l'heure Le Sidaner* was the name given to dusk by Le Sidaner's friend the critic Camille Mauclair (see Galliègue et al., *Henri Le Sidaner*, p. 14).

37 See A. Bertrand, *Les Curiosités esthétiques de Robert de Montesquiou*, I, Geneva, 1996, pp. 59, 149, 180, 184 and 194–7. Montesquiou, a close friend of Whistler, regarded the hydrangea as 'the aristocrat flower "which has no scent"' (ibid., p. 180). He wrote an anthology of poems called *Les Hortensias Bleus* (The Blue Hydrangeas, pub. 1896), and had Emile Gallé make a 'hydrangea' electric lamp and 'hydrangea' chest of drawers, as well as 'hydrangea' decoration for his bathroom.

38 For the *Hydrangea hortensia*, see Galiègue et al., *Henri Le Sidaner*, p. 46; for Le Sidaner's 'white garden', created from a former orchard and first painted by him in 1904, see ibid., p. 18 and p. 92.

39 See ibid., p. 17 and pp. 28–9. Le Sidaner's friends included critics and writers described by Jacques-Emile Blanche as waving 'nearly red flags', such as Roger Marx, Camille Mauclair and Gustave Geffroy, and Republicans like Henri Duhem (see ibid., p. 28); his close friend Henri Martin was, of course, in turn a friend of Jean Jaurès, the Socialist leader. For the Villa Zonneschijn, see de Heusch, *L'Impressionisme et le Fauvisme en Belgique*, p. 152.

40 See Hadfield, *A History of British Gardening*, pp. 380–1.

41 E.g. Jenny Montigny painted in Hyde Park, and Alphonse Proost in Kensington Gardens; see

Goyens de Heusch, *L'Impressionisme et le Fauvisme en Belgique*, pp. 157 and 162.

42 E.g. *Roses*, decorative panel of 1909–16 by Quost, Musée d'Orsay, Paris.

43 Frédéric, *The Fragrant Air*, 1894, reprod. no. 15 in S. Polden, *A Clear View The Belgian Luministe Tradition*, London, 1987; Wiethase, *The Young Gardener*, n.d., no. 29 in ibid.; and Gaillard, *Spring (Le Printemps)*, no. 31 in ibid.

44 *The Gardener (Le Jardinier)*, n.d., Museum voor Schone Kunsten, Ghent, reprod. pl. 79 in de Heusch, *L'Impressionisme et le Fauvisme en Belgique*.

45 One of the most prominent of the Belgian begonia growers was Louis van Houtte, founder of the Ecole d'Horticulture at Ghent and of the journal *Flore des serres et jardins de l'Europe* (1845–83).

46 For Spencer's remark (1882), and the developing role of leisure in 19th-century American life, see Weinberg et al., *American Impressionism and Realism*, New York, 1994, p. 89 and pp. 92–4. Cf also Thorstein Veblen's *Theory of the Leisure Class*, New York, 1899, which related aesthetic taste to economic factors.

47 Andrew Jackson Downing (designer of gardens at the Washington State Capitol, White House and Smithsonian Institution), quoted in Chadwick, *The Park and the Town*, p. 181.

48 E.g. *Prospect Park, Brooklyn*, c. 1887, The Parrish Art Museum, Southampton, New York, and *Boat House, Prospect Park*, c. 1887, private collection; see B. Gallati, *William Merritt Chase*, New York, 1995, p. 72 and p. 74.

49 *In a French Garden* (reprod. in Gerdts, *Down Garden Paths*, p. 51) was one of a group of garden paintings Hassam undertook in 1888 at Villiers le Bel near Paris; see U. Hiesinger, *Childe Hassam American Impressionist*, Munich and New York, 1994, p. 50. The description of Thaxter's garden is by Maud Appleton McDowell, in C. Thaxter, *The Heavenly Guest*, Andover, 1935, pp. 129–30, as quoted in Gerdts, *Down Garden Paths*, p. 65. Thaxter's own account of her garden, *An Island Garden*, 1894 (reprint, Cassell, 1989) was illustrated by Hassam.

50 For this exhibition ('The Impressionists of Paris'), which included Monet's *Garden at Vétheuil*, 1881 (W683), see F. Weizenhoffer, 'The Earliest American Collectors of Monet', in Rewald and Weizenhoffer (eds), *Aspects of Monet*, pp. 75–8. It prompted extended analysis of Monet's work by Celen Sabbrin (pseudonym for Helen Cecilia De Silver Abbott, Mrs Michael) according to her theory of 'triangulated' composition; see ibid., and Gerdts, *Down Garden Paths*, pp. 37–53. Other important Monet garden paintings shown in America included *The Artist's House at Argenteuil*, 1873 (W284) (Boston, 1883); *The Garden*, 1872 (W202), *Hyde Park*, 1871 (W164) (New York, 1895; *Hyde Park* was also shown in Boston in 1895); *Corner of the Garden at Montgeron*, 1876 (W418) and *Alice Hoschedé in the Garden* (W680) (New York, 1891); and *Camille Monet with a Child in a Garden* (W382) (Boston 1905, with *Alice Hoschedé in the Garden*).

51 Gerdts, *American Impressionism*, p. 221.

52 H. S. Adams, 'Lyme – A Country Life Community', *Country Life in America* (April, 1914), p. 94, quoted in Gerdts, *En Plein Air*, p. 29.

53 Florence Griswold Museum, Old Lyme, Conn.; reprod. ibid., plate 3.

54 Ibid., p. 31.

55 See ibid., p. 61. Payne's shingled birthplace is portrayed in *Home Sweet Home* (1886, Guild Hall Museum, East Hampton) by Lemuel Maynard Wiles, one of the East Hampton 'colony'.

56 See K. Pyne, 'Social Conflict and American Painting in the Age of Darwin', in Keyes and Simon (eds), *Crosscurrents in American Impressionism*, p. 81.

57 Ibid. pp. 81–2.

58 Robinson's early orchard subjects (e.g. *Gathering Plums*, 1891; see Gerdts, *Monet's Giverny*, p. 54 and p. 82) reflect his admiration (shared by Gill) for Pissarro, whose *Apple-Picking* he could have seen in Paris at the Impressionist exhibition of 1886 or at George Petit's gallery in 1887 (see ibid, pp. 80–2 and p. 88).

59 Cabot Perry's recollection is quoted in ibid., p. 40. Other 'first wave' *givernistes* included Henry Fitch Taylor and the Canadian William Blair Bruce. For detailed accounts of the colony, see ibid. and Kilmer et al., *Frederick Carl Frieseke*. Though Breck was cold-shouldered by Monet for making advances to Suzanne Hoschedé, Theodore Butler was eventually allowed to marry first Suzanne and, after her premature death, her sister Marthe; Robinson attended Monet's wedding to Alice Hoschedé in 1892.

60 Kilmer et al., *Frederick Carl Frieseke*, pp. 86 and 88.

61 M. Koopman, 'Giverny', in *25th Anniversary of the Founding of Miss Wheeler's School 1889–1914*, Providence, R.I., 1914, pp. 26–31, quoted in ibid., p. 85.

62 See comments by Emma Bullet and other visitors to Giverny in Gerdts, *Monet's Giverny*, p. 133.

63 *Blossoming Time*, 1901, is in the collection of the Union League Club of Chicago (reprod. fig. 13, p. 49 in Robinson and Cartwright, *An Interlude in Giverny*); *Corner of the Garden in Winter*, 1902, is in the Musée Municipal A.-G. Poulain, Vernon (reprod. fig. 15, p. 50 in ibid.).

64 *Mrs Frederick MacMonnies and Children in the Garden of Giverny*, 1901, Musée des Beaux-Arts, Rouen, reprod. fig. 15, p. 19 in ibid.

65 Butler's description is quoted in Gerdts, *Monet's Giverny*, p. 129; Candace Wheeler's articles were published in *The Atlantic Monthly* (3 parts: 1899, vol. 85, pp. 779–84; vol. 86, pp. 99–105 and 232–38; reworked as a book of the same name, 1901; see Gerdts, *Down Garden Paths*, p. 122).

66 See Kilmer, *Frederick Carl Frieseke*, p. 78.

67 Quoted in C. T. MacChesney, 'Frieseke Tells Some of the Secrets of His Art', *New York Times*, 7 June, 1914, sec. 6, p. 7, as given in ibid., p. 88.

68 *The New York Times*, 25 December, 1910, quoted in Kilmer, *Frederick Carl Frieseke*, pp. 94–5. The Chicago exhibition was at the Thurber Gallery and the New York one at the Madison Galleries.

69 Guild Hall Museum, East Hampton, reprod. Gerdts, *En Plein Air*, p. 17.

70 See C. C. Eldredge, 'American Impressionism goes West', in Keyes and Simon (eds), *Crosscurrents in American Impressionism*, pp. 100–17.

71 See Hobhouse and Wood, *Painted Gardens*, p. 13. The association of the cottage garden with the perceived perfection of a pre-industrial age derives also from Ruskin, including his ideal of England as 'a little garden' (see Helmreich, *The English Garden and National Identity*, pp. 21–2).

72 Mallarmé, 'The Impressionists and Edouard Manet', pp. 91–7. This was published through the agency of Mallarmé's friend the Irish poet Arthur O'Shaughnessy.

73 Moore, *Modern Painting* (1893), p. 211, quoted in McConkey, *British Impressionism*, p. 104.

74 In particular, *Le Banc de jardin*, 1882, Andrew Lloyd Webber Collection; see R. Dorment et al., *The Pre-Raphaelites and other Masters. The Andrew Lloyd Webber Collection*, exh. cat.,

Royal Academy of Arts, London, 2003, pp. 174–5 (cat. 134).

75 *The Art Journal* (1907), quoted in McConkey, *Impressionism in Britain*, p. 155. For interest in de Goncourt and Bergson, see McConkey, 'A Walk in the Park', in *Memory and Desire*, pp. 183–201. A related image in this context is Sargent's twilight subject *In the Luxembourg Gardens*, 1879 (Philadelphia Museum of Art).

76 See, e.g. McConkey, *Impressionism in Britain*, pp. 57, 82 and 82. An exhibition of Constable's paintings and sketches was held at the Victoria and Albert Museum in 1888.

77 For Sargent's 'garden studies', including *Garden Study of the Vickers Children*, see Olson et al., *Sargent at Broadway*, pp. 42, 44 and 65. *Midsummer* is in the Royal Scottish Academy, Edinburgh (reprod. McConkey, *Impressionism in Britain*, pl. 68); *The Hind's Daughter* (1883) is in the National Gallery of Scotland, Edinburgh.

78 See J. Bernac, 'The Caillebotte Bequest to the Luxembourg', *The Art Journal*, 1895, pp. 230–2; 308–10; and 358–61. Lavery's picture is in a private collection (reprod. McConkey, *Impressionism in Britain*, p. 69).

79 Walter Osborne, *Tea in the Garden* (1902), Hugh Lane Municipal Gallery of Modern Art, Dublin, and Harold Knight, *In the Spring* (1908–9), Laing Art Gallery, Newcastle, reprod. in McConkey, *Impressionism in Britain*, pp. 70, 144.

80 E.g. *The Garden, Garth House*, 1908, Walker Art Gallery, Liverpool; see ibid., p. 133.

81 *The Picnic* is in Manchester City Art Gallery (reprod. ibid., p. 83); Dewhurst's account is *Impressionist Painting: its Genesis and Development*.

82 *Victoria Embankment Gardens*, coll. Anthony d'Offay; *September*, Laing Art Gallery, Newcastle. For de Glehn's Cannes gardens, see *British Impressionism*, exh. cat., David Messum Fine Art, London, Spring 1994, pl. 41.

83 Moore, quoted in McConkey, *Impressionism in Britain*, p. 67.

84 See Willsdon, *Mural Painting in Britain*, pp. 327–8.

85 See Broude (ed.), *World Impressionism*, p. 352.

86 Publications by Meier-Graefe such as his *Entwicklungsgeschichte der modernen Kunst* (History of Modern Art), 3 vols, Stuttgart, 1904, gave key emphasis to Impressionism.

87 For Tschudi's collecting, and interest in modern French art and elsewhere in Germany, see von Hohenzollern and Schuster, *Manet bis Van Gogh*. Bonnard and Vuillard were in turn invited to Hamburg by Lichtwark in 1913.

88 For the Hamburg 'Gartenausstellung', see 'General Exhibition at Hamburg, 1897', in *The Gardener's Chronicle*, 3rd ser., XXI, 9 Jan. 1897, p. 26; 'Carnations at Hamburg', in ibid., 14 Aug. 1897, p. 109; and 'Hamburg Exhibition', in ibid., 9 Oct. 1897, p. 254; for both the Hamburg and Berlin exhibitions, see 'Hamburg' in *Journal of Horticulture and Cottage Gardener*, 34, 6 May, 1897, p. 382, and 'German Shows through English Spectacles' in ibid., p. 381.

89 See Sieveking, *In Praise of Gardens*, p. 404; the Hamburg 'Gartenausstellung' included a historical account of the city's gardens (see ibid., p. 351).

90 See Teut, *Max Liebermann*, pp. 10–11.

91 Liebermann maintained that the genuine work of art was that which embodied 'a sincere feeling' (speech at opening of Cassirer's Berlin gallery, 1899, quoted in ibid., p. 96); for his comment about intimacy (made in 1901 in Holland, where he spent the summers prior to his purchase of the Wannsee property), see ibid., p. 14.

92 See ibid., p. 15; cf also Liebermann's *Sonnenflecken* ('sunspots', i.e. effects of dappled sunlight; see *Max Liebermann in Holland*, exh. cat., Haags Gemeente Museum, The Hague, March 1980).

93 Lichtwark maintained that 'The art of the garden is the art of the interior' and that 'House and garden form a unified spatial entity' (quoted in Teut, *Max Liebermann*, p. 47). For his advocacy of *salons de verdure* see ibid., p. 11.

94 Goethe, *Wahlverwandtschaften* (Elective Affinities), 1809. *Plein-air* and proto-Impressionist effects are to be found in the work of, e.g. Adolphe Menzel (admired by Degas; cf ill. 102), Carl Blechen, Wilhelm Leibl, Hans Thoma and Wilhelm Trübner; see Broude (ed.), *World Impressionism*, pp. 336–47.

95 The 'English Garden' in Munich was the first such in Germany, designed in 1789 by Count Rumford. The key German example is that at Wörlitz, Dessau (see J. Geyer-Kordesch, 'The Hieroglyphs of Nature: the Garden, the Numinous, and the Pagan in the Enlightenment' in A.-C. Trepp and H. Lehmann (eds), *Antike Weisheit und Kulturelle Praxis*, Göttingen, 2001); the genre was further promoted by Prince Pückler-Muskau in the 1830s (see Chadwick, *The Park and the Town*, pp. 250-1), and its influence is felt even in the 'wilderness' garden of Elizabeth von Arnim's highly popular book *Elizabeth and her German Garden* (1898), which Mary Cassatt admired. Other painters of the Swiss landscape in quasi-paradisal terms were Barthélemy Menn and François Bocion, a contemporary of the French Impressionists; see Broude (ed.), *World Impressionism*, pp. 319–21 and A. Neuweiler, *La Peinture à Genève de 1700 à 1900*, Geneva, 1945, pp. 142ff.

96 Tschudi, 'Foreword' to the 'Jahrhundert-ausstellung der deutschen Kunst' ('Centennial Exhibition of German Art'), Berlin, 1906, quoted in von Hohenzollern and Schuster, *Manet bis Van Gogh*, p. 364. For Kessler's association with Lichtwark, Tschudi and the Belgian avant-garde, see ibid., pp. 288–301.

97 Runge's *Hülsenbeck Children* (1805–6) and *Times of Day* (1803) are in the Hamburg Kunsthalle; see illustrations in K. Hartley (ed.), *The Romantic Spirit in German Art 1790–1990*, exh. cat., London and Munich, 1994–5, pp. 288, 124 and 94–5. Runge was a native of Lichtwark's city, Hamburg. Liebermann's *Beergarden* (1883–4) is in the Bayerische Staatsgemälde-sammlung, Neue Pinakothek, Munich; his *Children Playing in a Park* (1882) was sold at Christie's, 25 May, 1990. Cf also his *Playtime in the Amsterdam Orphanage*, 1882, Städelisches Kunstinstitut, Frankfurt, and *Eva*, 1882, Kunsthalle, Hamburg.

98 'German Shows through English Spectacles', p. 382.

99 Following Liebermann's death in 1935, his Wannsee house was plundered by the Nazis in 1940; his wife, condemned to deportation to Theresienstadt, took her life. See Teut, *Max Liebermann*, pp. 104–7.

100 The other artists at the town hall were Edouard Castres, Léon Gaud (a pupil of Menn), and Simon Durand.

101 See Broude (ed.), *World Impressionism*, p. 350.

102 1912, Österreichische Galerie, Vienna.

103 R. Bionda and C. Blotkamp (eds), *The Age of Van Gogh Dutch Painting 1880–1895*, exh. cat., Burrell Collection, Glasgow and Rijksmuseum Vincent Van Gogh, Amsterdam, Zwolle and Amsterdam, 1990, p. 170. For van Looy and Karsen's garden scenes, see ibid., pp. 177–8 and pp. 170-1.

104 See Broude (ed.), *World Impressionism*, pp. 178–80.

105 Ojetti collection (reprod. pl. 226 in ibid.).

106 De Nittis's *How cold it is!* (Jacomon and Ida Jucker collection), depicting three fashionable women in a chill winter park, was a huge success at the 1874 Paris Salon, even as he showed more freely-brushed 'studies' in the first Impressionist exhibition. For Rosso's *Conversation in the Garden* (Galleria Nazionale d'Arte Moderna, Rome), see A. Dumas, *Degas and the Italians in Paris*, exh. cat., National Galleries of Scotland, Edinburgh, 2003, pl. 54.

107 *Garden of Fortuny's House*, c. 1874, Casón del Buen Retiro, Museo del Prado, Madrid (reprod. pl. 274 in Broude (ed.), *World Impressionism*). The painting was completed by Madrazo after Fortuny's death.

108 1896, Galleria Internazionale d'Arte Moderna di Ca'Pesaro, Venice; see ibid., p. 233 and pl. 264.

109 E.g. *Portrait of Don Alfonso XIII*, 1907, Palacio Real, Madrid (pl. 298 in ibid.); *María in the Gardens of La Granja*, 1907, Museo Sorolla, Madrid (pl. 300 in ibid.).

110 *La Glorieta*, 1909, Musée d'Orsay, Paris, reprod. R. Rosenblum, *Paintings in the Musée d'Orsay*, New York, 1995.

111 E. Tufts, in Broude (ed.), *World Impressionism*, p. 240, suggests that Krøyer's beach scenes in particular influenced Sorolla's.

112 *Hip, Hip, Hurrah! Artists' Party at Skagen*, 1884–8, Göteborgs Kunstmuseum, Sweden (reprod. pl. 352 in ibid.).

113 *Portrait of the Swedish Painter Karl Nordström*, Nasjonalgalleriet, Oslo (reprod. pl. 56 in K. Varnedoe, *Northern Light*).

114 'Karl Nordström och det nordiska stämnings-landskapet', 1896, in *Om konst och annat*, Stockholm, 1919, p. 122, quoted in Gunnarsson, *Nordic Landscape Painting*, p. 170. For the broadly favourable reactions in late 19th-century Scandinavia to French Impressionism, see ibid., pp. 174–80 and pp. 190–2.

115 See ibid., pp. 168–9.

116 Ateneumin Taidemuseo, Helsinki; reprod. and discussed in Varnedoe, *Northern Light*, pp. 58–60.

117 Prins Eugen met Monet during the latter's painting trip to Norway. His reactions to modern French painting when an art student in Paris are pub. in D. Widman, 'Prins Eugen', in *Gazette des beaux-arts*, vol. 101, 1983, pp. 214–22.

118 U. Dammer, 'Gardening in Russia' (part 2), *The Gardener's Chronicle*, XXI, 24 April, 1897, p. 269.

119 Vasilii Dmitrevich Polenov Estate-Museum, Polenovo, Tula Region, reprod. in Broude (ed.), *World Impressionism*, pl. 485.

120 Julie Manet records this incident as one often related to her by Morisot, her mother; see *Journal de Julie Manet* (pref. J. Griot), Paris, 1979, p. 110.

121 Quoted in Tabarant, *Manet et ses oeuvres*, p. 240, from a 'testament' by Callias, published by Charles Cros in 1885 (the year after her death).

BIBLIOGRAPHY

Adler, K., 'The Suburban, the Modern and "Une Dame de Passy"', *Oxford Art Journal*, vol. 12, no. 1, 1989
——, *Pissarro in London*, exh. cat., National Gallery, London, New Haven and London, 2003
Aitken, G., and M. Delafond, *La Collection d'estampes japonaises de Claude Monet à Giverny*, Paris, 1983
Ajalbert, A., 'Le Salon des impressionistes', *La Revue moderne*, 20 June 1886, in Berson (ed.), *The New Painting*, I, pp. 430–4
Alexandre, A., 'Le Jardin de Claude Monet', *Le Figaro*, 9 Aug 1901
Alphand, A., *Les Promenades de Paris*, 2 vols, Paris, 1867–73
André, E., 'Le Parc de Monceaux', *Revue horticole*, 1862, p. 394–6
——, 'Les Jardins de Paris', in *Paris Guide par les principaux écrivains et artistes de la France*, II, Paris, 1867
——, *L'Art de jardins: traité générale de la composition des parcs et jardins*, Paris, 1879
Apter, E., 'The Garden of Scopic Perversion', *October*, vol. 47, Winter 1988, pp. 91–115
Audiganne, M., and P. Bailly, *Paris dans sa splendeur: Monuments, vues, scènes historiques, descriptions et histoire*, 3 vols, Paris, 1861
Audot, L. *Les Nouveaux Jardins des Champs Elysées, du Parc Monceau, et des squares de la ville de Paris – composition et entretien*, Paris, 1865

Bailey, C. B., *Renoir's Portraits: Impressions of an Age*, exh. cat., National Gallery of Canada, Ottowa; Art Institute of Chicago; Kimbell Art Museum, Fort Worth, 1997
——, et al., *Masterpieces of Impressionism and Post-Impressionism: the Annenberg Collection*, exh. cat., Philadelphia Museum of Art, 1989
Baltet, C., *Conférences de l'Exposition universelle internationale de 1889. L'Horticulture française, ses progrès et ses conquêtes depuis 1789*, Paris, 1890
Barron, L., *Les Environs de Paris*, Paris, 1886
Barter, J. A. and E. Hirschler, *Mary Cassatt: Modern Woman*, exh. cat., Art Institute of Chicago, Museum of Fine Arts, Boston, and National Gallery of Art, Washington, D.C., 1998
Baudelaire, C., *Les Fleurs du Mal* (ed. A. Adam), Paris, 1961
——, *The Painter of Modern Life and Other Essays* (transl. and ed. J. Mayne), London, 1964
——, *Art in Paris 1845–1862: Salons and Other Exhibitions* (transl. and ed. J. Mayne), London, 1965
——, *Le Spleen de Paris: Petits poèmes en prose* (ed. Y. Florenne), Librairie Centrale Française, 1972
Bax, M. et al., *Symboles en fleurs. Les fleurs dans l'art autour de 1900*, exh. cat., Institut néerlandais, Paris, 1999
Becker, C., *Camille Pissarro*, exh. cat., Stuttgart, 1999
Berard, M., 'Renoir à Wargemont et la famille Berard', *L'Amour de l'art*, 1938, pp. 315–20
Berhaut, M., *Gustave Caillebotte: sa vie et son oeuvre: catalogue raisonné de peintures et pastels*, Paris, 1978
Berson, R. (ed.), *The New Painting: Impressionism 1874–1886: Documentation*, 2 vols. I: *Reviews*; II: *Exhibited Works*, San Francisco, 1986
Block, J. (ed.), *Belgium The Golden Decades 1880–1914*, New York, Washington, D.C., Baltimore, Bern, Frankfurt-am-Main, Berlin, Vienna and Paris, 1997

Boggs, J. S., *Degas*, exh. cat., Grand Palais, Paris, National Gallery of Canada, Ottowa, and Metropolitan Museum of Art, New York, 1988
Boime, A., *Art and the French Commune: Imagining Paris after War and Revolution*, Princeton, 1995
Boitard, P., *Traîté de la composition et de l'ornement des jardins avec 96 planches représantant des plans de jardins, des fabriques propres à leur décoration, et des machines pour élever les eaux*, 3rd edn, Paris, 1825
Bomford, D. et al., *Art in the Making: Impressionism*, exh. cat., National Gallery, London, New Haven and London, 1990
Bouillon, J.-P., *Félix et Marie Bracquemond*, exh. cat., Mortagne and Chartres, 1972
Bowness, A., and A. Callen, *The Impressionists in London*, exh. cat., Hayward Gallery, London, 1973
——, et al., *Gustave Courbet 1819-1877*, exh. cat., Grand Palais, Paris and Royal Academy of Arts, London, 1978
Brenneman, D. (ed.), *Monet and Bazille: A Collaboration*, exh. cat., High Museum of Art, Atlanta, 1999
Bretagne, C., 'Les Fleurs de Giverny comme au temps de Claude Monet', *Jours de France*, 12–18 July, 1980, pp. 36–44
Brettell, R., *Pissarro and Pontoise: The Painter in a Landscape*, New Haven and London, 1990
——, *Impression Painting Quickly in France 1860–1890*, exh. cat., Sterling and Francine Clark Institute, Williamstown, Mass.; National Gallery, London; and Van Gogh Museum, Amsterdam, New Haven and London, 2001
——, et al., *A Day in the Country: Impressionism and the French Landscape* (ed. A. P. A. Belloli), exh. cat., Los Angeles County Museum of Art and touring, New York, 1984
——, and C. Lloyd, *A Catalogue of the Drawings by Camille Pissarro in the Ashmolean Museum*, Oxford, 1980
——, and J. Pissarro, *The Impressionist and the City: Pissarro's Series Paintings*, exh. cat., Dallas Museum of Art and touring, New Haven and London, 1992
Broude, N., *The Macchiaioli: Italian Painters of the Nineteenth Century*, New Haven and London, 1987
——, *Impressionism: a Feminist Reading, the Gendering of Art, Science and Nature in the Nineteenth Century*, New York, 1991
——, (ed.), *World Impressionism: the International Movement, 1860–1920*, New York, 1990
——, (ed.), *Gustave Caillebotte and the Fashioning of Identity in Modern Paris*, New Brunswick, 2002
Bullock-Kimball, B.S., *The European Heritage of Rose Symbolism and Rose Metaphors in View of Rilke's Epitaph Rose*, New York, Bern, Frankfurt am Main and Paris, 1987
Bumpus, J., *Impressionist Gardens*, London, 1990
Burollet, T. (intro.), *Symboles et réalités. La Peinture allemande 1848-1905*, exh. cat., Musée du Petit Palais, Paris, 1984–5
Bury, J. P. T., *Gambetta and the Making of the Third Republic*, London, 1973

Cachin, F., 'Le Paysage du peintre', in P. Nora (ed.), *Les Lieux de Mémoire*, II, *La Nation*, Gallimard, 1986, pp. 435–86
——, et al., *Pissarro*, exh. cat., London, Paris and Boston, London and Boston, 1980

——, et al., *Manet 1832–1883*, exh. cat., Grand Palais, Paris, and Metropolitan Museum of Art, New York, 1983
Callen, A., *The Art of Impressionism: Painting Technique and the Making of Modernity*, New Haven and London, 2000
Castagnary, J., 'Exposition du boulevard des Capucines: Les Impressionistes', *Le Siècle*, 29 April, 1874, in Berson (ed.), *The New Painting*, I, pp. 15–17
Chadwick, G. F., *The Park and the Town Public Landscape in the Nineteenth and Twentieth Centuries*, London, 1966
Champa, K., *Studies in Early Impressionism*, New Haven and London, 1973
Chevrel, C. (ed.), *L'Art des jardins. Catalogue des collections de la Bibliothèque Administrative de la Ville de Paris, de la Bibliothèque Forney, de la Bibliothèque Historique de la Ville de Paris, de la Bibliothèque de l'Ecole de Breuil*, Paris, 1999
Chevreul, M.-E., *The Principles of Harmony and Contrast of Colours and their Applications to the Arts*, London, 1859
Choay, F., 'Haussmann et le système des espaces verts parisiens', *Revue de l'art*, no. 29, 1995, pp. 83–99
Clark, E. C., *Theodore Robinson, His Life and Art*, Chicago, 1979
Clark, T. J., *The Painting of Modern Life: Paris in the Art of Manet and his Followers*, rev. edn, London, 1999 (first pub. 1984)
Clarke, M., *Lighting up the Landscape: French Impressionism and its origins*, exh. cat., National Gallery of Scotland, Edinburgh, 1986
——, and R. Thomson, *Monet: the Seine and the Sea 1878–1883*, exh. cat., National Galleries of Scotland, Edinburgh, 2003
Clemenceau, G., *Claude Monet: Les Nymphéas*, Paris, 1928
——, *Claude Monet par Georges Clemenceau. Cinquante ans d'amitié*, La Palatine, Paris and Geneva, 1965
Collaert, J.-P., 'La Dynastie des Vilmorin', *Vivre au Jardin*, Dec. 1989
Conzen-Meairs, I., et al., *Edouard Manet und die Impressionisten*, exh. cat., Staatsgalerie, Stuttgart, 2002
Corbin, A., *The Foul and the Fragrant: Odour and the French Social Imagination*, London and Basingstoke, 1994
——, *L'Avènement des loisirs 1850–1960*, Paris and Rome, 1995
Corpechot, L. and M. Charageat, *Parcs et jardins de France: les jardins de l'intelligence*, Paris, 1937
Coustols, C., *Henri Martin*, exh. cat., Palais des Arts, Toulouse and Mairie annexe du Vè arr., Paris, Toulouse, 1983
Cox, M., *Artists's Gardens from Claude Monet to Jennifer Bartlett*, New York, 1993
Crary, J., *Suspensions of Perception. Attention, Spectacle and Modern Culture*, Cambridge, Mass., and London, 2001
Cristal, M., *Le Jardinier des appartements, des fenêtres, de balcons et de petits jardins*, Paris, 1863
Cunningham, C., *The Elegant Academics: chroniclers of nineteenth-century Parisian Life*, exh. cat., Sterling and Francine Clark Institute, Williamstown, Mass., and Wadsworth Atheneum, Hartford, Conn., 1974
Curry, D. Park, *Childe Hassam An Island Garden Revisited*, exh. cat., Denver Art Museum, New York and London, 1990

Daulte, F., *Frédéric Bazille et son temps*, Geneva, 1952
——, *Auguste Renoir. Catalogue raisonné* , vol. I, *Figures, 1860–90*, Lausanne and Paris, 1971

Decaisne, J., and C. Naudin, *Manuel de l'amateur des jardins: Traité générale de l'horticulture*, 4 vols Paris [n.d. but c. 1862]

Delacroix, E., *Journal* (introd. A. Joubin), Plon, 1996

Delvau, A., E. Duranty, et al., *Paris qui s'en va et Paris qui vient*, Paris, 1859

Deny, E., *Jardins et parcs public: Histoire générale des jardins. Les Maîtres de l'école moderne et les principaux créations de style paysager exposé de ses principes et son application*, Paris, 1893

Distel, A., *Les Collectionneurs des impressionistes: amateurs et marchands*, Paris, 1989

——, et al., *Gustave Caillebotte: The Unknown Impressionist*, exh. cat., Royal Academy of Arts, London, 1995

Drower, G., *Gardeners, Gurus and Grubs*, Sutton, 1999

Druick, D., *Renoir*, Art Institute of Chicago, 1997

Dumas, A., and M. E. Shapiro, *Impressionist Paintings collected by European Museums*, exh. cat., High Museum of Art, Atlanta, Seattle Art Museum, Denver Art Museum, New York, 1999

Duranty, E., *La Nouvelle Peinture: A propos du groupe d'artistes qui expose dans les galeries Durand-Ruel*, Paris, 1876 (reprinted in Berson (ed.), *The New Painting*, I, pp. 72–81)

Edelstein, T. J. (ed.), *Perspectives on Morisot*, New York, 1990

Ehrlich-White, B., *Impressionism in Perspective*, Englewood Cliffs, N. J., 1978

Elisseeff, V., *Grandes et petites heures du Parc Monceau - Homage à Thomas Blaikie (1750–1838): jardinier ecossais du Duc d'Orléans*, exh. cat., Musée Cernuschi, Paris, 1981

Ernouf, A. A., and A. Alphand, *L'Art des jardins*, 3rd , amplified, edn, Paris, n.d. c. 1870s (first pub. 1868; 5th edn, 1886)

Flint, K. (ed.), *Impressionists in England. The Critical Reception*, London and Boston, 1984

Florisoone, M., 'Renoir et la famille Charpentier: Lettres inédites', *L'Amour de l'art*, Feb. 1938, pp 31–40

Forestier, J. C. N., 'Le Jardin de Claude Monet', *Fermes et Châteaux*, Sept. 1908, pp. 13–16

Forestier, L., and P. Pia, *Oeuvres complètes de Charles Cros*, pub. Pauvert, 1964

Foulon, B., *Berthe Morisot*, exh. cat., Musée des Beaux-Arts, Lille and Fondation Pierre Gianadda, Martigny, Paris and Martigny, 2002

Fournel, V., *Paris nouveau et Paris futur*, 2nd edn, Paris and Lyons, 1868 (first pub. 1865)

——, *Paris et ses ruines en mai 1871, précédé d'un coup d'oeil sur Paris de 1860 à 1870*, Paris, 1874

Fowle, F., and R. Thomson (eds), *Soil and Stone: Impressionism, Urbanism, Environment*, Aldershot and Burlington, Ver., 2003

Frascina, F., et al., *Modernity and Modernism: French Painting in the Nineteenth Century*, New Haven and London in association with the Open University, 1993

Gage, J., *Colour and Culture: Practice and Meaning from Antiquity to Abstraction*, London, 1993

Galiègue, J., et al., *Henri Le Sidaner en son jardin de Gerberoy 1901–1939*, exh. cat., Beauvais, pub. Beauvais and Saint-Rémy-en-l'Eau, 2001

Geelhaar, C., et al., *Claude Monet: Nymphéas: Impression: Vision*, exh. cat., Kunstmuseum, Basel, 1986

Geffroy, G., *Claude Monet: sa vie, son oeuvre* (ed. C. Judrin), Paris, 1980 (reprint of 1st edn, 1924)

Georgel, P., *Monet: le cycle des 'Nymphéas'*, exh. cat., Musée de l'Orangerie, Paris, 1999

Gerdts, W. H., *Down Garden Paths*, exh. cat., Montclair Art Museum, N. J., Cranbury, N. J., London, and Mississauga, Ont., 1983

——, *American Impressionism*, New York, 1984

——, et al., *En Plein Air: The Art Colonies at East Hampton and Old Lyme 1880–1930*, exh. cat., Old Lyme, Conn., and East Hampton, New York, 1989

——, *Lasting Impressions: American Painters in France 1865–1915*, Illinois, 1992

——, *Monet's Giverny. An Impressionist Colony*, New York, London, and Paris, 1993

Gillet, L., 'L'Epilogue de l'impressionisme: les "Nymphéas" de M. Claude Monet', *La Revue hebdomadaire*, 21 Aug. 1909, pp. 397–415

——, 'Après l'Exposition Claude Monet: le testament de l'impressionisme', *Revue des deux mondes*, 1 Feb. 1924, pp. 661–73

Girard, P., *Firmin-Girard 1838–1921*, Luchon, 1988

Goncourt, E. de, *La Maison d'un artiste* (1880), in *Oeuvres complètes*, XXXIV–XXXV, Geneva and Paris, 1986

——, *Hokusai*, Paris, 1896 (1st pub. 1895), in M. Forrer, *Hokusai (with texts by Edmond de Goncourt)*, New York, 1988

Goody, J., *The Culture of Flowers*, Cambridge, 1993

Gordon, R., 'The Lily Pond at Giverny', *Connoisseur*, Nov. 1973, pp. 154–65

—— and A. Forge, *Monet*, New York, 1983

Grad, B., and T. Riggs, *Visions of City and Country Prints and Photographs of 19th-Century France*, exh. cat. Worcester, Mass., 1982

Gray, C., *Armand Guillaumin*, Chester (Conn.), 1972

——, *Armand Guillaumin: de la lumière à la couleur*, exh. cat., Musée d'Art et d'Histoire, Belfort, 1997

Groom, G., *Edouard Vuillard Painter-Decorator Patrons and Projects, 1892–1912*, New Haven and London, 1993

——, *Beyond the Easel: Decorative Painting by Bonnard, Vuillard, Denis and Roussel, 1890–1930*, exh. cat., Chicago and New York, pub. New Haven and London, 2001

Gubernatis, A. de, *La Mythologie des plantes ou les légendes du règne végetal*, vol. I, pub. Connaissances et Mémoires Euopéennes, 1996 (reprint of 1878 edition)

Guide de l'étranger dans Paris et ses environs, Hôtel du Louvre, Paris, 1874

Guillaud, J. and M., et al., *Claude Monet au temps de Giverny*, exh. cat., Centre Culturel du Marais, Paris, 1983

Guillemot, M., 'Claude Monet', *Revue illustrée*, vol. I, March 1898 [unpag.]

Gunnarsson, T., *Nordic Landscape Painting in the Nineteenth Century*, New Haven and London, 1998

——, *Impressionism and the North: the late nineteenth-century French avant-garde and the arts in Nordic countries, 1870–1920*, exh. cat., National Museum, Stockholm and Copenhagen, 2002

Haddad, H., *Le Jardin des peintres*, Paris 2000

Hadfield, M., *A History of British Gardening*, 3rd edn, London, 1979

Hale, N., *Mary Cassatt*, New York, 1975

Hardouin-Fugier, E., 'Simon Saint-Jean et le symbolisme végétal au Musée des Beaux-Arts de Lyon', *Bulletin des musées et monuments lyonnais*, VI, no. 4, 1977

——, and E. Grafe, *The Lyons School of Flower-Painting*, Leigh-on-Sea, 1978

——, *French Flower Painters of the Nineteenth Century: A Dictionary* (ed. P. Mitchell), London, 1989

Hauptman, W., *Charles Gleyre 1806–1874*, 2 vols. Zurich, 1996 [catalogue raisonné]

Haussmann, G. E., *Mémoires du Baron Haussmann*, 3rd edn, 3 vols, Paris, 1893

Heard Hamilton, G., *Manet and his Critics*, New Haven and London, 1986

Helmreich, A., *The English Garden and National Identity: The Competing Styles of Garden Design, 1870–1914*, Cambridge, 2002

Herbert, R. L., 'City and Country: the rural image in French Painting from Millet to Gauguin', *Art Forum*, Feb. 1970, pp. 44–55

——, 'Method and Meaning in Monet', *Art in America*, Sept. 1979, pp. 90–108

——, *Impressionism: Art, Leisure and Parisian Society*, New Haven and London, 1988

——, *Monet on the Normandy Coast: Tourism and Painting 1867–1886*, New Haven and London, 1994

——, *Nature's Workshop: Renoir's Writings on the Decorative Arts*, New Haven and London, 2000

Heusch, S. Goyens de, *L'Impressionisme et le Fauvisme en Belgique*, exh. cat., Musée d'Ixelles and Museum van Elsene, Ludion, Brussels, 1990

Hiesinger, U. W., *Impressionism in America: The Ten American Painters*, Munich, 1999

Hill, M. Brawley, *Grandmother's Garden: The Old-Fashioned American Garden 1865–1915*, New York, 1995

Hillairet, J., *Dictionnaire historique des rues de Paris*, 2 vols., 10th edn, Paris, 1997

Hobbs, R. (ed.), *Impressions of French Modernity: Art and Literature in France 1850–1900*, Manchester and New York, 1998

Hobhouse, P., *Plants in Garden History*, Pavilion, 1992

——, *Gardening through the Ages. An Illustrated History of Plants and their Influence on Garden Styles*, New York and London, 1992

—— and C. Wood, *Painted Gardens: English Watercolours 1850–1914*, London, 1988

Hocquart, E., *Guide du parfait jardinier-fleuriste*, Paris, 1873

Hohenzollern, J. G. Prinz von, and P.-K. Schuster, *Manet bis Van Gogh: Hugo von Tschudi und der Kampf um die Moderne*, exh. cat., Berlin and Munich, enlarged edn, Munich and New York, 1997

Holmes, C., *Monet at Giverny*, London, 2003

Hoog, M., *The Nymphéas of Claude Monet at the Orangerie*, Paris, 1987

Hoschedé, J.-P., *Claude Monet ce mal connu: intimitié familiale d'un demi-siècle à Giverny de 1883 à 1926*, 2 vols, Geneva, 1960

House, J., 'Renoir and the Earthly Paradise', *Oxford Art Journal*, vol. 8, no. 2, 1985, pp. 21–7

——, *Monet: Nature into Art*, New Haven and London, 1986

——, et al., *Renoir*, exh. cat., Hayward Gallery, London, Grand Palais, Paris and Museum of Fine Arts, Boston, 1985

——, et al., *Landscapes of France: Impressionism and its Rivals*, exh. cat., Hayward Gallery, London, and Museum of Fine Arts, Boston, 1995

——, 'Monet's Gladioli', *Bulletin of the Detroit Institute of Arts*, vol. 77, no. 1/2, 2003, pp. 8–17

Hunt, J. Dixon, 'Caillebotte and the Gardens of French Impressionism' [review of P. Wittmer, *Caillebotte and his Garden at Yerres*], *Apollo*, 124, August 1991, pp. 138–9

——, 'French Impressionist Gardens and the Ecological Picturesque', in J. Dixon Hunt (ed.), *Gardens and the Picturesque: Studies in the History of Landscape Architecture*, Cambridge, Mass., and London, 1992

Hyams, E., *A History of Gardens and Gardening*, London, 1971

Isaacson, J., 'Monet's Views of Paris', *Allen Memorial Art Museum Bulletin*, Oberlin College, Ohio, Autumn 1966, p. 422.

——, *Monet: Le Déjeuner sur l'Herbe*, London and New York, 1972

——, *Claude Monet: Observation and Reflection*, Oxford, 1978

——, J.-P. Bouillon et al., *The Crisis of Impressionism, 1878–1882*, exh. cat., University of Michigan Museum of Art, Ann Arbor, 1979

Jekyll, G., *Colour in the Flower Garden*, London, 1908
Joel, D., *Monet at Vétheuil*, Woodbridge, 2002
Jolles, A., et al., *The Second Empire: Art in France under Napoleon III*, exh. cat., Philadelphia Museum of Art and Grand Palais, Paris, Paris, 1978
Jourdan, A. et al., *Frédéric Bazille Prophet of Impressionism*, exh. cat., Musée Fabre, Montpellier, Brooklyn Museum of Art, Dixon Gallery and Gardens, Memphis, 1992
Joyes, C., et al., *Monet at Giverny*, London, 1975

Kahn, M., 'Le Jardin de Claude Monet', *Le Temps*, 7 June 1904
Kemp, G. van der, *A Visit to Giverny*, Versailles, 2001
Kendall, R. (ed.), *Monet by Himself*, London, 1989
Kern, S., et al., *A Passion for Renoir, Sterling and Francine Clark Collect, 1916–1951*, exh. cat., Clark Institute, Williamstown, 1996
Keyes, D. and J. Simon (eds.), *Crosscurrents in American Impressionism at the Turn of the Century*, Georgia, 1996
Kilmer, N., L. McWhorter, et al., *Frederick Carl Frieseke: The Evolution of an American Impressionist*, Princeton, 2001
Knight, P., *Flower Poetics in Nineteenth-Century France*, Oxford, 1986
Kropotkin, P., *The Conquest of Bread and Other Writings* (ed. M. S. Schatz), Cambridge, 1995

La Bédollière, E. de, *Histoire des environs du nouveau Paris*, Paris, 1860
La Tour, C. de, *Le Langage des fleurs*, 6th edn, Paris, 1845
Larousse, P., *Grand Dictionnaire universel du dix-neuvième siècle*, 15 vols, Paris, 1866–78 and 2 supplementary vols, Paris, 1878–90
Le Coeur, M., *Charles le Coeur (1830–1906), architecte et premier amateur de Renoir*, exh. cat., Musée d'Orsay, Paris, 1996
'Le Gaulois à la Galerie Georges Petit. Exposition Claude Monet', *Supplément au Journal* Le Gaulois, 16 June, 1898
Lefèvre, A., *Les Parcs et jardins*, Paris, 1871
Legarrec, B., *Photographies: Parc et Château de Rottemburg Montgeron: sur les traces de Claude Monet* Montgeron, exh. cat., Musée de Brunoy, 1986
Lemirre, E., and J. Cottin, 'D'un paradis l'autre: la mort-fleur', *Revue des sciences humaines*, Lille, no. 264, Oct.–Dec. 2001, pp. 111–36
'Les Joies du jardinage', extract from the *Magasin pittoresque*, in *Flore des serres et jardins de l'Europe*, VII, 1850–1, pp. 230–1
Levine, S. Z., *Monet and his Critics*, New York and London, 1976
——, 'Décor, Decorative, Decoration in Claude Monet's Art', *Arts Magazine*, Feb. 1977, pp. 136–7
——, *Monet, Narcissus and Self-Reflection: The Modernist Myth of the Self*, Chicago, London, 1994
Lhote, P., 'Mademoiselle Zélia', *La Vie moderne*, Paris, 11 Nov., 1883, pp. 707–8
Lloyd. C. (ed.), *Studies on Camille Pissarro*, London and New York, 1986
——, et al., *Retrospective Camille Pissarro*, exh. cat., Tokyo, Fukoka, and Kyoto (Kyoto, 1984) (international edition)
Lloyd, R., *Mallarmé: the Poet and his Circle*, Ithaca and London, 1999

Macmillan, J.F., *Napoleon III*, London, 1991
Mainardi, P., *Art and Politics of the Second Empire: The Universal Exhibitions of 1855 and 1867*, New Haven and London, 1987

——, *The End of the Salon: Art and the State in the Early Third Republic*, Cambridge, 1993
Mallarmé, S., 'The Impressionists and Edouard Manet', *The Art Monthly Review and Photographic Portfolio*, 1, no. 9, 30 Sept. 1876, pp. 117–22 (reprinted in Berson (ed.), *The New Painting*, I, pp. 91–7)
Mangin, A., *Les Jardins: histoire et description*, Tours, 1867
Marx, R., 'Les Nymphéas de Claude Monet', *Gazette des beaux-arts*, 4th period, vol. I, 1909, pp. 523–31
Mauner, G., *Manet, peintre-philosophe: a Study of the Painter's Themes*, University Park, London, Penn., 1975
McConkey, K., *British Impressionism*, Oxford, 1989
——, *Impressionism in Britain*, exh. cat., Barbican Art Gallery, London, London, 1995
——, *Memory and Desire: Painting in Britain and Ireland at the turn of the Twentieth Century*, Aldershot and Burlington, V.T., 2002
Michel, F. B., *Frédéric Bazille*, Paris, 1992
Michelet, J., *Oeuvres complètes de Michelet* (ed. P. Viallaneix), Paris, 1985–
——, *Nos Fils*, in *Oeuvres complètes*, XX, Paris, 1987
——, *La Femme*, in *Oeuvres complètes*, XX, Paris, 1987
Mirbeau, O., *Octave Mirbeau: Correspondance avec Claude Monet* (ed. P. Michel and J.-F. Nivet), Tusson, Charente, 1990
——, *Octave Mirbeau: Correspondance avec Camille Pissarro* (ed. P. Michel and J.-F. Nivet), Tusson, Charente, 1990
——, *Combats esthétiques*, 2 vols (ed. P. Michel and J.-F. Nivet), Nouvelles Editions Séguier, 1993
Moffett, C. N. , et al., *The New Painting: Impressionism 1874–1886*, exh. cat., The Fine Arts Museums of San Francisco and the National Gallery of Art, Washington, D. C., 1986
Monneret, S., *L'Impressionisme et son époque: Dictionnaire international illustré*, 4 vols., Paris 1987 (first pub. 1978–1981)
Moore, A. and C. Garibaldi (introd. A. Pavord), *Flower Power: the Meaning of Flowers in Art*, exh. cat., Norwich Castle Museum and Art Gallery and The Millenium Galleries, Sheffield, London 2003
Morizet, A., *Du vieux Paris au Paris moderne: Haussmann et ses prédécesseurs*, Paris, 1932
Mosser, M., 'Jardins "fin-de-siècle" en France: historicisme, symbolisme, et modernité', *Revue de l'art*, no. 129, 2000, pp. 41–60.
——, *The History of Garden Design: the Western tradition from the Renaissance to the Present Day*, London, 2000
——, and P. Nys (eds.), *Le Jardin, art et lieu de mémoire*, Les Editions de l'Imprimeur, 1995

Neuville, A. de, *Le Véritable Langage des fleurs*, Paris, 1863
Nevins, D., 'Morris, Ruskin and the English Flower Garden', *Antiques*, vol. 129, June 1986
Newman, S.M. (introd. J. Russell), *Bonnard: The Late Paintings*, London, 1984 (English edition of earlier French publication)
Newton, J., 'Emile Zola impressioniste' (2 parts), *Les Cahiers naturalistes*, no. 33, 1967, pp. 39–52, and no. 34, 1967, pp. 124–38
Nochlin, L. (ed.), *Impressionism and Post-Impressionism: Sources and Documents, 1874–1904*, Englewood Cliffs, N.J., 1966
Nora, P. (ed.), *Les Lieux de mémoire*, 3 parts. I, *La République*, Paris, 1984; II, *La Nation*, Paris, 1986; III, *Les France*, Paris, 1992
—— (ed.), *Realms of Memory. Rethinking the French Past* (transl. L. D. Kritzman), 3 vols., New York and Chichester, 1996–8
Nord, P., *Impressionists and Politics: Art and Democracy in the Nineteenth Century*, London and New York. 2000

Olson, S., et al., *Sargent at Broadway The Impressionist Years*, New York and London, 1986

Paris, Guide par les principaux écrivains et artistes de la France, 2 vols, Paris, 1867
Park und Garten in der Malerei, exh. cat., Wallraf-Richartz Museum, Cologne, 1957
Peel, E. (ed.), *Joaquín Sorolla y Bastida*, London, 1989
Perillon, Y., et al., *Images des jardins: promenade dans l'histoire des jardins français* exh. cat., Musée national des monuments français, Paris, 1987
Pétry, C., et al., *L'Ecole de Rouen de l'impressionisme à Marcel Duchamp 1878–1914*, exh. cat., Musée des Beaux-Arts de Rouen, 1996
Peyré, Y. (ed.), *Mallarmé 1842–1898: un destin d'écriture*, Paris, 1998
Philipponneau, M., *La Vie rurale de la banlieue parisienne: etude de géographie humaine*, Paris, 1956
Pingeot, A. and R. Hoozee (eds.), *Paris Bruxelles Bruxelles Paris: réalisme, impressionisme, symbolisme, art nouveau. Les relations artistiques entre la France et la Belgique, 1848–1914*, exh. cat., Grand Palais, Paris and Musée des Beaux-Arts, Ghent, 1997
Pinkney, D. A., *Napoleon III and the Rebuilding of Paris*, Princeton, 1958
Pisano, R.G., *Idle Hours: Americans at Leisure 1865–1914*, Boston, Toronto and London, 1988
Pissarro, C., *Correspondance de Camille Pissarro* (ed. J. Bailly-Herzberg), 4 vols. I, 1865–1885 (Paris, 1980); II, 1886–1890 (Paris, 1986); III, 1891–1894 (Paris, 1988), IV, Paris, 1989
Pissarro, J., *Camille Pissarro*, New York, 1993 (French edn, Paris, 1995)
——, *Monet and the Mediterranean*, exh. cat., Kimbell Museum, Fort Worth and touring, New York, 1997
Pissarro, L. R., and L. Venturi, *Camille Pissarro, son art-son oeuvre*, 2 vols, Paris, 1939
Posner, D., 'The Swinging Women of Watteau and Fragonard', *Art Bulletin*, LXIV, no. 1, March 1982, pp. 75–88
Pouzet, E., 'La plus belle oeuvre de Claude Monet. Le Jardin de Giverny', *Jardinage*, Jan. 1927, pp. 98–100
Proudhon, P.-J., *Du Principe de l'art et de sa destination sociale* (ed. C. Bouglé and H. Moysset), Paris, 1939

'Rapport sur la visite faite aux jardins de la Ville du Havre', *Bulletin du Cercle Pratique d'Horticulture et de Botanique de l'arrondissement du Havre*, 1862, p. 63
Reed, N., *Pissarro in West London (Kew, Chiswick, Richmond)*, London, 1997
Reff, T., *Manet and Modern Paris*, Washington, 1982
Renoir, E., 'L'Etiquette', *La Vie moderne*, Paris, 15 and 29 Dec., 1883, pp. 799 and 831
Renoir, J., *Renoir, my Father*, London, 1962
Rewald, J., *The History of Impressionism*, 4th edn, London, 1973
——, *Studies in Impressionism*, London, 1985
——, and F. Weizenhoffer, *Aspects of Monet: A Symposium on the artist's life and times*, New York, 1984
Riout, D. (ed.), *Les Ecrivains devant l'impressionisme*, Paris, 1989
Rivière, G., 'L'Exposition des impressionistes', *L'Impressionisme*, 6 April 1877, in Berson (ed.), *The New Painting*, I, pp. 179–81
——, *Renoir et ses amis*, Paris, 1921
Robida, M., *Le Salon Charpentier et les impressionistes*, Paris, 1958
Robinson, J. H., and D. R. Cartwright, *An Interlude in Giverny*, exh. cat., Palmer Museum of Art, The Pennsylvania State University and Musée d'Art Américain, Giverny, Penn., and Giverny, 2000

Robinson, W., *Parks, Promenades and Gardens of Paris described and considered in relation to the wants of our own cities and of public and private gardens*, London, 1869

——, *The Wild Garden, or, Our Groves & Shrubberies Made Beautiful*, London, 1870

——, *The English Flower Garden*, London, 1883

Rocher-Juneau, M., et al., *Fleurs de Lyon 1807–1917*, exh. cat., Musée des Beaux-Arts, Lyons, 1982

Rodin, A., *Les Cathédrales de France* (introd. L. Bénédite), Paris, 1921 (1st pub. 1914)

Roos, J. Mayo, *Early Impressionism and the French State, 1866–1874*, Cambridge, 1996

Russell, V., *Monet's Waterlilies...the inspiration of a floating world*, London, 1998

Sarradin, E., 'Les "Nymphéas" de Claude Monet', *Journal des Débats*, 12 May 1909

Schulman, M., *Frédéric Bazille 1841–1870: Catalogue raisonné: Sa vie, son oeuvre, sa correspondance*, Paris, 1995

Seiberling, G., *Monet's Series*, New York, 1981

Shennan, M., *Berthe Morisot: First Lady of Impressionism*, Thrupp, Stroud, 1996

Shiff, R., *Cézanne and the End of Impressionism*, Chicago, 1984

——, 'The Work of Painting: Camille Pissarro and Symbolism', *Apollo*, vol. 136, part 2, Nov. 1992, pp. 307–10

Shikes, R. E., and Harper, P., *Pissarro: His Life and Work*, London, 1980

Shimoyama, H. et al., *Kurihara Chuji: A Bridge to British Art*, exh. cat., Shizuoka Prefectural Museum of Art, 1991

Sieveking, A. F., *In Praise of Gardens*, London, 1899

Silverman, D., *Art Nouveau in Fin-de-siècle France: Politics, Psychology and Style*, Berkeley, Los Angeles and London, 1989

Smart, A., *Alfred Sisley (1839–1899), Impressionist Landscapes*, exh. cat., Nottingham University Art Gallery, 1971

Smith, P., *Impressionism: beneath the Surface*, London, 1995

Soprani, A., *Paris jardins: Promenade historique dans les parcs et jardins de chaque arrondissement*, Paris, 1998

Sorolla, F. P., *The Painter Joaquín Sorolla y Bastida*, London, 1989

Spate, V., *The Colour of Time: Claude Monet*, London, 1992

——, et al., *Monet and Japan*, exh. cat., National Gallery of Australia, Canberra, and Perth, Australia, 2001

Stevens, M. (ed.), *Alfred Sisley*, exh. cat., Royal Academy, London, Musée d'Orsay, Paris and Walters Art Gallery, Baltimore, New Haven and London, 1992

Strong, R., *The Artist and the Garden*, New Haven and London, 2000

Stuckey, C. F., 'Blossoms and Blunders: Monet and the State, II', in *Art in America*, Sept. 1979, pp. 109–25

——, *Claude Monet 1840–1926*, exh. cat., Chicago, pub. Chicago and London, 1995

—— (ed.), *Monet A Retrospective*, New York, 1985

——, and R. Gordon, 'Blossoms and Blunders: Monet and the State', *Art in America*, Jan.–Feb., 1979, pp. 102–17

——, and W. P. Scott, *Berthe Morisot, Impressionist*, London, 1987

Stützinger, U., et al., *Charles Gleyre ou Les Illusions perdues*, exh. cat., Schweizerisches Institut für Kunstwissenschaft, Zurich, 1974

'T', 'The Abbot's Grange and Russell House, Broadway, Worcestershire. The Residence of Mr. F. D. Millet', *Country Life*, 14 Jan., 1911, pp. 54-61

Tabarant, A., *Manet et ses oeuvres*, 4th edn, Paris, 1947

Taylor, G., *The Victorian Flower Garden*, London, 1952

Teut, A., *Max Liebermann: Gartenparadies am Wannsee*, Munich and New York, 1997

Thiébault-Sisson, F., 'Choses d'art: les derniers travaux de Claude Monet', *Le Temps*, 8 May 1909

——, 'Un nouveau musée parisien: les Nymphéas de Claude Monet à l'orangerie des Tuileries', *Revue de l'art ancien et moderne*, vol. 52, June 1927, pp. 40–52

Thomson, B., 'Camille Pissarro and Symbolism: some thoughts prompted by the recent discovery of an annotated article', *The Burlington Magazine*, CXXIV, no. 946, 1982, pp. 14–22

——, *Vuillard*, London, 1993

——, *Impressionism: Origins, Practice, Reception*, London 2000

Thomson, R., *Camille Pissarro: Impressionism, Landscape and Rural Labour*, exh. cat., South Bank Centre, London and touring, London 1990

—— (ed.), *Framing France: the Representation of Landscape in France, 1870–1914*, Manchester, 1998

——, and M. Clarke, *Monet to Matisse: Landscape Painting in France 1874–1914*, National Gallery of Scotland, Edinburgh, 1994

Tinterow, G., and H. Loyrette, *Origins of Impressionism*, exh. cat., The Metropolitan Museum of Art, New York, New York, 1994

Toulgouat, P., 'Peintres américains à Giverny', *Rapports France-Etats Unis*, no. 62, May 1952

Toussaint, A., and J.-P. Hoschedé, *Flore de Vernon et de la Roche-Guyon*, Rouen, 1898

Truffaut, G., 'Le Jardin de Claude Monet', *Jardinage*, no. 87, Nov. 1924, pp. 54–9

Tucker, P. Hayes, *Monet at Argenteuil*, New Haven and London, 1982

——, *Monet in the 90s: the Series Paintings*, exh. cat., Museum of Fine Arts, Boston and London, pub. New Haven and London, 1989

——, *Claude Monet: Life and Art*, New Haven and London, 1995

——, *The Impressionists at Argenteuil*, New Haven and London, 2000

——, *Claude Monet: Life and Art*, New Haven

—— (ed.), *Manet's Déjeuner sur l'herbe*, Cambridge, 1998

——, et al., *Monet: Late Paintings of Giverny from the Musée Marmottan*, New York, 1995

——, et al., *Monet in the 20th Century*, exh. cat., Museum of Fine Arts, Boston, and Royal Academy of Arts, London, New Haven and London, 1998

Vallès, J., *L'Enfant*, in *Oeuvres*, II, 1871–1885 (ed. R. Bellet), Gallimard, 1990

Varnedoe, K., *Gustave Caillebotte*, New Haven and London, 1987

——, *Northern Light: Nordic Art at the Turn of the Century*, New Haven and London, 1988

Vauxelles, L., 'Un Après-midi chez Claude Monet', *L'Art et les artistes*, 7 Dec., 1905

Venturi, L., *Les Archives de l'impressionisme*, 2 vols, Paris and New York, 1939

Viaud-Bruant, J., *Jardins d'artistes; les peintres-jardiniers modernes*, Poitiers, 1925

Vilmorin, H., 'La Villa Thuret', Report of the 'Session extraordinaire à Antibes, mai 1883', *Bulletin de la Société Botanique de France*, 30, 1883, pp. XXVI–XLIX

Vilmorin, M.-L. de, 'Les Nymphaea rustiques', *Revue horticole*, 1891, pp. 17–22

Vilmorin-Andrieux et cie, *Les Fleurs de pleine terre, comprenant la description et la culture des fleurs annuelles, bisannuelles, vivaces et bulbeuses de pleine terre...avec des plans de jardins et de parcs paysagers avec notes explicatives et exemples de leur ornementation par Edouard André*, 4th edn, Paris, 1894 (first pub. 1863)

Vitet, L., *Etudes sur l'histoire de l'art: Quatrième série: Temps modernes*, Paris, 1864

Vollard, A., *Renoir: An Intimate Record*, New York, 1934

Walter, R., 'Les Maisons de Claude Monet à Argenteuil', *Gazette des beaux-arts*, 108th year, 6th period, vol. 68, 1966, pp. 333–42

——, 'Emile Zola and Claude Monet', *Les Cahiers naturalistes*, 1964, no. 26, pp. 51–61

Ward, M., *Pissarro, Neo-Impressionism and the Spaces of the Avant-Garde*, Chicago and London, 1996

Warner, M., and N. R. Marshall, *James Tissot: Victorian Life. Modern Love*, New Haven and London, 1999

Watkins, N., *Bonnard*, London, 1994

Weinberg, H. B., et al., *American Impressionism and Realism The Painting of Modern Life, 1885–1915*, exh. cat., The Metropolitan Museum of Art, New York, New York, 1994

Weizenhoffer, F., *The Havemeyers: Impressionism comes to America*, New York, 1986

White, B. E., *Renoir: His Life, Art and Letters*, New York, 1988

——, *Impressionists Side by Side. Their Friendships, Rivalries, and Artistic Exchanges*, New York, 1996

Wildenstein, D., *Claude Monet: Biographie et catalogue raisonné*, 5 vols, Lausanne, 1974–91, (vol. 1, 1840–81, 1974; vol. 2, 1882–6, 1979; vol. 3, 1887–98, 1979; vol. 4, 1899–1926, 1985; vol. 5, additions, drawings, pastels, 1991); reprinted (without correspondence), Cologne, 1996, as *Monet, or, the Triumph of Impressionism* (4 vols)

—— (introd. C. S. Moffett and J. N. Wood), *Monet's Years at Giverny*, exh. cat., Metropolitan Museum of Art, New York, 1979

Willsdon, C. A. P., 'Baudelaire's "Le Voyage" and Maxime Du Camp's Middle Eastern Photography', in C. Smethhurst (ed.), *Romantic Geographies*, Glasgow, 1996

——, *Mural Painting in Britain 1840–1940: Image and Meaning*, Oxford, 2000

——, '"Promenades et Plantations": Impressionism, conservation, and Haussmann's reinvention of Paris', in F. Fowle and R. Thomson (eds), *Soil and Stone: Impressionism, Urbanism, Environment*, Aldershot and Burlington, Ver., 2003

Wilson-Bareau, J., *The Hidden Face of Manet*, exh. cat., Courtauld Institute Galleries, London, 1986

——, *Manet, Monet, and the Gare Saint-Lazare*, exh. cat., Musée d'Orsay, Paris and National Gallery of Art, Washington, D.C., 1998

—— (ed.), *Manet by Himself*, London, 1991

Wittmer, P., *Caillebotte and his Garden at Yerres*, New York, 1991 [English translation of *Caillebotte au jardin: la période de Yerres 1860–1879*, Château de Saint-Rémy-en-l'Eau, 1990]

Zaccone, P. *Nouveau langage des fleurs avec la nomenclature des sentiments dont chaque fleur est le symbole et leur emploi pour l'expression des pensées*, Paris, 1853

Zeldin, T., *France 1848–1945: Politics and Anger*, Oxford, 1979

Zola, E., *Ecrits sur l'art* (ed. J.-P. Leduc-Adine), Gallimard, 1991

——, 'Les Naturalistes', *L'Evénement illustré*, 24 May 1868, in *Ecrits sur l'art*

——, 'Les Squares', *Le Figaro*, 18 June 1867, in *Oeuvres complètes*, XIX

——, *Oeuvres complètes* (ed. H. Mitterand), Paris, 1966–

LIST OF ILLUSTRATIONS

Dimensions of works are given in centimetres and inches, height before width.

p. 1 Armand Guillaumin, *The Nasturtium Path*, c. 1880. Oil on canvas, 79.5 x 63.5 (31¼ x 25). Ny Carlsberg Glyptotek, Copenhagen

pp. 2–3 Claude Monet, *Main Path through the Garden at Giverny*, 1902. Oil on canvas, 89.5 × 92.3 (35¼ × 36⅜). Osterreichische Galerie, Vienna. Photo AKG

pp. 4–5 Gustave Caillebotte, *The Orange Trees*, 1878. Oil on canvas, 157.2 × 117.1 (61⅞ × 46⅛). Museum of Fine Arts, Houston: The John A. and Audrey Jones Beck Collection

1 Monet painting at Giverny, c. 1915, photograph. Private Collection

2 John Leslie Breck, *Garden at Giverny (In Monet's Garden)*, c. 1887. Oil on canvas, 46.0 × 56.6 (18⅛ × 21⅞). Terra Foundation for the Arts, Daniel J. Terra Collection

3 Camille Pissarro, *Compositional study of a male peasant placing a bean-pole in the ground* (c. 1894–1903), grey wash with chinese over black chalk, 15.2 × 9.2 (6 × 3⅝). Ashmolean Museum, Oxford

4 Claude Monet, *The Gardener of Graville*, pencil sketch signed 'le 5 septembre, Graville' in 1856 sketchbook. Sketchbook whereabouts unknown

5 Félix Braquemond, *Marie Bracquemond sketching on the Terrace of the Villa Brancas*, 1876. Etching 25.5 × 35.5 (10 × 14). British Museum, London

6 Edouard Manet, *Marguerite in the Garden at Bellevue*, 1880. Oil on canvas, 92 × 70 (36¼ × 27½). Foundation E.G. Buehrle Collection, Zurich

7 Gustave Caillebotte gardening at Petit Gennevilliers, photograph taken by Martial Caillebotte, February 1892. Private Collection

8 Henri Martin, *The Pond at Marquayrol*, c. 1930. Oil on canvas, 79.6 × 112.5 (31½ × 44⅜). Private Collection. Photo Christie's Images Ltd. © ADAGP, Paris and DACS, London 2004

9 Edouard Vuillard, *Morning in the Garden at Vaucresson*, 1923 (reworked 1937). Distemper on canvas, 151.2 × 110.8 (59½ × 43⅝). The Metropolitan Museum of Art, New York, Catharine Lorillard Wolfe Collection, Wolfe Fund, 1952. © ADAGP, Paris and DACS, London 2004

10 Pierre Bonnard, *The Garden*, c. 1936. Oil on canvas, 127 × 100 (50 × 39⅜). Musée du Petit Palais, Paris. © ADAGP, Paris and DACS, London 2004

11 Armand Guillaumin, *The Nasturtium Path*, c. 1880. Oil on canvas, 79.5 × 63.5 (31¼ × 25). Ny Carlsberg Glyptotek, Copenhagen

12 William Merritt Chase, *Lilliputian Boat-lake – Central Park*, c. 1890. Oil on canvas, 40.6 × 61 (16 × 24). Private Collection

13 Charles Marville, photograph of figures in the garden of the Bagatelle at the Bois de Boulogne, Paris, c. 1850s–60s. Musée Carnavalet, Paris. Photothèque des Musées de la ville de Paris

14 Eugène-Henri Cauchois, *The Train has Passed*, early 20th century. Oil on canvas, 166 × 186 (65¼ × 73⅛). Musées de la ville de Rouen

15 Pierre-Auguste Renoir, *Monet painting in his Garden at Argenteuil*, 1873. Oil on canvas, 46 × 60 (18⅛ × 23⅝). Wadsworth Atheneum, Hartford

16 Claude Monet, *Monet's Garden at Argenteuil (The Dahlias)*, 1873. Oil on canvas, 61 × 82.5 (24 × 32½) National Gallery of Art, Washington, Janice H. Levin Collection

17 William Merritt Chase, *The Open Air Breakfast*, c. 1888. Oil on canvas, 95.3 × 144 (37½ × 56¾). The Toledo Museum of Art, Gift of Florence Scott Libbey

18 Ludovic Piette, *Camille Pissarro painting in a Garden*, c. 1874. Gouache, dimensions unknown. Present whereabouts unknown (formerly Collection Bonin-Pissaro, Paris).

19 Joaquín Sorolla, *Louis Comfort Tiffany*, 1911. Oil on canvas, 155 × 225.4 (61 × 88⅞). The Hispanic Society of America, New York

20 Gustave Caillebotte, *Thatched Cottage at Trouville*, 1882. Oil on canvas, 54 × 65 (21¼ × 25⅝). The Art Institute of Chicago, Gift of Frank H and Louise B. Woods

21 Georges d'Espagnat, *Landscape at Cagnes*, c. 1913. Oil on canvas, 65.4 × 80.7 (25⅝ × 31⅞). Private Collection. Photo Christie's Images Ltd

22 Alfred Sisley, *View of Marly-le-roi from Coeur-Volant*, 1876. Oil on canvas, 65 × 92 (25⅝ × 36¼). Metropolitan Museum of Art, New York

23 Adolphe Binet, *The Convalescent*, late 19th century. Oil on canvas, 60.3 × 73.3 (23¾ × 28⅞). Musées de la ville de Rouen

24 Simon Saint-Jean, *The Gardener-Girl*, detail. See ill. 46

25 Louis-Léopold Boilly, *Outing in the Tuileries*, before 1845. Oil on wood, 14.2 × 19 (5½ × 7½). Musées de la ville de Rouen. Photo Catherine Lancien/Carole Loisel

26 Jean-Baptiste Camille Corot, *Florence, View from the Boboli Gardens*, 1834. Oil on canvas, 51 × 74 (20 × 29¼). Musée du Louvre, Paris.

27 Charles Gleyre, *The Terrestrial Paradise*, c. 1870. Oil on wood, 24 (9½) diameter. Musée Cantonal des Beaux-Arts, Lausanne

28 Charles Gleyre, *Flowers and Head* (sketch). Oil on canvas, 73 × 59.5 (28¾ × 23½). Musée Cantonal des Beaux-Arts, Lausanne

29 Eugène Delacroix, *Baron Schwiter*, 1826. Oil on canvas, 218 × 143.5 (85¾ × 56½). National Gallery, London

30 Marie-François Firmin-Girard, *Walk in the Park*, late 19th century, 83 x 116 (32⅝ x 45⅝). Oil on canvas. Private Collection

31 Constant Desbordes, *The Broken Wagon*, 1820s. Oil on canvas, 162 × 190 (63¾ × 74¾). Beauvais, Musée de l'Oise – Jean Louis Boutillier, Amiens

32 Antoine Watteau, *The Embarkation for Cythera*, 1717. Oil on canvas, 130 × 94 (51⅛ × 37). Musée du Louvre, Paris

33 Camille Rocqueplan, *Rousseau and Mlle. Galley gathering Cherries*, 1851. Oil on panel, 65.8 × 48 (25⅞ × 18⅞). By kind permission of the Trustees of the Wallace Collection, London

34 Pierre-Joseph Redouté, *Empress Josephine Rose*, early 19th century. Watercolour on vellum, 38 × 19 (15 × 7½). Al Wabra Nature History Library

35 Eugène Delacroix, *Overturned Basket of Flowers in a Park*, c. 1848. Oil on canvas, 107.3 × 142 (42¼ × 55⅞). Metropolitan Museum of Art, New York

36 Jean-Jacques Champin, after Régnier, view of the house and garden at Meudon of the flower painter

Redouté, lithograph, early 19th century. Collections Musée de l'Ile de France – Sceaux. Photo Benoit Chain

37 Simon Saint-Jean, *Offering to the Virgin*, 1842. Oil on canvas, 120 × 100 (47¼ × 39⅜). Musée des Beaux-Arts de Lyon

38 Pierre-Auguste Renoir, *Still Life, Arum and Flowers*, 1864. Oil on canvas, 130 × 98 (51⅛ × 38½). Kunsthalle Hamburg

39 Claude Monet, *Spring Flowers*, 1864. Oil on canvas, 116.5 × 91 (45⅞ × 35⅞). The Cleveland Museum of Art, Ohio

40 Jean-François Bony, *Spring*, 1804. Oil on canvas. Musée des Beaux-Arts de Lyon

41 Edouard Manet, *Branch of White Peonies with Secateurs*, 1864. Oil on canvas, 31 × 46.5 (12¼ × 18½). Musée d'Orsay, Paris

42 Antoine Berjon, *Peonies*, before 1843. Black crayon, white and red chalk on paper, 62 × 48 (24⅜ × 18⅞). Musée des Beaux-Arts de Lyon

43 Hippolyte Bayard, *The Bottom of the Garden*, c. 1850. Albumen on glass, 12.8 × 17.2 (5 × 6¾). Austin (Texas), Gernsheim Collection

44 Gustave Courbet, *Still Life with Poppies and Skull*, 1862. Oil on canvas, 36 × 29 (14⅛ × 11⅜). Private Collection

45 Gustave Courbet, *The Woman with Flowers (The Trellis)*, 1862. Oil on canvas, 109.8 × 135.3 (43¼ × 53¼). The Toledo Museum of Art, Purchased with funds from the Libbey Endowment. Gift of Edward Drummond Libbey

46 Simon Saint-Jean, *The Gardener-Girl*, 1837. Oil on canvas, 160 × 118 (63 × 45½). Musée des Beaux-Arts de Lyon

47 Edgar Degas, *Woman seated beside a Vase of Flowers*, detail. See ill. 48

48 Edgar Degas, *Woman seated beside a Vase of Flowers*, 1865. Oil on canvas, 173.7 × 92.7 (29 × 36½). Metropolitan Museum of Art, New York. H.O. Havemeyer Collection. Bequest of Mrs H.O. Havemeyer, 1929

49 Frédéric Bazille, *African Woman with Peonies*, 1870. Oil on canvas, 60 × 74 (23⅝ × 29⅛). National Gallery of Art, Washington (Collection of Mr and Mrs Paul Mellon)

50 Frédéric Bazille, *African Woman with Peonies*, 1870. Oil on canvas, 60 × 75 (23⅝ × 29½). Musée Fabre, Montpellier

51 Frédéric Bazille, *The Pink Dress*, 1864. Oil on canvas, 145 × 110 (57⅛ × 43⅜). Musée d'Orsay, Paris.

52 'Le Jardin du Luxembourg' (engraved drawing), in *Paris Guide par les principaux écrivains et artistes de la France*, Part 1: *La Science – l'Art*, Paris, 1867

53 Line illustration of a 'jardin artificiel' on p. 3 of Arthur Mangin, *Les Jardins Histoire et Description*, Paris, 1867. Photo BNF, Paris

54 *Pelargonium zonale iniquium*, coloured lithograph plate in A. Alphand, *Les Promenades de Paris*, 1867–73, vol. 2. Photo BNF, Paris

55 *Syringa (Lilas) Président Massart*. Plate 352 in *L'Illustration horticole*, Ghent, 1863. British Library, London

56 Honoré Daumier, 'As for me, I am leaving beaten paths…', lithograph from *Les Plaisirs de la villégiature* (The Pleasures of Life in the

127 Camille Pissarro, *The Pont-Neuf, the Statue of Henri IV: Sunny Winter Morning*, 1900. Oil on canvas, 73 × 93.6 (28¾ × 36½). Krannert Art Museum, University of Illinois at Urbana-Champaign

128 Henri Martin, mural in the *Mairie* of the Vth Arrondissement, Paris, 1932–5. Photo the Author. © ADAGP, Paris and DACS, London 2004

129 Berthe Morisot, *Hollyhocks*, 1884. Oil on canvas, 64 x 54 (25 x 21¼). Musée Marmottan, Paris. Photo Bridgeman Art Library

130 Edouard Manet, *In the Garden*, 1870. Oil on canvas, 44.5 × 54 (17½ × 21¼). Shelburne Museum, Shelburne, Vermont

131 Rodolphe Walter, photograph of 21 Boulevard Karl Marx, Argenteuil, c. 1965. Archives du Wildenstein Institute, Paris

132 Gustave Caillebotte, *Portraits in the Country*, 1876. Oil on canvas, 95 × 111 (51⅝ × 43¾). Musée Baron Gérard, Bayeux

133 Berthe Morisot, *In the Garden at Roche-Plate*, 1894. Oil on canvas, 38 x 55 (15 × 21⅝). Musée Marmottan, Paris. Photo Bridgeman Art Library

134 Claude Monet, *The Artist's Family in the Garden*, 1875. Oil on canvas, 61 × 80 (24 × 31½). Private Collection

135 Claude Monet, *The Luncheon* (exhibited as 'Decorative Panel'), 1873. Oil on canvas, 162 × 203 (63¾ × 79⅞). Musée d'Orsay, Paris

136 Photograph of Eugène Manet, Berthe Morisot, and their daughter Julie Manet in the garden at Bougival, 1880. Musée Marmottan, Paris

137 Berthe Morisot, *Eugène Manet and his daughter at Bougival*, 1881. Oil on canvas, 73 × 92 (28¾ × 36¼). Private Collection

138 Mary Cassatt, *Lydia crocheting in the Garden at Marly*, 1880. Oil on canvas, 66 × 94 (26 × 37). Metropolitan Museum of Art, New York, Gift of Mrs Gardner Cassatt, 1965

139 Gustave Caillebotte, *The Orange Trees*, 1878. Oil on canvas, 157.2 × 117.1 (61⅞ × 46⅛). Museum of Fine Arts, Houston: The John A. and Audrey Jones Beck Collection

140 Marie Bracquemond, *On the Terrace at Sèvres*, 1880. Oil on canvas, 88 × 115 (34⅝ × 45¼). Musée du Petit Palais, Geneva

141 Claude Monet, *Camille Monet on a Garden Bench*, 1873. Oil on canvas, 60 × 80 (23⅝ × 31½). Metropolitan Museum of Art, New York

142 Engraving of Firmin-Girard's *Grandmother's Garden*, 1876 from *L'Illustration*, 6 Nov. 1875. Photo BNF, Paris

143 Claude Monet, *The Artist's House at Argenteuil*, 1873. Oil on canvas, 60.5 × 74 (23⅝ × 29⅛). The Art Institute of Chicago

144 Claude Monet, *Gladioli*, 1876. Oil on canvas, 60 × 81.5 (23⅝ × 32⅛). Detroit Institute of Arts

145 *Fuchsia Varietates Hortenses* (Garden Fuchsia), plate 42 from *L'Illustration horticole*, vol. 2, 1855. Photo British Library, London

146 Claude Monet, *Camille at the Window*, 1873. Oil on canvas, 60 × 49.5 (23⅝ × 19½). Virginia Museum of Fine Arts, Richmond, Virginia

147 Camille Pissarro, *The Garden of the Mathurins, Pontoise*, 1876. Oil on canvas, 115 × 87.5 (45¼ × 34½). Nelson-Atkins Museum of Art, Kansas City, Missouri

148 Claude Monet, *Lilacs, Grey Weather*, 1872. Oil on canvas, 48 × 64 (18⅞ × 25¼). Musée d'Orsay, Paris

149 Edouard Manet, *The Monet Family in the Garden*, 1874. Oil on canvas, 61 × 99.7 (24 × 39¼). Metropolitan Museum of Art, New York

150 Pierre-Auguste Renoir, *Camille Monet and her Son Jean in the Garden at Argenteuil*, 1874. Oil on canvas, 50.4 × 68 (19⅞ × 26¾). National Gallery of Art, Washington, Ailsa Mellon Bruce Collection

151 Alfred Le Petit, *Gardening and Politics*, 1870s caricature. Photo Special Collections, University of Glasgow Library

152 Claude Monet, *Manet painting in Monet's Garden*, 1874. Original painting lost

153 Honoré Daumier, *Poor France!...The trunk has been struck by lightning, but the roots are holding firm! (Current events)*. Lithograph from 'Album du Siège', *Le Charivari*, 1 Feb. 1871. Photo BNF

154 Claude Monet, *The Luncheon*, detail. See ill. 135

155 Claude Monet, *The Luncheon*, detail. See ill. 135

156 Claude Monet, *Camille in the Garden, with Jean and his Nurse*, 1873. Oil on canvas, 60.5 × 81 (23¾ × 31⅞). Private Collection. Photo courtesy Foundation E.G. Buehrle Collection, Zurich

157 Pierre-Auguste Renoir, *Girl with a Watering-Can*, 1876. Oil on canvas, 100.3 × 73.2 (39½ × 28¾). National Gallery of Art, Washington. Chester Dale Collection 1962

158 Edouard Manet, *Boy in Flowers*, 1876. Oil on canvas, 60 × 97 (23⅝ × 38¼). The National Museum of Western Art, Tokyo

159 Claude Monet, *The Turkeys*, 1876–7. Oil on canvas, 172 × 175 (67¾ × 68⅞). Musée d'Orsay, Paris

160 Pierre-Auguste Renoir, *The Rose Garden at Wargemont*, 1879. Oil on canvas, 63.5 × 80 (25 × 31½). Private Collection, Paris

161 Pierre-Auguste Renoir, *The Daughters of Paul Durand-Ruel (Marie-Thérèse and Jeanne)*, 1882. Oil on canvas, 81.3 × 65.4 (32 × 25¾). Chrysler Museum of Art, gift of Walter P. Chrysler, Jr. in memory of Thelma Chrysler Foy

162 Claude Monet, *Monet's Garden at Vétheuil*, 1880. Oil on canvas, 150 × 120 (59 × 47¼). National Gallery of Art, Washington

163 Pierre-Auguste Renoir, *The Ball at the Moulin de la Galette*, detail. See ill. 164

164 Pierre-Auguste Renoir, *The Ball at the Moulin de la Galette*, 1876. Oil on canvas, 131 × 175 (51½ × 68¾). Musée d'Orsay, Paris

165 Pierre-Auguste Renoir, *The Swing*, 1876. Oil on canvas, 92 × 73 (36¼ × 28¾). Musée d'Orsay, Paris

166 Edouard Manet, *Chez le Père Lathuille*, 1879. Oil on canvas, 92 × 112 (36¼ × 44). Musée des Beaux-Arts, Tournai

167 Pierre-Auguste Renoir, *Picking Flowers*, 1875. Oil on canvas, 54.3 × 65.2 (21⅜ × 25⅝). National Gallery of Art, Washington, D.C., Ailsa Mellon Bruce Collection

168 Pierre-Auguste Renoir, *Nana, Pauline and the others*, 1878, watercolour illustration to Zola's *L'Assommoir*, inscribed by Zola. Courtesy of Bonhams Auctioneers

169 Berthe Morisot, *Young Woman dressed for the Ball*, 1879. Oil on canvas, 86 × 53 (33⅞ × 20⅞). Musée d'Orsay, Paris

170 Pierre-Auguste Renoir, *Garden in the rue Cortot, Montmartre*, 1876. Oil on canvas, 151.8 × 97.5 (59¾ × 38⅜). Museum of Art, Carnegie Institute, Pittsburg

171 Pierre-Auguste Renoir, *Study (Nude in Sunlight)*, 1876. Oil on canvas, 81 × 64.8 (31⅞ × 25½). Musée d'Orsay, Paris

172 Pierre-Auguste Renoir, *Young Girls in a Garden in Montmartre*, 1893–5. Oil on canvas, 37 × 50 (14½ × 25⅝). Private Collection

173 Pierre-Auguste Renoir, *Nini in the Garden*, 1875–6. Oil on canvas, 61.8 × 50.7 (24⅜ × 20). The Annenberg Collection, USA

174 Pierre-Auguste Renoir, *The Gardens of Montmartre, with view to Sacré Coeur under construction*, c. 1896. Oil on canvas, 32.5 × 41.3 (12¾ × 16¼). Bayerische Staatsgemälde-sammlungen, Neue Pinakothek, Munich. Photo Bridgeman Art Library

175 Martial Caillebotte, photograph of Renoir in the garden of his house in Montmartre, winter, with Sacré Coeur under construction in the background, c. 1891–2. Private Collection

176 Period postcard showing 'the private gardens of Old Montmartre: alley of the Château des Brouillards, 13 rue Girardon, June 1904'. Photo BNF, Paris

177 Edouard Manet, *In the Conservatory*, 1879. Oil on canvas, 115 × 150 (45¼ × 59). Nationalgalerie, Berlin

178 Sebastien-Charles Giraud, *Dining Room of the Princess Mathilde, rue de Courcelles*, 1854. Musée National du Château de Compiègne. Photo AKG

179 'Stop', cartoon of Edouard Manet's *In the Conservatory*, 1879. From *Le Journal Amusant*, 24 May 1879.

180 Edouard Manet, *Madame Manet in the Greenhouse*, 1879. Oil on canvas, 81 × 100 (31⅞ × 39⅜). Nasjonalgalleriet, Oslo

181 Edouard Manet, *Jeanne: Spring*, 1881. Oil on canvas, 73 × 51 (28¾ × 20). Private Collection

182 Pierre-Auguste Renoir, *Among the Roses (Portrait of Madame Clapisson)*, 1882. Oil on canvas, dimensions and present whereabouts unknown

183 Henri Gervex, *Madame Valtesse de la Bigne*, 1889. Oil on canvas, 200 × 122 (78⅜ × 48). Musée d'Orsay, Paris. Photo AKG

184 Armand Guillaumin, *Garden behind old Houses, Damiette*, detail. See ill. 202

185 Jean-François Millet, *In the Garden*, c. 1860. Watercolour and pastel over black conté crayon on laid paper, 31.5 × 37.5 (12⅜ × 14¾). Museum of Fine Arts, Boston

186 Edouard Manet, *The Artist*, 1875. Oil on canvas, 192 × 128 (75½ × 50⅜). Museu de Arte Moderna, São Paulo

187 Edouard Manet, *The Laundry (The Laundress)*, 1875. Oil on canvas, 145 × 115 (57⅛ × 45¼). Barnes Foundation

188 Alfred Le Petit, *The Sun*, caricature of Gambetta from the series 'Flowers, Fruits and Vegetables of the Day', from *L'Eclipse*, 12 Jan. 1871. Photo Special Collections, University of Glasgow Library

189 Berthe Morisot, *Laundresses Hanging out the Wash*, 1875. Oil on canvas, 33 × 40.6 (13 × 16). National Gallery of Art, Washington, Collection of Mr. and Mrs. Paul Mellon,

190 Gustave Caillebotte, *Yerres, in the Kitchen Garden, Gardeners watering Plants*, before 1879. Oil on canvas, 90 × 117 (35½ × 46). Private Collection

191 Gustave Caillebotte, *The Gardener*, 1877. Oil on canvas, 60 × 73 (23⅝ × 28¾). Private Collection

192 Camille Pissarro, *Orchard in Bloom, Louveciennes*, 1872. Oil on linen, 45.1 × 54.9 (17⅞ × 21⅝). National Gallery of Art, Washington. Ailsa Mellon Bruce Collection. 1970.17.51

193 Camille Pissarro, *Kitchen Garden at L'Hermitage, Pontoise*, 1874. Oil on canvas, 54 × 61.5 (21¼ × 25⅞). National Gallery of Scotland, Edinburgh

194 Camille Pissarro, *Hillside in the Hermitage, Pontoise*, 1873. Oil on canvas, 61 × 73 (24 × 28¾). Musée d'Orsay, Paris

195 Alfred Sisley, *Misty Morning*, 1874. Oil on canvas, 50 × 65 (19⅞ × 25⅝) Musée d'Orsay, Paris

196 Robert Antoine Pinchon, *Market Gardens*, exh. 1921. Oil on canvas, 74 × 100 (29⅛ × 39⅜). Musées de la ville de Rouen. Photo Catherine Lancien/Carole Loisel

197 Camille Pissarro, *The Hermitage at Pontoise*, 1867. Oil on canvas, 90 × 150 (35⅜ × 59). Wallraf-Richartz Museum, Cologne

ACKNOWLEDGMENTS

The preparation of this book was generously supported through awards from the Arts and Humanities Research Board and the Authors' Foundation, and by the University of Glasgow. Among the many people who have given practical support, answered queries, or prompted new ideas through their comments on my theme, I would like in particular to thank Prof. Richard Brettell (University of Texas at Dallas), Dr Dennis Farr, CBE (former Director of the Courtauld Institute Galleries, London), Emeritus Prof. Robert Herbert (Mount Holyoke College, USA), John House (Walter H. Annenberg Professor, Courtauld Institute of Art, London), Richard Thomson (Watson Gordon Professor of Fine Art, University of Edinburgh and Director of the Visual Arts Research Institute Edinburgh), Belinda Thomson (Honorary Fellow, University of Edinburgh), and Alison Yarrington (Richmond Professor of Fine Art and Head of Department of History of Art, University of Glasgow). For assistance with the identification of plants and flowers in a number of Impressionist paintings, I am indebted to Dr Eric Curtis, former Curator of the Botanic Gardens, Glasgow, and for information on, and access to, a variety of historic horticultural resources, to M. Yves M. Allain (Directeur du Service des Cultures, Muséum d'Histoire Naturelle, Paris). I would also like to give special thanks to M. Perrin (Fondation Wildenstein), for drawing my attention to a range of relevant works; M. Gerald van der Kemp, Director of the Musée Claude Monet, Giverny, for access to Monet's house and garden; and Prof. Dominique Durand, Doyen de la Faculté, Ecole de Pharmacie, Paris, and M. Elie Bzoura of the Société d'Histoire de la Pharmacie, Paris, for information on Besnard's murals. Marina Rainey gave valuable information about Goetze's murals. Vivien Hamilton, Curator of French art at the Burrell Collection in Glasgow, Dr Frances Fowle, Leverhulme Curator at the National Galleries of Scotland, and Claire Pace, Senior Research Fellow at the University of Glasgow have all given further much-appreciated encouragement and support.

Many curators, archivists and individuals gave me access to works in their care, or responded to queries and requests, and I would like in particular to thank Annie Barbera (Palais Galliéra, Paris); Mme. Billot (Bibliothèque Historique de la Ville de Paris); Isabelle Bleeker and Laïla Tourki (Musée d'Art et d'Histoire, Geneva); Gilles Chazal, Directeur of the Petit Palais des Beaux-Arts de la Ville de Paris; Dominique Brachlianoff, Mme Brun and Valéry Duruy (Musée des Beaux-Arts, Lyons); Josette Galiègue (Musée départemental de l'Oise, Beauvais); Mme. Hodel (Musée du Petit Palais, Geneva); Geneviève Lacambre and Martine Ferretti (Musée d'Orsay); Yann Farinaux-Le Sidaner; Catherine Régnault (Musée des Beaux-Arts, Rouen); MaryAnn Stevens (Royal Academy of Arts); Jennifer Vine (Royal Horticultural Society Lindley Library); Dr Peter and Janet Webster; and the staffs of the Musée d'Art Américain, Giverny; Royal Botanic Garden Library, Edinburgh; Bibliothèque de la Société Nationale d'Horticulture de la France; Roseraie du Val-de-Marne, L'Haÿ-les-Roses; and Special Collections Department, Glasgow University Library.

Finally, I would like to thank the staff at Thames & Hudson whose expertise and dedication have been so valuable in bringing this book to completion. Special thanks are due to my editor Christopher Dell, for his very thoughtful and detailed attention to the progress of the book through its various phases; to Jenny Drane and Suzanne Bosman, for their sterling efforts in picture research; to Sheila McKenzie for her attentive eye in production; and to Sally Jeffery for her design.

I hope that others who have in differing ways contributed to this project and who are not mentioned here will nonetheless regard themselves as included in these thanks.